THROUGH AMATEUR EYES

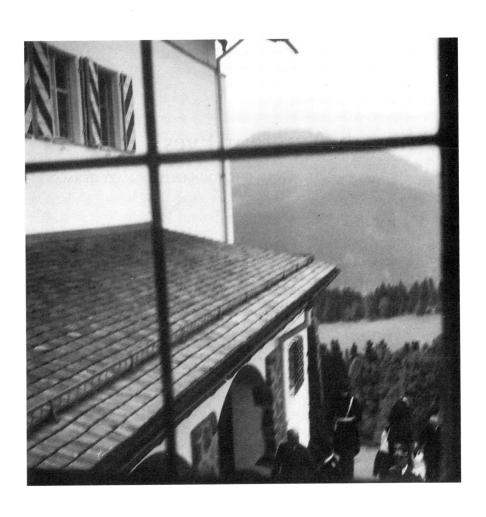

Through Amateur Eyes

FILM AND PHOTOGRAPHY IN NAZI GERMANY

Frances Guerin

University of Minnesota Press
Minneapolis
London

An earlier version of chapter 3 was published as "Reframing the Photographer and His Photographs," *Film and History* 32, no. 1 (2002): 43–54. Portions of chapter 4 were previously published as "The Energy of Disappearing: Problems of Recycling Nazi Amateur Film Footage," *Screening the Past* 17 (November 2004).

Published by the University of Minnesota Press
111 Third Avenue South, Suite 290
Minneapolis, MN 55401-2520
http://www.upress.umn.edu

Library of Congress Cataloging-in-Publication Data

Guerin, Frances.
 Through amateur eyes : film and photography in Nazi Germany / Frances Guerin.
 p. cm.
 Includes bibliographical references and index.
 ISBN 978-0-8166-7006-2 (hardback: alk paper)
 ISBN 978-0-8166-7007-9 (pb: alk paper)
 1. World War II, 1939–1945—Germany—Sources. 2. Germany—History—1933–1945—Sources. 3. Germany—Social conditions—1933–1945. 4. World War II, 1939–1945—Photography. 5. Vernacular photography—Germany—History—20th century. 6. World War II, 1939–1945—Destruction and pillage—Germany—Pictorial works. I. Title.
 DD253.G844 2012
 791.430943'09044—dc23
 2011030505

Printed in the United States of America on acid-free paper

The University of Minnesota is an equal-opportunity educator and employer.

18 17 16 15 14 13 12 10 9 8 7 6 5 4 3 2 1

For my friends

The critical aim . . . must . . . never be merely to deconstruct Holocaust narrative into so many columns of inert myths, grammars, and figures. Instead of engaging in a sterile pursuit of deep mythological, religious, and linguistic structures constituting only the literary texts of the Holocaust, the aim . . . is to explore both the plurality of meanings in the Holocaust these texts generate and the actions that issue from these meanings outside of the texts. Rather than merely deconstructing this narrative or its criticism, or de-historicizing it altogether, [the] attempt here [is] to re-historicize it by looking beyond interpretation to its consequences in history.

■ James Young, *Writing and Rewriting the Holocaust*

Its photographs . . . are customarily read for content and as illustrations of the well-known story of the immoral and barbaric ideology of the Nazi system. As long as the answer to the question as to what they show is known in advance, they will remain silent. . . . The questions as to what these images show, what they meant for the photographers and what they mean for us are answered neither by varied references to the murderous ideas of Nazi-racism nor by reference to the pathological psyche of actors. Only focusing on the concreteness of details and the iconography of the pictures will make "visible" what can be seen in the photos and break the blockade of silence.

■ Bernd Hüppauf, "Emptying the Gaze"

Contents

Acknowledgments

Writing *Through Amateur Eyes: Film and Photography in Nazi Germany* involved many people in archives and libraries, many of whom gave assistance with access to images and written material that did not always make it into the final manuscript. I am grateful to all of the archivists who gave of their time and knowledge at the Staatsbibliothek and the Stadtmuseum in Munich, the Bundesarchiv in Koblenz, the Bundesarchiv-Filmarchiv in Berlin, the Imperial War Museum and the British Library in London, and the Mémorial de la Shoah in Paris. I am also grateful to Dieter Schröder and Reinhard Schwarz at the Hamburg Institut für Sozialforschung. At the U.S. Holocaust Memorial Museum in Washington, D.C., Judith Cohen, Regina Longo, and Caroline Waddell were attentive and always helpful in facilitating my research, as were the archivists at the Library of Congress and the National Archives and Records Association in College Park, Maryland. In Poland, the State Archive in Lodz and the archive of the Jewish Historical Institute in Warsaw offered me exciting opportunities to research original documents, and I am grateful to the archivists at these institutions for their generous assistance. Alan Adelson showed me his duplicates of the Genewein photographs in 1997, a viewing that ignited my enthusiasm for the book. I am grateful to Harun Farocki, Péter Forgács, and Michael Kuball for material from their private collections and to Martina Roepke for her help in the early stages of the project.

Initial research for the book was generously funded by fellowships from the University of Kent, the Leverhulme Trust, and the British Academy of England. The Marie Curie Intra-European Fellowship, within the Seventh European Community Framework Programme, awarded by the European Commission gave me a two-year leave from teaching to pursue the project. I appreciate the generous support of these institutions.

My sincere thanks go to all those involved in the administration of the Marie Curie Fellowship, especially to Michael Baudzus and Susanne

von der Heyden at Ruhr University, Bochum, Germany. Frank Kessler and Christine Nöll Brinkmann supported my work and the project from its inception to its completion, and colleagues at Bochum provided collegiality and enthusiasm during my time there. My special thanks go to Vinzenz Hediger for his encouragement, energy, and input into the book at all stages.

Audiences at various conferences pushed me to think through ideas in formation, from my early presentations at the German Studies Association conference in Washington and at Orphans in South Carolina to more recent presentations at Syracuse University. The Visible Evidence community has been an ongoing audience and interlocutor with the book at conferences and in individual exchanges over the years in which I wrote and researched it. Two anonymous readers for the University of Minnesota Press offered valuable feedback, and I thank them. For attentive readings of parts of the manuscript I am grateful to Roger Hallas, Joe McElhaney, James Polchin, and Alexandra Schneider. Roger Hallas provided critiques and penetrating insight into the ideas and structure of the book throughout its development; his bibliographical assistance and willingness to engage in ongoing conversation about every aspect of the project influenced my work in ways that are difficult to acknowledge.

For camaraderie and collegiality my special thanks go to Ruth Abbey, Jaclyn Geller, Roger Hallas, Vinzenz Hediger, Paul Hendley, Joe McElhaney, James Polchin, John David Rhodes, Peter Rosenbaum, Alexandra Schneider, and James Williams: an intellectual and professional life without them would be not only very lonely but ultimately not possible. To them, and to all my friends, I dedicate this book.

Alternate Perspectives from Nazi Germany

In his bold intervention into the controversy surrounding the "War of Extermination" on the Eastern Front, and particularly the participation of the Wehrmacht and its soldiers in this war, Bernd Hüppauf calls for new ways of looking at the photographs taken by soldiers and officers present to the crimes committed in the name of Nazism. Time and again, amateur images taken by German officers and soldiers on the Eastern Front in the death camps and the ghettos, and on the roads in between, have been understood in terms of their visual instantiation of Nazi ideology and, in particular, their virulent anti-Semitism. As Hüppauf articulately explains, this interpretation is predicated on two blind assumptions: first, that an image can be equated with the political allegiance of the one who looked through the viewfinder, and second, that the soldier behind the camera shared the positionality, the perspective, even the identity of those high-level Nazis who wrote and disseminated the racist concepts of Jews, Slavs, and other enemies to be destroyed.[1] Although neither of these assumptions stands up to scrutiny, such "misleading oversimplifications" keep the past in the distance and alleviate the potential threat it poses through extension into the present.

Through Amateur Eyes addresses these problems of hermeneutics by looking from a unique perspective at a series of still and moving amateur images taken by German officers, soldiers, and civilians, Nazis and non-Nazis, during World War II. The book sees them first and foremost as amateur images. Due to the limitations and, at times, the blindness that results from the myopic interpretation of the gaze of the German-as-perpetrator, I initially hold this perspective in abeyance. The interpretations of the images as illustrations of Nazi barbarity are based on the content of the films and photographs. Although *Through Amateur Eyes*

never ignores the images' content, that content is not the only focus of meaning. In my analysis, the content—often violent crimes, propagandistic manipulations, or, at best, skewed realities—is one of a number of elements that informs a denser, more nuanced understanding of the images, how they functioned, and their significance then and now. The multifaceted nature of my interpretation is, in turn, the basis on which I bring images of and from the past into a dynamic relationship with their perception in the present. Ultimately, this relationship gives way to the possibility of new modes of witnessing the atrocities of World War II and the Holocaust. Thus my history begins from the novel perspective of the images as amateur, rehistoricizes the images, and subsequently reimagines the historical narratives to which they belong. It also considers the historical consequences of prevailing interpretations. However, at no point do I forget the ideological weight of the films and photographs. Rather, the ideology of everyday life in Nazi Germany as it pervades these images is one of a number of possible interpretations. We need to move beyond the singularity of the political ideological perspective if we are to acknowledge and draw on the full implications of these images in our efforts to remember the traumas of the past. And at all times, as Hüppauf would have it, my focus begins with the "concreteness of details and the iconography of the pictures[s and] . . . make[s] 'visible' what can be seen in the photos and break[s] the blockade of silence."[2]

If there is discomfort in looking at and analyzing images of the trauma of those who suffered, we can be reassured by Georges Didi-Huberman's forceful argument that looking at such images is in itself an act that counters the dictates and desires of the Nazis. The members of the higher command did everything they could to eradicate all trace of their monstrous activities both during and at the end of the war. Thus, to look at and judge images of their crimes is, after Blanchot, to make visible that which they were determined would remain invisible.[3] Didi-Huberman argues for the imperatives of first imagining, and then being open to interpretations and efforts at memorializing and witnessing the Holocaust, efforts that might otherwise be seen as a violation of the victims' suffering. He discusses four images that were taken from inside the gas chamber of Crematorium V and subsequently smuggled out of Auschwitz by

resistance workers in August 1944. The images show a cremation in an open-air incineration pit, and in spite of what we see—naked corpses laid out before a billow of smoke, naked women being herded into the gas chambers—we have a responsibility to look at and to see these images. We must look because, however incomplete, however restricted or *"inexact,"* as Didi-Huberman explains, "the image of hell . . . is nonetheless part of the *truth* of Auschwitz."[4] It is only then that the silence and the denial of history can be lifted.

Didi-Huberman also takes issue with the argument that images of the victims of the Holocaust, whether taken by the perpetrators or anyone else, must be "destroyed." They must be destroyed because these images represent and thus "legitimize the position of the Nazi." He quotes J.-J. Delfour only to refute his argument that "to look at [an image filmed by the Nazi] necessarily implies taking the position of a spectator, exterior to the victims, to therefore adhere cinematically, perceptively, to the Nazi position itself."[5] For Didi-Huberman, the eschewal of such images due to their so-called "voyeur structure" is founded on the assumption that the image has a fixed and singular meaning. But, as he convincingly argues, all images from the archive are in a continual process of transformation because history itself is constantly "under construction."[6] He says of the four photographs taken at Auschwitz what could easily be applied to those amateur images discussed in *Through Amateur Eyes*: the history they narrate is always going to be based on a series of uncertainties, lacunae, for example, like "the 'mass of black' in the photographs or like the difficulty of reconstituting the time that elapsed *between* the four images."[7] Thus, like Didi-Huberman's *Images in Spite of All*, *Through Amateur Eyes* insists on viewing and understanding amateur images not as definitive documents of the events seen by those behind the camera but as sources for reconstructing historical narratives that force us to keep regenerating our memories of the events of World War II and the Holocaust.

Central to the historical insights enabled by the amateur films and photographs is an inversion of the distance that in Hüppauf's critique leads to an ignorance and forgetting of the past. In Hüppauf's discourse, distance is the basis of an amnesiac relationship to an image and the past it represents. By contrast, in *Through Amateur Eyes* the distance that

begins with that of the camera from the events it sees ripples out to create a distance between photographer and image, image and event, viewer and image, thus events, between the past and the present, and between history and memory. Finally, one of the most productive tropes of distance created by the images is that which separates what are often conflicting layers of meaning. The multidimensional concept of distance, in turn, becomes the basis for my conception of the photographs as agents in processes of witnessing and remembering anew the events of World War II and the Holocaust.[8] Along the way to my conception of the amateur images as agents in processes of witnessing the past in the twenty-first-century present, I demonstrate their engagement in discourses other than that of Nazi ideology. Namely, whereas images of hangings and executions, of starving and diseased Jews, of Hitler lounging in his country house, of soldiers at rest and at play were once testimony to the "immoral and barbaric ideology of the Nazi system,"[9] in *Through Amateur Eyes* the same images are cast in a different light: they are seen, for example, as amateur images produced at the height of industrial modernity in Europe. Simultaneously, they are amateur images taken of, and at the time of, the destructive and inhuman events of World War II. Despite being taken by Germans of various identities, within my discourse the images are dense historical documents that can be mobilized to remember these events from multiple perspectives.

The individual chapters of *Through Amateur Eyes* present four very different types of images made between 1938 and 1944 by self-identified amateur cameramen and -women. The makers of the still and moving images were diverse: they were all Germans yet ranged from Nazi Party members through German military, soldiers, civilians, bystanders, and ordinary men and women to Hitler's lover, Eva Braun. We see black-and-white photographs taken on the Eastern Front by soldiers; Walter Genewein's color photographs taken in the Lodz Ghetto, where he was chief accountant of the German administration; color footage of everyday activities carried out on the battlefield and the home front during the war; and images from Braun's home movies and photo albums. Even though all of the image makers were self-identified amateurs, in my discourse the amateur status of an image is not dependent on the identity of

the cameraperson. Its amateur status, rather, presents a set of discursive and visual possibilities that coexist in the works I discuss. Thus the title *Through Amateur Eyes* describes not only the vision manifest in the existent images but also the discursive approach through which I see the same images. Thus I approach them through scholarship in the field of amateur film and photography.

I have selected the visual material for each chapter from among the wealth of archival documents that have become accessible thanks to the political and cultural shifts resulting from German reunification in 1989. Although some of the images will be familiar to the reader, others will be encountered for the first time. In most cases I came to the films and photographs through their contemporary recycling in films, museum displays, designated exhibitions, books, magazines, television documentaries, and on the World Wide Web. The exceptions are the films and photographs of Eva Braun, which I came across while researching other amateur material at the National Archives in College Park, Maryland. Without the recyclings, the still and moving archival images would have all but disappeared and would perhaps never have become apparent to scholars in the twenty-first century. However, because one of my most important lines of inquiry is to reconsider the meaning of the past and the present as they are exposed through the images as historical documents, it was important to trace them back from their recycled forms to their archival narratives. Thus my research began with the recycled narratives, in which certain kinds of relationships between past and present were already in existence. From there I returned to the archives and determined the different meanings of the images in their archival context. Consequently, the transformations in perception, in use, and in meaning of the images across time became ever more evident.

My history keeps these transformations alive through the inclusion of a discussion of the images in their recycled context at the beginning and end of each of chapters 2, 3, and 4. In chapter 5 the discussion of the contemporary appropriations comes only at the end, in keeping with the narrative of my discovery of Braun's images. Accordingly, the archival images are revealed in each chapter through a narrative progression that mirrors my own process of discovery. The often vastly different significance of a

film or photograph in the archival past and the recycled present in which I discovered it leads to the ultimate revelation of *Through Amateur Eyes*. Namely, the trafficking between images and diverse viewers, between past and present, and between the many cultural worlds in which the images have appeared reveals much about how these images, their meanings, their stories, and the histories they relate are repeatedly manipulated in accord with how the United States and Western Europe, in particular, choose to remember World War II and the Holocaust.

Although the images' relevance for contemporary memory and memorialization more generally is threaded throughout, *Through Amateur Eyes* opens with a chapter devoted to a discussion of this and other theoretical issues raised by the images and my particular approach to them. The four analysis chapters that follow place the films and photographs in their recycled and archival form, as well as giving historical context to both. Through the sustained image analysis we are able to see the nuances and multiple layers of meaning of images of what might otherwise be seen as one-dimensional views of Jews at work in a textile factory (chapter 3), German troops marching down the Champs-Élysées (chapter 4), or Eva Braun playing under a waterfall with her friends and biological family (chapter 5). As detailed later, my sustained attention to amateur images gives credence to the increasing historical insight of these particular visual objects in documentary image studies, as well as the value of all documentary images in the burgeoning fields of memory studies, visual studies, and cultural studies.

In many of the instances of recycling, the images have been used to perpetuate the homogenous myth of the Germans as Nazi perpetrators, anti-Semitic brutes, and inhumane executors of the great crime of the twentieth century. This myth has been reinforced even when the images have borne no trace of such a narrative and when Nazi ideology has not been immediately identifiable in the stories the images tell or the lives they have lived. I argue that the notion that images taken during World War II by German officers, soldiers, and civilians are agents of the crimes of the Nazi system is essential to a new generation of Western European and North American audiences in their attempt to distance themselves from these historical events. Although the underlying assumptions about

Nazi-affiliated Germans and everything they touched has a certain value, it tends to limit the meaning of images such as those I discuss. If we are to embrace the complexity of their meanings, functions, and use-value in the present and the future, we need to see them from alternative perspectives. Seeing the images in their recycled narratives side by side with their archival versions pronounces another distance, the distance between the same images in different contexts of presentation. In turn, I argue that we need to interrogate this distance and to find ways of using it to take responsibility for the signification of the past in the present historical moment as the two are played out in the images and our relationship to them. The discursive relationship between then and now is critical to understanding how the still and moving images are vital to today's urgent need to continue to witness the historical past, present, and future they represent.

Following the introduction in chapter 1 to the historical and theoretical issues at stake in *Through Amateur Eyes,* chapter 2 examines photographs taken by soldiers, officers, accomplices, and bystanders on the Eastern Front in the late 1930s and early 1940s. I foreground the distance between the camera and the events depicted, the temporal and geographical distance between then and now, and as a result a space opens up for contemporary viewers to introduce a narrative of memory into the viewing process. Thus the images are interpreted for their possible placement in present discourses of witnessing the crimes on the Eastern Front, specifically in relation to the now canonical conceptions of bearing witness put forward by Shoshana Felman and Dori Laub. The images are also analyzed for their contributions to ongoing discourses of modernity as these discourses are evidenced in the technological developments visible in the image. For example, when multiple versions of the same photograph were printed; bought, sold, and swapped as currency on the battlefield; sent home as evidence of the soldiers' well-being; and found on dead soldiers' bodies as mementos of their "travels" east, the images are understood to engage with discourses on the photograph as evidence, the commerce of experience, the imbrication of image-making with the burgeoning travel and leisure industry, and the developments in the use of photographs for anthropological and ethnographic investigation.

Chapter 3 analyzes the collection of more than six hundred color photographic transparencies taken by Walter Genewein, chief accountant of the Lodz Ghetto, between 1939 and 1943. Genewein used a camera confiscated from a ghetto inmate and pursued his pastime in close collaboration with the Agfa company, which was, at the time, developing the material and processing techniques for three-way color film. I also discuss the documentary realism that is visible in Genewein's transparencies. He insisted on creating an image of the Lodz Ghetto that accurately recorded the routines of everyday life therein, specifically the efficient processes used in the workshops. The result was a series of photographs that allowed the formulation of concepts of distance that are nevertheless quite different from those found in chapter 2.

I argue that Genewein's particular brand of realism also created the potential for the images to be appropriated in memorial discourses on the agony of the ghetto and the injustices that occurred before, during, and following its liquidation. Because Genewein consciously opted not to see the less desirable aspects of ghetto life through his camera, the images offer an opportunity to imagine these horrors through their conspicuous absences. The distance and coldness of Genewein's images are in fact formal qualities that today can be seen quite differently. As in chapter 2, in this chapter I explore the contribution made by Genewein's transparencies to the development of their medium, in this case, color photography. These developments were double edged because, on the one hand, they were largely made possible by the intimate ties between I. G. Farben and the ghetto administration and, on the other hand, they contributed to the history and development of the medium as it is in evidence today.

Chapter 4 examines an array of color film footage taken by German civilians, soldiers, officers, and Nazi dignitaries in an attempt to document the war and their experiences of the war. Specifically, I examine color footage with a range of subjects: the occupation of Paris in December 1940; the arrival in and observation of daily life in Krakow, Poland; a ghetto; and the concentration camp at Dachau. In addition, this chapter considers home movie footage shot by Hitler's butler, Arthur Kannenberg, around April 1939; films of the aftermath of the bombing of Hamburg; and views seen through the cockpit windows of fighter planes. The

film fragments are examined on the basis of formal qualities: the mise-en-scène, framing, and composition. I also attend to the apparent flaws in the image as a site of meaning. Close analysis gives insight into the similarities between these films and other amateur films from the period: for example, a fascination with the power of the medium to capture the world in color, as well as celebrations of home and family life. I also see these amateur films as akin to early travel cinema as well as films made for anthropological use. These insights enable reflection on the broader contribution of the footage to developments in the history of cinema as they are usually identified in other films.

Chapter 4 also brings into focus a theme that runs throughout the book: all of the images expose unsanctioned histories when they see things that they are not meant to see. For example, footage shot in the Warsaw ghetto sometime between 1942 and 1943 sees starving and diseased children lying on the streets close to death. Images such as these, which depicted anything other than the efficiency and productivity of the ghettos, were banned, at least in principle, by the German administration. But these unsanctioned visions of wartime activities are central to the historical contributions made by these and other amateur films.

In chapter 5 I analyze the home movies and family albums of Eva Braun. As Hitler's mistress, Braun had unprecedented access to Hitler and his immediate circle. This gave her images the potential to reveal many secrets about history and, more specifically, about Hitler. Although other critics have looked to the images to discover previously unknown or unacknowledged details of Hitler's private life, in chapter 5 I find secrets where they are least expected. Specifically, I interpret the home movies and photograph albums for their conversation with the visual modernity in their midst, as well as their contribution to a more complicated picture of Braun and her various "families" and, by extension, the role of women in the political and social elite of Nazi Germany more generally.

Eva Braun's images take a unique place in *Through Amateur Eyes;* their uniqueness begins with the fact that they are documents of a single person's life and extends to their documentation of her identity as a well-known historical figure. Thus they belong to a different memory culture. Although the images offer an alternative to the official story of Eva Braun,

her identification in and with the films and photographs is also the reason for their distance from the present. In turn, this distance enables a different kind of witnessing from that explored in relation to other images. Critics, beginning with Marianne Hirsch, have theorized the way that home movies and family albums typically encourage us to remember our own past.[10] And with this understanding as interpretive lens, Braun's images can be seen to engage the viewer in a complex process of identification with and distinction from what is seen therein. On the one hand, we are able to see ourselves in the everyday images and remember our own past, and on the other hand, Braun's identity and that of her lover simultaneously stymie identification and urge us to recoil from the images and to distinguish our own memories from those created by Braun. Ultimately, the fact that we can so easily see ourselves in these images makes them all the more repellent. Thus the distance of Braun's images enables the very intimate involvement of the present viewer, and the ambivalent responses they elicit really push us to consider our own processes of witnessing today.

I maintain that acknowledgment of phenomena such as the gender dynamics among the top-level Nazis is as important to our continual struggle to understand and remember the Holocaust and World War II as the acknowledgment of representations of the gas chambers. Recognition of, for example, gender relations produces a very different kind of understanding of different cultures, but all of them make up the complex fabric of the history of this period. In his influential work the Israeli–American scholar Saul Friedländer set the history of the Holocaust on a new path when he insisted on its inseparability from World War II. Similarly, as the title of his book indicates, the relationship between the Nazi regime and the Jews is key to contemporary histories of both.[11] By extension, *Through Amateur Eyes* brings together images taken on the Eastern Front of the battlefields, the Polish ghettos, the German occupation and invasion of other European countries, and home life at Hitler's Berghof. In all of these different places the amateur camera was used to document daily life, no matter how extreme and how inflected by the extraordinary events of history. In addition, each different set of amateur images gives us insight into a different aspect of Germany's war, the multitude of

perspectives from which it was lived and seen. In turn, with this knowledge we can be better equipped to continue our attempt to understand the Holocaust.

The success of *Through Amateur Eyes* will see these images brought back into circulation as incitations to memory and the memorialization of the history of World War II and the Holocaust. If, as Andreas Huyssen would have it, we live in an age marked by an obsession to document, to photograph and film as a way of remembering and producing mementos in both the public and the private spheres, it is also an age of amnesia.[12] Much work is being done to lift the repression or amnesia, the silence and blindness regarding the complicated web of the German past, and to bring it into present memory.[13] *Through Amateur Eyes* contributes to this ongoing project. And it does this through use of the amateur image as a visual object that has the potential to integrate the forgotten back into history. From there, *Through Amateur Eyes* ultimately hands back to the reader and the viewer of images the responsibility to continue to witness in the present. Specifically, it is my intention that readers will be encouraged to witness the traumas of World War II and the Holocaust from challenging and multiple new perspectives, perspectives nevertheless always seen through the optic of the amateur.

The historian Omer Bartov reminds us that the story of World War II and the Holocaust has no resolution.[14] It is also a story that changes over time, a story that must continue to be reassessed according to the changing ideological, sociopolitical, cultural, and moral lenses through which we see the world in our time. And it is for this reason that we must continue to approach and understand the Holocaust, Nazism, and their consequences from different perspectives. To see this period of German history through amateur films and photographs is an opportunity that must be seized. Only then will we be in a better place to see the continuities between the world that produced (and still produces) genocide and the world we inhabit. If, as Pierre Nora claims, memory in modernity undoes the authority of the past, if memory is immediate and unmediated, all of the images discussed in *Through Amateur Eyes* challenge us today to use them to subvert, to question, to counter the fixing of memory in official discourses of the past.[15]

Witnessing from a Distance, Remembering from Afar: How to See Amateur Images

> To bear witness is to tell *in spite of all* that which it is *impossible* to tell entirely.
>
> ■ Georges Didi-Huberman, *Images in Spite of All*

Looking at German Images from the Nazi Period

Until the past ten years, the films and photographs I discuss in these pages have been more or less ignored—forgotten or rendered inconsequential or invalid—in the ongoing urge to write the history of World War II and the Holocaust. Not only were they taken by "German perpetrators"; more important, many were not known to exist until recently. Either the works had lain dormant in public archives or they had been stowed away in attics, gathering dust, until their owners passed away and their families discovered them stored among other personal items. On the few occasions when the images have been brought to light, they have usually been dismissed as historically irrelevant on the basis of their status as amateur, marginal, and thus without legitimacy. But with the increasing prominence in the past two decades of amateur and private images in the formation of public history, together with the belief in the significance of the individual and the private to the writing of public histories, the amateur films and photographs of *Through Amateur Eyes* now need no legitimation as objects on which to found new and alternative histories of World War II and the Holocaust.

Through Amateur Eyes invites the reader to see these images, to hear their stories and all that emerges through the histories that shaped them,

the cultural and historical contexts in which they were made and received. By placing these amateur images in the foreground of historical inquiry, I demonstrate how they might function within the broader project of cultural memory and history today. It is my contention that if we look through the discursive lens of a Nazi gaze, the images become obscured from view and the lines of critical understanding are cut off. When we see the amateur films and photographs from a different perspective, our understanding of these images and all they represent is complicated; it is not replaced. In addition, *Through Amateur Eyes* looks to the images' appropriation, their experience in another world: a fin-de-siècle European and Anglo-American world immersed in memorializing, monumentalizing, and remembering World War II and the Holocaust. In these cultural contexts, *Through Amateur Eyes* asks what and how we see when we look at the images today, how and what they represented at the time of their production, and what is the relationship between these two: between then and now, as it is realized between and beyond the images in their archival and recycled forms.

Of primary concern is my displacement of the notion that these images are complicit in the great destruction of the twentieth century. Indeed, I relieve the images of such a burden. As I demonstrate, the images are visual objects that capture and interpret but do not collaborate in or contribute to the unfolding of historical events. Although the official images generated and disseminated by the propaganda companies and the Third Reich's Ministry for Propaganda were manipulated, the amateur films and photographs held a different status, led different lives. Although they may have been made with ulterior motives in mind, they were not automatically publicly used for purposes of complicity. To put it another way, the amateur images may be replete with manipulation, interpretation, myopism, and misconstrual, but this does not make them complicit in the events they represent. This claim regarding the complicity or otherwise of the images may appear obvious, but similar images—if not these specifically—have been treated as though they are guilty nevertheless.

The Nazis used images, both amateur and professional, unofficial and official, to incite racial prejudice and virulent anti-Semitism and to glorify

German national unity. To be sure, the Nazis were masters of the image as entertainment and also proficient in the production and use of images to survey, categorize, terrorize, and mark out their victims for destruction. In some cases, a more nuanced understanding of these strategies is revealed in the ensuing chapters. However, of primary importance is the fact that the ideology of the image is in the way it is used, how it is propagated, how it is received, and who saw it. It is not necessarily inherent in the image itself. Thus image analysis might lead us back to discourses of Nazi ideology, but Nazi ideology is not the predetermined and sole significance of these photographs and films. Similarly, the connections I make to other amateur images, avant-garde movements, and historical and cultural beliefs do not make the perpetrators' images innocent or aesthetically pleasing, nor does it relieve them of ideological responsibility. It merely places the images on a historical trajectory that demonstrates their significance beyond or in addition to that of the ideological.

Despite the distinction (elaborated later) between the amateur and the professional and official films and photographs taken in National Socialist Germany, I see my interpretations on a continuum with the groundbreaking work done on Nazi cinema by scholars such as Eric Rentschler and Linda Schulte-Sasse over the past ten to fifteen years. Indeed, my investigation of the amateur images produced in Nazi Germany adds a further dimension to these existing histories. The amateur images have received comparatively less attention from researchers in the recent past. There has been some analysis, but it has been scant compared to the vast quantities of literature devoted to the documentary films of Leni Riefenstahl and the entertainment films of Viet Harlan (*Jud Süß,* 1940; *Kolberg,* 1945), Dietlef Sierck (*La Habanera,* 1937) and, for example, Josef von Báky (*Münchhausen,* 1943).[1] The literature on the official films and photographs is sophisticated, and the debates continue to evolve. Thus, for example, although this literature began in the early 1980s with the same skepticism and overwrought appraisals echoed in early discussions of the amateur images, in the late 1990s critics took strides away from this position.[2] For example, in his important 1996 work on the Nazi entertainment film, Rentschler argued that the film industry in the Third Reich was not driven by fear and a call to anti-Semitic

propaganda. Rather, the films made in Germany under the Third Reich were "ambiguous and complex entities, . . . still resonant portrayals of an age's divergent official and popular responses since the Third Reich."[3] Moreover, Rentschler deflates the myth that audiences then and now were or are an "amorphous public manipulated by an ideological apparatus."[4] He argues that audiences were and continue to be quite capable of seeing through the currents of opposition and resistance at play in these films.[5] In these and other examples of more recent scholarship on Nazi cinema, historians offer nuanced analyses that avoid the extremes at which the films are either aesthetic or stylistic masterpieces devoid of all ideological and political responsibility or unremittingly ideologically determinist.[6] My examination of the amateur films and photographs moves along similar lines of negotiation in between the two extremes.

Much of the relatively small amount that has been written on these amateur films and photographs has been skeptical. This work ranges from Sybil Milton's invaluable introduction of the images to an English-speaking public in the 1980s and their discussion in the pages of *Fotogeschichte* in Germany in the 1990s through the intelligent analyses of Genewein's images by Ulrich Baer in *Spectral Evidence* and by Gertrud Koch in *Die Einstellung ist die Einstellung*. For the most part, these interpretations insist on the ideological presence of the German officer- or soldier-cameraman as a Nazi representative in the composition of the images.[7] Criticisms and commentaries on the moving images have been limited to their filmic recyclings as discussed at the beginning of chapter 4. Although scholarly interpretation of the photographs deepens our understanding of them, the view that they were determined by Nazi ideology forges a blindness toward and of the image and also renders it impotent to convey reliable historical knowledge. In addition, it isolates or distances the photographs because it takes them out of the cultural and social contexts with which they were continuous. *Through Amateur Eyes* takes images from literal and interpretive obscurity and places them in relevant historical and cultural narratives.

My approach thus begins with the image as I find it in its contemporary representation. Then, in order to understand the ramifications of the recyclings, I return to the archive and analyze it with the visual elements

of the image in the foreground. I then open up the discussion to an understanding of the possible placement within histories in addition to that of Nazi ideology. Along the way I discover that these alternative histories include those of the development of the modernist, technologically reproduced art form; the contemporaneous changing face of technological modernity; and representations of war. In no sense should this privileging of the visual and formal qualities of the image be taken as a triumph of its aesthetic value. On the contrary, I maintain that aesthetically, these films and photographs are not artworks. The color stock of the moving images taken by officers on the front, at home, and on leave in various European capitals may appear striking and beautiful because to our eyes it is old and tinted with nostalgia. However, the same images are not sensitive to the deeper philosophical problems of documentary representation. Neither do these same images appeal to our aesthetic sensibility in such a way that they are relieved of their negative qualities and content. Thus, although I am concerned to ensure that the images be seen and taken seriously and to situate them within other histories, I do not want to redeem them through praising their aesthetic value.

The Image Must Be Seen

My inspiration to see through the optic of the amateur, to situate the films and photographs within alternative histories, and to view them as possible sites of memory is found at the cross section of contemporary image studies and studies of Holocaust representation. In their marriage of the study of visual culture and the historical and philosophical conception of the image, contemporary scholars of image studies—such as W. J. T. Mitchell, Barbara Maria Stafford, and Bruno Latour—advocate the importance of understanding images on their own grounds, that is, not through the lens of linguistic frameworks. These writers are interested in the way images have historically been "colonized," "reduced to a subaltern position," "displaced," and impoverished by the "totemization of language as a godlike agency."[8] Consequently, scholars such as Mitchell and Stafford expose the way we think and write about images both to elaborate how these discourses treat images as though they were words

and, simultaneously, to find a language with which to speak about images. It is a language through which the "the pleasures, beauties, consolations, and, above all, intelligence of sight"[9] can be reinstated to their proper place in cognition, epistemology, and self-conscious identity. Moreover, this language must be found to liberate the image from the skepticism that masks it, from the accusations of its ethical and ideological corruption. For these writers, the image must be appreciated as "the most fascinating modality for configuring and conveying ideas,"[10] an appreciation that would duly reflect the presence and role of images in the historical and contemporary worlds. It is precisely this view of the image as a source of meaning, knowledge, and history that I aim to put forward in *Through Amateur Eyes.*

This interrogative bent of visual studies has begun to have an impact on traditional disciplines as evidenced in the integration of these ideas found in cutting-edge works within art history. Works such as T. J. Clark's *The Sight of Death* or Rosalind Krauss and Yve-Alain Bois's work on the "in/form" are exemplary here: both have in mind the unpredictability and incompletion of the artwork in its relationship to a viewer.[11] And for Clark, in particular, it is a viewer whose knowledge is arrived at through repeated visual interactions with the images under examination. Likewise, *Through Amateur Eyes* follows the cue of the groundbreaking work done in visual studies and art history over the past fifteen years when it places the image in the foreground. The first step in such an endeavor is to construct a platform of visual description on which practices of interpretation can be carried out. For these purposes, privilege is given to the sense of sight, to the visual presentation of the films and photographs, in short, to what we see when we look at them. Thus in images we might not instinctively take seriously as ripe for historical knowledge and penetrating insight, the amateur films and photographs are shown to offer an understanding of things that would ordinarily be taken for granted. It is important, then, to make clear that analysis begins by looking at, and actually seeing, the concrete visual elements within the frames of amateur film and photography produced and first distributed in Nazi Germany. As I discuss later, this privileging of the characteristics of the image as the primary generator of meaning is not ordinarily the first port of call

for understanding either amateur images or those made by Germans in World War II. Rather, the narratives into which they are placed are customarily the door through which access is granted.

Much has been written on the crisis of vision and visuality that occurred with the advance of the Enlightenment and, later, technological modernity. As philosophers such as David Levin and Hans Blumenberg discuss, the insight and renewed wisdom enabled by technological advances, together with the fragmentation, industrialization, and regimentation of modern life, go hand in hand with new forms of literal and metaphorical blindness.[12] Within this literature, "seeing" takes as many different forms as do the images that are perceived. To see variously means to imagine, cognize, realize, discover. In *Through Amateur Eyes* seeing is, quite simply, an engagement with the image through the perception of sight. And what is seen are films and photographs as visible objects whose meanings begin where light is made manifest in color and form on the surface of each image. To see the images means, first and foremost, to experience them visually. Thus *Through Amateur Eyes* sets out to redress the continued blindness and ignorance toward images with the simple gesture of looking at the visual elements of the films and photographs as a preface to their interpretation.

In cutting-edge approaches to art and images, the relations between the work and the viewer are placed above all else. These interactive relationships typically feed the most exciting component of the image's significance because it is here, in its relationship with a viewer, that the potential of the image is realized. Alfred Gell terms the potential of the image to incite action toward the reconfiguration of meaning and life the "agency" of the image. For Gell, the agency of the image lies in the relational: it is realized in the "fleeting contexts and predicaments of social life."[13] The image may not have any real agency in our world—it may not be able to look at us, speak to us, have desires and fears, or share in our most intimate emotional moments—but we nevertheless treat it as though it can and does. Once again, the agency of the image lies in what we do with it, where we take it, to whom we introduce it, the effect we let it have on our own intersubjective relationships. And the only way to begin to understand this power we bestow on the image is to know what it represents, to

see it on its own terms as opposed to imposing our preconceived notions onto it. The latter move overwhelms the image and destroys all potential for creativity.

In turn, if we are to take the amateur films and photographs seriously as valued historical documents, we have to meet them on their own terms, first by looking at and subsequently exploring the intertextual and intercultural relationships in which they are involved, thus enabling their agency. This achieved, through our relationship to the images we can then assume responsibility for the reanimation of the images as they give way to memories and histories in our own minds. Not only does this approach relieve the amateur films and photographs of the ethical and ideological judgments that are so often made of images and texts produced by Germans during this period, but it assists us to understand the way the same images have been appropriated in contemporary discourses. Not least of all, it ultimately leads to a more nuanced understanding of how Nazi ideology influenced daily life, an understanding built on the image and what little information we often have of its provenance. Finally, this approach opens up an interpretive space for our own continued witnessing of the traumas of World War II and the Holocaust. This, I believe, is the real agency of the image: its creation of a conceptual space for memories of the past in the present. And this space is one in which we wrest responsibility from the image for the continued memory of World War II and the Holocaust.

Iconoclasm toward Images Taken by German Perpetrators

All of the different forms of iconophobia and iconoclasm discussed by image studies scholars are writ large across the discursive treatment of World War II and Holocaust representation. The previously mentioned perceived danger of images taken by Germans is undergirded by three dominant fears. First, there is a resistance to look at images taken by Germans identifying themselves as sympathetic to the Nazi cause because of the fear that this will lead to the cultural objectification of the victims and, in turn, a fascination with the perpetrators. We could extend this caution to the material discussed in *Through Amateur Eyes* to assume

that such a privileging of amateur films and photographs produced by German perpetrators might lead to an unwarranted fetishization of the images themselves. Or, to put it another way, as unsuspecting spectators, when we look at the images made by Germans, we replicate the German gaze and thus reobjectify what has already been objectified through their "erotically preoccupied gaze."[14] And, to reiterate Hüppauf, we mistake this gaze as attributable to that of the Nazi system. Second, there is a fear that by looking at the images again and again, we will normalize them: we will become comfortable with them, and therefore their horror will become muted, their status reduced to that of banal objects. Such an outcome is an invitation to forget the history they imagine.[15] This is the double bind so common to many instances of witnessing historical trauma. Bringing the trauma to public knowledge and, in this case, sight, can so easily delimit in spite of the desire to liberate.[16]

Third, even before these fears about studying images produced by Germans in World War II comes the memory and reality of what the image meant and how it was used within the National Socialist system. The use of the image as propaganda, not only to reinforce National Socialism's singular symbolic system of an integrated, exclusion-based community but also as a way of representing that system through these images as a commodity for mass consumption, is uppermost in our minds when we look at the images of and by German perpetrators, usually equated with Nazis.[17] According to this logic, Nazism is no more than an image and was also dependent on images for its successful execution.[18] Just as there has always been a dogged resistance to memorializing the Holocaust through monuments for fear of adopting the National Socialist urge to monumentalize, there has always been a concern not to repeat the processes of aestheticization that so colored the myth of National Socialism throughout its lifetime. Yet again, as Didi-Huberman has emphasized, it is only when we fail to look at these images that all of these fears of violence, violation, and forgetting will be realized. We have no choice; we must look from every direction and perspective possible.

As a result of these fears, we are left with an untenable contradiction: such images are not put into cultural conversation for fear of their simultaneous power and potential mystery, and yet they have started to

be freely appropriated, particularly in the realms of popular culture. In the appropriated context, they are normalized and rendered banal. Some of the appropriations that I discuss in each chapter are, in effect, evidence of this cultural forgetting that motivates our contemporary relationship to the Holocaust and World War II. *Through Amateur Eyes* responds to this situation in which images made by German amateur photographers and filmmakers are either repressed or appropriated and, in both cases, forgotten. The first step is to see the images as they have been found in the archive. Although in some cases image analysis, historicization, and interpretation lead back to the ideological and political value of the films and photographs, it is always accompanied by a more nuanced under-standing, and it is never the only one. Similarly, it is not a given that the political, ideological, and psychological identity of the cameraman or -woman is discernable through analysis, and for this reason I do not privilege the image maker or his or her national or political identity in the initial stages of image analysis.

Most important is the perception of the images as amateur. Unlike professional or commercial images, they rarely search for mastery and control. Rather, they are usually open and often contradictory. In turn, their placement within the historical context of concurrent developments in amateur film and photography provides a perspective that sees the im-ages interacting with broader historical, cultural, and artistic discourses, an interaction that, in turn, provides insights beyond the ghetto, the con-centration camp, and the battlefield. The films and photographs discussed in *Through Amateur Eyes* connect to historical worlds that are otherwise hidden behind prejudices and assumptions about the national, political, and ideological persuasions of their creators. Thus I put these still and moving images back into a cultural conversation that ensures they are seen as dynamic objects in relation to history, objects that, in turn, open up our relationship to the past and create new memories of this troubled past.[19]

Images in History and Memory

Through Amateur Eyes also joins forces with the shift in the 1990s away from the previous separation of World War II perpetrators' histories from

those of their Jewish victims.[20] In his two-volume history of events, *Nazi Germany and the Jews, 1939–1945,* Saul Friedländer significantly changed the direction of these two otherwise parallel strains of history. He espoused the imperative both to understand the broader social context of the Third Reich's rise to power, which included its institution of anti-Jewish policies, and to realize that the lines between perpetrators and victims were not so clearly drawn.[21] Indeed, as Friedländer demonstrates, to grasp the full history, implementation, and impact of the crimes committed by the Nazi regime and the Jewish experience of these crimes it is necessary to understand their mutual imbrication. Thus Friedländer weaves together documents generated by the Nazis for public and private purposes, as well as personal stories and memories of their Jewish victims, to create a social history of World War II and the Holocaust.[22] From Friedländer I take this notion of the importance of the contextualization of documents and events and the impulse to study images taken by the perpetrators as a way of gaining insight into and knowledge of a much bigger picture. Once again, I am putting images into histories in which they have not previously been considered to have any place.[23]

Similarly, in an extension of Friedländer's influential bringing together of the history of the Jews with that of their murderers, the final chapter of *Through Amateur Eyes* analyses the home movies and photos of Eva Braun. Unlike the images in other chapters, Braun's present a portrait of a now well-known individual. However, through these films and photographs we also get a view of the broader cultural and historical world in which she took her photographs, the upper echelons of Nazi social culture. Ultimately, these still and moving images offer unique insights into the gender dynamics, and particularly the role of women, among elite Nazis. In the same way that Friedländer stresses the importance of entwining the history of the regime and that of the Jews in order to better understand the Holocaust, I include Braun's images in support of my argument that the Germans' perspective of daily life is part of the same weave of history as the knowledge of their public actions and policies. When images are shown of Nazis relaxing and eating, enjoying their daily lives, it is often tempting to go straight to what is not represented in the images, namely, the violence and destruction the Nazis instigated and committed. However, in keeping

with Hüppauf's call to look at the images and not at the political ideology we know infused them, my discussion of Braun's films and photographs demonstrates that productive use of these images in contemporary witnessing is based on what is visibly manifest in the images. Thus the visible comes first in the formation of memory today.

Their content aside, Braun's images share many characteristics of the films and photographs discussed in chapters 2, 3, and 4. These characteristics—stylistic, technical, and thematic—are also the basis of new memories of and processes of witnessing the Holocaust and World War II today. Huyssen insists that successful memorial objects of the period engage in a tension between the "numbing totality of the Holocaust and the stories of the individual victims, families, and communities."[24] This tendency of amateur images, including Braun's, to flow effortlessly between the personal world of individuals and public history, to reveal both subjective and collective experience, opens them up to appropriation in revisions of history seventy years later. And so, for all their differences from the images of other chapters, Braun's films and photographs are nevertheless, within my thesis, of the same kind.

Influenced by Friedländer, eminent scholars such as Dora Apel have reinforced the contemporary openness to accepting the inevitable imbrication of perpetrator and victim histories. The shifts marked by the discourses of scholars such as Apel and Friedländer in the 1990s came at a historical moment when it was recognized that future memory of the Holocaust would be carried and perpetuated by a generation of people who were not present at the events. Thus, as the original survivors become fewer and fewer in number, an even greater urgency to remember has been recognized. In turn, representations of the Holocaust by the second generation of survivors began to proliferate in the 1990s, and the field of what is known as appropriate memorialization began to expand. In a postunification Germany and Europe, where history, identity, and nation continue to be rethought and rewritten, we must continue to look outside the narrow discourses of the immediate postwar years for the possibility of remembering. Now that the twenty-first century is underway and these changes in European history and identity are in motion, it is an ideal moment to look at the images made by Germans—perpetrators,

bystanders, accomplices, and the like—for historical insight and memory. Following the cue of scholars such as Apel after Friedländer, I have based *Through Amateur Eyes* on the belief that a study of these images reveals not only insights into the meaning of being German in the 1940s but also the meaning of being involved in World War II, whether in the past historical moment or in its wake today.

Anyone writing about questions surrounding representations of World War II and the Holocaust is faced with a host of decisions regarding how and where to position the discourse. Despite the urgency and imperative to remember the scissions caused by the momentous events of World War II, its representation and the discourses surrounding these representations have never been so fractured. There is no such thing as a neutral position from which to see the Holocaust or the war carried out in the East. Aware of the inevitable shortcomings of any Holocaust and World War II history, in *Through Amateur Eyes* I have demonstrated my belief in the use of specific images and their close analysis as capable of exposing larger theoretical and historical insights that function on broader cultural, national, and ideological levels. This is a position most vociferously articulated by James Young in his groundbreaking histories of Holocaust representation and memory. Young's position has become synonymous with the postmemory context of twentieth-century representations of the Holocaust. However, what is unique to Young's histories, and what *Through Amateur Eyes* emulates, is the focus on the image and its analysis as a gateway to broader historical and memorial processes.[25] But first we must review the beliefs and assumptions about the image that underwrote the late twentieth-century blindness toward the Holocaust image.

The belief in the image as ideologically determined dominated Holocaust scholarship in the late 1980s in particular, but it continues today. This position was launched, and is still typified, by Claude Lanzmann's film *Shoah* (1985), with the deliberate eschewal of the image as document that bears witness to events. Lanzmann's *Bilderverbot,* or prohibition against images, stemmed from the apparent "absolute obscenity" of the archival image as a claim to presence or as a claim to evidence the how, why, and what of the experience of the Holocaust.[26] The Lanzmann position is, in effect, an explicit critique of the claim to truth of an image of,

in particular, the Jewish victim. In turn, this position is directly related to the historical argument that the Holocaust is unspeakable and unrepresentable, an argument that, although compellingly articulated by figures such as Elie Wiesel and George Steiner, is no longer useful in the ongoing exploration of the fractured and layered structures of the Holocaust in different countries. As Primo Levi pronounced in response to Adorno's call for the end of poetry after Auschwitz, if the Holocaust cannot be imagined, this is reason to continue to imagine the Holocaust.[27]

Lanzmann's position is concretized and elaborated by contemporary scholars such as Koch and Baer. Before them, critics such as Sybil Milton, Judith Levin, and Daniel Uziel claimed that to look at the German perpetrator's photograph is to look through his lens, and therefore from his perspective.[28] If we see through his eyes, we assume all of the prejudices and hatred that defined his ideological and political perversion. Koch goes one step further than Lanzmann; for her and other critics such as Baer, it is not merely the structure and context of the photographs that overshadow their significance, nor is the identity of the photographer or cameraman automatically a charge against the image. Rather, Koch turns to psychoanalysis to argue that the composition of the image itself is permeated with a not-so-unconscious Nazi ideology. For Koch, images made by Germans aligned with the Nazi system are indeed Nazi images. This may not be a foregone conclusion or the place from which she begins, but it is always the one she comes back to. From the mid-1990s onward, in keeping with the shifts outlined earlier, there has been more openness to the possible historical insight of images taken by the German perpetrators. As Susie Linfield logically points out, these images "say very little about Jews, other than what was done to them, but they say an awful lot about their German conquerors."[29]

Openness to images of the so-called perpetrators does not imply a blind, relativist acceptance of and applause for all representations. Rather, it translates to a shift from the former focus on policing such representations. Young's groundbreaking work on memory and memorialization as they are enlivened through Holocaust representation has had a significant impact on the broader debates about how to remember the past and how to discuss these memories.[30] What is so useful here is that, as Young

says, it is not whether a representation is good or bad but what kind of life it lives. Thus, the meaning of a work is relational: it is created in the historical, cultural, and aesthetic relations between the artist and the work. In turn, this social life of representation, by necessity, includes how both interact with, affect, and involve the viewer.[31] For Young, this set of relationships, the three-way interactions, are the aesthetic of the memorial. This aesthetic is constituted by not only how these works "reinforce particular memory of the Holocaust period, but also . . . the ways events re-enter political life shaped by [them]."[32] Art historians and critics before Young, ever since Erwin Panofsky, have insisted on the importance of cultural context and the ways of seeing of both artist and viewer. Thus Young's work does not exist in a vacuum, but it does bring into sharp focus the interactions among the multiple participants in a work of art for the generation of its meaning.[33] Similarly, it is critical to the conviction of *Through Amateur Eyes* because, even though the sensuous qualities of the image are foregrounded, ultimately this analysis is only the first step toward a historically valued interpretation.

Young's work is powerful, and it is influential for *Through Amateur Eyes* because, as he says, the monument is about the past and remembering that past as much as it is about the present and how we remember the past in the present. Again, this relationship of the past and the present to memory is not new or revelatory, but Young brings the ideas of French philosophers into the field of Holocaust studies and its memorials.[34] The continuum of time, the trafficking of past and present embraced by memorials and monuments, are not only the basis for a creation of collective memory in the present. They also keep the memorial structures alive, in motion, always changing, never crystallizing, and therefore never attaining the monumentality of a fixed, monolithic, usually State-led conception of history for the bolstering of present politics and ideology.[35] Young does not discuss the type of documentary images from the archives that are the concern of *Through Amateur Eyes*. He is interested in monuments and "after-images,"[36] spatial and site-specific representations that have been conceived, debated, and erected in the last ten to fifteen years.[37] Thus it is his approach to the images, not the actual insights about them, that is instructive for *Through Amateur Eyes*.

Although the amateur archival films and photographs do not consciously embrace the instability of Young's examples, as I demonstrate, their meaning is often in flux. The uncertainty that characterizes the amateur images usually begins with their "amateurness," their hesitation as works that were made on a whim, images taken in haste, their existence outside of commercial production and distribution circuits, and various other traits. Thus, although on the one hand I am reluctant to define what constitutes an amateur image, on the other hand I also hold onto the characteristics that recur in these works that might be aligned with their status as amateur images. Although it may not come with the self-consciousness of the experimental or the political documentary, they have a discursive openness that begins with their status as amateur nevertheless. Before exploring this notion of the amateur, a word must be said about how the image analyses will fit into the historiography of postwar Germany.

"Normalization" of German History

In his social history of the developments in and transformations of collective memory in Germany, Wulf Kansteiner traces the shift in memory of the Holocaust from its place as the cornerstone of definitions of German history and identity to that of the linchpin in the conceptualization of Europe in the twenty-first century. He describes how, since the immediate postreunification years of the 1990s, the responsibility for this past has also shifted from Germany to Europe. Kansteiner identifies this shift as a strategic political move designed, among other things, as a "normalization of the political memory of the Third Reich."[38] This so-called normalization of the past has taken place since reunification and, more significantly, in the wake of the fiftieth anniversary of the end of World War II in 1995. The shift moves beyond the key self-examination of a united Germany's historical culture to a new paradigm that has transformed "what initially was a more narrowly conceived Holocaust memory into an abstract, versatile memory of European human rights abuses. In this abstract, iconographic format, the memory of World War II and the Holocaust which had once served to define a unified German identity, now assists in integrating this same unified Germany into the European

community."[39] Hand in hand with this politically motivated shift, the Holocaust and its representation have come to occupy a different position in the popular imagination in Germany, Europe, and the West more generally. Kansteiner examines the cultural and representational transformations in German history as they are mirrored in West German television productions about World War II and the Holocaust in particular.[40] He traces the shifts from documentaries on the Jewish people through histories of the "Final Solution" and Jewish victim and survivor narratives,[41] profiles of prominent Nazis and eyewitness accounts, and representations of the concentration camps. Kansteiner notes that the closer the broadcasts come to depicting deportations, pogroms, and camps in which "ordinary" Germans were involved as bystanders and perpetrators, the more marginalized these programs are by television stations. This is because the world of persecution is populated by the same people who comprise the contemporary German television audience, and their responsibility must be avoided at all costs. In this way, the memory of the German past has shifted from a historical issue to a political one.

My examination of the historical recycling of amateur images taken by Germans during the war responds to Kansteiner's observations in a twofold manner. First, analysis of some recyclings demonstrates the curious spread of the normalization of German history and the Holocaust, where normality is reinstated in the name of a new patriotism after reunification. Related to this, in other Western countries, in particular the former Western Allies, I argue that this normalization is paralleled by a forgetting of the complexities and contradictions of the past. However, it is a forgetting that is more subtle, less obviously designed, than the blatant repression of German history that we know from the immediate postwar period in West Germany. Second, there are recyclings that keep the memory of the Holocaust and World War II alive through a creative and open use of the images. In short, "responsible" recyclings obey the ambiguity and open-endedness of the amateur image as opposed to attempting to cover it over, thus oppressing it. Ultimately, these recyclings contribute to ongoing debates by pointing to the way that many narratives of recycled images focused on World War II and the Holocaust are designed for our own convenience, that is, to help us forget our responsibility to

the past. Alternatively, the more recent narratives assign responsibility for the past in the present and the future through the strategic reuse of archival images and thus add texture to the memorial landscape. Even though politically and socially the role of the Holocaust has shifted over the past ten to fifteen years, that is, has shifted within the popular imagination, we need to keep alive the issue of how it is remembered. Thus the discussion always returns to this central and urgent question: As we move further away from the era in which World War II and the Holocaust defined history, how do we avoid losing sight of what happened?

In an early chapter of his book Kansteiner discusses the search for interpretive instability and self-consciousness in representation of the Holocaust, an instability that is identifiable in some recyclings but not in others.[42] He says there is a necessity to create a disruption to identification with both the victims and the perpetrators and that this disruption can be effected through a visual tension not simply at the level of discursive communication but at that of the aesthetic as well. He proposes that the reason this tension does not exist in the examples he discusses (predominantly from mainstream television) is that it would undermine the entertainment value of the television program and is therefore strategically avoided in the interest of maintaining ratings.[43] Although those recyclings that most articulately disrupt order, systematization, and viewing pleasure are not found on broadcast television, there are significant reproductions that are able to effect the discursive disruption Kansteiner is looking for. It is with these concessions and disruptions in mind that I conceive of certain recycled images as opening up the memory of German history rather than closing it down, as do the examples from broadcast television. Indeed, if the amateur films and photographs are allowed to see for themselves, if they are placed in the foreground of the recycled narrative as an interpretation as opposed to overwhelmed by other elements of narration, we are able to mobilize them for future discourses on memory, on witnessing, on modernity.

Home Movies, Amateur Films, and Small-Gauge Films

To reiterate, perception through the optic of the amateur enables me to depart from the contemporary iconoclasm that continues to pervade studies

of the Holocaust and World War II. However, the amateur is a contested notion, and due to the idiosyncrasy of my use of the term, it behooves me to clarify what it means within my discourse. What distinguishes amateur from professional? Indeed, what defines the amateur image in general, and what makes those discussed here amateur? In turn, what can we make of and how do we place the amateur image taken by a Wehrmacht soldier that was subsequently published as official propaganda? Was this amateur image transformed into a professional object?

As one of the leading scholars on the amateur cinema, Roger Odin, warns, the definition of the amateur is in constant flux. As new and ever more available image technologies come onto the market, the so-called amateur image is continually evolving. What defined an amateur image and its production in wartime Germany is not what defines an amateur image today. And, as Laurence Allard explains, the amateur has recently become identified with an emergent technology: thanks to its accessibility and portability and indeed the uncertainty surrounding its potential, new audiovisual technology is usually enthusiastically taken up for the creation of amateur images.[44] Through the use of cinema at the time of World War II, super-8 technology in the postwar period, home video in the 1970s, and today digital cameras, the World Wide Web, and, most recently, cell phone technology, the amateur image has often been the first to explore the possibilities of new developments in these respective media. To be sure, this freedom to explore the possibilities of a new visual medium produced experiments as well as what Michael Kuball refers to as "a unique authenticity" from the earliest days of cinema and photography in Germany well into the 1930s and 1940s. Nevertheless, each phase of image-making has distinct cultural characteristics. In the pre–World War II culture of amateur filmmaking, accessibility to technology was more limited, and therefore much of the pioneering work being done by filmmakers and photographers was done under the umbrella of film clubs.[45] These clubs gave would-be filmmakers and photographers access to equipment they would not otherwise have had an opportunity to use. Today the amateur is more likely to pursue his or her passion in isolation, among friends, or when traveling abroad. Thus not only have the technology and the relationship of the amateur image maker to his or her

technology evolved but the social and cultural spaces in which images are created have also shifted dramatically since World War II.

Odin declares that it is better to find alternative approaches to amateur images than to struggle against their labile nature by creating definitions. He chooses to examine the discursive and material fields that give rise to the production of amateur images: the family, the amateur film club, independent cinema.[46] However, even in the ten years since Odin began to write, the terrain of the amateur image has continued to change dramatically, and it is possible to refute many of the claims he makes for specific genres and subgenres. With all this in mind, it is primarily for discursive purposes that I distinguish the images in this book as amateur. In short, they were taken by filmmakers and photographers for purposes other than the commercial. Similarly, none of the filmmakers and photographers were employed—either paid or otherwise—to produce the images they did with their cameras. They were soldiers, officers, civilians, or elite Nazis who pursued an interest in the still and/or moving image in a past time, albeit an image about which they, like many amateurs, were extremely serious. Alternatively, in the case of a handful of images taken by officers that I discuss briefly or to which I make passing reference, if the image makers were employed by the propaganda companies to film and photograph, the images I discuss were taken unofficially, mostly clandestinely, and never publicly shown. Thus the cameraman or photographer may have been officially employed, but the images he produced were not automatically officially sanctioned.

From the outset, I must emphasize that the status of an image as amateur is not determined by the identity (or lack thereof) of the person behind the camera. As I discuss later, the removal of the producer of the image from both its status as amateur and its historical meaning is a strategic and necessary rhetorical move that enables the agency of the image in narratives of memory and witnessing. Such is the optic or the discourse of the amateur through which I understand the archival images. It is the image itself and the journey it traveled in the wake of its production, not the one who took the image, that is the basis of my optic of the amateur. At first glance, it may appear that the images taken by and of Eva Braun in chapter 5 are exceptions, because in them I find her portrait. However,

this portrait is the result rather than the precondition of my examination of their status as amateur.

In particular, I identify the amateur image through a focus on the manifest qualities of the image: the visible flaws and mistakes are the basis on which I interpret their potency. Indeed, the mistakes of home movies and amateur films are critical to their recasting within the historical landscape of World War II. Péter Forgács offers some useful comments about the particular realism of the amateur image. Forgács is a filmmaker who works extensively with amateur film, reediting and refashioning it into documentaries that re-vision World War II and the Holocaust through the eyes of the private, everyday worlds in the footage.[47] He says that these so-called mistakes and the imperfection of home movies and amateur films are what make them powerful and real, giving them a truth value that, in turn, bestows on them an authority that supersedes that of a journalistic newsreel.[48] I also believe that when we find mistakes, repetitions, ellipses, blurred and upside-down images in the films and photographs shot by Germans, they may well be constructions, performances, and fictions. Nevertheless, these visible seams signify the authenticity of the images and thus the valuable insight they offer. Although we may want to remain skeptical of the propaganda and other official images produced by Germany in wartime, the amateur images represent a form of visible evidence.

It is true that the thinking of Forgács here leans on a tradition of looking at the realist image from a perspective that begins with the work of André Bazin and the French documentary film movement.[49] It is thus also the case that the so-called truth of these images is not static or one-dimensional, and yet Forgács is concerned to validate the amateur image as an authentic aesthetic object. I mention this because, although the idea of the image's imperfections as the site of possibility is useful in an interpretation of the amateur photographs taken during World War II, contrary to the conception of a Bazinian realist image, those I discuss are not, and must not be, privileged as aesthetic objects. The images produce a meaning that does not depend on seeing them as art. I engage the films and photographs through certain assumptions about the modern realist image and reject all notion of them as artworks. In addition, my interpretations should not be

seen as attributing to the films and photographs a privileged authenticity. I use this thinking as a heuristic device that enables an alternative reading of the images, one that makes them available to further and future processes of witnessing the horrors they do and do not depict.

Beyond the visual elements that help us to recognize an amateur image, rather than defining more boundaries, my interpretations will in fact privilege a transgression of boundaries. Of critical importance is how the amateur images visualize, and subsequently can be seen in relationship to, the categorical distinctions that are usually used to define them. In my discourse, the chosen images not only blur the lines between distinctions, but in that very fungibility they also make their most valuable contributions to conceptions and histories of World War II and the Holocaust. Thus, rather than laying out the definition of amateur images and demonstrating how the images here do or do not meet those definitions, with the inconsistencies of the visible image as the ground, I consider each set of images through the lens of a series of tensions: the tension between what constitutes the professional and the amateur, between the image as an articulation of an individual's vision and an anonymous document of historical events, between the very ordinary everydayness of the image as representation and the extraordinary events of World War II that were the "everyday" that lay before the camera, between the image as the product of a supposed perpetrator and the same image as given over to the process of developments in modernity. As the result of all of these tensions, there is an enormous (productive) confusion between public history and private memory as it is set in motion by the encounter between a personal vision and the presence of World War II as the great aporia of the twentieth century.[50] In each case I consider how we as twenty-first-century viewers encounter these tensions and consequently bring the images to life. Herein lies the power of the amateur.

Critics of amateur and home movies have also remarked on the unique way that they transgress the conventional line between the profilmic and the filmic representation. Amateur films and, by extension, photographs are unique for their consistent tendency to make visible the process of filming itself. This, as Alexandra Schneider points out, is often the legacy of the mishaps so common to amateur and home movies. In the example

given by Schneider, a child runs to greet her father behind the camera while the film is still rolling, thereby crossing the line between reality and representation. Such incidents caught on film, together with the unedited mistakes in these films, lay them open to a representation of the processes of filming itself. And, by extension, they are, as Schneider says, quoting Karl Sierek, documents involved in "making seeing visible."[51] This wearing on an image's sleeve of both the mechanics of production and the challenge to conventional spaces of representation confronts a viewer with the constructedness of the viewing space and the viewing experience. This provides another valuable basis for an interpretation that offers a whole different perspective of the historical events of World War II and the Germans' role in it. Although the relationship between visual representation and events in the official images made in Nazi Germany is usually constructed in the name of propaganda, in the amateur and home movies the relationship can be seen as the premise of an exploration of the technology and its encounter with broader cultural issues of modernity. In particular, *Through Amateur Eyes* takes these kinds of disturbances to the filmic illusion as seeds for an exploration of how amateur and home movies and photographs recall the nascent developments in their respective media.

The Significance of Distance

In the introduction I mention various distances that are crucial to the role of the amateur image in processes of witnessing. The distances that I identify in the chosen photographs are typical of the amateur image. For example, amateur images commonly forge a distance between the events depicted and the camera. We see this distance in the physical remove of the events in the photograph or film image: amateur images typically show events in long shot, in the distance, to the point at which we sometimes have difficulty discerning what is taking place. In film images, this length of the shot is also often mirrored by the length of the take, a length disproportionate to the significance of the action taking place before the camera, thereby causing the viewer to become distracted from the film. Other imperfections of the amateur film or photograph create a self-conscious

image that draws attention to its status as representation: mistakes, repetitions, out-of-focus blurs, underexposure, and overexposure, for example. In such examples we are reminded of the presence of the camera as an instrument of mediation, thereby forging a disconnection between the representation and the photographed events. Similarly, there is a distance between the meaning of the image in the late 1930s and early 1940s and its meaning today. We recognize this through the aging of the filmstrip or photograph: the fading of the color dye, stains on the image, tears and creases that tell the story of the photograph's being folded up and placed in a wallet or a pocket for safekeeping, or the film's screening at family gatherings year after year. Similar to this, there is a historical distance between the events depicted and the images themselves, a distance that has often been collapsed in the interest of indicting the image for its violence. This distance might be conceived of as the distance between what the officer or soldier saw through his viewfinder and the events as we see them represented all these years later. All viewers may not perceive the events in the same way: there is an inscription of distance between various levels of possible viewing, and possible interpretations among different viewers (maybe even by the same viewer), at different moments in history.

We are required to notice the image, to imagine its completion, to narrativize it in a way that the amateur image does not and cannot do for itself. The indefiniteness of amateur images is thus at the heart of their status as agents in our memory work today. The various levels of distance, and in turn the various ways that perceptual, emotional, and intellectual spaces are created, encourage us to take up the images in our own narratives of memorializing the events that they show and we, by extension, witness from a distance. As I say, distance is critical here; distance invites reflection, frustration, provocation, and judgment. Distance, as I conceive of it, thus enables and even encourages us to insert ourselves, what we know and do not know, what we believe and what we doubt, what we feel and do not feel, into the communicative relations created by the images. And so a conversation, an argument, comes alive, and the memory of the heinous events of World War II and the Holocaust is revivified in the mind of the viewer. Thus the distance of the amateur reanimates the events from another perspective—our perspective.

Another of the multiple tropes of distance that plays a key role in the conviction of *Through Amateur Eyes* is that between my discourse and my reader's possible understanding of the argument. This is an interpretive distance that begins with my detailed examination of the images in their archival environment; carries over into their juxtaposition with artistic, cultural, and historical developments in their midst; and, where possible, shows an awareness of the multiplicity of possible interpretations. My re-presentations of the images are neither neutral nor innocent. Nevertheless, I create reflective spaces through various juxtapositions of different interpretations that, I anticipate, will build an openness and flexibility into my discourse. Specifically, I create a space or distance that invites the reader to reflect upon his or her response to my readings. This ensures the possibility of continuing the project of witnessing as it is enabled by the amateur films and photographs themselves and realized in some of the cutting-edge filmic re-presentations.

Witnessing

The conception of witnessing within my discourse is unique. Although more sustained engagement with the notion of witnessing as it relates to individual images is found in the ensuing analysis chapters, the basic theorization is consistent throughout. In our anthology *The Image and the Witness,* Roger Hallas and I extend the groundbreaking work of Dori Laub and Shoshana Felman to conceive of the potential for images to be used in processes of bearing witness to traumatic historical events.[52] We argue that the image can be conceived to mediate between intersubjective relations that are commonly accepted to animate the process of witnessing itself.[53] In the vast theoretical literature spearheaded by the work of Laub and Felman, to witness means much more than to narrate or to be present at a traumatic event, in this case the Holocaust. Rather, bearing witness to the truth of what happens takes place only in the relationship between the survivor and the listener. According to Laub, for example, the truth or the location of the truth of the trauma is enabled in the space created by the conversation between the Holocaust survivor and the psychoanalyst as listener. The psychoanalyst enables the

survivor to identify the trauma, to give it a language thus to own it, and, in the process of externalization, to internalize it.[54] The ethical weight of this process demands that the psychoanalyst–listener also be a witness to his or her self and thus to the process of bearing witness. The one who bears witness is not the passive facilitator of knowledge but rather must also listen to herself, her responses, her experiences in order to keep the testimony alive. Finally, the psychoanalyst–interviewer must be a witness to the "flow" of "trauma fragments" and respond to them to ensure their continued flow.[55]

Felman adds a historical dimension to Laub's witness. Significantly, she extends the generative relationship to one that develops among the survivor, the enabler or analyst, and the imagination of the viewer or, in Felman's case, the reader. External to the time and place of the trauma, the process of bearing witness takes place in the relationship among the survivor, the listener, and the public imagination as it is formed through exposure to the survivor–listener relationship. Thus bearing witness is a process that involves a transporting of the private internal trauma into the external public imagination. Bearing witness realizes, often in an alternate form, what is otherwise unavailable to the imagination.[56] Within Felman's work this alternate comes in the form of the written allegorical narrative. According to Laub's and Felman's carefully considered concepts of bearing witness, there is very little support for an argument that the amateur films and photographs discussed in *Through Amateur Eyes* could be considered witnesses to the Holocaust. Although neither discusses the image, we can extrapolate and speculate that, following their logic, the image could mediate only the intersubjective relationship between survivor–witness and listener– or viewer–witness.[57] However, via the spectator's engagement with the manifest visual details of an image, it can be placed in an intersubjective relationship that serves to articulate a process of bearing witness to historical trauma.[58]

Recalling Gell's notion of the agency of the image, when the photographic and filmic images are in relationship with a viewer or viewers, in the life that we give them, they become agents of historical memory and historical witnessing. In particular, the conviction of the images in this role as agent is strengthened by the fact that we view them from the distance

of seventy years. This relationship between viewer, viewed, and subject matter or myself, image, and unfathomable crimes gives the photographs a power of involvement in the picturing and, today, in the revivification of history. In the temporal, geographical, and emotional spaces between the viewer and the events taking place, in the intersubjective process of reception, history becomes reenergized, witnessed with these images as instigators of the process. It is true that these particular images will open up different memories from those enabled by survivor images. However, this difference does not invalidate—it actually fuels and complicates—the memories and histories spawned by the perpetrator photographs.

Nevertheless, as Hallas and I argue in *The Image and the Witness,* the very presence of an image has the capacity to generate an intersubjectivity: the image opens up a site at which a witness (in this case, the contemporary viewer) who did not directly observe or participate in the traumatic historical event now has the ability to witness, at a distance, the ordeal of those photographed. When we see the photographs, it is our responsibility to bear witness to ourselves as we revivify and prolong the historical memory of the traumatic events.

To place these images of brutality on the historical stage of witnessing is a controversial move, if for no other reason than that I turn to images most often taken by perpetrators for my discourse on historical witnessing. The other criticism that can be leveled at my approach is that it potentially places the images in such a light that they, and my discourse, fail to do justice to the human magnitude of the events they witness. That is, it is a strategy that does not focus primarily on the suffering of those victims of the historical trauma as they were seen by the camera.[59] And yet, as documents involved in processes of witnessing, these images are among all we have left for the continued memory of World War II and the Holocaust.

The Absence of the Photographer as Author

Of critical significance to my concept of bearing witness and to my consequent interpretation of the images is that no author, no photographer or filmmaker of the image, is present to any of the documentary images. The photographer or filmmaker is necessarily absent, unidentifiable at a

given moment; in effect, he or she is removed from the image (if only temporarily), and the image becomes what I refer to as anonymous. To emphasize: it is not that the documentary image offers a window onto the reality of the events it shows but rather that we believe in the power of the image's phenomenological capacity to bring the event into iconic presence. And our engagement with that presence is made possible only through the absence of the image maker as mediator. Consequently, we have the opportunity to become openly receptive to the experiences of those who were present at the event in the image. Thus knowledge or identification of the national and political allegiance of the photographer or filmmaker is not necessary to a revivification of the photograph, to our process of witnessing. Although this process differs for the different images I discuss throughout, the one consistency in my discourse is that the removal or temporary bracketing of the image maker gives us the freedom to look from different perspectives, through different eyes—our eyes.

I must emphasize that the distance incurred through my specific conception of the amateur image as anonymous is a conceptual, not a literal, definition. Within my argument, an image can be anonymous even when the photographer is identified. Anonymity is better defined as an inability to infer the meaning of the photograph based on the identity and presence of the maker. Even when the amateur photographer or home movie maker can be named, his or her images are generic, often identical to thousands of others.[60] Similarly, the images were often freely reproduced and distributed, passed on from party to party throughout the war. Again and again, the same images resurface in the archives with conflicting attributions, contentious ownership, and inconsistent contextual information. In addition, the mise-en-scène is frequently abstracted, the historical context is vague, and the postwar provenance can be sketchy at best. From the outset, these images remain unable to be pinned down, an evasion that I refer to as a form of anonymity. To reiterate, the precise form of the maker's absence from the image hermeneutic, and therefore its role in processes of witnessing varies from one set of images to the next. At this stage it is worth noting that the inclusion of works by figures such as Walter Genewein and Eva Braun, both of whom can be identified as authors of the images they took, are crucial to a reinforcement of

this notion of the anonymous image and, by extension, the amateur, as discursive constructs. To take the example of Braun's images, not only do I extrapolate the collective memory and public history present to her images, thus demonstrating their shift from individually authored images to documents that represent a general social and national identity. In addition, in many of her images she is not present, and neither is she identifiable as the author; even if she is, they have a generic quality that makes them open to appropriation in the memories we author. Thus I would be building on fragile ground indeed if I were to interpret her subjective vision as the sole producer of meaning in Braun's films and photographs.

Amateur Film in Nazi Germany

The historical conditions under which amateur film and photography were being explored, distributed, and exhibited in Germany at this time also contribute to the way they are interpreted and reinvigorated to facilitate memory and history. Although the years leading up to World War II saw important growth in filmmaking and photographic activity in many European countries, the 1930s provided a particularly fertile landscape for growth in Germany. Film clubs were growing, affiliated publications were flourishing in number and in content, and film and photography were becoming integrated into the cultural experience of everyday life. Most important, both were nurtured by the Nazi Party (the Nationalsozialistische Deutsche Arbeiterpartei or NSDAP) because of their potential for the propagation of the party's ideas about social organization and economic prosperity.[61]

The National Socialists encouraged the ownership of cameras and their use to document everyday life. Kuball quotes Walter Benjamin in his reminder that fascism looked to organize the masses into a mechanical body in which all individual expression would be effaced. The photographic camera was the ideal apparatus for this purpose. Not only could the camera document the mechanical rhythms of Germans at work and in training to serve their country, as well as the machinery of industry in motion;[62] it was also available to everyone to represent daily life from a

supposedly objective point of view. Many of the images and techniques for filming the rhythms and patterns of home life, work, and relaxation are indeed recognizable in the well-known documentary films made by the NSDAP. One thinks immediately of the soldiers on parade at Nuremberg, the workers exercising, the Hitler Youth marching in formation in Riefenstahl's *Triumph des Willens* (1935) (*Triumph of the Will*). In these images we find the structured formations of the people as an anonymous mass, formations that we now associate with the repetitious movements in unison of the tiller girls made famous by Siegfried Kracauer's observations.[63] Just as this image of German organization and prosperity was dependent on the technological apparatus, so were developments in amateur still and moving image-making as valuable as those in the official arena to explore its parameters.

Throughout the 1930s, as amateur filmmaking in Germany continued to grow, new technologies were developed—lenses, cameras, transparency film, and processing techniques—and were all made more sophisticated. Similarly, the film clubs grew and their publications, such as *Film für Alle, Film Amateur,* and *Jahrbuch des Kino-Amateurs,* blossomed into forums for discussions of the ongoing amelioration of film and photographic technology and technique. There were also annual competitions, most of which were community or state organized: these evidenced the Nazi encouragement of an ever more developed and effective film and photographic product. When the NSDAP established its film department in 1930, it did not distinguish between amateur and professionally produced film. The department's interest was in the use of film and photography to educate the German people in the building of the unified German nation. Likewise, when Kulturfilm–Vetriebs–GmbH set up its lending program (presumably for exhibitors) in the mid-1930s, the catalogue included amateur documentary films as well as studio-produced fiction films.[64] Of course there was not a random endorsement of all film and photographic products for their own sake, and indeed some films were rejected, others celebrated. However, value was not determined by amateur or professional status. Value was ideologically, not aesthetically, determined. German film censorship had been a feature of the market since its earliest years.[65] Thus the fact that only films that promoted life in

accordance with National Socialist policy were distributed and exhibited under the Third Reich did not appear as a radical change in policy.

Finally, in the 1930s German industry began to boom, and the new Reichsfilmkammer und der Reichsvereinigung Deutscher Lichtspiel-stellen, Kultur-, und Werbefimhersteller insisted that the industrial firms Agfa and Siemens work together with people making films, including members of amateur clubs.[66] These firms worked with filmmakers and photographers not only to better the technology but also, in the interest of having film and photography available to more and more people, to create technologies that would cost less. For example, in 1936 Agfa developed its super-8-format film and Siemens refined the corresponding apparatus for distribution to a mass market. The new technology was quicker, safer, and more comfortable to use, not least of which because of its relatively light weight and portability. These developments would have a resounding impact on the extent to which cameras were used in the late 1930s and 1940s once World War II was set in motion.

In keeping with the enthusiasm for film and photography as media to represent and mobilize the masses at this time, the NSDAP was ready to exploit all possible avenues of production. In the same vein as its promotion of images that furthered their cause, the party encouraged the production of films and photographs whether they be amateur or professional. The commitment made was to the development of the respective media such that they could be put in the widest possible circulation for propaganda use, and, to reiterate, there was little discrimination in terms of the professional status of those doing this development.[67] Nevertheless, the vast majority of images chosen for distribution as propaganda were manipulated before or in the process of publication. Thus the fact that the films and photographs I discuss might have been produced within a structure of Nazi politics and ideology does not mean that they were official or sanctioned by that system. Similarly, films and photographs taken by soldiers, bystanders, and civilians may have been produced in transgression of the structures set in place by the Nazi system, and yet they may nevertheless have been appropriated for propaganda purposes. Thus, because such images negotiated the line between amateur and official propaganda, they not only demonstrate the inefficacy of such hard and

fast distinctions but also remain open to be taken up in contemporary processes of witnessing and remembering the crimes they evidence.

Contemporary Visions of the Amateur

As a result of its focus on the amateur at the crossroads of a number of discursive contradictions, *Through Amateur Eyes* builds in significant ways on the revitalization of studies of amateur images that have emerged over the past ten years. In the early wave of scholarship, amateur films and photographs were embraced for their insights into the breadth and diversity of histories, histories often overlooked in the standard versions written by the socially privileged, those who occupy the center of public life.[68] Amateur films and photographs were seen to open history up to the perspectives of those on the margins, for example, women and other disenfranchised groups.[69] However, the embrace of the richness of the visual qualities of the image itself is a relatively new phenomenon.

Following the formative work done on amateur images in the 1980s by scholars such as Zimmermann in the United States and Roger Odin in France, until recently English- and French-language scholarship tended to focus on the sociological and historical significance of amateur film and home movies. Such scholars believe in the necessity to look at the deep underlying meanings of such images by focusing on content and context.[70] Indeed, both Zimmermann and Odin consciously bracket the amateur and home movie aesthetic in preference to expounding their sociological, ideological, and historical value. Zimmermann, for example, chooses to emphasize the ephemerality of amateur films, and rather than analyzing their aesthetic attributes, she understands them as "social documents." She argues that amateur films "more often than not lack form, structure, style, and coherence of normative visual tropes, precisely because they occupy psychic realms and psychic fantasies that are themselves unformed and forming." Zimmermann believes that their status of always being in a process of formation "forces us to analyze these films not as artistic inventions (although that strategy certainly erupts from time to time), but as a series of active [social] relationships."[71] In the other founding work in the field, Odin emphasizes the social use of the home movie as a forum that brings

various family members together: the camera is a go-between in family relations.[72] Thus, if this logic is transposed to Braun's film footage—for example, when Hitler smiles at Braun's two sisters on the shores of the Königsee and Eva coyly smiles at the camera—the film establishes a set of relationships among Hitler, his lover, and her sisters. For more traditional scholarship, it is the contours of these relationships that is the insight of the home movie.[73] Although these interpretations are of utmost importance to *Through Amateur Eyes,* I am also interested, for example, in Braun's use of certain types of film stock, cameras, and frame composition; the gender relations of each shot; and the fact that her work bears many of the hallmarks of travel films from the same period. Both Zimmermann and Odin, on occasion, turn to specific examples of amateur and home movies, and indeed these rare and curious images are the foundation of their arguments. Nevertheless, the social issues they raise, not the visual aspects, are the primary focus of their founding scholarship.

Building on the significant insights of these scholars' early contribution to the study of home movies and amateur images, the understanding of these fragile and often stigmatized images has recently undergone a renaissance. A number of younger scholars have, over the past few years, returned to the archives to excavate the often orphaned films made by amateurs—both Germans and other Europeans—during World War II. Similarly, these scholars have chosen to begin their analyses with careful attention to the sensuous qualities of the film image.[74] Martina Roepke, for example, plays detective with a fragment of anonymous footage from World War II Germany.[75] Her interpretations reinstate the multiplicity, the lability, and subsequently the agency of the image within its historical context. In turn, although not all of these scholars take their observations to a theoretical level, the results of visual analysis and historical understanding of the integrity and agency of the image usually facilitate productive discussions on the relations between past and present. Furthermore, this slow process of discovering Holocaust and World War II images leads to an understanding of the role of the images in memory and, at times, public history.

The footage shot by dignitaries, officers, soldiers, and civilians in wartime Europe is of a very different order than that of the home movies

analyzed by Roepke and other scholars; however, their analyses provide a way of approaching the material at hand.[76] *Through Amateur Eyes* takes the compelling uses of the archival image of Roepke and scholars such as Schneider as models for interpretation one step further. Specifically, I reflect on how the images engage with other discourses of their generation, thereby expanding the social and cultural contexts within which they ultimately make sense. Thus again, interpretation may come back to the cultural and moral questions at stake in earlier work on amateur film and photography, but it travels a very different route and, in doing so, makes new discoveries along the way.

Home Movies or Amateur Films?

Finally, just as fluid distinctions clarify what constitutes an amateur photograph or film, there are subtle differences between a home movie and an amateur film or photograph. Nevertheless, I make no distinction between home movies and amateur films, because the former can be considered a subgenre of the amateur movie. The problems with adhering to distinctions between the two are made immediately obvious if we consider Odin's discussion of the two different forms. Odin distinguishes between amateur and home movies and photographs when he identifies the concern of the home movie and photograph as the family. According to Odin, these are films and photographs that are interested in a different set of questions than those taken up by professional images: they are not motivated by economic, creative, or social recognition. Rather, they are made in the interests of exploring the dynamics, identity, and unity of the family as an institution.[77] Again, Braun's home movies and family photo albums illustrate the fragility of this line between amateur and familial. She may have been filming a family picnic in one shot, but in the next she rested her camera on the beauty of the natural landscape surrounding the Berghof.[78] Indeed, her primary motivation was not always the subject of the family—either her biological family or her family of friends and associates—before the camera. She was, as I demonstrate, fascinated by the development of her medium and committed to exploring her talents and skills with the camera. Not to mention that her family included the

most despotic public figure of the twentieth century, so her images were never confined to the concerns of an immediate biological or even social family. Similarly, there were times when, as I demonstrate, the soldiers on the battlefield filmed and photographed their fellow infantrymen with the same communal intimacy, curiosity, and fascination with the subjectivity of their fellows as a father or brother filming his family might have shown. And, once again, the Wehrmacht soldiers were often interested in exploring the materiality of film, a characteristic that is typically the concern of the amateur. Similarly, from the earliest days of film and photography, the line between amateur and family photographs, amateur and home movies, was always tenuous. In his history of amateur film in Germany, Kuball confirms this dichotomy when he gives precedence to the technical and aesthetic developments and explorations in the amateur film clubs and yet demonstrates that many of the members of these clubs were practicing their talents by filming their families.[79] Ultimately, because the images in *Through Amateur Eyes* oscillate freely between so-called family and amateur images, I observe this restlessness in my own discourse and leave the distinction flexible.

On the Eastern Front with the German Army

The hundreds of thousands of photographs taken on the Eastern Front include some of the most difficult of the World War II visual documents for the historian to reckon with. They are difficult for a number of reasons, most significantly for the disturbing nature of what is photographed. Unlike many of the other images I discuss in this book, the photographs taken on the Eastern Front, often by soldiers and officers, are replete with the worst kinds of violence, with no attempt made to veil or displace it: the images depict cold-blooded murder, ditches filled with corpses, lynchings in process, proud soldiers posing alongside freshly murdered corpses, the execution of brutal, perverse slaughters. We see bombs exploding, women and children at gunpoint, the humiliation and abuse of Jews, prisoners of war begging for food, and soldiers shooting already dead corpses at short range.

However, these are not the only subjects of these photographs. In addition, there is an abundance of photographs of a different sort, including images of landscapes and what might be called travel snapshots or ethnographic studies, images of soldiers at rest, at play, and on duty carrying out procedures, along with photographs of weaponry on display, communication facilities, first aid stations, and so on. The soldiers were also photographed performing their daily rituals and routines, including eating their meals together, working in their battalions, and engaging in leisure activities. Simultaneously, like family albums, the soldiers' images relate their high points, the special or extraordinary occasions that represented a break from the routines of their everyday lives at war.[1] Therefore, photographs taken on the battlefield in the East do not represent a coherent collection, and, by extension, they do not stand up to a single interpretation. This creates another challenge for the historian. In

addition to the varied subject matter of the images, the multiplicity of possible interpretations is fuelled by their ambiguity. For example, often because of the distances involved and the sizes of the processed images, there can be a lack of clarity as to what is represented that complicates interpretation.

The sheer number of photographs that continue to be brought to light today also creates problems for interpretation. Not only was a seemingly infinite number of photographs taken, but in keeping with the possibilities of the medium of photography, they were also freely reproduced and distributed, at times passed on from party to party throughout the war. Thus, interpretation of these photographs becomes further complicated by the uncertainty of their historical context, as well as their wartime circulation and postwar provenance. Similarly, the same photographs pose problems because, of all the amateur images that have surfaced since World War II, the photographs taken by anonymous soldiers, officers, and at times bystanders, partisans, and resistance fighters are accompanied by very minimal, not always reliable, documentation. When they were placed in albums and captioned, it was usually done in retrospect at the war's end. Thus from the outset these images have been unable to be pinned down: they are beset by conflicting attributions, contentious ownership, and vague, even nonexistent, contextual information.

In this same vein of uncertainty, the locations of the photographs are often unknown or, at best, ambiguous. Throughout this chapter I refer to the activities as they took place on the Eastern Front and to the photographs as documents of activities in this vast geographical area. I have included the locations in the image captions when known, locations that stretch from what is now eastern Poland across Belarus and as far south as the former Yugoslavia. Nevertheless, I insist throughout on referring to the geographical coordinates with the more generic identity of Eastern Front. The photographs may well witness activities in specific regions and locations on the battlefield; however, an atrocity that took place in Minsk as revealed by an image could just as well have taken place in Czechoslovakia or what was, during World War II, Sudetenland. Thus, although images are referenced specifically, they envision tragedies far and wide.

Despite, and perhaps because of, the slipperiness of the images, those aspects which challenge the fixity of interpretation demonstrate all of the characteristics of hesitation and fluidity that I identify as key to amateur films and photographs from the Nazi years. Accordingly, the images offer a productive place to begin visual analysis, move out toward a historical context, and ultimately find new ways of understanding these so-called perpetrator images. Thus in this chapter the photographs lead to a reconsideration of the complex, often contradictory ways that Nazi ideology becomes identifiable in such images. Similarly, I argue that if we suspend the imperative to see through the lens of the identity of the photographer and approach the images through the optic of the amateur, we have the option to put them into other contexts, for example, conceptions of the relationship between industrial modernity and representation. Having seen from this perspective, we are often then led back to the ideological significance of the images. However, it is a significance that coexists with other historical insights we draw from the same images. Perhaps most important and most urgent, interpretation through the optic of the amateur opens up the possibility of appropriating these photographs today for the continued memory of the atrocities that took place on the Eastern Front. I demonstrate how some of the most odious photographs can be mobilized in the project of witnessing traumatic historical events of the past.

When the time comes to interpret the images that do not depict massacres, humiliations, lynchings, and mass executions, new layers of knowledge about the role of community among soldiers and its existence on the battlefield, about the creation of identity at war, and about the convergence of photography, modernity, and the battlefield are opened up. I have already touched on the centrality of the Nazi elite's story in ongoing attempts to understand the atrocities of the Holocaust. Likewise, a fuller and more comprehensive understanding of the events that took place on the Eastern Front will be gained if we look around and behind the photographs that represent the atrocities themselves. The ordinary life of the soldier at rest, on his journeys, in the company of other soldiers is equally valuable and necessary to the role of visual representation and its history in World War II. And a part of this day-to-day life was a pursuit of photography, a pursuit that coincidentally contributed to the development of the

medium—if only in terms of its mass dissemination—during the war. The historical significance of amateur German photography cannot be fully grasped by looking only at images of atrocities, nor can it be understood by seeing such images as unadulterated perpetrations of Nazi ideology.

The Soldier Sees

It is estimated that more than one hundred thousand German soldiers packed cameras together with their few personal belongings when they went to the Eastern Front from 1939 onward. Many of them owned cameras, because the technology was available for mass ownership from around 1930 in Germany. It is estimated that in 1936 between five and six million Germans owned cameras, and three years later, in 1939, the number had risen to seven million.[2] Not all soldiers who owned cameras would have taken them to war because the space in their packs was limited and the extra weight was unwanted. Nevertheless, the novelty of the medium and the anticipation of visiting far-off places was reason enough for many to pack their cameras. At the time it was possible to buy empty albums with "Zur Erinnerung an Meine Dienstzeit" (In memory of my service years) or a version thereof, along with a Nazi insignia, such as a swastika or an eagle, embossed on the front. These albums were purchased in anticipation of photographs that would tell the stories of travel in far-off lands.[3] Thus soldiers were encouraged to take photographs as part of their war experience. They carried a variety of cameras, ranging from Agfa box cameras to the recently invented, more expensive Leicas usually owned by officers.

The hundreds upon hundreds of thousands of photographs taken by soldiers, officers, bystanders, accomplices, and resistance fighters served a multitude of purposes. The soldiers used them as illustrations of the stories they told and the travels they related in their daily journals and letters home. In some cases, the photography replaced journal-writing as a way of recording their experiences. The images were signs sent to their families, with or without accompanying letters, that they were alive and that their health was intact. Similarly, the photographs provided detailed examples of life at war for loved ones and family back home.

And in some cases, photographs were taken merely as a way of observing the events and happenings of everyday life as the photographer experienced it. Alternatively, photographs were documents of the work done by soldiers in their army "professions": for example, artillerymen used cameras to document the weaponry and its use, and doctors photographed first aid trucks and the sick and wounded over and over again. Often the soldiers wrote on the backs of the photographs, sometimes on the fronts, describing events for their families or anonymous future viewers. Their families, in turn, pasted the images into albums at home, with descriptions written on the pages of the albums.[4] Alternatively, the soldiers themselves carefully reconstructed their personal war narratives in the years following the war, often through the use of photographs, letters, propaganda pictures, and other paraphernalia they had collected while at the front. The albums were made as mementos, reminders, and histories, often to be passed onto the next generation, as documents of family life in times of war.

It was usual for strips of film to be developed and copies made on the home front, and when the soldiers received their images, they proudly showed them to their comrades, often sold them for coveted items such as tobacco, bartered with them, or gave them away as gifts when they were not sent home. Thus soldiers who did not own cameras still had access to the images and bought photographs from comrades to use in making their own albums.[5] Initially, photographs were also processed on the front, in Poland, for example, by private businesses at whose establishments copies might be made and swapped for tobacco, sweets, or other rarities.[6] However, it was discovered that the Poles in the local photo-developing shops were making and keeping copies of the German soldiers' photographs, so very quickly orders were issued not to have film processed by these private firms on the front.

Verbrechen der Wehrmacht

I first became aware of these photographs when I went to a conference in the name of an exhibition that never took place: the New York installation of *Verbrechen der Wehrmacht: Dimensionen des Vernichtungskrieges*

1941–1944 at the Cooper Union in 1999.[7] The exhibition was conceived and first mounted in 1995 by the Hamburg Institute for Social Research to mark the fiftieth anniversary of the end of the war.[8] It comprised around fourteen hundred photographs and substantial written text. The images depicted regular German soldiers engaged in lynchings, mass slaughters, random executions, and other crimes. The exhibition was divided into ten sections titled War and Law, A War That Differed from All Others, Genocide, Soviet Prisoners of War, Reprisals, Starvation as a Strategy of War, War against the Partisans, Deportation, Options for Action, and The Postwar Period. Each section included a conglomeration of materials: still images, descriptions of events on wall panels and in audio cabinets, visual reproductions of objects, documents, maps, and LCD monitors showing postwar interviews and statements on film. For example, visitors could see human trains of Jewish and Gypsy victims on their way to execution, the shooting of a Jew in Dubno in 1941, a seven-day pogrom in Tarnopol, and other morbid images of such things as the digging of mass graves and the accompanying shootings and, of course, the infamous Minsk hangings.[9]

The exhibition had been conceived and installed in Germany in 1995 by the Hamburg Institute for Social Research, a private organization committed to public research projects with rotating thematic focuses. Although the New York installation of the exhibition differed slightly from that of its German versions, its theoretical and historical focuses were identical, and the differences were primarily at the level of the visual contents. In Germany the exhibition, which had already traveled to a number of cities in Germany and Austria, was intended as a historical, not a scientific, project. Whatever its designs, it was interpreted to raise historical consciousness through turning the spotlight on the responsibility of lower-level Nazi personnel and those Germans who had, throughout the postwar period, been considered either victims of or, at worst, bystanders at crimes committed by high-level Nazi leaders. The exhibition was received as a challenge to the longstanding assumption that the Wehrmacht soldiers had been pawns in the war dictated by Hitler, members of the SS (the Nazi Protection Squadron), and other senior members

of the Nazi Party, all of whom were held responsible for the atrocities committed during World War II. In the archives at the Hamburg Institute for Social Research, the repository of images told a different story. Thousands of photographs bore witness to the fact that ordinary soldiers and air force officers had apparently been responsible for, or at least the perpetrators of, the persecutions, the torture, and the slaughter of Jews, Gypsies, resistance fighters, and other victims on the Eastern Front. And even if they had not actively participated in the crimes, they were eager onlookers. This claim was indeed huge: it would ultimately challenge the certainty that existed beneath the silence of forgetting and the ignorance of responsibility for World War II and the crimes in the East. It was a challenge that did not just stir a national debate but led to demonstrations and the fear of a neo-Nazi resurgence. The tensions rose between the political left and the right, fathers and children, soldiers and curators, historians and the Institute for Social Research. Indeed, the very identity of a postwar, postunification Germany was at stake in the vociferous debate that was ignited in the presence of the traveling exhibition.

What struck me all along as I followed this debate was the status of the image as a realist document of crimes committed by Wehrmacht soldiers. It is true that many written documents were used in support of the argument made by the original exhibition, but it was the images that were held by critics and spectators to be definitive proof of the crimes. The disputes and struggles over exhibition policies, the role of the institute in fashioning German history, and of course the soldiers' role in the crimes in the East have been well documented.[10] However, in all of the debates and in the subsequent commentary and criticism of them, the currency of the images presented by the exhibition as evidence has been all but ignored. Surprisingly, there has been almost no mention, let alone interrogation, of the assumptions about the images that underlay the significance of the exhibition and its many twists and turns. These assumptions, together with a curiosity about images that never made it to the United States, drew me to Hamburg to the archives of the Institute for Social Research to see what none of the arguments had given even a glimpse of: the photographs in their archival contexts. What were these images that

were at the heart of a national scandal? What kind of photographs had this type of power? But first I shall conclude my account of the checkered history of the exhibition.

Despite the intentions of the Institute for Social Research, it became clear that the research for the exhibition was neither exhaustive nor watertight, and, as a result, flaws in the argument were identified. The press and publicity around the exhibition repeatedly focused on the incomplete research and the hasty attribution of the images: in particular, the victims in a few photographs were identified as victims of the Red Army, not of the Wehrmacht.[11] As a result of the criticisms, the organizers closed the exhibition in November 1999 for an indefinite period, an independent commission composed of historians was appointed to scrutinize the exhibition, and more thorough research was carried out. When the exhibition reopened in November 2001, the number of photographs had been substantially reduced.[12]

Between critics, members of the independent commission, and the scholars at the institute, it was claimed that the controversy had resulted from the fact that the organizers had not thoroughly researched the images in the first place. This may or may not have been the case; however, it is not my focus here. The history and criticism of the exhibition raises another issue, a problem that potentially contributed to the confusion and ultimate rejection of the veracity of the images. Namely, although the commission dismissed allegations that the institute had manipulated and faked the photographs, there was never any mention of the fact that the amateur image itself is an incomplete and open form that, by its very definition, is replete with flaws and fragmentation. In turn, the less than concrete images were ultimately being asked (by critics and historians) to bear the weight of a controversial argument and, subsequently, a radical shift in the terrain of postwar history and memory. The institute inadvertently acknowledged this expectation when, in the rehanging of the exhibition, the amateur photographs were, for the most part, removed and professional photographs made by the propaganda companies for which there was a known provenance and usually a known photographer were used exclusively. Nevertheless, none of the journalists or critics of the exhibition seemed to acknowledge that they were placing

on the photographs a burden too great for these fragile and fluid images to bear. Without even having seen them, we know that the distance, the openness, and all of the questions that are asked of but never answered by these images means that they cannot easily be forced into a veridical status as realist evidence. Thus, given the suspected instabilities, rather than looking to the images to answer the question of who was responsible for which crimes, the *Verbrechen der Wehrmacht* exhibition and the controversy surrounding it, it is more productive to look at their manifest visual qualities before narrativizing them by considering their use as evidence in processes of witnessing. First I want to explain the problems with conventional approaches to such photographs.

Problems in Interpretation

As already mentioned, until recently it had been commonly agreed that the wisdom of orphan images lies in the contexts of their production, exhibition, and reception.[13] Whether the new context given to the images by their contemporary viewers and commentators or that of their original production, which is usually reconstituted by the contemporary exhibitor or viewer, the narratives into which amateur or private films and family photographs have been placed are traditionally considered to harbor their secret revelations. Hirsch, for example, argues that the profundity of the family photograph is found in the narratives and contexts that lie behind the image, outside of its frame. Here, in the stories that bring it into existence, in the narratives woven around the image, one finds what Hirsch identifies as its contestatory claims. Otherwise, the family or amateur snapshot is a surface gesture that complies with the ideological status quo. Hirsch writes:

> This work of contestation appears not so much in actual family photographs as in meta-photographic texts which place family photographs into narrative contexts, either by reproducing them or by describing them: novels and short stories, fiction and documentary films, photographic albums, installations and exhibits, autobiographies and memoirs, as well as essays and theoretical

writings about photography. The composite imagetexts that are the subjects of this book both expose and resist the conventions of family photography and hegemonic familial ideologies.[14]

Hirsch is careful to attend to the many images she discusses, but for all their revelations, their most significant moment, namely their intervention in the ideologically scripted versions of family and identity, is always outside of the image.[15] Indeed, the static images breathe only when the layers of narrative intrigue outside their frames are exposed. To reiterate, this approach is invaluable because it has effectively bestowed value on personal memory—especially as it is ignited by the family photograph—in second-generation witnessing of the Holocaust.[16]

However, to commence by looking at what is behind and around the photographs taken on the Eastern Front during World War II raises problems. To reiterate, in the majority of cases there is, at best, scant information regarding their original production, distribution, and reception histories. Though many of these images are found in the archives with inscriptions on either the back or the front, sometimes both, for the most part, the identities of the photographers, the motivation behind the images, where and how they were processed, who saw them, how widely they were distributed, and other significant details that would explain their origin remain a mystery.[17] It is true that many of the images arrive at the archives in albums, but the album as a context is only a reflection of the narrative wanting to be communicated. Although this narrative is, in itself, interesting and provides a valuable history, because of its subjective organization, each context—or, in this case, album—must be approached as a singular, not a generic, entity. Thus the meaning of a photograph in an album is potentially very different from its meaning when the image is found in the wallet of a dead soldier. So we are still left with the question of how to look at, how to approach, images that are without context, such as many of those that depict life and events on the Eastern Front. If contextual information does exist, it typically comes in the form of snippets that speak less about individual images and more about the general historical moment in which they were taken. The concerted efforts of a

number of scholars have unearthed much detailed information that still only nods toward a more comprehensive understanding of the images' context. The information available is not yet adequate to the complexity of the production circumstances and the sheer number of these orphaned photographs.

The Presence or Absence of the Soldier-Photographer as Author

In the German critical literature and the significantly fewer English sources of the past fifteen years devoted to the photographs taken by the soldiers, officers, and other amateurs on the Eastern Front, critical insights have almost always been based on the identity of the photographers as authors.[18] Even when an author is described as "anonymous" or perhaps designated as "a Wehrmacht soldier," the author is key to interpretation. Although comments about the images may move beyond a reiteration of the violence of the German war and the destructive, inhuman act of taking a photograph of such atrocious events, authorship is always a primary lens for interpretation. This follows the standard approach of the 1980s, when the silence around these images was first broken, of basing research into amateur photographs on the possibility of identifying their authors. Today many critics and historians continue to base their arguments and observations about the photographs on the equation between the image and what it reflects, where both are assumed to be an ideological and political expression of the maker.

Critics such as Hanno Loewy argue that the images betray the violence and complicity of the Wehrmacht soldiers who took them. For example, he indicts the soldiers as perpetrators of crimes just because they were behind the camera. He refers to those who photographed the shaving and cutting of Jewish men's hair thus: "The point, it would seem, was not whether photographs were taken or not, but the awareness of the photographers that, in taking these pictures, they became conspirators, accomplices, perpetrators, and thereby fully subscribed to the regime and its aims."[19] Loewy believes that the photographer was always guilty even if he did not commit the crime taking place before the camera.

In the many cases in which the individual behind the camera cannot be identified, the political and ideological system to which the photographer is assumed to have belonged is identified as author. In a permutation of the idea that the photographer-author as creative individual can be located in the image via his or her aesthetic or stylistic hallmarks, critics have searched for Nazi ideology as author in the style, composition, performance, and image quality of these amateur photographs.[20] They supposedly discover the racist, xenophobic totalitarianism of Nazi ideology as author.[21] In reality, however, these critics were always looking for evidence of this ideology, an ideology they assumed in advance was there to be pointed out.

Alternatively, critics such as Klaus Latzel depend on the soldiers' writings to argue for the self-articulated collective identity through which they saw themselves.[22] According to the journals and letters, once they were in uniform, soldiers did not see themselves as individuals with distinct personalities but rather as men whose images and writings reflect and speak of a representative Wehrmacht soldier and German military experience. Similarly, if the soldier was to display emotional or personality characteristics, these characteristics, too, were generic: courage, bravery, toughness and strength. These qualities were the characteristics of the ideal National Socialist man, whose self-image was formed by Hitler, the Messiah. In short, the soldiers' letters and diaries indicate their identification as the German *Volk* espoused by Hitler's ideological vision of a unified German people. Thus, argues Latzel, the photographs they took, like the letters they wrote home, were generic, communal documents of life at war. In turn, the images are the visions of this German *Volk*, with all its racism and single-minded vision of victory at any cost.

However, in all of these approaches that begin with the perspective of the photograph's author, we are still left with a series of questions, most notably concerning who was in fact the author: Was it the often unknown soldier who took the photograph? The soldier posing in the image? Was it the one in whose wallet, on whose dead body it is found? The one who wrote his memory on the front or reverse side of the photograph? Perhaps it was every German soldier present at the event. Alternatively, it might indeed have been the German nation that sent these troops to the battlefield. In yet another permutation, the author could have been the

ideal, mythical man that Hitler wanted his soldiers to be. Or indeed, the photographs could be seen as an expression of the army unit as a communal author.

Many of these images were seized from dead or wounded soldiers by members of Allied armies, in particular the Russian Army. It is striking that the same photographs have resurfaced in different archives or have been found in the collections of different soldiers, often without attribution but with varied inscriptions on their front or back.[23] In these cases, the soldier as owner of an image has inscribed on it his identity, thereby claiming a type of authorship. Irrespective of the content of the caption, the act of giving the photograph a caption designates its integration into the life story of another soldier. Families were also known to put the images in albums at home, giving them yet another narrative. For his family, the soldier's photographs were part of a swathe of photographs contributing to narratives of the different generations. Thus the authorship and ownership of these photographs was constantly shifting, even before the photographs found their way into archives and museum displays.

Given the confusions resulting from an author approach, I propose that the distance of any identifiable author be seen as contributing to the justification of alternative interpretations, interpretations that privilege a heterogeneity of viewer responses. Not only the distance or absence of an image's author but also the distance between camera and event, between perpetrator and victim, between viewer and photograph, between then and now can be mobilized as the basis for our response and, in turn, our recognition and remembrance of these past events. These distances create spaces into which we are invited to reflect on the events depicted in the image. And if these spaces are recognized, the photographs have the power to reignite historical memory and perpetuate processes of witnessing the past.

Witnessing Crimes

The photograph as an agent in witnessing the atrocities of everyday life on the Eastern Front engages the three contemporary fields within which witnessing takes place: the law, theology, and atrocity studies.[24] The image as witness, like the legal witness, testifies to the brutal, if not absolute,

reality of the events depicted. Because these photographs are often the only documents we have of the events represented, we cannot ignore them as a form of evidence of what lay before the camera. The specific details of the images may be indeterminate—the precise time and place where the image was taken, who appears in the image, and so on—but on this most immediate level, many of the images reflect and thus testify to brutal slaughters, parades of hangmen, the violence of the perpetrators, bodies left to rot, prisoners obeying orders for fear of their lives, and other atrocities. The photographs may be cropped and some events consciously included in the images, while others were deliberately made to fall outside the frame. Nevertheless, there is every reason to put our faith in the correspondence between the representation and the event depicted.[25] Unlike the official propaganda images that were taken in abundance by Nazi photographers and filmmakers, given the sheer number of amateur images produced, together with the costs involved in manipulation and the fact that they were not intended for any commercial or public use, at least initially, we can assume that the amateur photos were spared retouching and fabrication in the processes of production. Due to their status as amateur and private photographs, they were taken and processed with abandon, with little attention paid to technical mistakes, unwanted details, or uncensored inclusions. Thus the events they depict can be seen as, on some level, historical truth. There may be other truths, particularly those that do not appear in any of the photographic images, which are only ever fragments of the time and place of which they are traces. And their truths must not be privileged above any others. Nevertheless, the photos in existence are, in a legal sense, evidence of the events at which their authors were once present.

Although somewhat remote from the process of witnessing the Holocaust, like the theological witness, these photographs are evidence of the existence of events and happenings that were typically prohibited, denied, or repressed by official (German) histories. The prohibition on representations of German crimes is key to an understanding of the importance of these images in processes of witnessing what took place on the Eastern Front. Again and again, these and other photographs see what they were not supposed or allowed to.

The Distance of Prohibitions

The authors of the many photographs available did not obey the censorship laws that were in place during the war in the East. The list of prohibited subjects was not long, but it was definitive: all locks, bridges, and harbors; close-ups of weapons and machinery; anything that would give away attack and defense strategies or in any way endanger the authority of the German Army. Although it was acceptable to photograph an enemy who was already dead, it was strictly forbidden to capture the execution in motion. In short, any image that slurred the name of the Wehrmacht was also prohibited and censored.[26] Similarly, any image that might compromise the Germany Army by leading to potential imprisonment was prohibited.

The soldiers went ahead and photographed the censored subject matter anyway. Images of violence, brutality, and slaughter are everywhere in the archives. Moreover, the transgressions displayed in these photographs are critical to the images' role in the processes of witnessing. Most obviously, the photographic image is evidence of what was not always officially documented. In addition, these photographs have an unacknowledged power to disturb the authority of official history by representing what has been denied and repressed. This potential challenge to authority, to expose the existence of events that must be denied to maintain power, is familiar territory for the amateur image. Because the amateur sees and remembers events that otherwise fall through the cracks of official history, the amateur image opens a window onto an alternative view of history. In turn, these otherwise unexplored visions prompt us to reconsider this historical moment anew. Thus, although on the one hand the photographs taken on the Eastern Front are suspect because they show the battlefield seen through German eyes—even when they were taken by bystanders or other participants, it is claimed that they reflect a German perspective—they also evidence the plurality of alternative histories seen by the perpetrator and of perpetration.

It must be acknowledged that in spite of the uniqueness and potential transgression of the often forbidden perspective of the amateur photographs, they also offer an unethical perspective of the crimes in the East.

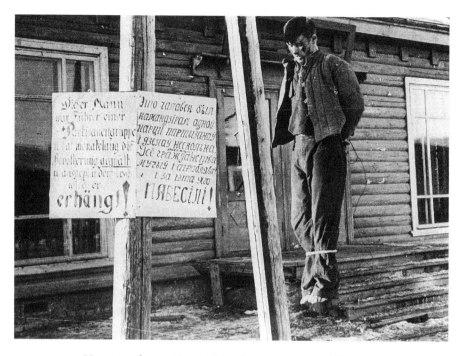

FIGURE 1. *Hanging of a partisan in Minsk, circa 1942–43. The same text was written in Russian and German on separate signs: "This man was leader of a group of partisans and for a month he tortured and plundered the people, therefore he will be hanged!" Bundesarchiv Bild 146-1976-127-15A; photographer unknown.*

Images that depict anything from a dozen local Jews lined up before a firing squad through lynchings in progress and lynched corpses hanging like Christmas decorations from light posts and balconies or strung up in the main street of a small Russian, Polish, or Serbian town or village (Figure 1) to corpses collapsed against wooden poles against which they were shot[27] are, according to some discourses, categorically unacceptable as testimonies to the heinous crimes of the German soldiers. They are unacceptable because to witness the survival of the Holocaust—and here the crimes in the East—goes hand in hand with a moral and ethical imperative to be responsible to the events in some way. Accordingly, these photographs are ideologically saturated: they objectify the victims, ignore their suffering, and foreclose the possibility of the victims' speaking their own stories.

The many photographs that show rows of dead bodies; groups of ema-ciated, cowering figures holding tightly to each other or with their hands at their sides, lined up for execution; or corpses hanging from balconies for all to marvel at register a brutal distance rather than a necessary intimacy and the "total presence of the [soldier and his photograph] as other."[28] As Hüppauf convincingly argues, these images are drained of human con-tent and often verge into the terrain of abstract, formal compositions.[29] The trauma and experience of the victim is certainly not seen or expe-rienced from the inside; the human figure is often so far removed from the lens of the camera that it is impossible to respect the individuality of the individual's internal experiences, the singularity of his or her trauma. As a result of this distance, no relationship is established between victim and perpetrator's image (as mediator). Seen from this vantage point, the camera and the resultant images take no responsibility for the traumatic experience of the victim. The photographs un-self-consciously violate the integrity and humanity of those who have been murdered at the hands of the German Army. Not a thought is given to their suffering; rather, the victims appear as points of interest on a sightseeing tour (Plate 1) or become merged with the landscape (Plate 2).[30] Witnessing does not take place as an experience between a subject and an intimate other; these photographs are too intent on calling attention to the authority and dis-tance of the one who saw. Finally, the photographs depart significantly from the accepted document that bears witness because they do not nar-rate the story of survival. Rather, the victims have already been killed, and to bear witness to their trauma would be akin to psychoanalyzing a dead man. The images are far removed from the profound processes of self-realization and historical realization that we have come to associate with the processes of witnessing.

Although I want to hold onto this possible interpretation as it is seen through the lens of Laub and Felman's witnessing, it is not the only per-spective from which to see. As Barbie Zelizer and others have claimed, often in passing rather than through sustained argument, the images taken by the amateur German soldier-cameramen can witness the Holo-caust.[31] But these same critics also stop short of explaining how these im-ages witness. Given the complexity of the conception of bearing witness,

possible answers to this question are now long overdue. It is not enough to claim the photographs as evidence of what lies before them; we need a more sophisticated conception of how they might be taken up in our efforts to responsibly witness World War II and the Holocaust.

In his renowned collection of amateur and official photographs and documents that tell the history of the Holocaust, *Der Gelbe Stern,* Gerhard Schönberner argues that the images of the perpetrators reveal a curiosity that speaks of their very troubling "tactlessness."[32] The images collected in his book are of the same genre as those discussed earlier: long shots that document violent crimes. According to Schönberner, the images verge on a lie because they are superficial visual representations that do not even approximate the brutality and incomprehensibility experienced by the other senses.[33] The same images of slaughter and inconceivable human destruction may tell other truths: they show the thinking of the Nazis, their self-identity as heroes and that of their victims as subhuman, the truth of what they deemed worthy of photographing, and their anti-Semitic ideology.[34] For Schönberner believes that the images exist only at the level of the optical, that is, their only reliable truth is in their presentation of what their makers saw: the events that took place before the camera. Thus the perspective of the perpetrator and, in particular, the impact of Nazi ideology on this perspective renders the photograph superficial, useless in any attempt to witness the inhumanity of ghettoization, deportation, torture, execution, and mass expulsion. This impotence in the process of witnessing that is the logical extension of the identified opticality is in keeping with the thoughts of Laub and Felman. For to witness is to experience the events in their the sensuous richness, not simply as visual occurrences. Thus to witness entails the experience of other senses: the stench of bloodied, decomposing bodies; the taste of death; the sounds of bullets ringing out and orders being yelled; the emotions experienced by the participants. Certainly none of these experiences were had at the level of the atrocity photographs as evidence. Thus we must go further. As Zimmerman says vis-à-vis amateur and home moving images, we must mine the photographs for their buried truths.[35] And in order to go further and deeper, we must look at our reception of and interactions with the photographs.

Whether the viewer is German, Jewish, Russian, American, or of any other identity, when he or she sees the photographs seventy years later, the eyes of the German perpetrator or the supposed collaborator behind the camera directs what is seen only for so long. That is, the image is not seen as it once was by the cameraman. Today's viewer sees with the advantage of seventy years of history and sees from different cultural and political perspectives. First and foremost, when we look at images such as that of a group of Russians, Poles, or Gypsies huddled together, heads bowed, with their only protection at the point of a gun being their choice to look away, we recognize a confrontation between the soldier-cameraman and his victims. We imagine the trauma of the mass unidentifiable subject, the perceived injustice, the underlying fear and promise of death. In other images we note the camaraderie, curiosity, and obligation of those grouped by the threat of execution before the camera. In fact we are likely to notice a whole spectrum of responses, emotions, and meanings, a whole range of circumstances and dispositions.

Cathy Caruth points us toward one potential interpretation of the images if they are accepted as vehicles for the articulation and rearticulation of history, that is, as springboards to the process of witnessing. She argues for the "double telling" of the narrative of trauma in a model that is very close to that of Felman. Nevertheless, for Caruth the double telling is in the image itself. Following Freud, Caruth sees witnessing as the making available to consciousness of a traumatic experience that was not assimilated when it occurred through telling a story. Thus confrontation with or witnessing the trauma comes in the reiteration of the same trauma. According to Caruth, the listener as witness to the trauma of the other (pictured) faces an encounter between life and death in himself.[36] Accordingly, when faced with the contentious perpetrator photographs taken on the Eastern Front, we are forced into a devastating awareness of the death of the victims as human beings, and we are repeatedly struck by the soldier's survival before and behind the camera. Before we judge the victims' death and the soldiers' survival, the reawakening of these historical events to consciousness is in itself a process of bearing witness.

To extend the interpretation following Caruth, Kathrin Hoffmann-Curtius argues that the death of the victim as the other reinforces the

exposure of the Wehrmacht soldiers' own vulnerability. According to this logic, the photographs as agents can be understood to allow viewers—no matter their historical period—to see the soldiers' (in and out of frame) wrestling with their own potential deaths through the creative act of photographing the victim.[37] Accordingly, the photographs enable a vision and re-vision of the codependent relations between victim and aggressor on the battlefield in the depicted historical moment. Of course, this is only one interpretation.

Another interpretation might see a photograph such as one in which a soldier is aiming his rifle at resistance fighters lined up along a nondescript wall in Russia—an image in distant long shot framed by two soldiers—as a narrative of self-surveillance. The same photograph brings to light the rebellion within the ranks of the German Army because the photographer took a photograph that was strictly forbidden. Such an image can become an agent in the witnessing of the complex relations and self-positioning of soldiers within the army, especially as they relate to the orders handed down to them, the beliefs being instilled in them. Another interpretation might be that offered by Hüppauf in his insightful theorization of the same genre of photographs in "Emptying the Gaze." According to Hüppauf, such photographs depict a decorporealized gaze that, in turn, effectively creates a timeless and objective "space of destruction" that has different meanings for different viewers of the image.[38]

Whatever the interpretation, the ability to position ourselves at a distance from the eye behind the camera due to the distance of the pro-photographic event, to see the photograph as evidence of the presence of a traumatic event in the past that took place between an aggressor and his victims, between various ranks within the army, enables the events to come back to memory as a complex historical experience. The most important recognition is that only when the image is detached from the one behind the camera and the specific identity of the subject is it possible to see it as an agent in the process of witnessing the atrocious events of World War II.

Most significantly, these are not straightforward pictures of slaughtered bodies. As viewers, we do not automatically assume the position of the soldier: for example, we do not look with glee and pride at a photograph

of Jewish elders being mocked and tormented, all the time trying to assert our power and hide from our own fears of death and our guilt for persecuting others.[39] Nor do we look with indifference at groups of men such as those in Zhitomir in the Ukraine, knowing that they will ultimately be killed (Plate 3). Such a reading could not be further from the reality of our experience of the photographs. The images belong in a process in which our responses can vary significantly: we are moved by the violence and outraged by the suffering they narrate, perplexed by the soldier's dependence on the corpses or body of the enemy for his identity as a loyal servant of his country, repulsed by his sadistic violence, and disturbed by the care taken in composition of the image as though it were of a picturesque landscape. Our complex responses to the photographs as evidence of the atrocities on the Eastern Front, as testimony to the trauma, bring the events into our present. In turn, this is the process by which the images can be validated for their role as agents in the process of witnessing this war.

It is true that our responses are determined by the evidence of the photographs, which, in turn, are not naïve or unbiased. And it is true that any viewer's vision is clouded by cultural and historical persuasions, just as the image is soaked in the ideology of everyday life in Nazi Germany. Thus there is no objective or authentic interpretation of the photographs; nevertheless, the minute they engage a viewer, they are vehicles in a vivification and revivification of history. They have a potential for involvement in the process of bearing witness to the pogroms in the East from a position removed in time. And this animated process is enabled through the complex web of distances that are woven into the photographs: the distance of the subject from the camera, the psychological and emotional distance between the perpetrator and his victim, the distance between subject and viewer created through focal length. In addition, the process is generated by the flaws of the image such as blurring, scratching, and writing, all of which further distance us from the events represented. Even the physical image itself, with its curious 6 × 9 or 4.5 × 6 centimeter format, its discolorations, and the curvature that comes from sitting stacked for years in a box at the back of a drawer creates another level of distance, an objectification of images from another era. Indeed this distance is even

more pronounced today in a digital age in which photographs as physical objects no longer exist. Moreover, these same distances are what invite us to insert ourselves into the worlds they visualize and thus to remember with new insight the acts of violence they depict. Similarly, the potential of the photographs to act as agents in new histories and memories is enabled by the distance of seventy years. As Hüppauf points out, the time that has elapsed means that these photographs "no longer produce the urge to look away."[40] The distance of the camera from the subject and the distance of the viewer from the events depicted are the vehicles for the renewed potency of these photographs.

I want to hold open the possibility of differing experiences, differing sensory and emotional responses to the photographs taken on the Eastern Front. Indeed, variety is expected given the changing historical, political, ideological, and cultural contexts of the images' reception. Although readers may want to challenge the responses experienced by the contemporary viewer as inauthentic, nonempathic, or removed from the victims', even the survivors', traumatic experience, we do well to remember that this is the nature of memory or "postmemory" and second-generation witnessing, as Hirsch would have it.[41] The doubts cast over the authenticity of the agency of the photographs taken on the Eastern Front do not make the histories they represent any less valuable, the memory they create less profound than those produced by photographs taken by Jews or Allies. In fact, Hirsch points out what is now an evident fact but was once—in the 1980s—a radical idea: it is impossible for any photograph to reproduce the perspective of the victims or to narrate history in the voice of the dead because they are necessarily silent.[42] Furthermore, if any representation attempted to reproduce the original trauma on behalf of the one to whom it belonged, it would be considered tasteless. Thus the only perspective from which these images might represent is, in fact, that of distance.

To summarize, there is a violence to the images about which I must speak. We cannot and must not ignore the pride and sense of achievement expressed by the soldiers in some of the photographs. And yet we do not imitate these responses. If we understand an image as representing a complex relationship between the perpetrator and his victim, between the photograph and its subject, between the viewer and the photograph, we

can mobilize a violent image in the process of witnessing these traumatic events. Moreover, there is no obligation to invite the soldier-photographer to explore, to act as a guide or a companion on our journey of witnessing. Thus the status of the image as agent is not dependent on the photographer's respect or disrespect for the silence of the dead. Most significant, the German perpetrator-photographer is not the conduit for testimony, the testimony of the victim. Thus if we extend the notion of witness to include its definition of the document as evidence in a court of law and to embrace the possibilities opened up for the viewer as a second-generation witness, these photographs offer a unique opportunity to witness through igniting and reigniting our memory of events to which we have previously not had access.

Images of Modernity

Industrial modernity influences and is influenced by both the medium and the events represented in the photographs taken by soldiers, bystanders, collaborators, resistance fighters, and others on the Eastern Front.[43] These photographs function, simultaneously, to evidence a tragedy of disproportionate scale as well as a particular moment in photographic production. This was a moment in which photography was being explored for its capacities beyond that of a window onto the world. In turn, by taking the viewer back to groundbreaking moments of photographic production and reproduction, the amateur photographs can be seen to make sense within an otherwise latent historical context. Their place within photographic modernity provides an interpretive optic that attends to the form, such that the medium and visual characteristics of the photographs open up to their significance as historical documents beyond their contribution to the articulation of Nazi ideology. And yet, typical of their heterogeneity, when seen through this lens, the photographs also function to reiterate the Nazis' ideological program. They do this when they remind us of the Nazis' belief in the need to systematically exterminate masses of people, at times on the basis of their physical appearance. Industrial production, systematization, the proliferation of documentation—such as the documentary photograph—and so on were

all exploited by the Nazis in their annihilation of all who they imagined stood in the way of a powerful, unified nation.

Thus on the one hand, if we see the images as amateur, anonymous, somewhat generic products of industrial modernity, they enrich our vision of the possibilities of photographic representation as it was being explored at this time more generally. On the other hand, simultaneously, they are indisputable evidence of the ideology of everyday life under Nazism. These different, not incompatible, levels of meaning instantiate tensions within the photographs taken on the Eastern Front by soldiers, bystanders, and other unknown photographers that inaugurate a space for reflection and, in turn, provoke us to think about them differently.

In his discussion of the role of photography in nineteenth-century modernity, Alan Trachtenberg explains photography

> as a medium of communication, an application of science to the making of pictures, as a veritable symbol of revolution and progress. [Early theorists] recognized its link to other new media of communication, and to the shifts in population toward the city and its consequent enlargement of the market for pictures.[44]

Even today, when photography is valued for its social and political as well as its artistic dimensions, it is still seen as a technological invention that came hand in hand with modernity and the modern life in its environs. The photographic medium contributes to and is shaped by the forces of technological modernity. Moreover, as Hüppauf argues, photography and the modern battlefield were inextricably linked in their respective self-definitions in World War I.[45] During World War I, the two joined forces to usher in exciting new developments in photographic representation and the way that war was carried out. However, it was not until twenty years later, in World War II, that the technology was available to the masses, resulting in a proliferation of photographs. Together with the development of other technologies, this proliferation brought further redefinitions of the battlefield: for example, it fuelled a collapse of the boundary between battlefield and home front as the photographs were sent freely between

the two. In addition, the very existence of the photographs, their survival through seventy years of prejudice toward the image and particularly the image of the German soldier and Nazi officer, testifies to the power of the photographic image to document or evidence histories of World War II. Similarly, its longevity and reappearance today keeps alive and also continues to shape the public imagination about World War II histories.

In addition, these photographs intervene in the history of the photographic medium in a way that is typical of amateur images. Namely, like amateur photography in general, these images reiterate (often anachronistically) crucial moments in the development of their medium. In this instance, they keep alive questions surrounding the photograph as substantive evidence of what lies before the camera. While photography in other arenas—for example, the artistic and journalistic arenas—was exploring the possibilities of abstraction and creating stories, amateur photography was insisting that there was still more to be done in the medium, in particular, in its capacity to produce visible evidence. In turn, these reiterations invite us to rethink the place of the photograph as evidence within established histories of photography. In addition, the productive distances, which I place at the crux of the photographs as agents in processes of witnessing, provide an alternative optic for seeing and knowing ethnographic photography in its nascent stages of development. When the ethnographic aspects of the amateur photographs are juxtaposed with early examples of ethnographic documentation, they contribute to two simultaneous contexts. First, they make sense within the social and political spheres defined by the Nazi machinery's use of the technologically modern visual culture. Second, they participate in much broader movements in modern European representational practices and cultural forces.

The photographs are defined by their ubiquity, multiplication, and replication. Not only were the same images reproduced ad infinitum; there are many different photographs of events that look the same and are, for all intents and purposes, interchangeable. When they have no context, such as would be given by an album, the photographs could have been taken anywhere, at any time, during the years when German soldiers were moving through Eastern Europe. Thus, for example, any of the

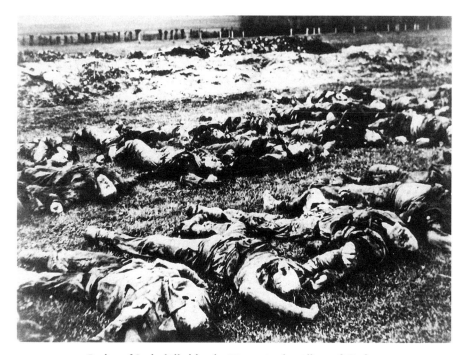

FIGURE 2. *Bodies of Serbs killed by the Ustasa in the village of Gudovac, Yugoslavia, 1941. The Ustasa, or Croatian Revolutionary Movement, was a fascist organization appointed by the Nazis in 1941 to rule in Yugoslavia. Members of the Ustasa were responsible for much of the Holocaust in Croatia. Muzej Revolucije Narodnosti Jugoslavije. Courtesy of U.S. Holocaust Memorial Museum, image 46708.*

photographs in a series of photographs taken in the Nazi puppet state of Ustasa in the former Yugoslavia could have been taken at any number of locations in the East. In these long-shot photographs we see columns of bodies neatly laid out in a muddy landscape (Figure 2). Similarly, the many undated photographs in which prisoners of war are identifiable as Soviets only because of their uniforms are nevertheless ambiguous (Figure 3). We may have a general idea of who is represented, but where, when, by whom, and for what reasons they were photographed were often left ambiguous. Many of the images are unidentified and unidentifiable. Dead bodies en masse, barren landscapes, prisoner of war trains, faceless soldiers, usually Soviet, all in long shot—these disturbing sights

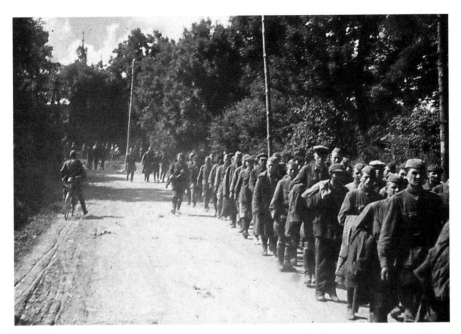

FIGURE 3. *Soviet prisoners of war on a dusty street in Kharkov, summer 1941. The prisoners are being driven forward by Wehrmacht soldiers. Several months later, on October 24, 1941, the German Wehrmacht captured Kharkov, then capital of the Ukraine. Original caption of photograph: "Russische Kriegsgefangene aus den Kesselschlachten bei Charkow und am Don, Sommer 1941" (Russian prisoners of war from the tank battles in Krakow on the River Don, summer 1941). Bundesarchiv Bild 169-0864; photographer unknown.*

were common to much of Eastern Europe in 1941–42. The mise-en-scène of the photographs is nondescript, the figures often too far from the camera to be individualized or identified.

At times the photographs can be identified as representing a specific event that took place at a specific time. However, this is usually possible only when a notation appears on the front or back of an image or if the image has been archived with letters, maps, and journals in an album. Perhaps there are street signs or declarations hung around the neck of a lynched corpse, perhaps someone wears a uniform that can be identified, or in the background there is a building that helps locate the city. Even then, at times, these notations and signs are too small to read or have been

shown to be unreliable because the same photographs appear in different archives with different inscriptions, different descriptions. The form and aesthetic of the photographs, the death of the one who took them or owned them, the paths they traveled following the war have made precise attribution impossible.[46] Remembering that the images were also given away, sold, exchanged, and sent home and that it was usual for more than one copy of each to have existed, precise attribution is even more elusive.

Thus, in addition to its creation of memories of World War II, this proliferation is evidence of the excitement over the reproducibility of the photograph, a reproducibility that is a hallmark of industrial modernity. Furthermore, the photograph's multiplication contributes to its status as evidence of the excitement for the reproducibility through proliferation of the photograph as an agent of industrialized modernity. It also connects soldiers and their comrades, the battlefield and the home front. And its anonymity, in terms of not only its creator but also what it represents and where and when it was taken, gives the photograph a permeability. In turn, this openness means that it has had a capacity to be appropriated, both then and now, for different narratives. The engagement of the photographs described in this book with the issues of technological representation in modernity is thus the basis of their usefulness and potency for a twenty-first-century viewer. And of course all these attributes have made photography the perfect medium for propagating far and wide a message of hate and destruction. Photography was as ideal for the agitation of the masses during World War II as it is as a medium of memory today.

The early wonder at the reproducibility of the photographic image, its ability to be produced without human intervention, and debates regarding the certainty of its access to truth are brought back to life through the existence of these amateur images.[47] Similarly, before Benjamin's celebration of the aura of photography that reinstated the photographic form within a pictorial tradition, anonymity and objectivity were the ontological priorities of the medium. Even though it was not long before critics in the mid-nineteenth century were to understand the human (even artistic) intervention as a safeguard of quality control in the composition of the photograph, they remained convinced of its status as an

industrial process that offered mechanical accuracy. Indeed, this belief in the iterability of the photograph as an accurate portrayal of events was present everywhere in the production, distribution, and reception of the wartime images. Earlier I discussed the way these images were used—for example, as signs to a soldier's family of his well-being, as mementos of places visited, as documents of the atrocities. Even if they had been manipulated at all different stages of their production and reception, they were always seen to have a historical accuracy. This accuracy and documentary dimension, however naïve, married the photographs taken on the Eastern Front to some of the earliest conceptions of photography. In turn, the wartime regeneration of uses of photography that had, for all intents and purposes, been left by the wayside since the late nineteenth century broadened the conception of the photographic medium at this time. This same conception of the photograph was taken up with equal force by the Nazis for their propaganda efforts. In turn, it underwrote the amateur images' transgression, albeit unwittingly, of the propaganda efforts. And in the space between the photograph as an ideological vehicle and the photograph as implicitly exposing the flaws of that ideology, we are able to intervene in determining how the photograph can be used anew to remember the events of this treacherous war differently.

Looking back from a postwar perspective, we have come to understand the amateur photography of the late 1930s and early 1940s as explicitly connected to modernity for two primary reasons: first, because the technology being used—the portable camera, the negative film, the paper print—was a result of industrial modernity and second, because amateur photography, like sport, travel, and shopping, was an activity pursued in leisure time, itself an invention of industrial modernity and the rationalization of time.[48] Photography's continuity with industrial modernity is perhaps best identified via the many photographs taken on the Eastern Front in leisure time. The images of soldiers cooking, eating, playing cards, drinking together, and relaxing in the summer sun (Figures 4 and 5 and Plate 4) are as abundant in the archives as images of their crimes. More than the images taken of the action on the battlefield, these photographs of the soldiers at rest strikingly resemble snapshots taken by

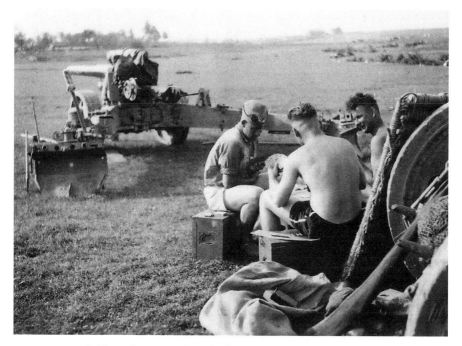

FIGURE 4. *Soldiers playing cards and relaxing, circa 1941. The photographer, Jürgen Wöbbeking, was an artillery man in the German army who made albums of his travels to the front. He collected reproductions of paintings with old tanks in the background, travel snapshots, diaries, and maps of the front with a date marking each place visited. Wöbbeking, Box 5, O22. Courtesy of Hamburg Institute for Social Research.*

other amateur photographers at home and on vacation in the late 1930s and early 1940s. The soldiers' everyday lives were simply transposed to the battlefield, where they were pictured with tanks belonging to their battalions rather than cars belonging to their nuclear families, cleaning their guns and mending their uniforms rather than doing the gardening or playing with their families.

In addition, one could argue that wearing uniforms and working for the army were in keeping with the instrumentalization of modern life. As unidentifiable soldiers in uniform, in groups, and at leisure, their very existence before the camera signals the photographs' engagement with the discourses of modernity, not the least of which was the waging of modern

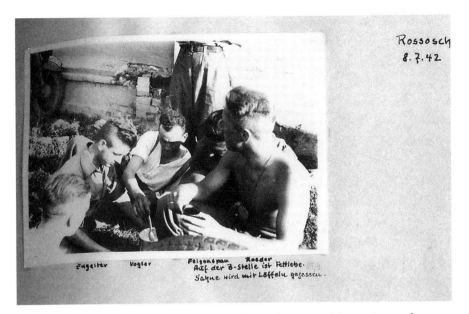

FIGURE 5. *Soldiers eating cream at Rossoch on July 8, 1942. The caption reads "Auf der B-Stelle ist Fettlebe. Sahne wird mit Löffeln gegessen" (Good times at the construction site. Cream is eaten with spoons). Wöbbeking, Box 5, XII, 9. Courtesy of Hamburg Institute for Social Research.*

warfare in which they were engaged. At the same time that these images tell of soldiers at leisure, they reveal the instrumentalization of time and behavior as that from which the soldiers were taking a break. As I discuss later, many of these photographs were collected in albums that take the form of vacation or travel albums. Individual travel was a pursuit born in the modern era. It was inextricable from the machinery of modernity, most notably modern, industrial modes of transport for physical journeying over long distances. And for many young men, going to war was an opportunity for mobility. War and movement through distant lands went hand in hand with modernity.[49] These resonances with the culture of modernity enable us to appropriate the photographs to get a picture of the past in which the photographs and the war they document belonged to the contours of historical modernity.

The frame composition of the images also lends itself to a discussion of the photographs as the product of industrialized modernity and

modernization: the order and symmetry of each frame, the frequent picturing of people as a mass, the camera's perspective from high in the sky or at a distance all speak of the capacity of the apparatus to rationalize perception and to explore modes of vision not previously available to the naked eye.[50] In addition, all of these compositional features of the image were in keeping with the photography suggestions and guidelines published in the journals of the amateur film clubs of the time. Images such as those shown in Plate 2 and Figure 2 are all but abstract visions in which the mass of bodies and the uncultivated land merge into one another in the distance. All are hallmarks of industrial modernity as it was both captured and produced by technologies such as the photographic apparatus.[51]

Similarly, typical of the paradox of modernity, hand in hand with the rationalization of perception came a chaos that can be identified in the images. This took the form of not only the mistakes and flaws (blurring, unbalanced frames, deterioration) of the amateur images but also the disarray of what was taking place before the camera.[52] These imperfect constructions and mises-en-scène were unbalanced and unpremeditated, opening up the visual and conceptual space for a recognition of the underside of the rationalization of army life: that which was not depicted in the images. Most notably, hand in hand with the systematic march to victory by the German Army went an everydayness, the routine of daily life, which was in fact uneventful and perhaps even dull. If we accept that the visual characteristics of the images mirror the social world, the aggressive war on the Eastern Front and the strength and resolve of the German Army were underwritten by the banality of daily life.

The multitude of images of soldiers preparing and eating meals, relaxing with their battalions, setting up camp, testing artillery, or simply posing for the camera are further evidence of the everydayness of war. It is an ordinariness that exists hand in hand with the extraordinariness of the events going on all around. In the same way that empty, unstructured time is the necessary companion to the temporal exigencies of travel, a routine existence filled with trivial tasks is the reality of life at war. The amateur photographs invite us to witness this everyday life in a way that official photographs do not. Thus these images offer a larger picture of

wartime, a picture that deepens and broadens our historical knowledge and our perspective of the past. In chapter 5 I discuss in relationship to the private albums of Eva Braun how images of home and family are essential to a fuller knowledge of World War II. At a time when the lines between home front and battlefield were already blurred, an understanding of this war is incomplete today without a sense of the shape of the everyday life that was going on behind the scenes of destruction. However, here it is enough to remark that the banality and seeming obliviousness to the destruction going on beyond the frame of the images of atrocity reflects the bourgeois normality of life in the midst of war.

The notion of the banality of Nazi evil has become familiar following Hannah Arendt's penetrating insights into Adolf Eichmann's public servant–like disposition and attitude toward his job. However, here the notion of banality sees the amateur photographs engage with a different everyday. The amateur images of the re-creation of family and community on the battlefield, the apparently quiet and inconsequential nature of most days on the front, invite us to witness the bourgeois normality that framed the stress of war. The soldiers' organization of daily life according to the structures and routines of family, community, and work in spite of what was happening around them is evidenced nowhere but in these photographs.

When seen through the optic of the amateur, the photographs and, consequently, the lives represented therein did not replicate Nazi ideology as much as they clung to a familiar sense of community for an identity, for a rationale and basis of daily life. These structures had as great an influence on subjectivity and its motivations, including the vision through the viewfinder, as did the political structures of Nazi ideology. As I elaborate in chapter 5, the ideology of family, community, and work as it is represented in and defines these photographs produced a possibility of conflicting interpretations that, in turn, open up the space into which we can insert our memories and our histories and thus reassess our knowledge of the historical past. In addition, if we take these images seriously and include the amateur visions of daily life side by side with those of the mass violence, we will see more complexity in the history of World War II, a complexity that is critical to a fuller understanding of the past that informs the present.

Travel Mementos

The private narratives told in the albums into which the photographs were placed both during and after the war bear many resemblances to the narratives into which family vacation travel snaps were routinely woven. Like photography, travel was a luxury promised by modern life in the first half of the twentieth century. Travel was dependent on locomotive trains and the resultant possibility of crossing geographical borders with ease. It was also enabled by the imperative to relax—while spending money on a vacation— from the eight-hour working day. And the technologically reproducible image, in both its still and its moving variations, was the appropriate means by which to document these activities. Like the images in albums of travelers and tourists throughout the second half of the twentieth century,[53] the photographs from the war are of most interest to those within the immediate community—the photographer, the owner, the soldiers in his battalion, the photographer's family and loved ones, or anyone who saw and experienced similar events. And yet, because of the historical context of these particular photographs, they are also of profound historical interest. In turn, this historical interest can be placed into various narratives, including that inspired by their relationship to ethnographic photography at the turn of the century. Nevertheless, the photographs depart from ethnographic photography because they were produced within the borders of wartime Germany, where the notion of home and foreign land had a very specific meaning in the Nazi period.

The many instances of soldiers' posing with victims remind us of photographs of vacationers in front of famous sites and curious scenes. A soldier stands in the foreground of an image in which a mass execution takes on the role that the Eiffel Tower or the pyramids would for a different traveler: it serves as an icon in the background. What is important is that the soldier was there, that he saw this unusual scene with his own eyes (Plate 5). In an article that contrasts the letters of the Wehrmacht with those written home by World War I soldiers, Latzel draws attention to the touristic attitude of the Wehrmacht soldiers when they traveled through Europe. He quotes from their letters home to show that, from the soldiers' perspective, the war was a wonderful opportunity to travel, to see the world, to see different

cultures, and to come face to face with other peoples. This was, after all, the era when mass tourism had become a defining feature of modern life, and often the only way for these soldiers to live out the dream handed to them by their developing society was to go to war.[54] Indeed, as mentioned, discourses surrounding the war experience—including the sale of empty albums—encouraged its conception as an opportunity to travel and to record the voyage in photographs. This attitude toward the soldiers' travels East explains why the photographs bear many of the same characteristics as vacation snaps.

The images depict a mixture of curiosity about and differentiation from the people met and events stumbled upon, responses that are akin to those of meeting foreigners and seeing novel sights in undiscovered lands. The photographs use the language of power typical of the Western tourist journeying across foreign lands. Also similar to travel photographs, and amateur photographs in general, those taken by and of soldiers on their travels through Europe were taken in anticipation of some point in the future. They would, it was hoped, function to help the soldiers recall these unforgettable moments in years to come.[55] And today we are indebted to this attitude of looking toward the future because it motivated the safekeeping of the albums in attics and closets and thus preserved the photographs for our use in processes of witnessing today.

The photographs as representations of curious events, exotic peoples and landscapes, and objects encountered on journeys through the East also remind us of visual documentation of ethnographers at the turn of the twentieth century, when photography and film had become a novel mode of studying other cultures, other peoples.[56] In his groundbreaking study of the science and art of ethnography, James Clifford writes of the contours of an ethically sanctioned, knowledge-producing investigation. He maintains that today, legitimate ethnographic study self-consciously explores a dialogue between subject and ethnographer.[57] Such study creates sympathy for the culture encountered, empathy for the people under investigation, and an emotional connection that produces knowledge of the cultural other from an ethical vantage point. It is a way of giving voice to one's experience of the other culture. In addition, ethnographers are, according to Clifford, always in search of their own desires, the realization of their own

selves, their own subjectivity.[58] Thus the ethnographic representation sees the realization of both subject and other. And if it is ethically arrived at, the experience of the other is given a space in this same process.

The photographs taken on the Eastern Front do not even begin to approach the empathy and dialogue that Clifford believes is central to ethically responsible ethnographic discourse. Like so many early ethnographic images, those taken during the war in the East show no dialogue between the photographer and the photographed, no visible sympathy for the photographed, no attempt at emotional connection, and no self-consciousness that might have complicated and opened the space for a dialogue among photographer, photograph, and photographed. Rather, these images are expressions of authority and domination. They are examples of cultural imperialism at its most virulent. As discussed, these photographs taken on the Eastern Front are, if approached through this lens, unquestionable assertions of superiority.[59]

We might want to argue that the same is true in general of ethnographic photographs taken at this time. It was not until after World War II that ethnographic photographers began to develop a sensitivity to the identity and integrity of their subjects as more than curious objects of observation.[60] However, what distinguishes the photographs taken on the Eastern Front is that members of the German army did not see themselves as journeying through foreign lands. Nor did they perceive the "non-Aryan" peoples they photographed as other in the usual sense. We recall that the Nazi goal was to extend the German lebensraum, or "living space," eastward so that greater Germany would have the land and raw materials necessary for its realization. In turn, this gave rise to the Nazi policy to kill, deport, or enslave all Russian, Polish, and Slavic people, not only Jews: they were considered less than human because it was believed that "they choke the growth of healthy budding elements."[61] Non-Germans, non-Aryans, were not other but rather abject and inhuman. Their lands were not simply colonized but appropriated by racist expansionism. In chapter 4 I discuss more fully the consequences of the uniquely German lebensraum policies on interpretations of the amateur image in relation to the color film footage taken on the Eastern Front. However, it is important to recognize the uniquely wartime German inflection of these

photographs as ethnographic documents. In this sense, these images are deeply embedded in the ideological structures of everyday life in Nazi Germany, especially during wartime. And the inescapability of this ideological dimension creates tensions within the images. Unlike other amateur photographs from the period, these images, even as they appear to be benign travel and ethnographic images, display a deep conflict. They are tainted by the conflict between an engagement with broader industrial developments taking place across Europe and the specific exploitation of these developments by the Nazis in the name of racial superiority. Nevertheless, this irresolvable conflict or tension is the place at which we stop to bear witness, because it makes the images troubling, and when the conflict is not easily resolved, we are unsettled and thus provoked to reflect on the various discourses that pervade the images. In other words, the moment of trouble is the moment of the photograph's opening up to the possibility of being appropriated in processes of witnessing the past.

Given the xenophobia, anti-Semitism, and all the other discourses of hatred surging through these images, how are we to see and appropriate them today in an ethically appropriate way? It is of utmost importance that we not repeat or reinforce the violations of the photographs as they exist within the context of Nazi culture and ideology. An ethically responsible understanding is made possible by the space that opens up in the various distances at play in the images. When we take all levels of the representation into account—the physical abrasions to the images; the crimes depicted; the images' role as travel photographs, ideological vehicles, documents of modernity, and so on—we are able to conceive of ways to productively place them in memory discourses.

Eduardo Cadava leans on Walter Benjamin's *Theses on the Philosophy of History* to conceive of the dialectical tensions that enable images to create our memories of what history has otherwise destroyed. He says that

> emergence and survival of an image that, telling us it can no longer show anything, nevertheless shows and bears witness to what history has silenced, to what is no longer here, and arising from the darkest nights of memory, haunts us, and encourages us to remember the deaths and losses for which we remain, still today, responsible.[62]

For Cadava, responsibility takes the form of reading (or seeing) the traces of the past in the images' continuous relationship with the present, in the emergence of "now time" or history as an image. In Cadava's discourse, after Benjamin's, the photograph itself, with its dialectic of light and dark, presence and absence, composition and dissolution, instantaneity and infinity, is the fundamental level of dialectical tension. In the dialectical space, or distance, the photograph inaugurates history, as an image, in our minds. This process captures that of our potential engagement with the photographs as they become agents in our processes of witnessing. And the tensions between different interpretations—in this case, of the image as a product of industrial modernity and as a conveyor of Nazi ideology—also rekindle our ethical relationship to "what history has silenced."

The different contexts, and consequently the different interpretations of the photographs, are an injunction to reflect on how we see them, how we might otherwise have been suspicious of them—in short, to think more about them and that to which they testify. Through the coexistence of multiple though not necessarily incompatible interpretations, readings, and viewings of amateur photographs taken by Germans during World War II, we are provoked. In between these different readings, between camera and subject, between then and now, we remember, and we marry what we see with what we know and do not know, what is depicted and what is not. And thus the images reanimate in us an experience of the photographs and the events at a distance, in the present. The presence of this experience is seen in our very willingness to carry responsibility for a past that should never have happened, but because it did, should never be forgotten or repeated.

Blurring Distinctions

Professional and Amateur

I have mentioned the photographs' mimetic authenticity and inauthenticity, their frequent flaws, the minimal degree to which they have been manipulated, and their vision of events about which we have no other record. In addition, the photographs taken on the Eastern Front by soldiers,

bystanders, partisans, and other observers pose a radical challenge to distinctions traditionally upheld between official and unofficial, professional and amateur, private and public histories, everyday life and extraordinary events. Acknowledgment of these blurred distinctions gives way to insights into the articulation of identity on the battlefield as it is conceived through power over and differentiation from the enemy within. And yet the photographs' instability is the site of their power, their representation of the power of the perpetrator, their power as images that puncture the myth of the wonders and glories of the future Germany. This double edge of the photographs, in which the hermeneutic of the image as medium runs counter to the power of the German perpetrator over his victim, shines a light on the contradictions of Nazi ideology. We will see how the same photograph can be interpreted as ideologically saturated and, simultaneously, as contesting the edicts of the National Socialist state.

The Nazis embraced and encouraged amateur image makers' depictions of everyday life as a symbolic affirmation of the people's devotion to the party. It was a forum in which people would demonstrate the integration of National Socialist ideals of race, family, work, and community into their everyday lives. Whether by citizens on the home front taking photographs of special family occasions or soldiers on the battlefield capturing their lives at war, amateur photography was an activity to be used to demonstrate and develop allegiance to Hitler and his vision.[63] It was, after all, the most immediate, apparently unpremeditated, view of the ideality of the everyday, an ideality that symbolized the perfection of life in the National Socialist state. In turn, when amateur photographs demonstrated a commitment to these ideals through their depictions of idyllic landscapes and industrious, productive workers, it was common for the unofficial image to be appropriated, manipulated, and reproduced as official propaganda.[64] Thus, although the mode of production of a given photograph may have accorded with the processes and visual traits of the unofficial and amateur, it always had the potential to be appropriated by the system. This was only the beginning of the amateur photograph's capacity to confuse the distinction between official and unofficial.

The discourses around the prohibition of photography by Nazi officialdom point to the most obvious collapse of the amateur and the professional,

official and unofficial. Particularly in instances in which the orders regarding prohibition were ignored, we are able to locate the historically penetrating insights of the photographs as they traffic between the two unstable classifications. Reifarth and Schmidt-Linsenhoff, among other critics, discuss the signs and written warnings of the punishment— execution—that would be delivered if the soldiers were caught taking photographs.[65] They describe the passing down of warnings from Himmler, Heydrich, and other officials that read, "Every instance of spectating and photography is prohibited."[66] Not only did the tight censorship of images produced within the National Socialist state tempt the amateur to turn his camera to the strictly forbidden, but official photographers also transgressed the laws of production. Thus hundreds and thousands of unofficial or forbidden photographs were also taken by professional cameramen.[67]

Two photographs reportedly taken by a Hamburg radio reporter named Stubbening depict a massacre of Jews in Konskie, Poland, on September 12, 1939.[68] The first of the blurred, somewhat decayed images taken from above shows the now familiar scene of those to be executed obediently digging their own mass grave. The other is equally familiar, showing six or seven corpses lying against the wall of the building against which they were shot. The photographs accompany Bernd Boll's discussion of the orders regarding prohibited photographs. Boll refers to these images as private, by which he means that they were not taken with publication in mind. The photographs, taken at a distance from obtuse angles, are blurred, the setting and time indeterminable, and in all other ways they are indistinguishable from those taken unknown by so-called amateur soldiers. Nothing about the images indicates the identity of either the photographers or their potential uses in propaganda publications. In fact, they are defined by very opposite qualities. Their primary and only purpose was to record the digging of the grave, the dead bodies slumped in the street, abutting a wall. The common visual, technological, and evidential traits of these photographs means that they cannot be linked to the identity of a photographer employed for his craft. The images are no different from those of an anonymous amateur. Also found in Stubbening's albums is an image of three German soldiers with famed filmmaker Leni Riefenstahl in the background, the faces in medium shot, the expressions

ranging from shock and curiosity on the part of the soldiers to a deep distress seen on Riefenstahl's face.[69] It is true that this image must have been taken by someone with privileged access: the focal length betrays a lens that was more sophisticated than those available to amateur photographers. Other photographs exist of Riefenstahl reeling in horror at the Konskie massacre in September 1939, thus confirming the location of this image.[70] Nevertheless, the onlookers, including Riefenstahl, were never photographed with the massacre, and there is nothing about the other images that would enable identification without accompanying documentation. All we can be certain of is that we see the professional journalist employed to take official photographs producing anonymous images that are indistinguishable from unofficial, illegal examples taken by unknown soldiers who happened to have cameras and who happened to be at the scenes of crimes. If it were not for Riefenstahl's presence in the photograph, the unidentified and unidentifiable onlookers could be anywhere on the Eastern Front.

This silent collaboration of amateur and professional, official and unofficial opens up to a discourse of resistance that exposes the inconsistency of actions and reactions within the ranks of the German Army and its envoys. In addition to discourses on issues such as the guilt of the German Army, which drove the controversy of the *Verbrechen der Wehrmacht* exhibition, the same images tell another story if they are seen through the optic of the amateur. Stubbening's images were forbidden because, like so many others, they saw things that the Nazis knew would be damaging to them. If these events became public knowledge, the German course of action would be questioned, German power would be endangered, and, at worst, the images could be used as counterpropaganda. Streets lined with lynched corpses hanging from lamp posts, bodies splayed along the streets of war-torn towns, and open graves brimming with bodies were far from Arcadian landscapes of snow-capped mountains and bucolic Aryan men and women at rest on the land and in the villages.[71] As these photographs have been handed down to us today, they tell an otherwise submerged story of the varied and sometimes incompatible way of living according to Nazi dictates. Namely, even those in service to the Reich did not always adhere to its laws. And, as in the case of Stubbening in

Konskie, it was often at that moment when the professional or practiced photographer assumed the role of an amateur to take unofficial images that the contradictions were exposed.

Typical of the contradictions that powered every Nazi edict and gesture, the two landscapes, one of destruction and waste, the other of ease and abundance, were interdependent for their existence. The one was not possible without the other. Although high-ranking dignitaries claimed that they could celebrate their fantasy without a trace, without responsibility for the process of realizing it, the reality was a different story. The images of death and destruction depict a truth that had no place in the Arcadian vision of the German Reich, at least as it was imagined and propagated to its people and the world. And yet the same photographs expose the underside that had to exist in order for the élan of the Nazi vision to become a reality. This constitutive contradiction is an insight that is communicated thanks to the documentation of travels in the East, pictures taken through amateur eyes. It is the luxury and the complexity of the amateur—in this case, unofficial and prohibited representation—that, however unwittingly, exposes the inconsistencies of power for all to see.

Power and Ideology in the Amateur Photograph

The photographs of the killing fields in the East do not always express inconsistencies in attitudes toward the power wielded by the Nazi system. Indeed, in many instances these images are overwhelmed with the destructive power dynamics between perpetrator and victim and are frighteningly oblivious of any evidential value they may have. In many examples, the primary goal was to exhibit control and oppression through the photograph's "mastery, possession, appropriation, and aggression." According to Abigail Solomon-Godeau, this power of the photograph develops from the belief in the visual mastery conferred on a spectator who becomes an all-seeing, omniscient eye in a world constructed by framing and distance.[72] When this double-edged power is identifiable in photographs, they have a unique ability to disturb. Among the photographs taken on the battlefield, some of the most upsetting expressions of power are found in a genre of photographs in which soldiers laugh at

the victims as objects of persecution. The dynamics of power are in no way ambivalent in these examples. In one familiar and repeated image, soldiers objectify Jewish elders in Poland by pulling at their beards and laughing.[73] Such photographs could be interpreted thus: the pride and ruthless victimization accord with the official propaganda platform of one nation, one people, one leader, the cost of which is irrelevant. Similarly, the sadistic urge to photograph such scenes fueled the obvious power relations of perpetrators and victims. There was no apparent intention to threaten the stability of National Socialist rule; therefore, the resistant edge of the photographs is nonexistent. Again, images such as those that show soldiers smiling for the camera in front of hung corpses evidence a sadistic pleasure on the faces of those present at the slayings and their aftermath. Through the insidious perversion of these specific photographs the photographers did not necessarily strive to convince a population of the repulsion they should feel toward the enemy and the need to eradicate him. But they did celebrate the murders and the murderers. Thus the images tell us little about the victims and a lot about the perversion of the perpetrators.

The pervasive power and program of victimization surging through these photographs must be acknowledged. The gestures and facial expressions of the perpetrators seen in the photographs are wholly congruent with the directives for racial cleansing handed down by the system's officials. Similarly, in these cases the identities of the photographers were erased in the name of fulfilling Nazi Party objectives.[74] Nevertheless, seen by us today, these images, in flagrant disregard of the Nazi protocols for taking photographs, openly disclose the cruel victimization and the unnecessary violence directed toward masses of people. Not only are they violent images; they also transgressed official policy by laying bare, thus demythologizing, the programs of destruction that infected the trails of the German Army's path eastward. Thus, in its public manifestation, a Nazi ideology that typically hid its abuse is questioned by these amateur images.[75] The photographers of these images had internalized the imperative to cleanse the body politic of all aberration and threat. However, their particular expressions of this imperative are in the form of unexpected revelations of the perverse need to achieve a coherent nation.

Once again, my reading of the power dynamics of the amateur image and its ambivalent challenge to Nazi edict is born of a genre of battlefield photography marked by compositional attributes that create a distance. In addition, a distance is forged between different strains of the sometimes irreconcilable meanings generated by the photographs. The power of the photographs to disturb comes from these variant distances—between photographer, camera, and subject; between all three and the contemporary viewer; and between different layers of meaning. The distance introduces new levels of truth to the discourses around the images and, simultaneously, new conceptions of how an uncertain allegiance to Nazi ideology was photographically realized. Finally, this distance opens up the possibility for a viewer removed in time from the events shown to reflect on the complex power dynamics and their undoing at stake in the photographs. Following this logic, the final responsibility for these photographs today is with us—how we see them, what we do with them, the discourses into which we insert them.

Private Histories, Public Memories

Critics have repeatedly theorized amateur and family photographs as private mementos that are simultaneously documents of public history.[76] These arguments are based on the belief in the public dimensions of the body, the family, sexual identity, memory, and other personal discourses. Likewise, the amateur photographs taken on the Eastern Front contribute to the creation of public memories and histories. However, they do so in a specific way: they envision a transformation in the constitution of public history as it is realized through a private vision. Similarly, the images testify to the way that individual memory is determined by historical forces and, in particular, by the World War II battlefield. For example, the fact that, for the first time in history, so many soldiers were in the habit of taking cameras to the battlefield; the accessibility of photography; the possibility of having photographs developed on the home front and then sent back to the battlefield to be collected, sold, bartered, and given away—all these circumstances marked an important shift in the way photography contributed to the collapse of the distinction between

public history and private life. And this shift can be understood as exaggerated in the amateur images discussed here because of the fact that they were produced on the stage of World War II.

Amateur photographs usually found their way into private albums and were intended for personal consumption. To reiterate, scholars document that many of the images in existence today were found in wallets on the bodies of dead or imprisoned soldiers and were then confiscated by the Red Army, which anticipated using them as evidence in future war trials.[77] In such cases, the care taken over the photographs indicates that the events on the battlefield represented something their makers held dear, something they were proud of, and, of course, the images were private, personal mementos of individual experiences.[78] Alternatively, the images have come to light over the past several years as surviving relatives of recently passed away soldiers have sorted through and cleaned away the neglected belongings of the dead. Or, as the recent *Fremde im Visier* project has demonstrated, still living soldiers have come forward with their albums, keen to have them seen by a broader public. Yet again, photographs that have come to light in this way are identifiable as keepsakes or mementos of special occasions; they were taken, developed, and put away, pulled out from obscurity maybe once in a while but perhaps never again.[79] In support of the personal nature of the stories told by the photographs, the organization of the images in private photo albums often shifts, sometimes abruptly, sometimes effortlessly, between different times and places, different subject matters, in the interests of creating personal narratives. So it is not the genres or themes of the photographs but the trajectory of their makers' journey eastward that is privileged as the subject and focus of the photographs. Thus images of lunch in the sun, the preparation of weaponry, tanks moving along mud roads, and "exotic peoples" often appear within a few pages of each other. For example, the album of one soldier records the departure from Deggendorf in February 1941 and, on the following page, images with captions identifying them as "Saturday cleaning in Komorowo," the "brother-in-law" with a broom, and "on watch."[80] When a soldier is at war, the extraordinary events of life on the battlefield and the public history of nations in conflict are the very fabric of everyday life. At war, all private life is automatically

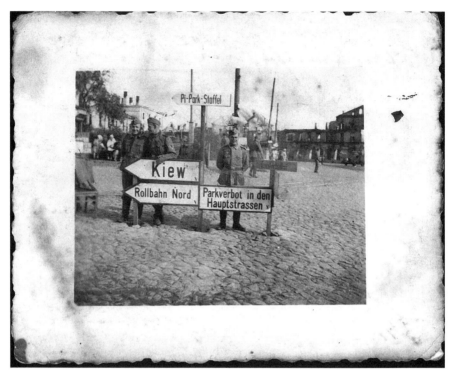

FIGURE 6. *Sixth Army soldiers standing in front of signs to Kiev on August 4, 1941. The back side of the photograph reads "Auskunft in Reims" (Arrival in Reims). Courtesy of Yad Vashem, image 136G07.*

subsumed as a public phenomenon. Likewise, public historical events are internalized by an individual in the creation of his identity, in this case, as a soldier in the German Army, moving eastward.

The repeated presence of the soldier, any soldier, in an image is one of the most convincing aspects of its status as a private image that imagines an individual identity. I refer here to the full-frontal, direct-to-camera address of unknown soldiers in images such as that shown in Figure 6, in which they pose for the camera in one of the main squares of Kiev, or even that of a soldier reading a sign hung around the neck of a lynched corpse.[81] The soldier's presence, posture, and facial expression, as well as the composition of the photograph at three-quarters to full length and outdoors, are all typical of the personal or family snapshot in which an

individual or a group of individuals produce memories. Unlike a public document of a given site or event, a travel photograph does not capture the sounds, the smells, or the emotions of the moment. It is not the objective characteristics of what lies before the camera that are important but rather the expression of the presence of the individual pictured at the site or events—"I was here." The famous monument or location is the background to the fact that the person in the image was there. The image designates the site as belonging to the identity of the person pictured. It is a private memory rather than a public fact that is captured. As in images of soldiers posing with local civilians, in particular, women and children in White Russia,[82] the power dynamics between the soldiers and the locals at their sides are, on the one hand, not important. What is important is that the identities of the individual soldiers are shaped or further developed by their presence in Russia or Poland next to these curious foreigners whom they have met on their travels. And yet, on the other hand, the identity of the others is key to the public significance of the German soldiers' colonizing presence in Poland as newly claimed territory. Thus such a photograph is, at one and the same time, a document in the service of a private identity and a public historical assertion.

In the same way that the surge in production of mass and amateur photography put pressure on the distinction between official and unofficial, amateur and professional, the lines between the public history and the private memories captured on film became merged at this historical moment. These tensions can be identified as a much broader phenomenon that reflected industrial developments, and yet it was nowhere more vividly captured than in these specific photographs taken by members of the German Army as they moved through the East. Hüppauf argues for the mutual dependence of developments on the battlefield and those of photography and modernity in his writings on representations of earlier wars.[83] By the time of World War II, a historical moment when, thanks to the increasing sophistication of modern phenomena such as the photographic camera, fighter planes, and modes of transport, the battlefield literally bled together with the home front, the violence and destruction of war had well and truly infiltrated everyday life; the most extreme examples were the slaughters of civilians and the irrational destruction of

whole cities. This literal extension of the battlefield to the supposed safety of the home and private life was repeated at the level of representation through these photographs.

There are many other ways that these photographs merge the public and the private. In her discussion of family photographs, photographs taken to enable the subjective memory of individual family members, Patricia Holland points out that such images are not only socially influenced:

> Family photographs are shaped by the public conventions of the image and rely on a public technology which is widely available. They depend on shared understandings. Private interpretations which may subvert collective meanings are considered disruptive and discouraged. But above all, the personal histories they record belong to narratives on a wider scale, those public narratives of community, religion, ethnicity and nation which make private identity possible.[84]

The photographs taken on the Eastern Front were no different. Images such as the one I described earlier of the humiliation of a Jewish rabbi are as much about the sadistic pleasure of the individual soldier as he creates a memento of his involvement in this event as they are about the narrative of Jewish victimization and the Nazi project of racial cleansing. Following the logic of Holland's argument, in such cases the ostracization and extreme othering of the Jew were made possible only through the identity given to the soldier by a German state that strove for purity and for freedom from the Jews as vermin. The German soldier's identity as both an individual and a public figure became dependent on his cruelty toward and his power over the Jew. It is a socially sanctioned, culturally accepted, ideologically perverted perspective that we see in these images. Through this optic, an image is not only about the individual soldier; it is simultaneously about the Nazi ideals that he had internalized.

And so we have returned to the photographs as an articulation of Nazi ideology. Along the way, we have encountered the complex way that this ideology was constructed. It is not consistent in all the photographs, taking a different face in those representing violent crimes and those of the

soldier at rest, with his battalion, or "on tour" through the East. Similarly, as the photographs oscillate between the personal and the political, we become attuned to the ways that ideology was internalized by the soldier as he posed for the camera, and also by the photograph when we look at it seventy years later. In some photographs we clearly recognize an internalization of Nazi ideology, whereas others are better described as amateur photographs that happened to come into contact with these incredible events.

Seeing the photographs taken on the Eastern Front by an array of anonymous photographers as tools of destruction that mirror or contribute to the abhorrent happenings before the camera allows limited understanding. When we see them through the multiple optics opened up by their status as amateur images in the twentieth century, we gain insight into their discursive coincidence with, for example, the discourses of modernity, ethnography, and social and photographic history. Seen from these varied perspectives, these otherwise reviled photographs are, despite their infusion with the conflicts of Nazi ideology, more complex than a designated focus on this same ideological content would allow for. Moreover, this complexity is what allows them to serve as agents in processes of witnessing and inspiring historical memory in the twenty-first century.

Revisiting the *Verbrechen der Wehrmacht* Exhibition

With the findings of these complex perspectives in mind, we can now assess the significance of the various phases of the *Verbrechen der Wehrmacht* exhibition as an interpretation of the amateur photographs. First, however, I must acknowledge that the debates spawned by the exhibition were far more complex than I represent here. Indeed, the debates were not only heated and intricately argued but they involved all sectors of the German population: politicians, the press, intellectuals, and the general public. The exhibition incited argument throughout Germany, from the voices of Germany's political parties through those of pacifist organizations to those of neo-Nazis. However, for my concerns, the most striking facets of the 2001 rehanging of the exhibition were, as I mentioned earlier,

the removal of many of the questionable photographs and the incorporation of extensive textual documentation and description of those that remained on display. Images of events that ostensibly enabled identification of the perpetrators and their actions were accompanied by even more textual documents in the second installation.

To give the most significant example of the problems with the 1995 installation, it was claimed that photos of the Tarnopol pogrom represented victims of Wehrmacht soldiers lying in the street. However, visitors to the museum who had been in Tarnopol knew that the perpetrators had been members of the NKVD (the Soviet secret police), not the Wehrmacht. In fact, it turned out that the offending attributions were not so misleading after all; it was determined that there were two layers of bodies in the street at Tarnopol, one the result of the NKVD slaughter, the other the result of the Wehrmacht slaughter. Nevertheless, four years later, the Hamburg Institute for Social Research yielded to the criticism that had been mounting about such inaccuracies in its attributions. By 1999, serious scholarly publications had appeared, both in Germany and internationally, against which the institute had no defense. In the most influential of these publications, Kristian Ungvary, a Hungarian historian, argued on the basis of his research that the Wehrmacht had never been in Tarnopol and that the photographs in question showed the victims of other soldiers, including members of the SD (the Nazi Security Service) and SS and some Soviets. Irrespective of the veracity of Ungvary's claims, they were among the criticisms that prompted the formation of the independent commission and the withdrawal of the exhibition from circulation.[85] In the second installation, additional textual documentation took the form of victims' passports,[86] maps, letters, orders to transport, reports, and of course, the infamous Nazi lists: lists of victims; lists of when, where, and how many evacuees were moved; and lists of activities to be undertaken in, for example, the "fight against the partisans"[87] and other events. And all of these documents functioned to substantiate various levels of action, responsibility, and lack of involvement of Wehrmacht soldiers and officers.

It is significant that, in the face of accusations of misattribution and their consequences for the conception of German history, the organiz-

ers chose to remove the offending images and replace them with text. Ultimately, the agency of exposition that was given to the images in the 1995 version of the exhibition was withdrawn, and the veridical weight was transferred to the written word. This gesture made clear that the argument about the criminality and complicity of the Wehrmacht and its soldiers was more important than the significance of the photographs. The images were no longer transparent, realist visions of what took place on the Eastern Front, and thus they had to be removed. They no longer mattered. By 2001 the exhibition was not one of archival images and documents as it had been in 1995. Rather, it had been transformed into a conscious, textual narrative that would reiterate with substantiation the argument regarding the Wehrmacht actions on the Eastern Front. The images were no longer being asked to bear the burden of documentary evidence. On the contrary, the text's eclipsing of the image spoke of the explicit distrust of the latter's capacity to represent history, as well as its secondary status relative to the exposure of German criminality in the war years. In effect, the rehanging of the exhibition confirmed what had been perhaps less than obvious in the initial exhibition: images are no more than superfluous visual accompaniments to textual evidence of the German Army's exploits in Eastern Europe. And, by extension, images are unreliable historical documents.

This measure forcefully demonstrated that the exhibition had not, in fact, been conceived in the name of bringing these amateur archival images to the attention of the German, European, and, ultimately, the American public. Although this might have been claimed as its motivation, the *Verbrechen der Wehrmacht* exhibit was concerned with making an argument about the responsibility and resultant guilt of the so-called ordinary German soldier for the crimes in the East. That is, the argument existed with or without the photographs. They were relevant only up to the point at which they were able to prove the preconceived argument. Once their status as evidence became shaky, they had to be removed.

There are two levels on which this story of the exhibition and the role of images in it contributes substantially to my investigation. Namely, hand in hand with the confusion, redress, and rehanging of the exhibition, an exhibition that set out to demonstrate the "at times active,

at times passive participation of the Wehrmacht in these crimes,"[88] as well as the deep implication of the wider German public, went the disruption of that project by soldiers and their families. Although this was only one aspect of the controversy, it was a significant aspect, because through it the individual memories of the soldiers and their families became an intervention in the direction and shape of collective memory, national identity, and European history. As a result of the controversy stirred by their memories, the institution that had taken charge of historical memory was disenfranchized and removed the "offending images," when in fact it was not the images that had offended in the first place but rather the challenge to an argument about them. Or, put another way, it was not the soldiers' images or the images of soldiers but their refusal to be identified as responsible for the crimes of World War II that led to a public controversy. The Hamburg Institute for Social Research chose to re-create the exhibition so it was "less controversial." Thus the "offense" of images that arose out of their uncertainty and ineffability was "corrected" by removing them and effectively recasting the argument through textual explication. At the same time, history was set right and the institute was able to legitimate its rewriting of German history.

Secondly, it is striking here that what cleared the way for a re-vision of the exhibition was a reflection on the role of image–text relations.[89] Thus, at stake was not a debate over German history and whether or how the Hamburg Institute for Social Research could have acted differently. Never was the institute asked to rethink its argument. Rather, the controversy arose because the institute initially took the images as transparent documents that were windows onto the world. It used them as visible evidence of the participation of ordinary soldiers in the crimes in the East. This assumption was, as noted earlier, quite simply naïve. Nevertheless, it is an assumption that is consistent with a world in which the image is constantly privileged as substantive visual evidence and yet never trusted to tell the truth.[90] In turn, when the soldiers, their families, historians, and onlookers at Tarnopol became actively involved in the representation and its exhibition, they followed the logic of how amateur images need to be seen: they are only ever completed in an exchange with the viewer. Visitors to the exhibition accordingly responded to the

images with the veracity of memory and experience as their authority, and in turn, these memories came to affect the shape of public history. Ultimately, the discourse of collusion among the SS, the SD, and the Gestapo in mass shootings and other crimes remained dominant, but it was not a polemic that could be successfully argued through the unproblematic use of amateur photographs. The photographs were relieved of the burden initially imposed upon them. However, they were relieved only through their removal.

There are two conclusions to be made as a result of these observations on the use of amateur photographs in the *Verbrechen der Wehrmacht* exhibition. First, all of the possible insights regarding the role of these images in discourses on the absence of the photographer as author, the inherent ideology of an image taken by a German soldier, the complex issues surrounding whether and how these images have a role in processes of witnessing the crimes in the East, and their contribution to contemporary developments of the photographic medium were effaced in the re-presentation of the amateur photographs in the rehanging of the exhibition. In short, their lives have been cut short and all they have to communicate is forgotten or ignored when they are made impotent by an exhibition that has no faith and very little interest in images. In addition, there are strands of German history within these images that were ignored and have not since been interrogated because of the scramble to create memories and a national identity of a more coherent kind. If all, even some, of the possible interpretations pointed to earlier could have been explored in the *Verbrechen der Wehrmacht* exhibition, the monolithic nature of the either/or "Germans as perpetrators/Germans as victims" notion of German history would be easily dismantled and, effectively, a more convincing and nuanced history put in its place.[91] Of course we must remember that Germany was not ready to look at the revelations of these images in the way I am asking that they be seen. It is only with the distance of fifteen years that we are able to see them critically and from the vantage point of having worked through the guilt and shame of the Wehrmacht's activities on the Eastern Front.

Second, on a more general level, in its search for the accuracy and truth of representation the *Verbrechen der Wehrmacht* exhibition was not able to

account for or accommodate the inconsistencies and fluidity of the amateur image in its representation of history. Thus, in its zeal for accountability the institute demonstrated a devaluing of the image. Similarly, it was only when various responses to the images were made public—responses both from the general public and from scholars alike—that the institute paid attention to the images.[92] It was then that the institute interpreted these responses as trustworthy, whereas they believed that the images had proven either of minimal interest or unreliable. Nevertheless, today, as I have argued, it is those aspects of unreliability and unevenness that are, in fact, what make the images so challenging within the context of the *Verbrechen der Wehrmacht* exhibition. The very unpredictability that has the potential to forge new historical discourses is the same attribute that the organizers felt compelled to redress. Most significantly, as I argue, the absence of substantive evidence of where and what these images depict, of who took them and when, is the basis of their innovation. Whereas the unanticipated fractures in the images and their flaws are what give them their potential for appropriation in creative discourses of memory and witnessing, the institute tried to suppress these caesuras, and ultimately, these same efforts gave way to a controversy.[93] Although these photographs were presented as historical documents designed to detail historical events outside of themselves, they ended up inviting contemplation of their own presence in the exhibition, as well as their presence at (and absence from) past events. Their slipperiness as amateur images gives the photographs a potential to disrupt the discourses of institutional rationalization in the *Verbrechen der Wehrmacht* exhibition. Nevertheless, in the end, when the images were deemed too unreliable, when this potency was understood to be too unruly, the photographs had to be removed from sight.

Coming full circle to the ideas discussed earlier, the exhibition called attention to the role played by images designed to memorialize and remember in the creation of national identity. The interaction of these images with their display context and the relation of both to the exhibition visitor forge a unique space for the contesting of national identity and memory. Thus the exhibition was the perfect arena in which to ignite a creative process of memory. Indeed, it was intended as a consciousness-raising event, the

creation of an opportunity for Germans in particular to reconsider their memories through a carefully crafted historical narrative, the narrative of their ancestors'—and in some cases their own—experiences. It was as a German that the anticipated visitor would identify with the memories of his or her fellow countrymen. Thus the exhibition was intended as a site of communal national remembrance, albeit without the ideological weight and systematization of a government- or state-organized equivalent. And yet, when the discussions and arguments began, arguments based on the depiction of the images, the exhibition began to scramble for legitimacy. Donald Preziosi claims that the modernist institution needs a common vision, a common history on the basis of which to begin to iterate the past and to build a sense of national identity.[94] Based on this logic, when the amateur images taken by Wehrmacht soldiers could not carry the conviction of a common vision, rather than question the coherence of the vision, the legitimacy of the images was eroded.

It is only if and when we see photographs taken by soldiers, officers, bystanders, and partisans on the Eastern Front through the optic of the amateur, when we understand that we are looking at visual documents that offer a possible range of discourses, from a potential variety of perspectives, that we are open to their possible adoption in processes of individual and, subsequently, historical witnessing. This witnessing by the contemporary viewer (of not only German identity) is the result of the inconsistency and fluidity of the amateur image. It is not only the apparent flaws and inconsistencies in the visual manifestation of the image but also its transgression of categories—public and private, official and unofficial, history and memory, among others—that create ruptures and conflicts that are the catalysts for reflection on and rethinking of the past. Herein lies the potential power and agency of these images as historical documents. However, as we see in the example of the *Verbrechen der Wehrmacht* exhibition, this potential can also be appropriated and pressed into the service of a history that is nowhere to be found in the images. We shall see this kind of appropriation again and again in the chapters to come. And other recyclings will be shown to be even more irresponsible or unresponsive because they want to ignore the image in the interests

of expounding an argument that is better made through textual articulations. Nevertheless, at this stage it is enough to note that, however we have seen and thought about such images taken by Nazi perpetrators or even by ordinary German soldiers, and in spite of the existent examples of recycling to remember, these archival images have in them the potential to create discourses of memory and witnessing that demonstrate a responsibility to the images, to the events, and to all those who suffered.

The Privilege and Possibility of Color:
The Case of Walter Genewein's Photographs

Some of the most extraordinary photographs from World War II were those taken in color. These images are remarkable because the technology used to produce and process color-transparency film stock was in its infancy in the late 1930s. Due to this innovation, together with beliefs regarding the potency of its representational qualities, the Nazis were keen to explore the color photograph as a weapon of domination. According to the Ministry of Propaganda, color photography had the potential to sway the masses emotionally and thus open people's imaginations to political persuasion.[1] This said, however, its use was rare because the results were too unpredictable. Yet this unpredictability was the Nazis' inspiration to put time and energy into the development of color film for use in a future they believed was theirs to own. As critics have pointed out, the first known color negative represented female workers before a laboratory in Wolfen with a swastika flag in the background.[2] As I detail in this chapter, the relationship between Agfa, a subsidiary of I. G. Farben, and the Ministry of Propaganda was ever more intimate as the war progressed. Color photography had a potentially key role in the realization of National Socialist goals, and I. G. Farben was happy to provide stock and processing, especially to high-ranking officers who could be entrusted to carry out experiments and explore developments in the new medium.

Color stock fell into the hands of officers such as Walter Frentz, a photographer for the German Air Force who was to become Göring's official photographer, and Adolf Würth, a research anthropologist for whom photography was central to the exposition of the "Gypsy and Jewish problems."[3] Weper Hermann was another photographer who produced color images of familiar scenes such as soldiers at rest and the

campaign on the Eastern Front. Like Frentz and Würth, Hermann was employed as a unit photographer—for which he was equipped with a Leica camera—and radio operator. Another well-known set of color photographs is that made by Johannes Hähle of the roundup of Jews and prisoners of war in Kiev and their mass burial at Babi Yar ravine in 1941. Hähle was a member of Propaganda Unit PK637 of the Sixth Army, which was fighting in the Ukraine at the time.[4] These officers were designated unit photographers and thus had access to color stock and processing. However, color stock was also known to be available to ordinary soldiers as amateurs, though perhaps not as readily.[5] Nevertheless, in this chapter I focus on the photographs of Walter Genewein, chief accountant of the Lodz Ghetto and self-identified amateur photographer. Genewein himself may not be anonymous, but his photographs engage with the medium to incite a sustained reflection on their generic status as amateur color photographs. Moreover, I will show that Genewein was distant and absent from the anonymous realist images he took, ordered, and archived. This distance is, once again, key to the images' role as potential agents in processes of witnessing the crimes committed in, around, and behind them.

Genewein's photographs came to me through their recycling on a rainy winter's night in New York City when I saw the 1998 film *Fotoamator (Photographer)* by Dariusz Jablonski.[6] Prior to the making of Jablonski's film, the images were first brought to public attention when they were exhibited at the Jewish Museum in Frankfurt in 1990.[7] I was impressed by *Fotoamator;* I found it haunting, convincing, and thought-provoking, presenting a complex vision of the Holocaust. And perhaps most fascinating was its relationship to the images it presented. The film does not accuse them of anything, nor does it point a finger at their creator. It is true that the film uses conventional documentary strategies to reveal the images, but all the time, Jablonski draws attention to Genewein's camera and film through the discrepancy of image–sound relations, the conflicting testimonies of those who are profiled, the use of color and black-and-white footage, and other techniques I discuss later. *Fotoamator* seemed to be more about questions of the transparencies as representation—how they change across time, across generations and countries—and how to

represent and see them today. The affect of Jablonski's film was not anger and outrage at the crimes committed in Poland in World War II; rather, it sparked an intrigue that sent me on a search for Genewein's transparencies. I was fortunate to find that the only set of duplicates was in the possession of Alan Adelson, filmmaker, writer, and director of the Jewish Heritage Project, who was at the time living on Prince Street in New York City.[8] Thus Prince Street became my first port of call.

Genewein's images resurfaced from the dustbins of history when some 400 transparencies were sold anonymously to an antique bookseller in Vienna, Löcker Verlag, in 1987.[9] At the time, the seller refused to disclose his identity, but Löcker traced the provenance of the images to Genewein, and the man who sold them is thought to have been Genewein's "companion."[10] Löcker then sold a copy of the transparencies to the Jewish Museum in Frankfurt, which in turn staged their exhibition in 1990.[11] Jablonski must have seen the transparencies in this exhibition. When they arrived at Löcker, each transparency was fastidiously mounted between two glass plates, precisely labeled with a number and a caption, and the images were placed in especially made felt-lined wooden boxes. In 2002 Robert Abrams gave the U.S. Holocaust Memorial Museum a further 279 slides, some of which are near duplications of those in the Frankfurt collection. Abrams found them at a yard sale in Bethesda in suburban Washington, D.C., in a box marked "Daddy's Europe Oldies." A piece of paper inside the box indicated that the slides had been found by a liberator, whose name was not given. The paper read, "Slides from a Jewish Ghetto (German Labor Camp) Litzmannstadt, Poland. Found in home of German Director of camp in Bremen Germany."[12] The transparencies found by Abrams were also glass mounted and numbered, but not all of them were captioned, and unlike those that had come to Löcker, they were in an old cardboard box rather than felt-lined wooden boxes. Perhaps the most interesting aspect of Abrams's find is that, when the images are put next to those in Frankfurt, one can see that the numbers written on the slides—all of which are consistent with Genewein's handwriting—reveal gaps. Thus we can strongly infer that there are more Genewein slides that have not yet surfaced, the finding of which could potentially challenge my argument.[13]

The photographs themselves are often unremarkable: a building on a corner, the fence surrounding the ghetto, the bridge over Zgierska Street at Koscielny Square,[14] people walking near a fence (Plate 6), displays of Luftwaffe and other army hats manufactured in the Ghetto (Figure 7), carpets, an immaculately preened Genewein at his desk counting money (Figure 8). It is not only the subject matter of the photographs that makes them unremarkable; their style and form are unobtrusive: objective long shots with their human subjects usually centered in the frame, the particulars of the faces often too distant from the camera to appear anything other than indifferent. The color of the photographs is, of course, striking. It is outstanding for its very existence at a time when color photography was in its infancy.[15] The bright yellow stars of David on the breasts and backs of the Jewish people's coats (Plate 7), the soft blue of the sky, and the red of the SS flag on the front of Himmler's car stand out, surreal

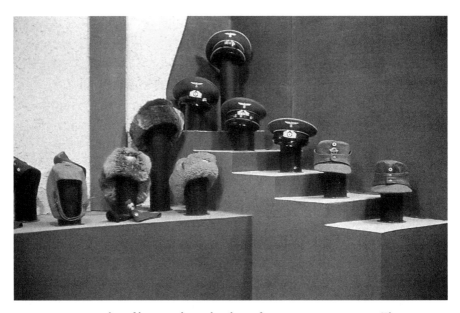

FIGURE 7. *Display of hats made in the ghetto factories, circa 1940–44. The manufacture of both civilian and army clothing was the logical work of a city in which the textile industry had thrived before the war. Each of the workshops specialized in a particular item of clothing. Jüdisches Museum der Stadt Frankfurt. Courtesy of U.S. Holocaust Memorial Museum, image 00391.*

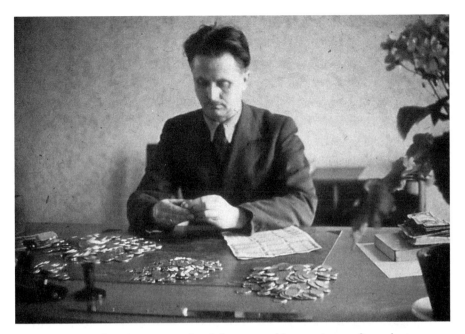

FIGURE 8. *Walter Genewein at his desk, presumably counting confiscated coins, Lodz, circa 1940–44. Original German caption: "Getto L'Stadt Finanzleiter" (Ghetto chief accountant), #33. Jüdisches Museum der Stadt Frankfurt. Courtesy of U.S. Holocaust Memorial Museum, image 74506.*

against the bland dull gray and brown of the streets, the buildings, and the carts that were the only mode of transport in the ghetto.[16] Aside from the few images of the photographer himself, his office, his colleagues, and his home, Genewein's photographs are not at first glance so different from those of two of the best-known Jewish wartime photographers, Mendel Grossman and Henryk Ross, both of whom were in the Lodz Ghetto until its liquidation in August 1944.[17] However, Genewein's images are all in color.

In Genewein's medium- to long-shot photographs we see meticulous documentation of the mechanics and activities of everyday life in the Lodz Ghetto between 1940 and its liquidation in 1944. We see young boys crowded around machines in the metal factory (Plate 8), the bustle of the streets, gatherings outside a tea room, booksellers in the marketplace

(Plate 9).[18] Also included in the collection are images of the various locations that made up daily life: the administrative buildings, the factories, the checkpoints, the hospital (Figure 9), the fire station, and so on. Similarly, the ghetto's Jewish administration figures were photographed, usually in the workplace, in direct frontal medium and long shot, staring, as if frozen by the camera's gaze. The color is faded; the blues, greens, browns, and reds at times overwhelm the images. Often the surfaces bear the signs of physical wear and tear, perhaps resulting from the images' movement through a projector. The overwhelming tone of the photographs is one of silence: the stasis of the subject matter, the distant long-shot composition, the years passed as measured through deterioration of the color, and our recognition of the subject matter all cast a shadow of sadness and silence. We find these qualities, including muteness, again and again in amateur images from the period. In spite of the qualities of Genewein's transparencies that are generic to amateur images, there is no comparable collection of photographs of Jewish life taken by a German from the time. For this reason alone, they are objects that pique our curiosity.

In addition, Genewein's images can be placed in and fed back into histories beyond the immediate concerns of World War II, in particular, that of the sealed ghetto at Lodz. Namely, we see how they contributed substantially to the sophistication of color photographic technology as we know it today. And we gain insight into the aspirations and motivations of a Nazi officer. In addition, close study of Genewein's transparencies from different perspectives—within the context of contemporaneous photographic developments, as amateur photographs looking to evidence reality rather than images of Nazi officers tormenting Jewish victims—illuminates the limitations of the conviction that such documents are unwavering illustrations of Nazi ideology. Although my interpretations do not preclude the possibility of their ideological understanding—and indeed, lead to the conclusion that Genewein used the camera to make his way within the system—this is only one of a number of discourses that course through them. Perhaps most urgently, when Genewein's photographs are viewed outside the ghetto, they show the potential to lead to new forms of witnessing, new ways of continuing to remember in the present the traumas of the German past.

FIGURE 9. *Lodz Ghetto Hospital No. 4, 1942. In one of their cruelest maneuvers, the Nazis liquidated hospital facilities in September 1942, sending all occupants to the Chelmo death camps. Until this time, the hospitals had been highly functioning and well used. Jüdisches Museum der Stadt Frankfurt. Courtesy of U.S. Holocaust Memorial Museum, image 74533.*

Documentary Realism and the Nazi Myth

Genewein's photographs are a unique set of images that put forward two conflicting yet interdependent versions of German history, particularly as it was dictated by National Socialism. On the one hand, they reveal the Nazi imperative to document every detail of daily life, and on the other they expose the impossibility of the Nazis' conception of the photograph as evidential documentation. At first glance, these images may represent the cool and ordered functionalism of the ghetto, but their visible surface is only a thin veil of rationalization behind which hides another reality: the cramped quarters, open sewers, disease, starvation, and death that plagued ghetto life. On close inspection, this reality seeps through to disrupt the cold objectivity of Genewein's vision. As a result, the constitutive contradiction of Nazism is revealed in these photographs: the imperative

to rationalize, to order and contain, in this case through rigorous photographic documentation, is seen side by side with the chaos, death, and destruction that were brought about in the attempt to achieve these conditions.

The photograph, divorced from the gestural expressions of human intervention, was considered the ideal instrument for the iteration of this world of mechanization and scientific rationality. From the turn of the twentieth century until the time that Genewein was working in the ghetto in the early 1940s, the authority of the photograph was "immediate," and it was seen as a "means of record and a source of evidence." Furthermore, it was accepted and applauded by institutions of authority.[19] Similarly, the photograph as scientific evidence was appropriated as the working tool of the social sciences of modernity: anthropology, criminology, physiognomy, and psychology. According to John Tagg, this discourse of the power and legitimacy of photography as a truth-telling medium was constructed in the name of propagating authority and oppression:

> As a means of record, [the camera] arrives on the scene vested with a particular authority to arrest, picture and transform daily life; a power to see and record; a power of surveillance that effects a complete reversal of the political axis of representation which has confused so many labourist historians. This is not the power of the camera but the power of the apparatuses of the local state which deploy it and guarantee the authority of the images it constructs to stand as evidence or register a truth.[20]

To be sure, the National Socialist state lauded the authenticity of photographic mimeticism as passionately as did those capitalist states that are the subject of Tagg's Foucauldian argument. Portraits, head shots, and mug shots were of particular value to the Nazis' urge to document and classify the enemy as other in affirmation of the truth of their beliefs about the self. The unworthy, diseased, and dangerous bodies produced by an out-of-control modernity needed to be purged in order to ensure social order and the command of history.

All this said, although Genewein founded his pursuits in Lodz on a notion of photography as evidential truth, he did not take it in the same direction as did his fellow National Socialists. Genewein's images do not necessarily mark the Jewish bodies as deviant, nor do they automatically highlight their difference, their cultural and physical "diseases" and deformations, as was the wont of the head shots, images of humiliation, and typecastings found in the news media, on posters, and often in published studies in the fields of phrenology and physiognomy.[21] It is true that the Genewein archives include a number of medium-length head shots of Jewish men in the ghetto streets, apparently as illustrations of Jewish "types."[22] Genewein chose, in all cases, to photograph religious men with full beards and hats for this purpose (Plate 10). Although the anti-Semitism of these portraits must be acknowledged, it is important to note that such typecastings are few in number and that there are many other photographs in which the work performed by the ghetto prisoners was the purpose of the images. Genewein's photographs do not always picture the Jewish inmates as other to the healthy, robust Aryans.

In photographs taken with a confiscated Movex 12 camera, Genewein recorded street scenes from a distance, the ghetto factories, modes of transport, and every level of Jewish work life in the ghetto. Genewein was no traveler or tourist. Unlike the images discussed in the previous chapter, Genewein's photographs show no interest in documenting his presence at unknown sites of atrocity or public humiliation at unspecified moments on his journeys. On the contrary, they document recognizable actions and events in identifiable locations. There is little ambiguity as to the goings-on in these photographs. The photographer appears in only two of the approximately six hundred images in existence. Although the documentary realism of Genewein's photographs must be interrogated, they appear to offer a detached, objective representation of the daily goings-on in the Lodz Ghetto. Even when they are examined for their hidden agendas and covert intentions, these images are more than personal mementos of their photographer's wartime experiences. Furthermore, unlike most amateur photographers, Genewein did not automatically pick up his camera on special occasions, when he traveled or attended celebrations, or to document the more extraordinary moments of his life as an official

in the ghetto. Again, quite contrarily, these aspects of life number very few among the slides known to be in existence. As I demonstrate, Genewein's primary motivation was the careful, meticulous documentation of the ordinary. He did not ignore extraordinary moments but neither were they his primary focus. He photographed the routine, the habitual, one might even say the monotonous actions and events of everyday life in the ghetto. Genewein's concern was to use the medium of photography to create an accurate record of the minutiae of daily life. These carefully staged color photographs display comprehensive documentation of the efficient processes of the production facilities in the Lodz Ghetto. As I interpret them, they present a showcase of the ghetto for the approving eyes of other Nazi officials both inside and outside the ghetto.

Although Genewein's photographs reach for mimetic transparency, they are not so straightforward. Indeed, images of the Ghetto market, the saddlery, the ghetto police, the cemetery, and so on are engaged in a complex struggle between documentary realism and performative fiction. At one and the same time, they are documents of the seemingly inconsequential everyday and a very consciously determined perspective of that life, a perspective strikingly marked by what is absent. In keeping with his zeal to document the organization and productivity of the Ghetto accurately, Genewein tried to overlook the disease, desperation, death, and dilapidation that we know were part of the reality of Jewish life in the Lodz Ghetto. As Ulrich Baer has argued and I shall elaborate, the photographs nevertheless let slip these hidden narratives in spite of themselves. Their strategic concealment of certain other realities of ghetto life are as revealing of their engagement with documentary realism as they are of the narrative of efficacy. In turn, the ambivalent discourses of photographic realism found in Genewein's images are involved in an equally ambivalent relationship to Nazi propaganda and, again, to the strains of photographic realism and the documentary image of the 1930s and 1940s. This ambivalent relationship to the officially sanctioned image is at the heart of their force as historical documents today.

To reiterate, Genewein deliberately numbered and captioned the glass-plate transparencies that he collected in wooden boxes. As the catalog to the photographs' exhibition at the Jewish Museum in Frankfurt

points out, the numbering and labeling reveals the order in which the photographer meant them to be seen. Indeed, as a series, the transparencies cohere to narrate the fate of the ghetto and its Jewish prisoners. This narrative is confirmed if we compare those sold in Vienna and those found by the American liberator in Bremen, which were not always captioned.[23] The first twenty-two images in Genewein's narrative familiarize the viewer with the physical parameters of the ghetto through shots of its literal borders seen first from outside and then from inside its walls. These are followed by four images of the visits of Heinrich Himmler and other National Socialist dignitaries, then those of the Jewish administration: the police, firemen, postal workers, and so on. The following images represent the exchange of goods in the markets and those who lived in the ghetto, the "types" of persons who might be found there.[24] By far the largest group of images is that of workshops and factories, and these are followed by images of the Gypsy camps, the deportations, and finally, the poignant collection of goods at Pabianice.[25] The final image in the series is a haunting, blue-green transparency of a throng of naked bodies packed close together facing a single uniformed Nazi officer with his back to us in a high-angle long shot. The caption reads "Pabianice. Jewish bath."[26] Such is the visual record of the Lodz Ghetto. This narrative of arrival at the ghetto, familiarization with its routine activities, eventual deportation, and prospective extermination represents yet another reality that silently runs through the series. As we shall see, it is a narrative that is not so often found among the Nazis' documentation of their own actions.

The documentary realism identifiable in Genewein's photographs is inventorial in nature, just as the system would have wanted. As detailed earlier, the composition and compositional choices of images of Jewish workers and administrators point to the transparencies' conception as a truthful evidentiary record of ghetto reality. They are, with a few exceptions, medium-long to long shots, and they are compositionally balanced.[27] At face value, the use of color is muted: there is no excessive emphasis of the red flag with the swastika, and no effort is made to highlight the yellow Stars of David on the inmates' breasts. The human subjects are usually centered in the frame, there are no close-up portraits of the people, and when the camera does move in close enough to

observe facial expressions, the resultant image is not a study in gesture or emotion. The photographs are overwhelmingly static. Even those that depict modes of transport are static: images of human load carriers show them stopped to have their photographs taken.[28] Sites usually associated with hustle and bustle, such as the train station (Plate 11) and the market (Figure 10), may indicate motion, but still there is a stasis and a heaviness to the images. Everybody and everything is stationary before the camera. The inertia of Genewein's photographs contributes to their particular search for a substantive truth: it articulates their matter-of-factness, their draining of emotion, and the erasure of the unpredictability and uncertainty that come with movement. Where might the people be going? Where might they have been? How fast do they walk, and with what vigor? In short, the unpredictability of human life is emptied from these images to present scenes in which people are stagnant objects—soulless, emotionless, in short, posed. To introduce such variables as energy and motion would be to embrace potentially competing narratives. Perhaps it would become evident that there is an unacknowledged chaos and agony seething beneath the surface of this orderly world. To allow for such unpredictability is to admit the relativity of what is thereby depicted as truth.

It is true that these aesthetic characteristics do not, by default, define the photographs as documentary; however, in the 1930s and early 1940s they were commonly accepted as defining characteristics of photographic realism. And, most important, they are the strategies that Genewein reached for in order to portray an objective, what for him was a truthful, image of the ghetto. Indeed, his persistent search for the evidential, the substantive reality offered by the photographic image is in the same vein as the Nazis' obsessive compilation of names, figures, physical descriptions, times, and places—in short, their inventorial records of every move, every gesture, every decision made by both themselves and their perceived enemies. Genewein's motionless, apparently objective photographs are presented as precise documents of what they saw. Just as did the scientific recording of names, facts, and figures, Genewein's images intended to present a faithful register of all aspects of ghetto life. References to photographs as documentation or records are few in the correspondence,

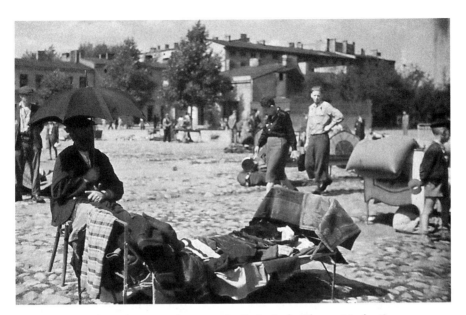

FIGURE 10. *A vendor sits under an umbrella in Lodz Ghetto, Market Square, circa 1940–44. The Genewein archive contains approximately forty images of the markets in Lodz. Walter Genewein appears to have documented each of the stalls according to the wares on sale. Jüdisches Museum der Stadt Frankfurt. Courtesy of U.S. Holocaust Memorial Museum, image 95092.*

announcements, and minutes kept by the German administrators of the ghetto. Nevertheless, the one or two references that do exist clearly confirm the belief that a photograph is an accurate replication of that which it reproduces. For example, in a letter from Hans Biebow, the German head of ghetto affairs, he matter-of-factly indicates that all documentation of construction plans must be duplicated, either through a blueprint or, if this was not possible, in a photograph.[29] Biebow's tone of factual communication strongly suggests that the photograph was routinely used as a form of duplication of existing documents, rather like today's photocopy, a faithful replication of the original. Thus it would have been entirely in keeping with ghetto practice to use the camera as an apparatus of control to objectively represent what it saw. Although this use of the camera was not new, having had its origins in late nineteenth-century

anthropological expeditions, the Germans took the principles and practice of photography as providing evidential documents to an extreme.

It is not only the visual presentation of Genewein's photographs that leads to this conclusion regarding their intended mimeticism. Genewein's methodical organization of the photographs into a narrative series that presents the history and the story of ghetto life also reveals his belief in the evidential qualities of the photographic image. Like the archive, Genewein catalogued the transparencies complete with very concrete captions such as "Lodz Ghetto law court" (Figure 11), "Jewish fire engine" (Plate 12), and "Ghetto postman"[30] to remove all hidden variables, all potential uncertainty or skepticism, from the images. Instead the logical order of the archive reduces the photographs to quantifiable entities that can be controlled, legitimated as objective documents of what they see.[31] Again, this process of numbering every person, object, idea, and document was entirely in keeping with the standard practices of cataloging and record keeping pursued by the Nazis in general and the German administration of the Lodz Ghetto in particular. Thus not only is the content of the photographs presented here as detached and factual but, in light of their archival organization, the photographs themselves are reduced to unemotional objects akin to the infinite numbers of anonymous people, things, actions, goods, and transportations recited on a daily basis under Nazi rule.

In their various ways, critics have explained this obsession to record, to create lists, to monitor and manage as the Nazis attempted to control what was effectively a messy, extended, chaotic operation: to locate, identify, round up, humiliate, incarcerate, dehumanize, deport, and murder Europe's Jewish population. Leading scholar Zygmunt Bauman, for example, explores the intricate interweave of the urge to rationalize, Nazi racism, and the Holocaust. He argues that it is explicable according to the gathering momentum of industrial modernity.[32] Bauman believes that the slipperiness of hierarchical ladders, the erosion of difference between cultures, the search for uniformity, and the unmanageability of physical mobility that went hand in hand with modernity produced an unbearable proximity between previously distinct social groups and, of course, between Germans and Jews. In turn, the muddying of these social waters

FIGURE 11. *Lodz Ghetto law court, circa 1940–44. Walter Genewein documented every institution in the Lodz Ghetto, both as a space and in use. Here we see two figures, likely the accused on the left and the Jewish courtroom clerk on the right. Jüdisches Museum der Stadt Frankfurt. Courtesy of U.S. Holocaust Memorial Museum, image 95113.*

led to the reactive pursuit of greater precision, codification, and scientific rationality in making distinctions between groups. The consequent urge to draw boundaries and create formality, functionality, and order where there was none or where the threat of chaos and blurred boundaries was too great to bear, were also a result of the flourishing modernity.[33]

I want to set aside Bauman's argument regarding the causal interdependence of modernity and the Holocaust. Similarly, archival evidence of the inhuman codification of the Germans' own daily routines, actions, and thoughts complicates Bauman's assertion that the obsessive systematization reflects an urge to distinguish self from other through rationalization of that other.[34] Nevertheless, the inextricability of the obsessive documentation and the desire to control the "messiness" of social progress and those people who did not fit in is convincing. In addition, there is little doubt that the Nazis' chosen methods of control—instrumental

rationalization of people as objects, mechanization of the bureau-
cratic administrative procedures, and extermination through complete
destruction—were learned from and made possible by advanced indus-
trialization. The modernity that burgeoned in Germany and the West
in the first decades of the twentieth century was marked by systematiza-
tion, efficiency, and the transformation of human individuals into im-
personal masses of facts and figures, all of which was celebrated in the
name of progress. Again, although this tendency was not specific to Nazi
Germany, Germany's belated second wave of technological industriali-
zation, which intensified in the 1920s and 1930s, was the stage on which
the National Socialist dehumanization was played out, if not necessarily
the cause of it.[35] In turn, this is a possible context within which to deter-
mine the import and insights of Genewein's images.

An image of young men in the ghetto's furniture factory highlights
the distinction between Genewein's photographs and officially sanctioned
propaganda photographs (Figure 12). In the direct-to-camera address of a
man at his workstation, his appealing face wears an ambiguous expression
that could be said to evoke anything from distrust, suspicion, insolence,
or uncertainty to indifference. Irrespective of the exact sentiments behind
this man's and the other men's expressions, the man knows he is being
watched in his work. The very fact that he is caught on camera, together
with the fact that he has stopped working and, like the obedient worker
he is, does not resist being photographed, indicates his status as subject
and object of display. Nevertheless, the ambiguity and ambivalence of his
expression might be seen as a wariness of being watched. His facial and
bodily expressions and those of the other men are, however, not the only
focus of this image. Within the logic of this image, the workers' operation
of the machines and tools, despite the interruption of their work for the
photograph, and the fact that they were working productively are equally
central. That is, the work they do is as important as their human presence
in the photograph. Contrarily, the productivity and diligence of Jews
in the workplace detracted from the Nazis' intentions of proliferating
stereotyped images of Jews to justify their program of annihilation. The
men in the furniture factory may not be pictured as carefree examples of
health and vigor, but they are productive nevertheless.

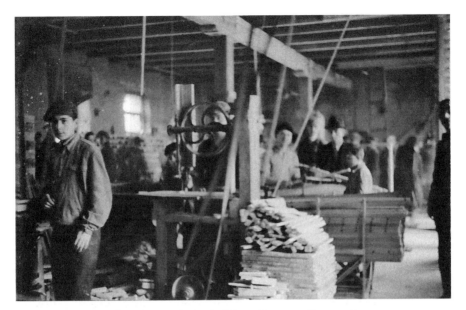

FIGURE 12. *Woodworkers in the Lodz Ghetto furniture factory, circa 1940–44. Original German caption: "Litzmannstadt Getto, Moebelfabrik" (Litzmannstadt Ghetto furniture factory), #13. The direct-to-camera address of the workers is surprising and unusual for photographs taken by Germans in the ghettos. Courtesy of U.S. Holocaust Memorial Museum, image 65822.*

Another level of the photograph in the furniture factory is revealed when it is considered in its relation both to other images of the same factory and to images of the other workshops in the ghetto. Within this context, the significance of the activities as primary to the inventorial eye of the camera is confirmed and extended. In the long-shot construction of the transparency in Plate 13, the faces of the workers in the middle ground are blurred and inconsequential, and, as in the case of many of the slides taken in the workshops, some figures are only partially visible.[36] Indeed, the spaces of the workshops and the processes and materials of manufacture are in many respects given precedence over the human participants in these images. Genewein did not only inventory physical and psychological characteristics of the Jewish workers; he also photographed the production activities. It is possible to argue that in Plate 13 the presence of the German inspector in his suit and hat, together with

his apparent control over the workers' actions, articulates the "difference" of the Jewish workers. Certainly the appearance of the woman in the front part of the image, with her sallowness, sunken cheeks, and slumped shoulders, is in contrast to that of the clean-shaven, clear-skinned, dapper German. However, again, this difference is not located solely at the level of physical or psychological bearing. It is also coded at the level of the photograph—in the inspector's pose, his privilege of being in focus, and the fact that he is observing the others as they work. To be sure, this set of images represents the manipulation of the Jewish subjects, because they had to stop and start their work at the order of the one who photographed them. Similarly, their images are controlled and colonized through Genewein's systematic organization of the photographs into an inventory of the ghetto. Nevertheless, the reality of the images departs from that found in the propagandistic realism common to images of Jewish people in Nazi Germany, most notably because these ghetto prisoners were productive workers, and they were given an identity that is not simply Jewish. Rather, their identity is also characterized by the work they do.

Unlike official photographers in his midst, Genewein was interested in more than an ethnographic study of Jewishness. His images carry none of the iconography that characterized the stereotypical evidence of the Jew as immoral, diseased, and a threat to the health and vitality of the German body and nation. Similarly, there are no traces in his photographs of the types of anti-Semitism that infect the images taken by Nazi officers in other ghettos, such as those of Heinrich Jöst in the Warsaw Ghetto.[37] Genewein's project was innovative because it did not depict solely Jewish otherness, degeneration, and infectiousness.[38] Therefore, these images go against the grain of the official narrative of Nazi history. Instead of narrating the necessity of obliterating the Jews as vermin, these photographs offer a justification for their continued existence.[39] They show the usefulness and productivity of Jewish labor in service to the attainment of modernity's promise of industrial productivity. Thus Genewein's photographs present a form of social usefulness whereas the sanctioned, professional images of Jews tended to argue for their extermination.[40]

I want to pause here to acknowledge the accepted perspective from which these and similar images have been and continue to be seen. In an article that appeared shortly after the exhibition of Genewein's photographs at the Jewish Museum in Frankfurt, Gertrud Koch carefully exposes the subtle manipulation of these images as depictions that are equally racist and equally destructive as the most blatant examples of propaganda.[41] Koch argues that the images betray a National Socialist aesthetic through subtle uses of lighting to emphasize the stereotypical Jewish nose, the slightly bowed heads marking the shame and subservience of the Jewish workers, the Jews as a "teaming pestilent mass." According to Koch, in the very moving image of the shower at Pabianice there is no difference between propaganda and its exploitative manipulations (Figure 13). Both point equally to the Nazi worldview of virulent racism and destruction. In short, Koch believes that, whatever their visible characteristics, the covert message of Genewein's images remains identical to that of overtly ideological examples. Koch's is the accepted discourse on images produced by self-identified Nazi Germans in general and these images in particular.

Notwithstanding the conviction of Koch's interpretation, there are alternative ways of seeing these photographs. To look beyond Koch's representative interpretation opens them up to the possibility of being appropriated for the present imperative to keep alive the memory of historical events they narrate. As I detail in chapter 1, prompted by Hüppauf, the one-dimensional interpretation of such photographs as reflecting Nazi ideology confines their significance to a single historical narrative of a now complete and distant past with which we are familiar today and to which we have no direct connection. To pry open these amateur images and discover their contradictory impossibilities, and consequently to situate them within other historical contexts, re-creates this broken connection: it facilitates our deepened understanding of the motivations, events, and consequences of World War II and the Holocaust.

Returning to the transparent realism of Genewein's photographs as it counters the official vision of the time, this idea gathers conviction in light of Genewein's proposal for the public display of Jewish culture in the ghetto. In an effort to publicize the productivity and efficiency of the

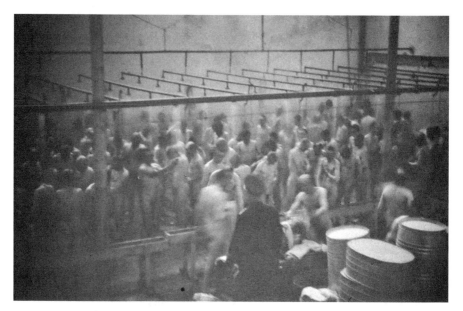

FIGURE 13. *Shower at Pabianice, circa 1940–44. Pabianice, approximately ten kilometers from Lodz, was a prosperous textile town that the Nazis turned into a labor camp and storage facility for the clothes and personal effects of the murdered Jewish population of western Poland. Original German caption: "Pabianice Juden-Bad" (Pabianice Jewish baths), #393. Jüdisches Museum der Stadt Frankfurt. Courtesy of U.S. Holocaust Memorial Museum, image 95294.*

ghetto, Biebow planned to establish a museum. The exhibits were to be devoted to the "Customs of Eastern European Jewry."[42] In 1942 Biebow entrusted Genewein with the task of assembling the museum displays. Convenient for Genewein and for the ghetto administration, he had already been photographing every aspect of ghetto life, including the activities of the Jewish administration, the elders, and their rituals. Hanno Loewy suggests that Genewein's existing knowledge of various aspects of Jewish culture, together with his already having begun to document it through photography, might explain the trust Biebow placed in him to establish the museum.[43] Whatever his reasons, it is significant that Biebow's request to establish a museum was denied because the central propaganda offices judged the type of displays being planned "too cultural." They believed the displays were too reverential toward the Jews.

Despite Biebow's retort that the exhibitions were designed to "arouse disgust in anyone who comes in contact with [Jewish life],"[44] the ghetto museum was never sanctioned. The German administrators of the Lodz Ghetto clearly had a notion of the reality of the ghetto that did not accord with that held by the Ministry of Propaganda. Genewein's photographs narrate a concept of Jewish captivity that had no place in the larger program of extermination: that is, that appreciation of the Jews' "cultural" creativity and productivity would perpetuate their existence.

The very existence of these photographs of the Lodz Ghetto also posed a potential threat to the Nazi authorities. Unlike other ghettos, Lodz was hermetically sealed from its very beginning in 1940.[45] The Litztmannstadt Ghetto, as the Germans called it, was totally self-sufficient: it had its own banks, its own currency, its own utilities. And because it was located in the old town to the north of the city center, there was no sewage system and therefore no underground tunnels through which to escape or traffic goods. Lodz was the model Jewish enclave. In keeping with the impossibility of movement across the ghetto barriers, at the time, photographic documentation of what took place on the inside rarely reached the outside. Of utmost importance to the Germans was the ghetto's continued productivity, its manufacturing of Wehrmacht uniforms and other goods that serviced the war effort. All other goings-on in the ghetto were hidden from view. Accordingly, in an attempt to ensure the smooth running of the factories, irrespective of the degraded working and living conditions, the propaganda offices prohibited the publication of images from inside the Lodz Ghetto.[46] Furthermore, as in the case of the censoring of unsolicited photographs on the battlefield discussed in the previous chapter, the central Nazi administration placed a strict prohibition on the taking of photographs inside the ghetto. Although the use of photography to meet administrative ends such as those discussed earlier was encouraged, any "documentation" of ghetto life was prohibited, particularly that of life in the streets. Even the German administration was prohibited from photographing the streets, with the result that most photographs of the streets of Litzmannstadt were taken in haste and from hidden vantage points.[47] Thus, in spite of Genewein's obvious desire to carry out the wishes of his superiors, his photographs were perhaps not the coveted

documents he intended them to be. On the contrary, as Florian Freund and his co-authors point out, these images were, strictly speaking, forbidden.[48] The illegality of Genewein's images comes together with their amateur status in documents that conflict with, and effectively pose a challenge to, the discourses of authority and officialdom.

This ambivalence toward conventional Nazi representations of Jewish people and culture further underscores the photographs' complex relationship to the narrative of modernity. Their complexity is also borne of typically contradictory edicts announced by the Nazi authorities. On the one hand, in Genewein's photographs he takes up the project of recording every single detail of daily life: the images reflect a documentary realism that contributes to the history narrated by the lists of names, figures, physical descriptions, times, and places that were obsessively recorded under National Socialist rule. This adherence of the photographer to the principles and modes of inventorial categorization speak to his compulsion to master and control what are effectively the stolen images of Jewish ghetto life in Lodz. Similarly, it was a modus operandi that sought to efface the visibility and the subjecthood of the Jews as the locus of confusion and anxiety of the historical moment. In short, Genewein's series not only silences the Jews when it empties them of all expression; it also rationalizes their existence within the ghetto and, by extension, within the German war effort. This was, of course, one very important aspect of the detached, clinical nature of the systematic operations that Genewein obsequiously upheld. Indeed, this is exemplary of the extremes of modernization and rationalization that were practiced by the Nazis.

On the other hand, Genewein's detached conception of his version of day-to-day life in the ghetto precludes the photographs' designation as laudable and legal. Ultimately, Genewein did not see the ghetto as a step toward Europe's "purification" of its Jewish citizens. His photographs bear no trace of the biological or moral perversions that, according to the Nazis, justified the Jewish genocide. The differences between his image of the Jews, discussed later, and the image of the Germans are subtle. Genewein saw the ghetto prisoners as central to the Nazis' progress toward victory through industrialization. His images do not seek to destroy that which is perceived as threatening in its difference. Rather they embrace the

other but efface the other's subjective desire, then place it in the service of an amateur photographer's own commitment to the greater project.

Realism and Forbidden Histories

As it is revealed in the transparencies, Genewein's historical consciousness is characterized by the belief that history lies on the visible surface of a photograph as a perfect imitation of day-to-day life. At this level, his practice was naïve. But before offering judgment, it is useful to clarify that the logic behind Genewein's pursuit of documentary photography was widely held at the time he was taking photographs. This logic is succinctly articulated by André Bazin, one of a number of photographic theorists from the first half of the twentieth century who believed in the direct correspondence between photographic representation and the object represented:

> The objective nature of photography confers on it a quality of credibility absent from all other picture-making. In spite of any objections our critical spirit may offer, we are forced to accept as real the existence of the object reproduced, actually, *re*-presented, set before us, that is to say, in time and space. Photography enjoys a certain advantage in virtue of this transference of reality from the thing to its reproduction.[49]

However, unlike Bazin, Genewein did not delve into the complex implications of this relationship. Genewein was not interested in the image's relationship to time, to life, to epistemology, or to aesthetics. Neither was his grasp of the phenomenological status of the image sophisticated to the point of envisioning the objecthood of the representation. Genewein believed that everything that needs to be noticed is apparent in the visible aspects of the image. Genewein and the Nazis alike saw the unproblematic re-presentation of the object before the camera as the power and authority of photography. The photograph is truth in its most rational form.

Ironically, Genewein's methodical detachment exposes—albeit inadvertently—the Nazis' more complicated approach to operations in the

ghetto. The multiple realities of the ghetto were borne of the Germans' inconsistency, their oscillation between equal measures of "detachment and brutality, distance and cruelty, pleasure and indifference."[50] In Genewein's image series he wanted either to hide or overlook the irrational physical violence committed under the auspices of building a strong and productive Germany. If the photographs discussed in chapter 2 show the chaos and contradiction of the idyllic Germany—the cost, so to speak, of German victory—Genewein's images calculate the same costs to be quite different. Genewein saw the cost as the treatment of the Jewish prisoners as a society of individuals who had a productive potential. This potential might have needed to be exploited, but it is important to recognize that Genewein's was a message of yield rather than destruction. Although his vision of success did not accord with the Nazi demand not to photograph the destruction and disease, the poverty and unhygienic conditions in the ghetto, Genewein was not so naïve an amateur photographer that he made the mistake of overtly portraying other facets of the unwanted image. He refrained from explicitly representing the underside of the German involvement in the ghetto, the precursor to the German genocide of the Jews.[51] In obeying this demand and simultaneously transgressing the rules requiring censorship of photography inside the ghetto but nevertheless encouraging documentation of daily life, Genewein was, unbeknown to himself, announcing the inherent contradictions of the National Socialist rules concerning photography.

In addition to the focus on Jewish productivity, there are still other narratives that lurk behind this veneer of healthy productivity presented in Genewein's transparencies. Still at the manifest level of the images, we notice that they include other aspects of the ghetto that the Nazi authorities would not have wanted to be publicized. Namely, if we look closely, we see that the photographs' reality is incomplete. The deliberate posing, the choreographed gestures of, for example, the diligent basket weavers in the straw factory, or the open welcome of the merchants are convincing indications that these workers "performed" their acquiescence. A handful of images corroborate the posed nature of the photographs. For example, one is a group photograph of the personnel at the furniture factory.[52] In another we see two policemen arresting an old Jewish man in an image

that is clearly staged.[53] Genewein's obvious stage management of the scene and his careful production of the image are evidence enough that something is hidden, left out of the frame. For if it is not, why would someone so concerned with authenticity need to orchestrate the reality?

It is unusual for amateur images to show a carefully constructed, symmetrical, balanced, and centered scene. There are few blurs, no extreme angles, and only a handful of mistakes in Genewein's series. If the people had not been interrupted in their activities, these photographs would be very different. Similarly, the emphasis placed on the art and techniques of photography that periodically overwhelm Genewein's images distract the viewer from what lurks in the background.[54] Of course it is the underbelly of ghetto life that is hidden behind qualities such as the grain of the image, the blue of the stock, the carefully composed and balanced images of streets, buildings, and bridges. It is important to recognize that these attributes are not so hidden. They may not be immediately evident—we may need to search the photographs for evidence of a different reality— but it is there. And the gap between what they claim to represent and what we see on close inspection is another site of their unacceptability to the Nazi powers.

One of the most profound narratives to be revealed on peeling away the immediately apparent is that identified by Freund and his co-authors.[55] Through their serial presentation, Genewein's photographs reveal a familiar narrative: the arrival of Jews at the ghetto and surveillance of the surrounding landscape and the identification and location of the institutions, both Jewish and German, upon which the ghetto's smooth running were dependent. As mentioned earlier, these expositional images are followed by the body of the series, showing the work that ensured the ghetto's continuation. Deportation and death, the silence of destruction, are located in the mounds of personal and not so personal effects at Pabianice. This narrative may be veiled; however, it is only barely disguised thanks to Genewein's deliberate numbering and labeling of the transparencies. Thus, as a coherent series prepared by Genewein, with characteristic attention paid to numbers, captions, and descriptions, we find transparencies that narrate a story never publicly admitted by the Nazis, not even as they were tried and judged at Nuremberg: that the European Jews were brought to

the Polish ghettos where they would be worked to the bone, robbed of their possessions and their personhood, and ultimately sent to their deaths at Chelmo (1942) and Auschwitz (1944). Thus, as well as representing a unique color vision of the ghetto, from this perspective Genewein's narrative is one that departs from the conventional trajectory of the German narrative regarding the fate of Europe's Jews. The story of ghettoization, exploitation through work, deportation, and extermination is the silent narrative that the Germans never admitted.[56]

Genewein's betrayal of the Nazis' ambition does not stop there. Indeed, we do not even need to look beyond the frames of the images to find the secreted narratives. For most viewers today, what is absent from these transparencies is the devastation, the disease, and the death that riddled everyday life in the ghetto. The apparent absence of these brutal truths from Genewein's images is sufficient evidence of the bias they present. We have only to turn to the reams of documents of the ghetto, the essays, monographs, letters, reports, and, of course, the encyclopedic *Chronicle of the Łódź Ghetto* to learn of the disease and impoverishment that lay behind the enormous productivity at Lodz.[57] The filth and sickness in the living quarters; the "pushing, fighting, hitting, swearing" in the food ration lines;[58] the stench of death and feces that filled the air of the streets are not immediately obvious to the viewer of Genewein's images. Very few Jewish people, only the privileged, had jobs on the ghetto police force or in the law courts, factories, and barbershops. The majority of ghetto prisoners stood in doorways, cleaned latrines, transported muck, and then returned to the stale air of drafty, overcrowded quarters with unsatiated hunger and no place to sleep.[59] Oskar Rosenfeld describes "the Face of the Ghetto" as he knew it:

> And people hurrying, trotting, hungering, barely stepping along. The majority carrying some kind of load, pushing carts, *schlepping* bundles, pails, vats, containers for soup. One scarcely speaks to the other. . . . Everyone and everything is without sense, like marionettes on a stage. And the more one observes this scene, the more senseless the whole thing seems. For whom? For what? How long? None of these questions can be answered.[60]

However, to reiterate, this version of life in Lodz is not absent from the images. It may not be as prominent as that which tells of the efficiency of everyday life in the factories, but it is present to the photographs nevertheless. As I shall elaborate, these apparently cold, detached photographs actually open up a space between this and another narrative prohibited from dissemination by the Nazis: that of the malnutrition, disease, and death that overwhelmed the experience of the Lodz Ghetto. In turn, this space, the distance between contradictory and prohibited visions, is the site at which we begin our narratives of witnessing and memory.

Witnessing a Holocaust

Given what we know from other sources about the agony of the Lodz Ghetto, the results of Genewein's insistence on the evidential and realist dimensions of the image have become subject to a very different interpretation seventy years on. When Genewein's pictures are placed side by side with other images from Lodz and other Polish ghettos, we see their myopism. And yet, to reiterate, if we look carefully, we will see another reality: corpses, piles of waste, decrepitude, and emaciation. For example, in one image a dead woman lies in the rubble of a collapsed house (Figure 14), and in another a barber is gaunt and ghostlike, appearing undernourished.[61] Germans ride in horse-drawn carriages while Jews are human rickshaws. And in Pabianice, the piles of goods such as those at the "Schuhlager" are so clearly confiscated, so clearly the remnant belongings of dead owners. These signs and hints of another reality—a less attractive, less "productive" reality of ghetto life—contribute to the complexity of the history Genewein represents. The piles of belongings, an old rabbi sitting in the cemetery, a corpse being transported, are the objects, the events, the images of a history that is as real as the workday in the ghetto. It may take a more discerning eye to detect these historical incidentals, they may still have been in distant long shots, but they are at times as present to the surface of Genewein's images as is the ghetto as an efficient, ordered manufacturing site.

Baer's analysis of Genewein's images focuses on these moments as the incursions of otherwise suppressed details of ghetto life into the clinical

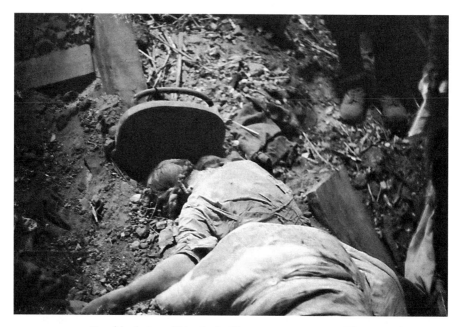

FIGURE 14. *Dead body in rubble, Lodz Ghetto, circa 1940–44. The image betrays the treatment of corpses in the ghetto as another form of trash. Courtesy of U.S. Holocaust Memorial Museum, image 95254A.*

mise-en-scènes. Baer attributes the incursions to the legacy of the medium Genewein used. They represent moments that the photographer could not control, inevitable moments that will always elude the urge to rationalize. These unexpected distractions are also the legacy of Genewein's adherence to his uncomplicated notion of the photograph as a precise mechanical register of evidence. No matter how preconceived, how staged these visions of the ghetto, if they are seen in location in the streets of Lodz, they must, by necessity, embrace the unexpected, that which cannot be mastered. Because the unexpected and uncontrollable are fundamental to the reality Genewein photographed. However, within Baer's analysis, these moments that mark what he terms the "beyond" of Genewein's photographs are made visible, indeed are perceptible, only through the use of a moving camera's interrogation of the still photograph.[62] In *Fotoamator* Jablonski's film camera effectively rescues the visual details that supply the material for our contemporary process of witnessing. However, I argue

that these aleatory traces of the trauma of the ghetto are identifiable in the photographs themselves. There is plenty within these images to evidence the multiple realities of the ghetto, including that of the victims' experience. Genewein's use of the long shot, stasis, and groups as subjects and, ironically, his urge to document the reality invited the possibility of uncontrollable variables into the frame itself. There is no need to use the film camera as a magnifying glass to see such incidents. On the contrary, the presence of these random unwanted realities manifests tensions at the images' visual level that, in turn, facilitate their agency, seventy years later, in the process of witnessing the tragedies of the Lodz Ghetto, because the discrepancies between juxtaposed and intertwined realities set us to thinking, reflecting, questioning.

There is still another level on which these incidental incursions are made visible when we see the photographs seventy years later. Even without the film camera to expose them, we see the moments of trauma, disease, and death because we are looking for them. We bring our knowledge of the degrading conditions of incarceration to an image such as that of the "Institute for Disinfection" and are able to perceive and to remember the tenets of purgation that dominated this phase of incarceration. Without knowledge and historical perspective, would we recognize the object carried by the four men in image 161 as a corpse? And would we know that they were walking past the cemetery wall? When viewing a series of images of sewage workers, would we discern with certitude that the workers were disposing of feces if we did not know the conditions to which the Jews were subject?[63] We can argue that our knowledge of these events comes though other images and narratives of life in Lodz, for example, those of Mendel Grossman and Henryk Ross. However, the keen viewer sees clearly the undisguised truths of the chief accountant's perspective in his actual images.

Thus, at a distance of seventy years, the reality of Genewein's photographs has accrued complexity. Their disguised (albeit scarcely) similarities to other images point both to the difference of the history they imagine— ordered and rationalized—and to the familiarity of the devastation and destruction they evidence. Therefore, these documentary images are, in fact, unique in their potential to hold the contradictory realities of the

Lodz Ghetto simultaneously. At the very same time that these irreconcilable contradictions make the images unacceptable as documents of the National Socialist reality as it was envisioned by those at the top, they are powerful agents in the continued memory of all facets of World War II and the Holocaust. The distance of both time and the camera's rationalization is here essential to the possibility of the viewer's detachment from what takes place. In addition, these same distances allow for other truths to seep into the photographs, to create inconsistencies that provoke the memories of their viewers. Genewein's photographs thus offer a unique opportunity to see, to remember, and to reconsider multiple narratives of the Lodz Ghetto. Thus, the ostensible objectivity, the chill of their distance and denial of distress, is the very springboard to their agency in the process of contemporary witnessing rather than simply the characteristic that condemns them as complicit in the German objectification and destruction of the Jews.

The discrepancy between the complex photographs we see and the realist documents that Genewein produced and arranged for dissemination brings to light the value of seeing them as more than ideologically saturated documents. As visual documents they represent much more than Genewein's intentions, his perspective, and the ideology he internalized. Theorists of photography have tended to argue that the structural alliance between photographer and viewer gives way to an intellectual and emotional allegiance. Solomon-Godeau, for example, argues that the shared structural point of view confers on the image a "quality of pure, but delusory, presentness."[64] Perhaps this is the case for some photographs, but it is not so for Genewein's. We may physically see what the photographer has seen; however, we do not automatically adopt his intellectual, ideological, or emotional point of view.[65] This is yet more reason to separate out Genewein-Nazi-photographer from the photographs themselves. To this end, it is critical to find another way of conceptualizing the Nazi's presence in the images. Only then can we clearly define the possible spaces from which we see and imagine. However, before discussing the complexity of Genewein's role as author of the images, I want to pause to reflect on the coincidences between these photographs and general trends in the medium contemporaneous with the

Lodz Ghetto documentation. This is another approach that forces us to question the wisdom of dismissing these color transparencies as no more than a tainted vision of a Nazi accountant. They are that and much more.

Beyond the Obvious

Like other documentary photographs from the first half of the twentieth century, Genewein's "[preserve] and [present] a moment taken from a continuum."[66] And the historical continuum from which they were appropriated has never been more present than here in the traces of its existence. Although all of these traces may not have been so obvious to Genewein, they are revelations that are the privilege of the distance of seventy years that stands between him and us. The motionlessness of these images draws us back into the flow of time from which they were arrested. Their details reach out to envelop us in the misery of their historical reality. If the documentary photograph makes present what is ultimately absent, desired, rendered forever mysterious in and by the image—here, the nightmare experienced by Jews in the ghetto—Genewein's photographs preserve the Jewish history of the ghetto.[67] That is, his static and mute images gesture toward a devastating history of which they nevertheless do not speak openly. Consequently, they create the sense of the past and of loss that envelops the photographic image. This is the ground on which the photographs thus become available to the process of witnessing events their creator tried not to see.

The absences that seep through the cracks in and between images lie at the core of Genewein's photographs in memorial discourses that witness a Holocaust. Koch's influential article on Claude Lanzmann's film *Shoah* (1985) explains this incitation to memory by demonstrating how the authenticity of Lanzmann's film is contingent upon the absence of that which is present to the image:

> Whenever something is narrated, an image *(Vorstellung)* is presented, the image of something which is absent. The image, the imaginary . . . is the presence of an absence which is located outside the spatiotemporal continuum of the image. . . . There

are no images of the annihilation itself; its representability is never once suggested by using the existing documentary photographs that haunt every other film on this subject. In this elision, Lanzmann marks the boundary between what is aesthetically and humanly imaginable and the unimaginable dimension of the annihilation. Thus the film itself creates a dialectical constellation: in the elision, it offers an image of the unimaginable.[68]

Koch wrote this in the late 1980s, a moment when accepted wisdom held onto the Holocaust as unimaginable and unrepresentable. And the acumen of her thoughts and their resounding critical influence can be seen in the shift her work marks toward recognizing the possibilities of representation of what was previously thought to be unrepresentable. As Koch sees it, as in the case of *Shoah,* when Genewein's photographs are viewed today, their design and serial presentation embraces the absence of the Holocaust "outside the spatiotemporal continuum of the image." In the events behind and to the side of Genewein's photographs lies the aporia that signals the presence of that which they do not see, about which they do not speak. To be sure, there is a difference in substance and texture between the multiple aporias in *Shoah* and those of Genewein's photographs. For the latter do not create elisions at the intersection of survivors' testimony in the present and the spatial locations of the past in which their memories were born. Nor do the still images span different countries, with an image of a walk through the forest at Treblinka accompanied by the words of a narrator in Israel. Rather, in images such as those of young men with yellow stars affixed to their coats laboring at machinery, the elisions are created in the interstices between what we see and what we know to have taken place, between the evidential history of the image and our constructed memory of events in the Lodz Ghetto.

To give an example, when we look at a photograph such as "Litzmannstadt-Getto Judenaussiedlung April 1942" (Plate 11) we know, and thus imagine with a heavy heart, that the hunched-over figures, protected from the cold by threadbare blankets and oversized coats, were bound for death. And we are too well aware that just out of view of images such as these there is probably a diseased and dying child, a skirmish for food, an orthodox Jew

being humiliated. It is in these interstices that we begin to give presence to what is visibly absent from Genewein's images. By extension, today we as contemporary viewers assume a responsibility for the continued memory of the Holocaust. So we take up the color photographs of the Nazi accountant as agents in our process of witnessing.

Genewein's photographs may not be responsible to the discourse of memory, and they are not ethically and discursively accountable to their subject matter. However, similar to the case of the photos taken on the Eastern Front, when we look at the color transparencies we are aware of the seventy years that stands between us and them. We see this temporal displacement in the color, the grain, and of course the subject matter of the photographs. Their coldness and distance, together with their deterioration, provoke us to imagine and remember what lies outside of them. Thus, for example, a photograph of the Jewish cemetery at Lodz, in which fresh mounds of dirt covered graves with temporary markers reach into the vanishing perspective of the horizon, might, on one level, be no more than documentation of the Jewish cemetery (Figure 15).[69] However, when we look at the image today, it is profound for what it reveals by default: mass death through starvation, suicide, the cold of winter, and so on. An image of a regular working day at the metal factory is otherwise benign.[70] But when we see the overcrowded conditions, the age of the boys at work, and the indifference of their gestures, the photograph is disturbing to us today. For we see their exploitation, their manipulation, and their servitude to a ruthless master, even though he is absent from the image. To reiterate, this history is not in the objective and distant images; it is spawned by the images because of the historical distance that exists between them and their subject matter and us, their viewers.

The images themselves are, to be sure, not responsible; they are irresponsible. However, their irresponsibility places us in a position of responsibility. This gesture of mediation, this passing on of the traumatic memory, the pain and suffering, of life in the Lodz Ghetto and what took place after its liquidation is the reason that the these images must continue to circulate. By enabling our memories, the images are agents that help us bear witness to a past of which we have no direct experience. It is a process of witnessing that demands the use of our powers of intellection

FIGURE 15. *Lodz Ghetto, Jewish cemetery, circa 1940–44. The Genewein archive contains approximately twenty photographs of the ghetto's Jewish cemetery, more than for any other of the ghetto's locations. These include close-up shots of particular tombstones, the various gates, the funeral chapel, and the morgue. The cemetery on Ewaldstrasse is the largest Jewish cemetery in Europe. During the existence of the ghetto, a separate burial area was demarcated at the southern end of the cemetery for those who died in the ghetto. U.S. Holocaust Memorial Museum, image 95120A. Courtesy of Robert Abrams.*

and imagination, our existing knowledge, and our ability to see what is invisible to the eye. Similarly, this process is made possible only in the spaces opened up by the particular form of Genewein's amateur photographs: his obsession with documenting the objective reality of daily life while evading (albeit unsuccessfully) the hardship, squalor, and disease that paved the ghetto's streets. Finally, the amateur status of the images feeds their possibility for appropriation in witnessing today: the fact that they exist at all, together with their experimental nature, the detection of flaws, their periodic lack of clarity, stymies them from fully displaying the vision and beliefs of official Nazi propaganda. These qualities render the openness—what I here refer to as distance—in stark contrast to the seamless closure of officially sanctioned Nazi images.

A Photographer of His Time?

Genewein's notion of the photograph as a transparent reproduction of reality is supported by his insistence that the rhetorical devices of his medium must be effaced as the marks of production. Genewein established correspondence with I. G. Farben as soon as he was in his position as chief accountant when he paid the bills for manufacturing supplies, including fabric dye. Thus it was logical that he send the color negatives to Agfa for processing. He also made a practice of corresponding with Agfa when he received the processed transparencies. Most often he insisted on the perfection of the color composition and bemoaned the "ugly reddish-brown" tone of some of his photographs because he did not consider it to present a picture of unmediated reality.[71] In one letter, Genewein complains about the gradual deterioration of images, again due to the lack of hold in the color: "For a short time, I made six complete color images from one series of film, which has been happening since April 1942, and I must point out again, that white patches appear pink, blue appear violet and green appear brown."[72] Even though he constantly stressed the technical aspects of the medium—the film, the processing, the color—in his correspondence, Genewein appears to be interested in these aspects only to the extent that they were the vehicles for his objective documentation of reality. Like Agfa, the manufacturer of his color stock and film processing, he was preoccupied with the tools of his art form, eager to improve the quality of his images.

The double-edged notion of the photographic image as both a substantive, evidential record of reality and a conscious construction of a particular point of view was not exclusive to Genewein and the Nazis.[73] The 1920s and 1930s saw the sustained interrogation of the parameters of photographic realism in Europe and the United States. Indeed, Genewein was working at the height of one of the richest moments in photographic culture of the twentieth century. It was a moment when photography as an artistic and a social medium was being defined in journals, through exhibitions, and in the reflections of critics and photographers on both sides of the Atlantic. Curiously, the realist projects in the Soviet Union and Germany, together with the conceptualization of documentary film in Britain and the

photograph in the United States as realist documents were all in pursuit of liberating working people from class oppression. It was believed that the realist mode was antibourgeois. And realism was a way of depicting the reality of daily life, as we see in the images of Lewis Hine and Jacob Riis or the already mentioned theories of realist photography written by Bazin or Siegfried Kracauer. Although Genewein's photographs were anything but antibourgeois, they do intersect with the conceptualizations of photography of this period, conceptualizations that were also adopted by amateur photographers keen to explore the possibilities of their medium. Thus Genewein's images are best seen within the context of developments in the medium taking place elsewhere, especially in amateur photography.

A series of photographs that come close to Genewein's in visual terms are those of Lewis Hine, whose enterprise was, for example, to further the work of the Farm Security Administration (FSA) to create a continuous, unfolding archive of photo-documents.[74] Hine's archive and those of the FSA after him were designed to forge the social and cultural identity of working life in the sway of industrial capitalism. Their project was to create an identity for and restore dignity to the base component of the capitalist system: the worker. Simultaneously, the photograph was used as a form of reportage, with a view to political or ideological awareness of working culture.[75] Irrespective of the multiple forces acting on the photograph, Hine and those who took his lead in the 1930s also maintained that the camera, if put in the right hands, could tell the truth; therein lay its unique access to documentary realism.[76] Hine's images of laborers and children depict these subjects of industrial capital immersed in their working environment. Of utmost importance to Hine was that his subjects be represented and understood as subjects with agency, pride, and autonomy in their work. They were not to be seen as the passive objects of the photographic gaze. To this end, Hine introduced the frontality of the subject's posture and eye-to-lens contact as the basis of his realism.

Genewein shared this belief in the truth of the photograph to document or expose the social world in a gesture of social anthropology. Similarly, he gave participants the frontality of address that, in turn, granted them agency.[77] Although the direct camera address of the young

men in the furniture factory at Lodz does not show expressions of pride and sovereignty, it is striking that Genewein gave the Jewish subjects agency at all: at least within the moment of the photograph, he gives them an independence that, as mentioned earlier, facilitates their identity as subjects within the day-to-day running of Lodz. Even if compromised, these figures have the traces of the command of subjects who return their gaze. This interpretation that a relationship is being established between the Jew as an individual subject and the viewer of Genewein's photographs is at extreme odds with the preferred image of the Jew in Nazi Germany: as an iconic object of all that was to blame for Germany's social, political, and economic difficulties. Of course Genewein was interested not in the forward momentum of class struggle in a capitalist world but rather in the perpetuation of class definitions for the success of his oligarchy. Nevertheless, his images can be seen within the context provided by the language of realism that, taken from contemporaneous thinking about photography, was pursued by amateurs in wartime Europe.

When Lewis Hine and the FSA photographers gave precedence to the idea of photography as establishing a transparent relationship between images and the truth of the everyday, they were always aware of and acknowledged the processes of aestheticization that enabled their truth. However, Genewein's depiction of the truth would be achieved through the effacement, not the foregrounding, of stylistic traces. Genewein attempted to render the traces of his manipulation invisible, a gesture that clearly sets the photos apart from any documentary explorations in their midst.[78] However, this juxtaposition with the revolutionary developments of social documentary photography taking place elsewhere shows how naïve Genewein's images were. And this naïveté was arguably at complete odds with his authority as a photographer, a photographer who claimed to have a command over history. Again, the distance of seventy years brings to the fore the tension between his apparent authority and the actual naïveté of his images. In turn, this tension or impossible contradiction is what generates the presence of the unwanted in the frame and, ultimately, yet another space in which we are invited to reflect on what is inside and outside these photographs.

Blurring Distinctions

Authorship and Anonymity

Although the photographs discussed in chapter 2 were noticeable for their anonymity or, if identifiable, the fluidity and multiplicity of their authorship, Genewein's color transparencies of the Lodz Ghetto appear to reflect the exact opposite. At first glance, Genewein seems to be absent from the majority of the images, yet he is everywhere present therein. In the case of his photographs, there is definitive information to confirm who stood behind this camera. And yet Genewein all but effaces himself from the photographs. Their coldness, distance, and objectivity are all in the interest of the removal of his identity and its replacement with that of the committed Nazi Party officer. This said, however, their serial presentation after the fact reinstates the accountant as creator of this archive of documentary images. This contradiction, the fluidity between Genewein's presence and absence to the photographs, injects another level of flexibility and depth into the images. Specifically, investigation leads to a different type of anonymity common to amateur photographs.

In spite of Genewein's insistence on a detached objective vision of ghetto life, the distinct characteristics of the photographic realism he adopted are, in fact, markers of him as author. This is perhaps most strikingly identifiable when his photographs are juxtaposed with those taken by Jewish people of the ghetto. And though most of these other photographs can be attributed to Ross and Grossman, they were forbidden and, as a result, their stylistic identification is also erased. The prohibition on photography led to the taking of blurred, skewed, and long-shot photographs in which hasty compositions defy the possibility of a stylistic authorial presence. Genewein may not always have taken photographs that accorded with his superiors' designs for the status of Jewish life; however, he was obviously allowed to own a camera. Even though it was supposedly forbidden to take photographs in the ghetto, Genewein's very structured images testify to the fact that this rule was ignored by the German ghetto administration. And of course there are images of the German officers clearly taken with the full knowledge of all involved. In addition, the fact that Genewein's images were taken in color from as early as 1940

is evidence that he had the time, the patience, and the privilege to continually explore the possibilities of his medium. And it was this privilege that allowed him to develop what resulted in signatured photographs.

Even though Genewein was not interested in demonstrating his role as author of his images, he does appear in a handful of those now known to be in existence. Take the example of the image in which he sits at his desk, counting gold coins that we assume had been confiscated. In stark contrast to his tendency to photograph the direct-camera address of the Jews and other Nazis, Genewein does not look into the camera as he focuses on the task before him. Perhaps he did not even know he was being photographed. Similarly, although the soldiers on the Eastern Front were often photographed and filmed in the company of other soldiers as surrogate family,[79] Genewein, who had left his own family behind to take up the post as ghetto accountant, was not in the habit of using his camera to document either his own or others' familial bonds.[80] To reiterate, a number of his images are of Nazi officers and their wives at birthday parties and other celebrations, dinners, and other gatherings. However, the photographer does not appear in these images. As always, they are in long shot and display a distance from the photographer.

We can argue that Genewein, the photographs' author, is underlined by the symmetricality and balance of the impersonal visions of the ghetto and life within its walls. Nevertheless, what are identifiably his—the color, the composition, the balance, the use of the long shot, and so on—are not stylistic and technical flourishes. Rather, they are recognizable as his stamp of identification only because no one else in the ghetto had a Movex 12 camera or used color film. The images are unique not because of what is in them but because they are the only photographs of their kind to have been produced and to survive. Thus the attribution of authorship is again retrospectively determined by contemporary viewers.

Yet, at the very same time, in spite of Genewein's self-effacement from the style of the images, he is everywhere present in the series he prepared for public distribution. Through his self-designated status as an amateur artist and his attachment to the substantive reality of the photographic image, Genewein's presence pervades the images in retrospect. If we look closely at the images as a series, we are able to excavate Genewein's self-identity

within the Nazi machinery. It is, in effect, a self-identity that is marked by anonymity: the effacement of self from the presentation of the image was done in the interest of flaunting the success of the Nazi regime. This level of interpretation ultimately directs us back to locating the ideology and beliefs of National Socialism in the images, and along the way we learn about what it means to be an officer as cog in the Nazi machinery.

We recall that Genewein, the amateur photographer, was not required by his immediate superiors or by the Nazi system to document the ghetto in which his official position was that of chief accountant. Even though Biebow involved him and other section heads in preparing the exhibition, the photographs were taken of his own accord. Together with his concerted attempt to efface his hand from the photographs, Genewein's willingness to use his photographs for official purposes can be interpreted as a subordination of self to the interests of the administration for which he worked. Even though his practice was far from a scientific inscription of everyday reality, he clearly attempted to document everything he saw and oversaw in the ghetto methodically and objectively. The photographs represent the success of the administration to which Genewein was central. In theory, such a photographic project carries the weight and authority of command.[81] For all intents and purposes, Genewein presents a systematic archive of the successful industrialization of a community of which he has charge. Thus he is subtly present as a model Nazi officer in the collective image of his photographic oeuvre.

In contrast to Genewein's absence from the images, Biebow appears again and again. Biebow is always shown surveying events, always an observer in the photographs.[82] Because Biebow was the head of ghetto affairs, his presence and posture of surveillance serves to underline this notion that the primary focus of the images was the efficiency of ghetto production, an efficiency mirrored in the presentation of the people, processes, and products. Indeed, Biebow was a businessman who initially subscribed to exploitation of the Jews to profit from the war. However, once the mass deportations began, he did not hesitate to take charge of sending the inmates to Chelmo and later to Auschwitz. In Genewein's photographs he observes an eastern Jew being photographed, browses through books at a stall in a market, inspects ties, and idly strolls through the market. In

all of these images, Biebow is the debonair gentleman in civilian attire, attending to business, the director of Jewish ghetto prisoners, on stage to perform the epitome of Nazi productivity. Biebow's omnipresence is a constant reminder of his command and authority over this well-oiled machine. And, as such, together with Genewein's relative absence from the images, it is a constant reminder of Genewein's observance of his superior's authority and thus his own place in the hierarchy.

I have mentioned the surprising paucity of personal photographs in this collection by an amateur photographer. But the "family" images that do appear usually find Biebow at their center. One such photograph represents Biebow at his birthday party, surrounded by exotic flowers and rich foods, reading a book. As always, he is the gentleman at ease. The transparency is clearly labeled as showing Biebow's birthday party, and the image is in keeping with Genewein's urge to identify Biebow with the plenitude of the ghetto. There are other images, such as one of a gathering in winter 1941 at the home of Döhmer, another officer in the German administration at Lodz,[83] but all of them lead us to surmise that the "private" or "familial" world of Lodz, even among the Nazi officers, was one authored by the system. Here Genewein used his amateur pursuit not for the creation of private memories for the future but to show the hieratic importance of his superior officer. So even these so-called private images demonstrate Genewein's fantasy of advancement through the Nazi ranks on the back of his success as an administrator in the Lodz Ghetto.

The serial presentation, subject matter, and representational choices of these images work in tandem to reveal the presence of their author's enthusiasm for presenting the thriving production under the collective command of the ghetto administration. By extension, we can assume his zeal to advance through the ranks of the Nazi system from an amateur cameraman working with a confiscated camera to a position of higher responsibility. In turn, this struggle indicates the difficulty and idiosyncrasy with which officers could advance within the Nazi system. Genewein already held significant responsibility within the ghetto administration, but his ambition was for greater things. Documentation from the Lodz Ghetto left by the Germans gives further evidence that officers were subject to the same process of rationality and systematization as were their

victims. Obviously it was to a different degree, and the consequences cannot be compared; however, for German officers, there was less room to move within the set structures than might otherwise be thought. Genewein's photographs and the official response to them are tangible evidence of such rigidity.[84]

Genewein's eagerness to see the processes of photographic reproduction raised to new levels of imitation, as evidenced in his letters to Agfa, in conjunction with his obsessive attachment to the photograph as a mimetic representation of what it saw and his insistence on the perfection of the color gradations, was not only in the interest of the medium's development. Rather, his concern over the reddish-brown shades and the miscolored spots in the images also speak his attachment to the presentation of "truthful evidence" of his assiduity as an administrator. Other excerpts from Genewein's correspondence and memories undergird this diligence and ambition. He noted in his diaries the need to convert the ghetto accounts to carbon-copy bookkeeping due to the expansion of production. His handwritten accounts were apparently inadequate to the volume of ghetto production. And his biography reflects his pride at his promotion as an accountant and eventually as a Nazi officer: "Having passed an exam in Berlin, I was promoted to payroll level 4."[85] Genewein privileged the efficiency of his accounting practices over the lives that were expended to achieve these figures: the fear, hunger, and dehumanization that we know overwhelmed every waking hour in the ghetto were secondary to the statistics, facts, and figures. If Genewein could perfect the color reproduction of his images, they would appear as "truer" likenesses of reality, more accurate documents of history. What interested the self-absorbed Genewein was the fulfillment of his fantasy to progress through the official ranks of the Nazi system. Seen from this perspective, his letters to I. G. Farben might read as motivated by political ambition rather than the development of his medium. They testify to his self-fashioning as the model Nazi officer who offered himself as ripe for promotion.

Accordingly, the color images of the Lodz Ghetto can be interpreted as being authored not by the chief accountant but by the principles of Nazi rationality and the imperative to document fastidiously and accurately.

Even though they are in color, perhaps because of this, the matter-of-fact aesthetic indicates that the photographic medium was used here for the double purpose of effacing the creator from images while ostensibly representing the reality of daily life in the ghetto. Thus, linked to the lists, numbers, statistics, and obsessive systematization of the Nazis' industrialized slaughter of the Jews is Genewein's accession of his identity to the political party for which he labored. Simultaneously, however, when this accession is coupled with the photographic manipulations that Genewein indulged in, color can be recognized as a tool he used to have his images noticed, as a strategy for a technologization of the self that would lead to self-promotion of the already high-ranking Nazi officer. Genewein very strategically exploited his personal "pastime" in the hope of realizing his fantasy of success.

Professional and Amateur

Genewein's photographs recast the tension between the amateur and the professional photograph and that between the amateur and the professional photographer when the transparencies and the discourses that surround them shift from the creations of a novice photographer's private pastime to a body of work that struggles for recognition as a rare vision of a certified reality. In his letters and diaries, Genewein acknowledged his status as an amateur photographer. He was employed as an accountant, and his "dabbling in photography" was only ever a pastime and a passion. Similarly, there is no evidence to suggest that he was interested or engaged in photography before or after the war, as is often the case with professionally appointed photographers.[86] Moreover, like most amateur photographers from this period, as his letters to I. G. Farben indicate, Genewein was always in the process of teaching himself, perfecting his pastime.[87]

As discussed earlier, the search for the photograph as a certain kind of truth also marks these works as distinct from those that were officially sanctioned. The distanced, balanced long shots that were composed simultaneously with the taking of the images invited random events. Other aspects also contribute to their conception as amateur products. Notably,

even if they are few, there are nevertheless flaws and inconsistencies, irregularities that would not have withstood the scrutiny of official sanctioning: the sunlight overwhelms an image of German visitors to the ghetto with its reflection on the camera lens, a view of the ghetto from outside its perimeter is overexposed, an image of three men in a workshop in medium shot is underexposed (Plate 14), and the workers in other images are not all in focus.[88] Thus the meticulous presentation and organization of the photographs did not preclude the inclusion of the less than perfect. On this level, the images are in keeping with commonly agreed-upon notions of the characteristics of an amateur product.

However, if we look deeper, we can interpret the overall presentation as actually speaking to the fact that Genewein wanted the images to be seen as professional. The postwar collation or editing of the transparencies implies that they were originally slated for a role as more than the products of an amateur pastime. Baer suggests that the fastidious organization and labeling of the photographs indicates the slides' frequent exhibition and is "a sign of Genewein's own distrust in his capacity to recollect the events that his camera recorded."[89] If a photographer is concerned about remembering the events in his photographs, he labels them as we saw the soldiers did. Genewein's labeling and numbering of his images might support Baer's claim, but the narrative order is not usually in the interest of remembering specific events. The ordering of photographs in a private album is done in the interest of creating a narrative, usually with an unknown viewer in mind. An alternative interpretation of Genewein's narrative construction would have them organized post facto in anticipation of exhibition in the future. And if Genewein's prospective audience was his Nazi superiors, together with the evidence of his internalization of the Nazi belief that the photographic collection is an archive of scientific inscription, it would further explain why Genewein upheld the particular notion of the image as evidence. That is, the meticulous sorting and inventorial classification of the photographs underlines Genewein's presentation of them as evidentiary documents of incontrovertible truth. All potential disorder and threat are hidden from view as the photograph and that which it depicts are possessed, dominated, and objectified as

one of a larger series.[90] This preparation for public presentation casts the images into a space where they blur the boundary between amateur and professional. For even though they bear many traces of the amateur, their regulation and classification demonstrates to us, seventy years after the fact, that they were intended to be seen and accepted as a demonstration of Genewein's authority and control, his worth within the system for which he worked. They tell of the fact that he wanted them accepted as "professional," official documentation, not simply the work of an amateur photographer. Although the photographs themselves are not professional documents, they were designed for the fantasy of official acceptance. Genewein had it in mind to use these visual documents as evidence of his and the ghetto's professional status.

There is no evidence to suggest that Genewein sent his transparencies to his superiors outside of the ghetto for applause, and yet there is information to confirm that Genewein's chosen mode of publicizing the ghetto's productivity and success was rejected by the Nazi powers.[91] As we know, the Nazis were attached to the dehumanization and humiliation of the Jews rather than their perpetuation in the interests of Nazi success. Yet Genewein was not deterred. In the end, his desires came to fruition when immediately prior to the final deportations to Auschwitz-Birkenau, a series of screenings was organized to show slides of goods produced in the factories. As Loewy indicates, the small audiences that gathered for these screenings were customers from the various industries represented in the exhibition.[92] Thus Genewein's photographs were transposed from private visual records of the people, places, and events of the ghetto to a public demonstration, publicity for the work being done in this Nazi-run organization. With the help of Biebow, who, in turn, was keen to receive the approval of his superiors, Genewein turned these photographs from unsanctioned and nonconformist documents that implied the necessity of perpetuating the Jewish prisoners as the mainstay of the Nazi success into public representations of the Third Reich's cause. Thus Genewein's photographs blur distinctions because they were produced as amateur, but their author was always mindful of the fact that they could be used as official tools for publicity of the ghetto's immense productivity.

Visions of the Ordinary Made Extraordinary in Color

Although Genewein's transparencies capture the mundane, the routine, the painstaking details of daily life in a confined, determined space, they also come down to us today as extraordinary documents of an extraordinary historical moment. His photographs document the building on the corner, the fence surrounding the ghetto, the bridge over Zgierska Street, a man sitting on a gravestone, a woman selling pots and pans, all as part of a larger narrative about the daily running of the ghetto. And yet as ordinary, impersonal, and distanced as they are, the images are in color, and that makes them extraordinary. In turn, their being in color invites our witnessing of this extraordinary past in the present moment. Through their embrace of the possibilities of color stock and processing, Genewein's images point to the thriving relationship between industry and politics in Nazi Germany. In addition, the color opens up discourses on the relationship between technological development under the aegis of the Nazi regime and our contemporary dependence on these same developments.

As I mentioned earlier, the color is outstanding for its very existence at a time when color photography was rare.[93] However, Genewein does not appear to have exploited the color to its full potential; rather, the magnificence of the color comes from the technology he used and the subject matter he photographed. Yellow, blue, and red are the sole colors in an otherwise muted gray and brown world. If we compare these images to the photograph of the table prepared for Biebow's birthday party (Plate 15), we see that the brightness belongs to the event before the camera rather than to Genewein's vision of the event. In this photograph the prosperity of the subject is noticeable not only via the flowers on the table, the crystal glasses, and the silverware, but in the lightness and clarity of the moment. These qualities were presented to Genewein's camera, and color comes together with other aspects of the photographic mise-en-scène to emphasize the chasm between the wealth and health of the Nazi officers and the condition of the Jewish prisoners in other photographs. Similarly, in other images the clothes on display as the products of the workshops, displayed for maximum attraction to the buying public,

reveal an animation and brightness, a brightness that is further emphasized by the rich reds and blues of the color reproduction.

Even though Genewein did not dwell on the colors of the Nazi flag, the Jewish star, and other Nazi insignias, the ideology of everyday life in Nazi-occupied Europe seeps into his use of color film, because the color shows the discrepancies between the dull, cold streets of the ghetto and the public image put forward to the world beyond the ghetto walls. This is another example of how Genewein's images clearly cover over the depravity of the Jews' working conditions and the streets they inhabited. And yet the absence of color betrays another reality: the dullness of the brown and gray images is most striking when juxtaposed with the radiance of those of the Nazis at rest and the consumer items they advertise. The world of the Jews could never be colorful, because then the photographs would not adhere to the evidential reality Genewein attempted to capture. Thus these images must be infected by the ideological structures, actions, and beliefs that did not just surround them but, more important, enabled them.

In Genewein's letters to I. G. Farben he also insists that the precise reproduction of the color hues and tones is critical to the mimetic transcription of his photographs. As Michael Kuball points out in his book on amateur motion pictures, because color photographic reproduction had been in existence from the earliest days, black and white was only ever an abstraction of reality; it was never accepted as the definitive reproduction of reality.[94] When I. G. Farben/Agfa made color film stock available to the world in 1934, it was in direct competition with American Technicolor for domination of the international market. In order to set itself apart, Agfa established a reputation for its negative film stock as producing a more "natural," more "documentary" look as opposed to the garish plasticity of Kodak Technicolor.[95] Thus not only color but Agfacolor is central to the carefully weighed function of these images. The color and the complex stories it tells further underline the desire that these images be accepted as authentic documents of reality.

The intimate relationship between I. G. Farben and the Nazis during World War II ran deep and wide and was one of the strongest alliances between industry and the Nazi Party.[96] As Rolf Sachsse explains, the

development of color photographic stock and processing techniques went hand in hand with politics, industry, and economy in Nazi Germany.[97] Those at the helm of Germany's wartime propaganda production were adamant that color was critical to the psychological and emotional persuasion of the masses.[98] All but Hitler—who believed that engagement with color should be left to painting—that is, the Propaganda Ministry and the smaller Propaganda Companies, stressed the privilege and possibility of color film and photography as recording devices. Similarly, all efforts were made to maintain a supply of color film stock at the front for the documentation of Germany's successes, despite the increasingly short supply for the civilian population from 1937 onward. Gert Koshofer notes that "the PK Companies of the Wehrmacht captured the events on all fronts in thousands of color transparencies for evaluation after the final victory. In the name of the Führer, all art works and historical monuments will be taken in front of the destruction."[99] This said, color photography was more common than color film in official Nazi propaganda because the technology reached a level of stability that the moving image did not.

Coincidentally and conveniently, those at the helm of I. G. Farben also wanted to see their invention succeed economically. Therefore, the supply of stock and processing was freely given to the war effort. And I. G. Farben was dependent on enthusiasts like Genewein to perfect the medium. Again, it was in amateur rather than official or professional photography that the experiments took place, because the amateur image could accommodate the flaws, the mistakes, the less-than-perfect product of a technology that was still in the developmental stages, whereas the professional image could not. As mentioned earlier, I. G. Farben was in a close race with Kodak throughout the 1930s and early 1940s to perfect the quality of reversal color film stock and processing. Accordingly, money and research energies were poured into ensuring that the three-layered color film that was I. G. Farben's invention took the lead of the export market in the 1930s. Agfacolor, with its use of fixed color couplers to prevent the migration of colors between emulsion layers and the use of a single developer (while Kodak still used three different developers) to produce a positive image, was the market leader up until 1942.[100] This

success enabled Agfacolor to keep prices down and thus maintain its popularity. Agfacolor stock was less than half the price of the corresponding Kodak film negative: In the spring of 1937, Kodak stock cost RM 6.50 for eighteen shots, and a thirty-six-negative strip of Agfa cost RM 3.80. Obviously it was the brand preferred by photographers in Germany and abroad.

As Sachsse points out, from the very beginning, the Agfacolor negative betrayed the intimacy between politics and industry as it was played out through photography. One image shows two workers, their shoulders draped in multicolor fabric and a color chart for spectometeric analysis motion toward the front of the image while a swastika flag floats between background and foreground. The Nazi flag is at the center of both the image and industrial achievement. With its bold red background set off by the black-and-white swastika symbol, it is as though the flag was designed with color photography in mind. Or perhaps the ongoing refinement of color film stock was determined by the successful capture of the brilliance of the swastika flag's hues.

There is no evidence to suggest that the Propaganda Ministry financially underwrote the development of color film in wartime Germany. However, there was an active conversation between Nazi photographers and I. G. Farben. The connection between the development of color film and the growing fortification of Nazi Party politics was not as overt as was, for example, the company's manufacturing and supply of Zyklon B. However, there is no question of their mutual involvement. I. G. Farben did everything it could to ensure the availability of three-way color stock by the beginning of the war. However, by 1940 it was still not sufficiently refined for market release. So I. G. Farben made the product available by giving it away to publishers, authors, and photographers—including soldiers and officers. Thus it had placement as an advertisement in various publications, and the experimenters offered useful feedback for the product's further refinement. Further testing grounds were found in school classrooms and amateur photography clubs within the community. To carry out these testing programs that reached beyond the circles of higher-ranking Nazis, in the late 1930s I. G. Farben established two schools—the Klasse für Fotografie and later the Institut für Farbenfotografie—to teach

people how to work with the color stock, and thus encourage consumption and use. Genewein's access to and interest in the processes of color photography were thus dependent on and privy to this much larger structure, which was already in place by the time he arrived in Lodz in 1940.

The development of color photography technology is not usually associated with Nazi Germany. However, thanks to amateur photographers such as Genewein it became increasingly stable at the time. To be sure, color photography would exist irrespective of Nazi Germany's investment in the relations between politics and industry. Nevertheless, the three-way color material in circulation today is identical to its 1945 versions. It was in Nazi Germany that the foundation was laid for the color film we have now. Thus it is not only significant that the Agfacolor of Genewein's transparencies supposedly offers a more authentic documentation of reality of the Lodz Ghetto. Nor is it simply a question of the images' contribution to the development of photography as a medium that came onto the market the same year as the outbreak of World War II. In addition, these photographs provocatively illustrate that the relationship between politics and the development of technology in Nazi Germany is as central to European history as the terror and destruction wrought by the Nazis. This is not to condone the uses of the color photograph in the perpetuation of the war effort but rather to acknowledge that there are aspects of present history that are indebted to the productive relations between industry and politics in Nazi Germany.[101] Obviously, if Genewein's images are seen as no more than ideologically manipulated visions of the Jewish inmates as "subhuman" and other discourses that support the Nazi program of incarceration and extermination, there is no place for their contribution to European, and photographic, history.

Seeing and Remembering through Genewein's Transparencies Today

Due to the uniqueness of their color, Genewein's transparencies have often been re-presented since their rediscovery in 1989. As a result they have been seen in many different contexts, including on display in the *Holocaust Exhibition* at the Imperial War Museum in London and the *Unser einige*

Weg ist Arbeit exhibition at the Jewish Museum in Frankfurt, as well as in the narrative multiplicity of *Fotoamator.* I want to begin with two very different appropriations of Genewein's transparencies. On the one hand, W. G. Sebald invokes the images and opens up to their complexity and consequent power as agents in processes of witnessing. On the other hand, as an illustration of the tendency to republish the images as if they were transparent documents of reality with no attribution, I discuss Alan Adelson's problematic reuse of Genewein's photographs in his books.[102]

Janina Struk's *Photographing the Holocaust* demonstrates how common it is for amateur and anonymous photographs to be reproduced for any number of disturbing ends. In the final chapters of her history of the role of photography in the ghettos, in the camps, and on the battlefield in the increasing awareness of the Holocaust in Western democracies, Struk draws attention to the reuse of photographs for commercial, entertainment, and pornographic purposes, reuses that are usually without attribution.[103] Struk argues that the only responsible use of the photograph is to place it in a historical or educative context. However, she does not reckon with the possibility that such reuses might also be exploitative. To build on Struk's detailed history of photographic representations of the Holocaust and crimes on the eastern battlefield, we need to ask how these images might be reused in discourses of "post-memory," at a distance, by twenty-first-century viewers. It is not enough to assert that they must be used historically and for educational purposes, for such uses can produce extreme forms of forgetting and repression of both history and the images that envision it. Rather, we need to reinforce the imperative for responsible reuses of the images in their new historical and pedagogical contexts. After all, we could argue that Genewein's re-presentation of the Ghetto is indeed historical. However, the covert denial of attribution of the amateur photographs made by a German official such as Genewein falls dangerously close to a repetition of the oppression of history these narratives strive to expose and oppose.

First we must question Genewein's notion that the photographs are objective representations of reality. Similarly, even though I argue for their anonymity, it is a discursive anonymity dependent on his absence from the images, an absence (rather than an erasure) that opens the way for us to

use the images for appropriation in our discourses of memory and witnessing. To blindly reiterate both of these beliefs—that they are objective and that Genewein is nowhere present or identifiable in the images—echoes his belief. It is to see through Genewein's eyes. We must therefore distance ourselves from Genewein, the supposed reality of what the images claim to see, and his apparent absence from that reality if we are to take up the images in processes of witnessing. We must recognize the distance between then and now, between Genewein's reality and the one we see in the photographs, if we are to observe and remember the reality of the events of World War II. Books such as Adelson's do not recognize this distance and thus fall into the trap of reinforcing Genewein's reality.

In an otherwise profoundly moving book, *Łódź Ghetto: A Community History Told in Diaries, Journals, and Documents,* Adelson and Robert Lapides reproduce several of Genewein's images with no attribution. The book is a collection of letters, poems, and ghetto documents of Germans and Jews, as well as narrative descriptions of ghetto life and black-and-white as well as color photographs. The book includes glossy color full-page inserts where eighteen of Genewein's photographs are reproduced side by side with paintings by ghetto inhabitants Hirsch Szylis and M. Schwarz and contemporary photographs of retrieved objects. Although the photographers of the other images are credited, Genewein's images are accompanied by his uncredited descriptions of the contents ("Hans Biebow shopping for neckties," "Fecal workers dumping excrement at the outskirts of the ghetto," and so on). The only reference to the particularity of Genewein's photographs is in the blurb on the front flap: "Richly illustrated, *Łódź Ghetto* includes more than 140 authentic photographs from the ghetto—some in color and many never previously published." There is no mention of what they show and who made them. The black-and-white images referred to on the front flap, photos by Grossman and Ross, also remain uncredited. Although Genewein's images are in color and thus somewhat fetishized, like the photographs of Grossman and Ross, they are presented as realist documents of the ghetto. They are, in short, given the same evidentiary status as was given to the documentary photograph within the Nazi system and, more specifically, Genewein's archival collection.[104]

In their book Adelson and Lapides are understandably horrified by and unrelenting in their vision of the Nazis as evil and the Jews as victims of their crimes. They tell the story of the ghetto through the letters, diaries, and documents of the victims and perpetrators about the ruthless violence of the Nazis, the harsh conditions of life in the ghetto, and the courage of those who survived. No attempt is made to distinguish the images taken by Nazis from those of the inmates. All of them appear interspersed throughout. In addition, there is no interrogation of the status of the image as evidence. Why and how is it that in today's climate of skepticism and distrust of images taken by the Nazi perpetrators as supposedly unable to contribute to a historical understanding of the events they photographed that Genewein's photographs offer transparent evidence of day-to-day life in the ghetto? How can these images be both violent and laced with obfuscation and manipulation and, simultaneously, appear side by side with the photographs taken by the courageous captives, undifferentiated from them to the untrained eye? *Łódź Ghetto* is exemplary of the hypocrisy shown toward the German image in its recycled form. Although an author such as Adelson insists that any kind of cultural production of the Nazis is tainted by their ideological beliefs,[105] *Łódź Ghetto* demonstrates, through its unproblematic reproduction of Genewein's photographs as documentary evidence, that when convenient, such images can be used as neutral and objective evidence of what took place in the ghetto.

This duplicity can be insightfully explained through recourse to recent discussions on the denigration of the image in post-Enlightenment modernity. In Adelson's reproduction of Genewein's photographs we find a particularly potent example of the iconoclasm-iconophobia shown toward images made by Nazi perpetrators. As Mitchell has explored across his work, despite the apparent pictorial turn of the post-Enlightenment age, pictures are repeatedly misunderstood, deliberately misinterpreted, dismissed, and destabilized by the privilege afforded to the written word. And often the most egregious misunderstanding of the image results when it is relegated to an illustration of the authoritative text. Such forms of suppression of the image are, in effect, gestures that insist on negating the power of the image to hold up a mirror to our own paranoia, the

violence and other contradictions by which we live.[106] Ours is a fear of images that identify our own unpalatable selves. In the case of textual re-presentations such as Adelson's, I argue that conscious blindness and ignorance toward the image in the form of contradictory reuse alleviates any responsibility to history, to the image, and to those represented therein. To take responsibility requires some form of meditation on the relations between the different images, between image and text, and on the contemporary viewer's own relationship to the images, all of which would enable a more nuanced, less distanced, and more complete history of World War II and the Holocaust.

In another example also edited by Adelson, the cover of *The Diary of Dawid Sierakowiak,*[107] the diary of a prisoner who relates his experiences in the ghetto, shows an image of Jewish children lining up at the orphanage for lunch, an image easily identifiable as taken by Genewein. This well-composed photograph is in many ways appropriate to the task of illustrating the book: Sierakowiak was himself a boy who, if not among those holding their cups, bowls, and spoons in Genewein's image 170, was a boy in the ghetto.[108] This use of a photograph of specific Holocaust survivors to represent universal Jewish suffering and exploitation is a common strategy. As Holocaust critics such as Andrea Liss have argued, personal memories and memory objects of individuals are often put forward as devices to enable collective historical memory in the present.[109] In addition, Adelson's use of transparency 170 is a typical use of amateur photographs for the purposes of projecting our own memories, desires, and identities. Thus we see the cover image and immediately imagine Sierakowiak as a child in the ghetto, wearing a yellow star and thus destined for deportation and death. In this case, the image is attributed at the end of the book. Adelson notes that the photograph was taken by a German in the ghetto's administration:

> He was using color film that had recently been developed by Agfa. The 35-mm image, preserved as a glass-mounted slide, is part of a collection that contains as many festive snapshots of parties among the Germans as images of the doomed Jews in their ghetto. Strangely, a near duplicate of this photograph of

thirty ghetto schoolboys exists in black and white among the archives of Jewish photographers' prints. . . . Grossman or Ross must have spent some time going around the ghetto, side-by-side with the German photographer, recording the same images but with a very different intent. The Nazi Propagandists relished the way ghetto life dehumanized the Jews, while Grossman and Ross conveyed the enormity of both the Nazis' crime and humanity's loss by recording for posterity the very humanity and singularity of the ghetto dwellers as they lived their final days.[110]

Adelson's claim regarding Genewein's intentions aside, Genewein was certainly not working for the propagandists, and, as clearly evidenced in the German administration's documents, his amateur photographs were not accepted by the Nazi authorities as adequate, thus accurate, publicity of the ghetto. Whatever Genewein's images reveal, they do not "relish the way ghetto life dehumanized the Jews." Indeed they attempt, as I have argued, the very opposite. There is nothing in either the images or the surviving documentation to support the distinction made between the Nazi and the Jewish representations of the boys in the ghetto. It is more likely that critics and historians such as Adelson need to distinguish between the Nazi- and the Jewish-generated image because they proceed on the assumption that the image is an indictment of the person who took it. A more productive history would interrogate the complex discursive weave of the color transparencies as opposed to one that imposes the dichotomous relationship of the Nazi as perpetrator/Jew as victim onto the unsuspecting amateur image.

The contradictory and, at times, blind recycling of photographs taken by Nazi officers and soldiers did not begin with Adelson.[111] The Allied countries un-self-critically published photographic evidence of Nazi humiliations, particularly images taken in the concentration camps, without stopping to question the reliability or the truth of what was depicted. Barbie Zelizer nods toward the unresolved ramifications of the Allied use of photographs taken by Nazis when she examines the simultaneous suspicion of photographic images as reliable documents of war atrocities and the continued use of these same images to remember the Holocaust.[112]

Ultimately the troubling nature of such reuses of amateur images like those of Genewein rests in the blindness that is encouraged in their spectators and viewers when the photographs are presented as neutral, objective documents of, in this case, the Lodz Ghetto. This blindness toward and conceptual ignorance of the images ignores the history they narrate, and thus they are supposedly of no relevance to us in the present. By extension, if we are not distant from these amateur images, and thus not open to their possibilities, we have no hope of gaining insight into our responsibility for the continued memory of the past, a memory that can develop only if we embrace new perspectives of and new attitudes toward the past.

Quite distinct from the textual republication, Jablonski's *Fotoamator* takes care to re-present Genewein's photographs in a way that provokes us to reconsider our role and our responsibility in the horrors they depict and reference. However, before discussing this issue further I want to focus briefly on W. G. Sebald's vivification of Genewein's images for the reader's imagination in *The Emigrants*.[113] The placement of the images and the ekphrastic form they take are powerful. What is striking about Sebald's use of the images is the space created for the viewer to see the images for what they are rather than having a narrative imposed on them, a result Sebald achieved by not republishing the images. Sebald describes the image for us, and he describes it through the memory of Aurach, the visionary artist-narrator of the last of four stories that comprise *The Emigrants*.[114] Although Sebald's resistance to reproducing them is innovative, it is an innovation that lives in the promise of an image created in the mind. Nevertheless, as Mitchell argues, this kind of ekphrasis also reveals a fear of the image.[115] The image-text, as Mitchell would have it, closes all number of gaps including that which invites the desire for spectatorial mastery over the material image. To translate this into an interpretation of Sebald's linguistic representation of Genewein's transparencies, the form curtails the desire for power and knowledge over the image and thus stymies the suppression of the history it wants to tell. However, the linguistic presentation of an image also distrusts the material image; it fears its power and thus seeks to silence it with words. Thus

a dilemma is posed: on the one hand, the privilege of words, and in particular description, gives far more insight into history than images ever could because history becomes imagined and remembered in the reader's mind. Moreover, there is nothing to fear about these words, no challenge to be had, no possibility of mastering the image. However, simultaneously, the material image itself remains hidden from view, as though it is evil, as though it is responsible for some misdemeanor it does not know it has committed.

Stefanie Harris characterizes the first side of this dichotomous relationship to images thus:

> Sebald both exploits and denies the documentary status of the photograph, prompting us to look beyond the simple reading of these photographs as merely enhancing the non-fictional elements of the text and to ask how they might function with and against the language of the text itself in order to communicate a particular relationship to the past.[116]

Although we might read Sebald's use of Genewein's transparencies as enabling a dynamic relationship to the past, we might also end up in the same place as we did with Adelson's reuse of them. For the reader left to imagine the photographs, they haunt the page. Aurach reflects that the nostalgia of the "greenish-blue or reddish-brown" images of the "Litzmannstadt ghetto" brings them back to life when "the light falls on them from the window in the background, so I cannot make out their eyes clearly, but I sense that all three of [the Jewish prisoners] are looking across at me, since I am standing on the very spot where Genewein the accountant stood with his camera."[117] And Sebald's reader is, in turn, invited to stand in Aurach's shoes in the hotel room in the British Midlands and have the eyes in Genewein's photographs follow her. Aurach's implication in the history of Genewein's images is passed on to us through Sebald's imaginative rendering of the images. This relay of glances, within and outside of the text, is thus a powerful strategy through which to reanimate the images and the histories they narrate for the present processes of witnessing.

They bring back to life the plight of the pictured men, reminding us that their history is not finished: not only is it still with us today, but we are implicated in their history, connected through their look.

The other possible reading is that images taken by Nazis cannot be trusted for fear that we will identify too strongly with their creators, and thus it is safer not to publish them. According to this interpretation, Sebald's narrator and the narrative that accommodates him are in command of the images, carefully prohibiting our access to them for fear of how we might see them. But Sebald's use of the images, in his books generally and *The Emigrants* in particular, is more complex than this interpretation would allow for, because Aurach represents the photographs to us through his memory of them: he says that they are "pictures from an exhibition that I had seen in Frankfurt the year before."[118] And in his narrative they create a dialogue between then and now, between the one-time industrial centers of Lodz and Manchester, between his life and the death of those who populate his narratives, written as they are within Sebald's. In short, the material images are physically present to no one, and their relegation to memory is precisely what gives Genewein's photographs their agency in Aurach's, and thus our, processes of witnessing.

Typically, when Sebald includes photographic images in his narratives, they are placed in dialogue with the stories. They are never mere illustrations. Even though at first glance Sebald's images appear to illustrate a textual description, on close examination, no matter how much we may want them to illustrate the text, they never do. The two are always frustratingly incompatible. Thus they are independent agents in his narratives and those of his protagonists. At the same time, as in the case of Genewein's images, when Sebald includes vivid descriptions of specific images, they are always ekphrastic, leaving the creation of the image to the reader's imagination. In this way, Sebald characteristically creates tensions between text and image and, in turn, a space that gives both the image and the text their power to draw pictures in our mind. Therefore, any fixing of the static image can only ever be in the mind of the reader. And yet, together with the text, this is never the outcome.

Does the very existence of these multiple interpretations reflect the indecision of the photographs as I have just analyzed them? Sebald's

ekphrastic reuse of the photographs is a potentially creative re-presentation that captures the images' ambiguity, then opens this ambiguity out to the ongoing project of animating the past in the present in the search for its understanding. Because of the ambiguity and uncertainty on the page, this search can only ever take place in the reader's mind. Sebald does not accomplish this through an exposure of stylistic tensions or a challenge to the photographs' realist assumptions. Rather, in the same way that they interact with Auerach's present in industrial England, a present colored by his experiences of the past, their mutability is passed on to our present through the demand that we reimagine them, revivify them in our present. It is nevertheless a demand that is made by avoiding the re-presentation of the material image.

Fotoamator

Jablonski's film is a striking reuse of German amateur film and photography from the Nazi period that ensures the perpetuation of the archival images in contemporary memory discourses.[119] Through standard historical documentary techniques, Jablonski uses the camera, sound track, voice-over, and digital enhancement to expose and critique what I refer to as the realism of Genewein's photographs. This exposure of the constructedness of Genewein's images, along with the film's simultaneous self-reflection on its own status as an incomplete re-presentation of historical images, is key to its creative provocation and possibility: in the tension created between Genewein's images and those of *Fotoamator*, spectators' memories of the Lodz Ghetto are reignited and recast. To give one example, midway through the film is a long shot of the bustling activity of a train at a station, which is itself a re-presentation of one of Genewein's colored images. The train doors are open, and people crowd around the doors in the background of the photograph. The foreground is populated by two SS officers standing by a black car with a swastika flag, their backs to the camera as they watch the activity before them. The ground is wet, but what station platform is dry in the middle of winter? The sound track that accompanies the image is appropriate to a crowd at a train station: we hear a hum, the indiscernible sounds of what might be people bidding

their farewells, others greeting passengers after a long journey, the porters doing their jobs. Genewein's image could represent any train station in occupied Europe at the time. There is nothing to arouse suspicion of the photograph's veracity. In and of itself, the re-presented photograph is benign. Similarly, the sound track of *Fotoamator* is continuous with the photograph. However, in this instance Jablonski used the fragments that lie on either side of this image to undo all suggestion of its innocuousness. Prior to seeing the image, we hear a voice-over of a "report" that accompanies black-and-white present-day footage of the same station: "In autumn 1941, 19,837 Jews from the Reich were transported to the Radegast station. They arrived in special passenger trains. The Jews were well dressed and on average carried 50 kilograms of luggage per person." After perusing Genewein's photograph of the station platform, the film's camera wanders across and around three more colored photographs. It stops to focus on a small suitcase, a barrow filled with sacks, teeming groups of people—presumably Jews—walking along the bend of an icy road. The juxtaposed frames give a context to the image of the train's arrival at what we now understand to be the Radegast station. And suddenly, in Jablonski's narrative as context, Genewein's photograph is horrific to the knowing spectator.

The train and the train track are always the material records of the "death traffic" and its efficient circulation during the Third Reich. However, in *Fotoamator,* it is only in its conjunction with the preceding and ensuing fragments that Genewein's photograph is afforded such chilling dimensions. The quantitative documentation, the interest in the luggage and dress of the Jews of the report that accompanies a present-day image of the same station, empty of people, tells of what is hidden by the photograph, what lies in store for the people on the platform in the background of Genewein's image. The bustling activity is only a mask for the story of a highly rationalized transportation to death. Similarly, the camera's interrogation of the ensuing photographs—its pausing on items ripped from their owners, such as a suitcase and food, that have come to signify Jewish dispossession—relates the silence and fear that lie beneath the buzz of voices at the train station heard on the film's sound track. Here the context offers insight into the future nightmare of these cultured

and educated Europeans as they arrive at the ghetto.[120] And yet the film makes clear that the photograph alone does not necessarily picture the historical trauma. That trauma is only gradually revealed as the camera moves around the image, as someone reads a letter on the sound track, as the mention of Radegast sinks in.

Fotoamator is not concerned solely with dispossessing Genewein's image of its authenticity, its claims to truth and banality. For the multi-layered context into which Jablonski placed these images functions simultaneously to reveal their seriousness and reality as a certain vein of Holocaust representation.[121] Their reality lies somewhere amid the cold, calculating distance of the colored depictions of people slowly robbed of subsistence, protection, and integrity as human beings; of streets paved with disease and death; of routines designed to humiliate and objectify. One of the most telling realities of the images is that exposed through the contents of Genewein's own correspondence, which overlays the images in voice-over narration. Genewein's words, written or spoken in high bureaucratic German, match the formal precision and systematic organization of his amateur photographs. The words on the voice-over and the photographs on the image track join forces to represent the central role played by images in the Nazis' obsessive quest to document every moment of their undertakings. Ultimately, *Fotoamator* self-consciously reframes Genewein's photographs and thereby reminds us of two different notions of history. In its re-presentation of photographs supposedly intended to document ghetto life, the film reminds us of the Nazis' belief that history is located in the evidential, the visible. Similarly, through its specific use of the techniques of the film medium—voice-overs, camera work, the joining of disparate images to interrogate Genewein's photographs as historical documents, *Fotoamator* re-presents the Nazi's images for their suppression of history, and, by extension, it puts forward an alternative notion of history as a self-conscious construction. *Fotoamator* presents Genewein's images for their narration of a version of history that tells only one side of the reality of Jewish life in the ghetto.

According to the film, the photographs tell little about the hardship and victimization of being Jewish at that particular moment in time. Nor do they offer any trace of the biological or moral perversions that,

according to the Nazis, justified the Jewish genocide. Thus, like other Nazi documents, according to *Fotoamator*, Genewein's photographs are not even documents that might sanction the Nazis' undertakings in the name of eugenics. The only narrative they tell is of the detached, clinical nature of the systematic operations in which Genewein believed. They tell of the bureaucratic administration that pervaded every level of Nazi operations. In addition, in their new context of Jablonski's film, the images tell of the production of a particular version of historical consciousness, a version identified by the belief that history lies in the visible details of the photographic image as a perfect imitation of day-to-day life.[122] Thus the film reveals a certain gravity and urgency to Genewein's photographs that is, as I have argued, quite different from that it claims was intended by their photographer. This particular truth may not exactly be that believed by Genewein, but it is, nevertheless, a truth about the Nazis' documentation of the Holocaust.

These two versions of history are distinguished through the use of somber black and white to mark the present in contrast to the color of Genewein's images that indicate the past. Similarly, the sound of *Fotoamator* is in contrast with the silence of the original photographs. In the spaces created by these juxtapositions, the viewer is given the opportunity to imagine her own reality of what took place in Lodz. The film interweaves the irreconcilable discourses of Genewein's images and our memories of World War II, the past and the present, the ordinary and the extraordinary, both separating them out and binding them together to ensure the continued memory of the Holocaust. Even if *Fotoamator* does not trust or fully annex the reality of Genewein's vision, the film claims that it is, nevertheless, integral to the continuation of history. The creation of this third history, a memory vision, is thus a process that comes from the opening up of spaces between then and now, spaces that begin with Genewein's images and flow through to our contemporary knowledge of the past. In these spaces we are invited to imagine life in the ghetto and its inevitable goal of deportation and death. This creation of memory through the spaces of representation is underlined by *Fotoamator*'s drawing attention to its own construction. The film does not simply challenge the authenticity of

Genewein's perspective of the past; it casts its own vision in 1998 as only one version of the past we must continue to seek out.

Throughout, *Fotoamator* lays bare its own construction in a number of ways. In particular, the visual demarcation between past and present, Genewein's documents and the memories of a ghetto survivor, Arnold Mostowicz, in black and white in present-day Lodz, are woven together through a narration that at various moments collapses the distinction between them: between past and present, between black and white and color. For example, at one point the film camera zooms in on the same photograph of the children that is on the cover of *The Diary of Dawid Sierakowiak*. The children, all with the yellow star on their breasts, are lined up outside an otherwise nondescript building waiting for their lunch, but it could just as easily be deportation that they await. As the camera moves closer to the surface of Genewein's photograph, the image very slowly dissolves into a black-and-white image of the same space, and it continues to move through a passage to the street that we realize must have been hidden behind the building in Genewein's image. *Fotoamator* cuts back to Mostowicz in his apartment, relating his experience as a doctor involved in the process of giving lists of sick and elderly ghetto inhabitants to the Germans, knowing his actions meant deportation and death for those on the lists.[123] As sinister music swells on the sound track, Jablonski's camera returns to the same position outside the building in front of which the children had stood in Genewein's photograph. This time, as it moves eerily and unevenly in slow motion through the passage to the street behind, the camera finds Mostowicz, the man "guilty" of the children's deaths, striding through the courtyard entrance. And this time, sixty years later, the image is in black and white. We are taken aback at these sequences, surprised not only by their introduction of Mostowicz in a space outside his apartment. In stepping into the courtyard, Mostowicz steps into the very world of Genewein's photographs. And yet it is simultaneously Genewein's world in black and white, thus in the present.

Fotoamator underlines the fluidity between past and present through playing with our expectations that representations of the past are in black and white while the present is shown in contemporary color. Jablonski

uses the color of Genewein's photographs to challenge our assumptions and thus to confront us with the status of our existing memories and assumptions about history. Similarly, through this unusual reversal of the use of black-and-white and color images, the film visually underlines Mostowicz's own admission of his implication in the ghetto's liquidation. He walks through the same empty courtyards once occupied by the Nazis. Thus the film literally and metaphorically merges the reality of Nazi and Jew, past and present, history and memory.

Fotoamator may represent Genewein's color images as clinical and thus pronounce a skepticism toward them. However, it also makes clear that they cannot be dismissed as pure fabrication. If they are, *Fotoamator* shares this status of fiction. And that would be to undo the agency of the film image to ignite the discourses of memory, discourses that are the film's ultimate intention. Rather, Genewein's images are re-presented to intersect, even if only sporadically, with survivors' memories in a film that shows the complex reality of perpetration. Jablonski employs the subtlest of dissolves to enable Mostowicz to move effortlessly in and out of the spaces of Genewein's images and present-day Lodz. In turn, *Fotoamator*'s transgression of any distinction between past and present, a transgression effected through the blurring of the static color and kinetic black-and-white worlds, reinforces the multiplicity of realities that make up the fabric of the past, its representation in the present, and the relationship between the two.

This complex layering of black-and-white, color, still, and moving images, past and present, historical knowledge and creative memory comes together in *Fotoamator* to argue that these realities in collision are as relevant today as they were when Genewein's photographs were taken in the early 1940s. In turn, the third reality is in our hands: to create a narrative of memory via those narratives that the film pries open for reexamination. Thus the responsibility to make meaning is handed over to us through the fluidity of the film's relationship to the photographs. Genewein's photographs may be images taken by a Nazi perpetrator, they may be cold and distant and depict a reality we instinctively want to reject, but they are also among the only documents we have of the Lodz

Ghetto. As a result, they are indispensible for our continued memories of the reality of life in the ghetto.

Finally, we remember that the reanimation of this past through *Fotoamator* is dependent on the distance of the film from the photographs, of the past from the present, and our resultant ability to be able to see the Lodz Ghetto from different, conflicting perspectives. All of the discourses—visual, textual, auditory—of *Fotoamator* are shown by the film to be fragmentary, just like the amateur photographs that are represented here. And this fragmentation is reflective of the incompletion of the history constructed with only a single set of images or texts by a single image maker. If we take our cue from the claims made by *Fotoamator,* the processes of witnessing and memory, of taking responsibility for the past in the present, are only ever enabled by the discrepancies between multiple, conflicting histories.

▪ 4 ▪

Europe at War in Color and Motion

The camera pans across a snow-topped mountain range in central Europe, a man rows his boat with a child on a lake, there are mountains in the distance, and a doubles tennis match is being played on a glorious summer's day. These images depict a picture-perfect scene. A train pulls into the central station in Warsaw, and the city's pre–World War II skyline is the object of the camera's fascination. A gleaming white rocket punctures the crisp blue sky. The skyline of Warsaw aside, these and other images could have been taken anywhere in pre–World War II Europe. They could have been shot by anyone at some time in the late 1930s or early 1940s. There is no sign of the war that we now know was being fought somewhere outside of these frames. We can see that they are old—the coloring alerts us to the use of Agfacolor reversible three-way color negative film—but other aspects of their provenance are unclear. Like Genewein's photographs, these color moving images are objects of fascination for film scholars and historians. We are struck immediately by the brilliance of the turquoise-blue sky, the rich green of the lake, the grain of the image surface, the tactility of what are obviously early color film images, rich in temperature, tone, and hue; it is as though they have been carefully hand painted. The privilege of studying these film fragments in the archive is a rare opportunity to appreciate the complexity of each frame. But as we marvel at their color, the painterliness of their surfaces, the next image appears: the brilliant red of the Nazi swastika flag overwhelms the rest of the frame, filled as it is with sky, marching figures, the familiar and yet repulsive icons of power, criminality, and industrial murder. Our hearts sink, and we immediately distance ourselves from the films as for us they lose their beauty and conviction. The images were taken in the early 1940s by members of the German Army against the backdrop of a world at war.

Over the past ten to fifteen years, there has been a proliferation of documentaries made for European television, primarily in France, Germany, and the United Kingdom. The producers have scoured the archives for color amateur film footage taken in the years leading up to and during World War II. In such narratives this recycled footage is often misattributed or left unidentified. To give one example, of which there are many,[1] almost every television documentary that delves into the archives and represents the findings claiming to showcase rare visual material, depicts footage of the Warsaw ghetto. I now know that the material was from reel 20814 in the Bundesarchiv-Filmarchiv, Berlin, taken by visiting ethnographers sometime between 1942 and 1943.[2] As I discuss them below, the images are ambiguous and multifaceted, without decisive indications of their intentions and the political or ideological allegiance of their cameraman. Partway through the BBC production *The Third Reich in Colour* (2001), the camera follows ghetto inhabitants going about their daily business. In particular, it follows people who wear the physical signs of their religious orthodoxy: men with uncut beards, *pais*, and hats. These ghetto inhabitants are not aware of being watched or, more precisely, surveyed. Upon reflection, however, there is a striking similarity between these images and those taken in the ghettos by Jews, particularly in Lodz and Warsaw. The images of Grossman, for example, may not be in motion, they may not be in color, but they do show similar traces of life caught unawares, clandestinely shot from the safety of an undisclosed vantage point. Like Grossman's images, this color footage shifts to slow motion and includes obtuse angles, canted frames, uneven compositions. These images could have been taken by a camera placed in a coat pocket, or, in this case, behind an unseen window high above the street. However observational, the footage does not appear to be official documentation. It is true that the color indicates that it was taken by someone of privilege, and because it was inside the ghetto, it was likely to have been a German. Nevertheless, it shares many attributes with other clandestine, and thus very ambiguous, images.

To relieve us of the burden of interpretation, the voice-over of *The Third Reich in Colour* tells us what we are seeing: "Poland, 1941." As the camera moves slowly across the groups of Jews, the voice-over tells us

we are seeing from the perspective of the Jew-hating German behind the camera: "The Poles have a thin Germanic layer. Below that is a foul material; the Jews are the most disgusting things imaginable. If Poland had lasted any longer, everything would have been lice-ridden. A clear masterful hand is now needed here." This voice-over connects these otherwise disparate images of everyday life: Jews walking along streets, stopping to talk with one another, gathering in a crowd, buying and selling goods, as well as different modes of transport. In short, various of the infrastructural layers of life in the ghetto are here depicted and cohered through the voice-over. All of the complexities and potency that I associate with amateur footage—for example, its challenges to the official, its informative insights into industrial modernity, its apparent anonymity, and so on—are gone.

Another fragment from the Warsaw Ghetto also often finds its way into this and various other television documentaries: starving, sick, and wasted children who, covered in sores, are too weak to stand and instead lie on the sidewalk. Their illness is emphasized as we see the legs of people nonchalantly walking past them. Although the images in each of the television documentaries remain consistent, the voice-over each time tells a different story, and this story functions to impose a univocal narrative onto the otherwise complex and uncertain moving images. In *Hitler in Colour* (2005), dramatic, dirgelike music is interspersed with a voice-over, a disembodied voice reading from Goebbels's diary: "The Führer prophesized that if the Jews brought about another world war, they would experience annihilation. The world war is here; extermination of the Jews is the necessary consequence." Then the narrator announces, "By the end of 1942, almost 300,000 men, women, and children have been taken from the Warsaw Ghetto to the death camp at Treblinka. Hitler's Final Solution has begun." *Hitler in Colour* then cuts to images of Hitler and other Nazi officials on the balcony at the Berghof, and the subtitle informs us that we are in Berchtesgaden in 1941.[3]

In *The Third Reich in Colour*, narrated by British actor Robert Powell, this same footage was edited together to form what becomes a visual backdrop to a somber voice-over narration that tells a history of World War II. The same images of people in high-angle long shot moving through the streets of the ghetto are now accompanied by the voice of Robert Powell.

In a voice that carries all the weight and devastation of the Holocaust in its pitch, tone, and command, Powell tells us that the cameraman "filmed the Jewish population as if he were aiming at them with a gun." He continues: "Indeed these people stigmatized by the Nazis had been condemned." And when the film reaches the footage of the children on the sidewalk, he says, "Around this time, Action T-4, the code name for a euthanasia program initially targeting infants with mental and physical disabilities, also began in Germany." The secrecy and clandestine nature of what appeared to be forbidden images are lost in this claim that the cameraman shot them as though with a gun. Irrespective of the absurdity and insensitivity of this claim, what is so striking here is the distortion of the images through the imposition of a voice-over narration and dramatic music. The two work in unison to cover any inconsistencies, ambiguities, or complexities inherent to the footage. And again, the ambiguity and multiple discursive layers of the mute footage of the supine children taken at ground level are now background for the details of the euthanasia program that was instituted in November 1941. Apparently neither documentary is interested in the images and the many challenges they pose. Both are concerned with relating the violence of the extermination program, and they deploy the image of diseased and starving children on the street to reinforce the gravity of the events narrated through the voice-over.

Overwhelmed as the images are by music and voice-over, editing and subtitling—that is, through their regulation into an ordered narrative (of the history of World War II from a distance) that fixes their meaning— gone is the energy of the colors, the animation of the markets, the fascination of the camera in slow motion. The narrational strategies empty the fragments of all the tensions created through the collision of the film and its ambiguities with the excess of Nazi ideology. In their stead is the dramatization of Hitler's plans for evil. In the case of *The Third Reich in Colour,* the images become eerie, haunted, filled with mysticism through the imposition of dirgelike music and the weight and profundity of Robert Powell's voice. The music that overlays images of the ghetto on market day works to similar effect. On the one hand, it emphasizes the ordinariness of daily life: the goings-on become even more ordinary and the

people more lethargic in their movements, as though made drowsy from the sun. On the other hand, the images are artificially injected with the horror of the annihilation that awaits those they capture. The slow motion of footage shot at the wrong speed, the extreme angles, the off-kilter compositions all function to communicate the devastation that awaits the people filmed. *The Third Reich in Colour* as a television documentary does all our thinking for us. The technical attributes that I know are the basis of amateur footage's openness and potential for appropriation in discourses of witnessing are here reduced to evidence of a distant history that is now completed: the events belong to another era, another land. It is a history that has no connection to that of a twenty-first-century viewer of British television.

My dissatisfaction with the re-presentation of footage I anticipated would be more flexible and spontaneous than these television documentaries encouraged me to return to archives in Germany, London, and Washington. In the archives, the wealth of color film footage bears the identification marks of being made by Germans, ranging from unknown civilians through soldiers to Hitler's pilot, Hans Baur. Some cans of film are labeled, while other fragments include intertitles handwritten in German, and some of the footage contains images of the soldier-cameraman on leave at home or at rest on the battlefront. In the television documentaries, the footage is typically used to illustrate a very specific narrative version of the history of World War II, particularly Germany's role in that history. Ultimately these new narratives strive to address the fissures in European history: they are familiar narratives of German destruction, Allied redemption, and the imperative never to forget either. As Kansteiner argues and I elaborate on below, the fascination for this material and its repeated reuse in television documentaries about World War II and the Third Reich belong squarely within the project of coming to terms with the past in the wake of both German and European reunification.

The paradox of my critique of the reused archival footage in television documentaries runs deep. It was not only television documentaries such as *The Third Reich in Colour* and *'33–'45 in Farbe* (dir. Karl Höffkes, 2000, Polar Film, Germany) that inspired my return to the archives to see the images in their original context as fragments of amateur and

home movies in the first place. But in the case of the footage located in public German archives in particular, I was able to view the footage in VHS, 8-millimeter, or 35-millimeter print form only because copies had already been made for television production. Moreover, any historical information on the films held in the Bundesarchiv-Filmarchiv existed because it had been researched and collated for the television documentaries. Thus, although I am quick to point out the problems with the television reproductions, ironically they also gave me access to a body of work that I would not otherwise have been able to see. In turn, this footage brought new insights into the complexities of World War II, its visual representation, image-making processes at the time, and their place within the broader context of twentieth-century European history.

In a continuation of the concerns raised in previous chapters, the color film footage taken during World War II by German officers and dignitaries, Nazis and non-Nazis, can be placed within the context of technological developments of modernity, especially for their references to the experiments taking place in amateur film at the time. As in the case of Genewein's photographs in particular, this engagement with the historical and cultural worlds of production does not attribute an aesthetic value to the color film fragments but rather brings their complex significance and impact to the fore of the discourse on representation and memory of atrocious events, a representation not usually located in the frame. In addition, all of the attributes of the amateur image—the nonsubstantive relationship between image and object, the absence of identifiable style, the fragmentary status, the historical events being filmed, the subsequent anonymous lives of the images, and the blurring of distinctions between public history and private memories—are identifiable in these fragments. These and other characteristics typical of the amateur and home movie, such as the literal and metaphorical muteness of the fragments, are vital to the process of distancing already discussed with reference to photographs from the period. In turn, the various distancing strategies are again key to the films' potential to be taken up in contemporary memory discourses. Therefore, in this chapter I demonstrate how color film fragments participated in the processes of industrial modernity and its representation as both were developing across Europe in the late 1930s and the 1940s. I

simultaneously demonstrate how these discourses exist side by side with the imperative to examine the specifics of the ideological context within which they make sense. And ultimately I propose ways of seeing the films for their historical relevance within contemporary discourses of witnessing World War II and the Holocaust.

My impulse to look more closely at the color film is again fueled by the often invisible traces of the Nazi ideological agenda in the images: in spite of what the television documentaries would have us believe, there are at times no privileged German perspectives, no depictions of Hitler or other Nazi dignitaries, no atrocities, no visible interpolations of Nazi Party beliefs. Indeed, unless the images are viewed in the archive, it can be difficult to identify them as having been produced by someone looking through a German, let alone a Nazi, viewfinder. That said, on another level the film fragments are subtly identifiable as having been filmed within the structures of Nazi ideology as it pervaded everyday life in late 1930s and early 1940s Europe. In some cases, the double meaning and context are identifiable only because no one but a German would have had access to the scenes being filmed. In other cases, however, on examination the images reveal the enthusiasm and fascination, even the national allegiance, of a German image maker. Thus, typical of amateur images, these color film fragments can be seen from a variety of perspectives, for the multiple ways they make meaning and, as always, the inconsistencies between these interpretations is the source of their power and agency.

Images of Modernity

Color

With the introduction of Agfa's three-way chemically developed color film in 1936 it became possible to use color reversal with all film cameras, and by the beginning of the war, color was as available to amateurs as black-and-white film. Although there were something like forty different qualities of black-and-white film, color film came in only six variations. Thus, although the price of moving color film, including processing, was comparable to that of black and white, amateurs often chose not to film in color because of the greater sensitivities to gradations in tone of the

black-and-white process.[4] And, like color photographic film, color motion picture film had an instability that made the end result unpredictable. Therefore, although I choose to focus on the color amateur film from the period primarily because of what it brought to the development of the medium, for its emotional resonance, and for its uniqueness within our memories of World War II, amateur and home movie makers of the time often chose to shoot with black-and-white stock.[5] In addition, the examples I discuss were usually taken between 1940 and 1943. After 1942, film became increasingly difficult to come by as the war progressed, and thus it was rare to find color film after 1943.

Although technical innovations in Agfacolor had begun prior to World War I, as we know from chapter 3, it was in the mid- to late 1930s that the process was stabilized, and the product was finally introduced onto the market in May 1937 in 16-millimeter format. Thus color reversal film was made available five years prior to the official appearance of photographic color negative film and paper.[6] Conveniently, these developments coincided with the outbreak of war, and the first Ufa advertising film in Agfacolor was exhibited in German cinemas in December 1939. Unsurprisingly, then, the first feature film shot in Agfacolor was made in June 1939 under the auspices of the Ministry of Propaganda and was a costume drama: *Frauen sind doch bessere Diplomaten*. As the Agfa technology improved across the 1940s, the Ministry of Propaganda spent increasing amounts of money on its now well-known color fiction films, such as *Der Goldene Stadt* (1942), *Münchhausen* (1943), and Harlan's *Opfergang* (1943–44). Thus, in its official propagandistic role, color film was exploited for its ability to heighten the illusory quality of the film medium. This tendency was in keeping with early uses of color, particularly Technicolor, at the same historical moment in Hollywood studios.[7]

Although amateur film and home moviemakers in late 1930s and early 1940s Germany used color in the pursuit of the emotional response promoted by the heightened illusionism, they also believed in color film's ability to reflect more accurately reality as it appears before the camera. Thus amateur film was concerned with exploring the tension between these two incompatible goals.[8] As Roepke points out, the goal of the amateur color filmmaker was both to capture reality and to focus on the

quality of the color in objects that were particularly present to the film camera: red flowers, red clothing, and, though she does not mention it, the swastika flag. As a result of this insistence on realism, the material produced in these circles always had the *potential* to depart from the National Socialist program.[9] Its primary purpose was not always to stir emotions in the viewer, and thus carry an ideological message, but to explore the potential of the medium to adhere as closely as possible to nature and replicate the real world. The unpredictability of reality always had the potential to be transferred to film images. Conversely, the focus on the representational qualities of color often emphasized the illusion of the film medium and inadvertently solicited charged emotional responses. In this sense, color film often reinforced the ideological program. Accordingly, my understanding of the bifurcated goal of the amateur color film places it in an ambivalent relationship to the Nazi dictates regarding filmic representation. In addition, the tension between the film image as a representation of reality and the film image as an illusory construction, a tension identified in the amateur color films, places them in an interesting relationship to developments taking place in film technology and technique in Europe more generally.

Despite the exploitation of Agfacolor for the narrative spectacles made in the studios of the Ministry of Propaganda, Agfa stock was internationally considered more suitable for use outdoors. As mentioned, it was said to produce more natural colors due to its heightened sensitivity. Contrarily, Technicolor was considered ideal for studio use because it needed more intense light and it rendered objects in color more clearly defined and more separate.[10] Thus, even though Technicolor was not available in Germany during the war years, in retrospect, we are able to see how the amateur filmmakers were more faithful to the integrity of Agfacolor than were their official counterparts. Again, although not necessarily intentional, the amateur filmmakers' respect for the properties of Agfa means that their films offer insight into the developments of the film stock and processing techniques.

Also typical of Agfacolor motion film from this period but less so of static glass transparencies such as Genewein's, the archival color footage has faded and bled. This is particularly the case with the reds due to the

difficulty of fixing them on the cyan-based stock. In addition to the fact that this instability gives unique insight into the behavior of color film stock that cannot be found elsewhere, the warm tones and pastels have historical interest as evidence of Agfacolor in its earliest days. And, like Genewein's images, these moving images, no matter their state of deterioration, are historically fascinating.

Up until the past fifteen years—that is, until the television documentaries appeared and photographs such as Genewein's came to public attention— the memory of World War II, particularly in the Anglo-American context, has been shaped through black-and-white images.[11] The assumption that black-and-white images provide a more authentic representation of reality is perhaps best illustrated by Steven Spielberg's use of both color and black and white in *Schindler's List* (1994). To reinforce the authenticity of the Holocaust representation, Spielberg used black-and-white film stock, as he says, "to remain true to the spirit of documentaries and stills from the period."[12] He and others, including his cinematographer for this film, Janusz Kaminski, believe that black and white "stands for reality." It apparently mimics genuine documentary footage from the time. Film critics fully aware of the degree of invention, contrivance, and reenactment at play may want to object to Spielberg's truth claims. However, we can never ignore that for many viewers *Schindler's List* "proved" that the Holocaust took place. For those who identified as "Schindlerjuden" (Schindler's Jews), the film finally "told their story."[13] For all of the intricate staging of a documentary aesthetic through black-and-white images—particularly as it was used in Nazi propaganda from the period—black and white was and continues to be associated in the mind of the American viewer with this historical truth of World War II and the Holocaust. And yet we could argue that the color amateur images come closer to the truth than does any of the black-and-white footage from the period.

We also recall Spielberg's insertion of the hand-painted red coat of a little girl as she runs through the Krakow Ghetto as it is being liquidated, then later to mark her corpse on a moving cart. The red punctuates the black-and-white narrative both as a strategy to provoke our emotional compassion for the girl and also to signal Oskar Schindler's transformation from wartime profiteer to benevolent sympathizer with the Jews. It

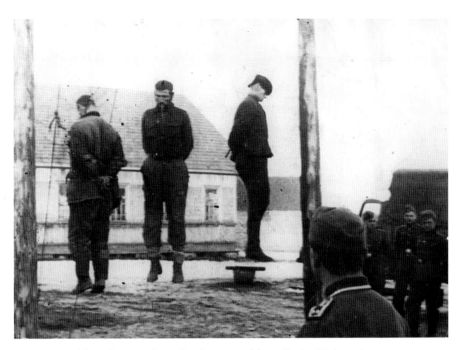

PLATE 1. *Three Russians hung by German soldiers, Soviet Union, circa 1941–44. The photograph, found on the corpse of a fallen German soldier, demonstrates how the German fascists hung the Soviets and how pleased the hangmen were with their work. Bundesarchiv Bild 183-R96547; photographer unknown.*

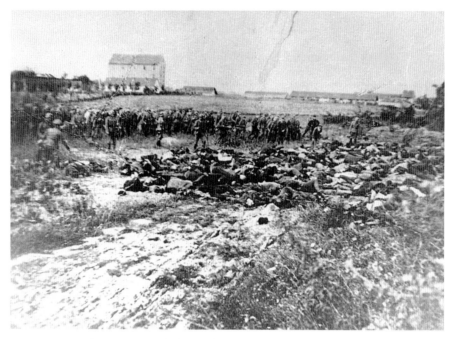

PLATE 2. *Bodies merged with the landscape. Unknown photographer and location. Courtesy of U.S. Holocaust Memorial Museum, image 78434.*

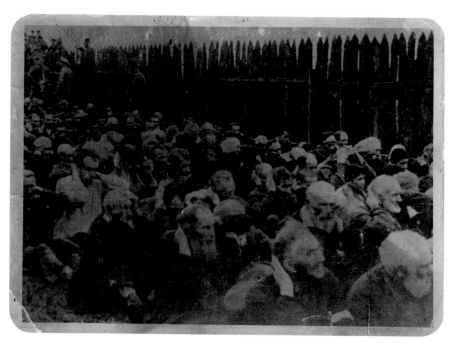

PLATE 3. *A large group of men is seated on the ground with their hands on their heads while being forced to watch the execution of Moshe Kagan and Wolf Kieper, two Jewish judges, in Zhitomir, northwestern Ukraine, 1943. Courtesy of U.S. Holocaust Memorial Museum, image 3339.*

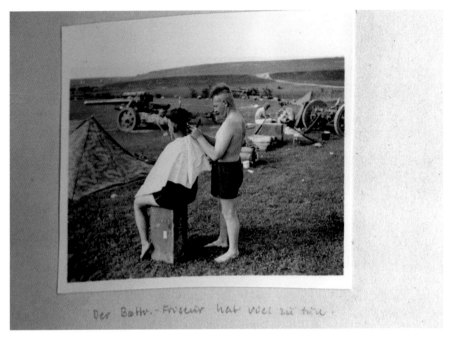

Der Battr.-Friseur hat viel zu tun.

PLATE 4. *The battalion barber had a busy job. This photograph, taken in Minsk, shows soldiers relaxing surrounded by cannons and other machinery of war. The presence of artillery in Wöbbeking's photographs is common, as he was an artilleryman in the army. Wöbbeking, Box 4, T 29. Courtesy of Hamburg Institute for Social Research.*

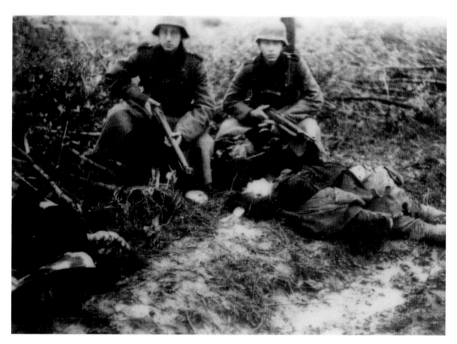

PLATE 5. *German soldiers pose with the corpses of recently executed men in an unspecified location in Russia on June 1, 1941 or 1943. It is not clear if the bodies are those of victims of these soldiers' rifles, but the photograph shows the pride of soldiers in the dead as trophies. Courtesy of U.S. Holocaust Memorial Museum, image 34224.*

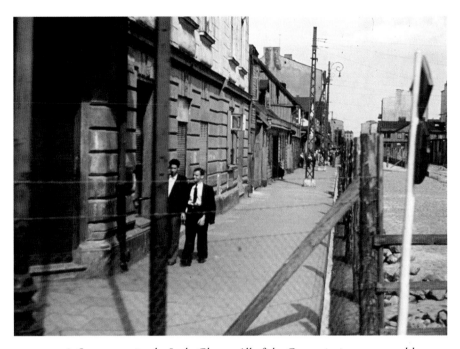

PLATE 6. *Street scene in the Lodz Ghetto. All of the Genewein images owned by the Jewish Museum Frankfurt have gone through color digital manipulations. Jüdisches Museum der Stadt Frankfurt. Courtesy of U.S. Holocaust Memorial Museum, image 95053.*

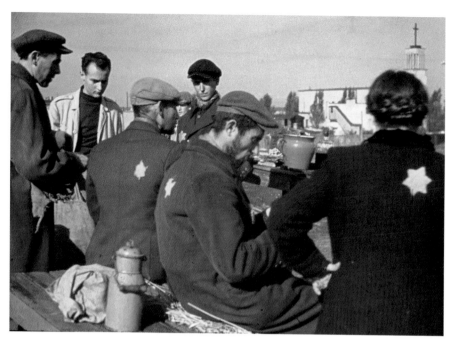

PLATE 7. *Lodz Ghetto inhabitants in the marketplace, circa 1940–44. People sold personal items at the ghetto market stalls. As of February 1942, this same square where the market was held was used for public executions. Jüdisches Museum der Stadt Frankfurt. Courtesy of U.S. Holocaust Memorial Museum, image 95162.*

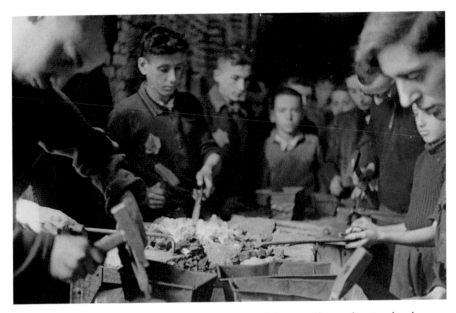

PLATE 8. *Teenage boys in the Lodz Ghetto metal factory. The workers in the ghetto workshops endured long hours to the point of exhaustion. Genewein's images were primarily intended to document activities, but they also betray many signs of the working conditions. Original German caption: "Litzmannstadt-Getto, Metallwerkstaette" (Litzmannstadt Ghetto metalwork place), #16. Courtesy of U.S. Holocaust Memorial Museum, image 95200A.*

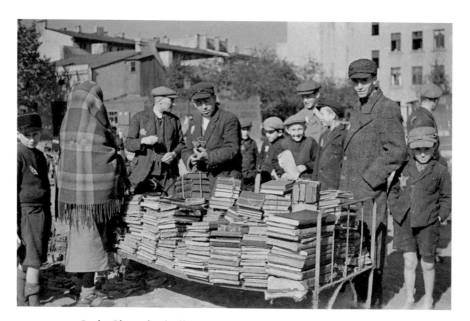

PLATE 9. *Lodz Ghetto booksellers, circa 1940–44. The smiling children would strongly suggest that this photograph was taken early in the ghetto's history. Original German caption: "Getto Buchhandlung" (Ghetto bookshop), #185. Courtesy of U.S. Holocaust Memorial Museum; image 74521A.*

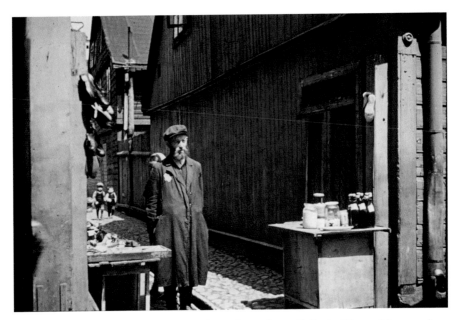

PLATE 10. *A bearded religious Jewish vendor at his stall, Lodz Ghetto. Many such images of bearded religious Jewish men were labeled by Genewein "Judentypen" (Jewish type). Jüdisches Museum der Stadt Frankfurt. Courtesy of U.S. Holocaust Memorial Museum, image 95141.*

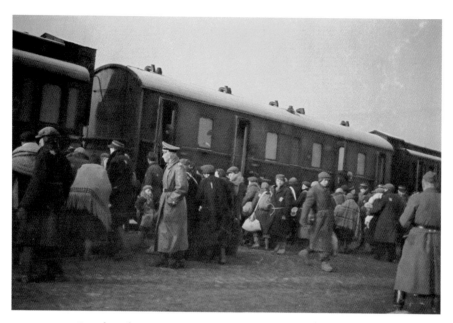

PLATE II. *Jews board a passenger train at Radegast train station in the Lodz Ghetto, 1942. Original German caption: "Judenaussiedlung" (Jewish resettlement), #153. The routes taken by displaced Jews into and out of the ghetto were identical: they arrived and departed by train at the same station and proceeded on foot in columns to (or from) the ghetto. Many Jews being resettled into the ghetto carried small bundles and satchels similar to those of Jews being deported. Courtesy of U.S. Holocaust Memorial Museum, image no. 65711.*

PLATE 12. *Lodz Ghetto fire truck, 1940–44. Original German caption: "Judenfeuerwehr" (Jewish fire engine), #121. Fire workers performed rescue operations and answered alarms for local fires, and references suggest that they performed their duties with devotion and enthusiasm. Courtesy of U.S. Holocaust Memorial Museum, image 95109A.*

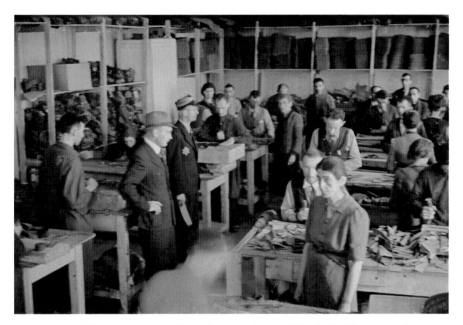

PLATE 13. *Workers in the saddle-making workshop of the Lodz Ghetto stand next to their work at an inspection. The downward glances and physical comportment of the workers are in striking contrast to those of the German official, probably Hans Biebow. Original German caption: "Litzmannstadt-Get, Sattlerei" (Litzmannstadt Ghetto saddlery). U.S. Holocaust Memorial Museum, image 65818. Courtesy of Robert Abrams.*

PLATE 14. *A Jewish man in a workshop in the Lodz Ghetto, circa 1940–44. The image, which shows signs of discoloration and deterioration, evinces the challenge of photographing close-up, indoors, and in color. U.S. Holocaust Memorial Museum, image 65724. Courtesy of Robert Abrams.*

PLATE 15. *German administrators at a party in the Lodz Ghetto, circa 1940–44. The lighting in this photograph stands out for its stark illumination of this celebratory scene. U.S. Holocaust Memorial Museum, image 65741. Courtesy of Robert Abrams.*

PLATE 16. *Family photograph, 1941. Eva Braun's brother Hans (left) and father, Fritz, stand in back. In the front are (left to right) an unidentified German official; an unidentified woman; Braun's mother, Fransizka; Eva Braun; and Gretl Braun. The album page is titled "Ausflug nach Beilngries" (Trip to Beilngries). Beilngries is a Bavarian town on the Rhein–Main–Danube Canal. Courtesy of National Archives, photo 242-EB-9-38 B.*

is not simply that we are fascinated by the technological sophistication of color film footage from this period; color footage has, again and again, as *Schindler's List* demonstrates, been associated with the arousal of an emotional response in the viewer. In turn, this emotional response associated with the drama connected to color supposedly leads us away from the truth of what took place. The amateur films I discuss here demonstrate that this is not always the case. The use of color actually creates more ambivalence and unpredictability than these assumptions would allow for. The films continually oscillate between documentary realism and a reveling in the excesses of Nazi ideology. And again, this oscillation and unpredictability are the basis of their creation of a space for appropriation in present-day narratives of memory.

In German amateur film journals from the period there was constant reiteration of the imperative to integrate the different effects of color into forceful dramatic narratives.[14] Similarly, there was little emphasis on the importance of the expressive, emotional, spectacular, or compositional qualities of color. However, the existing amateur films shot in wartime Germany digress from this imperative. In keeping with their amateur status, they bear more resemblance to early actualities than to searches for a narrative use of the new technology. Filmmakers often focused on the display of the new technology, the spectacle and appearance of color as it was presented through frame composition, and simultaneously created visual documents of everyday life. There are numerous examples in which color appears to interrupt the narrative or flow of images when the camera stops to watch a scene or an object in color. Similarly, the color footage has the tendency to abstract the image and remove it from the narrative flow as the camera goes in search of or stumbles upon material that will appeal to its capabilities, not only in an attempt to document what it sees or to construct a story. Thus, with color film in the camera, the goal appears to have been twofold: to document the reality as it unfolded before the camera and to isolate the striking colors in the profilmic world.

Certain images and certain scenes held a particular fascination for amateur cameramen shooting in color. Presumably due to the brilliance of the colors, again and again we find images of blazing fires—cities destroyed in the aftermath of bombing raids.[15] In one particular fragment depicting

the aftermath of a bombing raid on Hamburg, the camera pans from left to right, stopping now and again to ponder the fires. As we watch these images, like the camera, we are captivated by the brilliant oranges and reds of the raging fires. The patterns and shapes are mesmerizing. And though the fires are out of control, they are framed first by the charred windows and doorways through which they are seen and then by the parameters of the filmed image. This simultaneous ineffability and control of the fires renders the images painterly: the flames are like passionate brushstrokes animating a clearly contained canvas. The film's audience is invited to contemplate the fires' splendor as we would an abstract painting. The billowing smoke in black, white, and every shade of grey is mesmerizing as it swells into the sky. After a while, the camera moves on from these static shots that observe the fires. It pans, tracks, and wanders around the devastated landscape, tracing the motion of the uncontrollable yet slowly receding fires. Again, we admire the abstract compositions within the frame. Thick billows of jet-black smoke weave around structural remnants, the sky is indistinguishable from the white smoke of more recently ignited buildings, and every now and then flickers of orange punctuate the dark "smokescape."

In footage of a house on fire in Saaralben, a town on what is now the German–Austrian border, the camera stops its wanderings for what feels like an eternity at two openings that were once windows. It is fascinated by the blazing orange and red of the fire.[16] The camera moves to close-up so that we see only the frame within the frame of the black window and, through the window, the uncontrollable and yet, for the camera, beautiful and fascinating fire. The camera pans very slowly to the right and finds another window with an equally stunning image through its panes. Fire pours through these openings in the walls of the house. The frame is abstracted as we see only the walls of the house, the windows, the fire, and the smoke pouring out of the windows as though suspended in midair. There is never a shot of the ground or the roof, just the openings of the windows and doors. These images remind me of Expressionist paintings by Robert Delaunay, Ludwig Meidner, and Franz Marc.[17] They are like them in their appearance as a series of geometrical structures (the remains of buildings) woven into an abstract field of color.

Steve Neale explains how the painterliness of the early color film image was received with contradictory enthusiasm, as an impossible combination of realism and illusion:

> Colour is valued both because it is a "natural ingredient of visual reality *and* because it lends itself to artistic effects. Thus alongside a discourse in which Technicolor can advertise itself with the slogan "Technicolor *is* natural color" or in which a Kinemacolor programme can describe the Kinemacolor process as "The GREATEST INVENTION of the CENTURY Reflecting Nature in her ACTUAL COLORS," there is a discourse which constantly invokes artifice, art and, especially the paintings of the "Old Masters."[18]

This same undoing of realism through the introduction of color to create spectacle is seen in amateur films such as this one taken in Saaralben. In the closing stages of the film taken in Hamburg, the camera finds its way through the smoldering ruins of cathedrals, and the images echo haunting Romantic paintings such as Schinkel's Gothic cathedrals—great hulks of ruin against the penetrating light of the sky at daybreak.[19] Similarly, as the images shift from the resplendent red and orange of the fires to the cold blues and greens of the day after, they showcase the range of colors available to the Agfa film stock in use at the time. The devastation shown in the wreckage is made chilling by the intense blues and greens that result from the properties of the film material. As the firemen continue to extinguish the fires, they are dwarfed by the enormity of their task and the patterns made by the high-pressure water hoses. In these sequences, the vertical trajectories of water, not the firemen, consume the mise-en-scène. Here the film image is shown as a canvas onto which the early amateur color filmmaker painted his abstract visions. And yet the film is simultaneously a document of the extinguishing of fires in Hamburg. It is, at one and the same time, a document of reality and a construction of abstract visions, at once a factual account of the events and a celebration of the destruction seen through the viewfinder.

Although it is impossible to determine the provenance of the footage from the images themselves, they are labeled in the archive: "Firestorm

in Hamburg following English Airraid." The footage was thus shot in the summer of 1943.[20] Research done at the Bundesarchiv indicates that the cameraman was a member of the Hamburg Fire Brigade; however, visions of fires and the smoldering ashes of the day after are common to many amateur films of the period. The war provided plenty of opportunities to film raging fires all over Europe, fires set by Germans and Allies alike. The images of Hamburg on fire, like others such as the example from Saaralben, might have been taken in Germany or other countries. Although Hamburg on fire provided an opportunity to create these abstract images, the images are not about the city itself. The buildings could be in Russia, Poland, or Germany, in wartime or at peace. Nothing in the images ties them to Hamburg in 1943. Of course, in retrospect the charred shells of churches found among the ruins can be understood as those of Hamburg's great cathedrals. However, they are not instantly identifiable as such. For the cameraman was more interested in the display of color and light, the magnitude of the fires and destruction, than in taking us on a tourist's journey through Hamburg's famous sites. Indeed, without the labeling given this footage in the archive, there is little that identifies it as having been shot by a German, even in Germany.

Given the obscurity that derives from the Hamburg film's abstraction, there are a number of narratives that can be seen as woven into the film as a canvas for rich colors. For example, interpretation could focus on an exploration of material that is familiar for amateur color filmmaking in 1940s Germany: phenomena such as fires, water, smoke, and ruined landscapes were often filmed for their compositional potential, their abstract, colored beauty. The footage also reveals a number of aesthetic questions that have their roots in German art, in particular painting of the prewar period, questions that persisted into the late twentieth century among German and other European avant-gardes. This does not make the films artistic, but it does trace the possible connections among the more distant works of German Romantic painters, the Expressionists of the 1910s, and the amateur filmmakers' use of color and light. Here, then, we have concrete examples of the films as "paintings in colored light projected on a white screen," a development of works in oil, watercolor, or pencil on canvas.[21] In addition, the shots of the fires in their various stages of

destruction connect the amateur footage to the abundance of images that reveal the sublime power of war-torn or devastated landscapes in the Romantic tradition. Even though both sets of images explore these qualities in different media and for different purposes, with clearly very different results, the resonances are potentially productive and revealing. Through such resonances, the amateur color films provide a link that sustains the continuity of these aesthetic questions across the wars while official art and culture of the same era were in pursuit of blatant ideological propaganda.

The absence of information about the films pushes us to study the images themselves for interpretive meaning. In turn, this muteness of the films—both in the literal sense of an absent sound track and in the metaphorical sense of unknown provenance—underlines the speculative nature of my interpretations. Indeed, their muteness opens up the space for the historically distant viewer to see them as abstract images painted in light. A German viewer contemporaneous with the footage might have recognized people or events in the images from their experiences. Alternatively, the film might have been recognized as a document of the quality of fire and smoke and the possible ways of extinguishing them. The footage might in turn, then, have been used for educational or training purposes when shown to other firemen, in which case the attention to the fire's color, the shape of the smoke, and so on can be seen as reflecting not an abstract fascination (even if subconscious) but a need to document how fire functions in these specific types of bombings so as to learn how best to control it.[22] This mutability of meaning across time is typical of amateur and private footage that has come down to us without further information. And to reiterate, the mutability begins with the focus on color, a focus that leads us to recognize the oscillation between a use of amateur film as documentary realism and more aesthetically oriented representation. And the multiplicity of potential interpretations comes from the distance of seventy years between today's viewer and the silent color film.

In another interpretation, these images can be seen to reflect the destruction of Hamburg from a very particular perspective, a perspective we have not seen elsewhere. It is the perspective of someone watching the activities of the Hamburg fireman and the menace they combat, which

could, in turn, be divorced from the concerns of war. Alternatively, historical interpretation can understand the burning and smoldering fires as evidence of Hamburg's destruction by the Allies. The images of bombs dropping against the night sky of Dresden or the devastated ruins of the German capital, Berlin, are familiar visions, whereas the destruction of Hamburg is a rarer sight. Thus, in addition to exploring the visual elements seen in the fragments, the amateur camera went where official cameras did not and would not go. It represented a history that, in this case, is not so familiar. However we interpret the footage, it is imperative to remember that it is always caught between the drama inherent in the display of color, motion, and composition of the image and a realism which reveals the ruins and destruction of war. The interpretations are built on compositional and other visual foundations, the visible explorations of the medium and its technological advances, rather than on the invisible ideological determination of the images.

This said, however, all interpretation of the images must leave a space for the various possible motivations for filming them, that is, for accommodation of what we do not know about their provenance and use. Because, even though there is so much unknown about these images, the reasons for filming Hamburg on fire are critical to their ethical dimension. A fascination with the abstraction of fire that embraces distance for pictorial reasons is far more troubling than would be a distance from the events assumed for technical or professional reasons. Although we cannot judge the film because of the paucity of information, rather than assuming the ethical value, and ultimately the ideological significance, of the footage of Hamburg on fire, we have a responsibility to keep the multiple possible interpretations in mind. We have a responsibility to embrace the uncertainty of any one interpretation. This ambiguity, as a dynamic of marginalization typical to the amateur film, does not have to be a limitation. Instead it can provide the opportunity for inconclusive readings. In turn, inconclusiveness is another distancing device that creates an opportunity for the ethical reuse of the images in contemporary memory discourses.

Despite the ambiguous significance of, for example, images of the fires in Hamburg, when looking at other fragments we can justifiably turn

outside of the photographs for information that assists us to interpret the way the footage is steeped in the ideology of everyday life under Nazism. A striking example of this is found in the constantly repeated images of the Nazi flag, an image that can never be neutral. Due to the character of Agfacolor three-color negative film, magenta or red, yellow, and cyan or blue objects are always going to stand in relief from the browns and other earth tones of the battlefield. It is only when the material fades and bleeds that brown comes to dominate the mise-en-scène. And of course the most striking red object in the German war effort was the background for the swastika on the official flag of the Nazi Party. Time and again, we see the German camera pan across an otherwise insignificant field, a strip of sky, the line of an unremarkable vertical building, activities on a street, or a flagpole only to find the Nazi flag waving in the wind in all its glory. The camera rarely moves past the flag without pausing to marvel at it. It can be assumed that the camera stops on the flag because it symbolizes the pride of the cameraman in his country and the regime that leads it. Because the focus on the Nazi flag cannot be separated from the fascination with the red of its background, such focus is, I argue, rarely a neutral, artistic pondering of the icon of power. It is true that in these sequences, as in those in which the camera is fascinated with the blood of patients in a field hospital[23] or the brilliant red of the Red Cross station's flag, there is a celebration of the qualities of the film negative, its ability to capture the boldness of these symbols and to create striking compositions out of the material of the battlefield. However, these sequences are more than simply visually significant. In them we see the technology of color film being exploited to annex the most important Nazi symbol and, we could argue, the very fabric of Agfacolor developed in the interests of Nazi ideology.

As noted in chapter 3, the development of both still and moving-color transparency film at Agfa went hand in hand with the rise of the Nazi Party, and the first color image proudly displayed a swastika flag in the background. The propagandists of the Third Reich, most importantly Hitler, understood the visual pleasure delivered by the flag and its color. Hitler was personally responsible for the colors and design of the swastika flag and its red background. At least this was his claim in *Mein Kampf*.

Having rejected the use of various other color combinations, he decided that the black insignia against a white disk on a red flag was "superior," "harmonious," and "striking."[24] Throughout the term of the Third Reich, the Nazis' insignias were key to their successful overwhelm of everyday life with their propaganda offensive. Although there will always be discussion over how such propaganda strategies were received, the constant return to images of Nazi icons strongly suggests their infiltration into everyday experience and popular consciousness. Thus, when a camera dwells on the Nazi swastika flag as it repeatedly does, the resulting film image has to be ideologically saturated. It is never simply representative of a fascination with the bold red background.

In the same way, again and again the color blue captivates the amateur camera. A commonly repeated image found in the archives sees a film camera gliding through brilliant blue skies as it follows the displays of aerial prowess from the cockpit of an Allied or Nazi fighter plane.[25] Three, four, five, sometimes six planes soar in formation through a blue sky, and the horizon constantly shifts with the movement of the plane from which the footage is shot. The planes are in distant long shot, synchronized black shapes against the radiant sky. At times they leave blasts of white smoke in their wake, carving their way across the sky. The camera follows these shapes in motion and, as it does so, shakily shifts its perspective from the side to the front window of the plane from which it is shot. Like many hastily shot, sometimes awkward, images common to amateur film, these images include many mistakes and miscalculations. For example, as the hand-held camera follows the movement of other planes in formation, the image becomes obscured by the control panel, the roof, or the wing of the plane from which it looks. In time, however, the camera reestablishes its focus. On one occasion, when, after one of these momentary glitches, objects reappear in the frame, we are treated to an aerial view of a city below.[26] Then the camera finds the soaring fighter planes on the distant horizon once again. There are many moments in this footage when we are left with no more than the blue sky, as though it has become the protagonist of the film.

In this and other footage of similar length, we see the color and motion of cinematography on display. That these celebrations of the medium

are shot from the cockpit of a fighter plane appears to be more significant than the fact that it is or is not a Nazi plane. Indeed, we cannot always be sure of the political and national allegiance of the cameraman because so much of this footage shot from the cockpits of planes flying in formation appears in both German and Allied footage. Thus, rather than focusing specifically on the excitement and pride of German planes on the attack, in those instances, when the focus is on blue, it seems appropriate to view this footage for the way that it capitalizes on the opportunities of war in order to explore the medium of film. Similarly, we can appreciate the footage for the insight it offers into the early development of a color film aesthetic, the challenges faced by early amateur users of camera equipment, and the difficulties of both in-camera and postproduction editing. We can look at it and learn from the focus on certain colors, the use of color for compositional purposes, the mistakes that were common to the amateur film. In addition, we can appreciate that these insights were made possible by the advent of war in general as opposed to a German war in particular.[27]

The Relationship to Early Cinema

Schneider and other scholars have noticed the striking similarity between amateur films and the actualities and trick films of early cinema. In particular, they have stressed the tendency of amateur footage to mimic the character performance of Hollywood and early film.[28] Even when these films were not put into cause-and-effect narratives—for example, as in the home movies of the Swiss expatriates discussed by Schneider—the tendency of the amateur performer was to mimic the figures that had been glorified and whom he or she aspired to emulate. Although the films shot in Nazi Germany do not often include this specific quality of performance, they do reflect the concerns of the developments of their medium, in this case that of the early and silent film industry. Thus we see, for example, an intent focus on movement, both of the camera itself and the events that took place before it. It is also common to find the use of intertitles and, on occasion, voice-over in the archival films from World War II Germany. Textual explanation and clarification of the frame were

features of early film, and indeed there were many experiments with intertitles especially up until the narrative period, that is, before text was integrated into cause-and-effect stories. And the need for intertitles and textual explanation arose in amateur films because, as in the early cinema, these images are mute.

In addition, the amateur films of the Nazi period connect to the burgeoning industries of modernity through their striking similarity to early travelogues. As I touched on in chapter 2, travel film and photography began to thrive at this time, concomitant with a developing travel and tourist industry. As Alison Griffiths argues in her research on early ethnographic film, the cinema and the anthropological study of ethnic cultures grew hand in hand in the late nineteenth century.[29] We see this marriage between the scientific investigation of other cultures and filmic representation everywhere present in the films shot by soldiers and other active service members during World War II. However, the uses to which these same strategies are put, the consequences of the analogy to early cinema, are often radically different from those of their earlier counterparts.

The fact that amateur film of the 1930s and 1940s characteristically continued to explore the technological capacities of the medium as it had at the turn of the century strongly indicates that there was still more to discover, more developments to be made. Indeed, it was characteristic of amateur film in general at this time in Europe: the arena of the amateur was one in which experimentation was possible because there was always room for failure and the opportunity to try again. This was especially the case with color film. More important, however, yet again, through the references to the concerns of modernity and especially its representation in and through the cinema, these films indicate their participation in the proliferation of contemporaneous discourses. The amateur films make sense within the context supplied by the Nazis' use of technologically modern visual culture—contributing explorations in cinematic techniques and forms—as well as that of amateur filmmaking practices in Germany and Europe at the time. Yet again we see that the heterogeneity of the color moving images creates tensions and contradictions that are crucial to the opening of spaces for viewers' appropriation of these images when continuing to remember World War II and the Holocaust.

The Cinematic Apparatus

The fascination with the cinematic apparatus and the audience's thrill at displays of this technology are often cited as defining characteristics of early cinema. Tom Gunning's notion of the cinema of attractions has become synonymous with the uniqueness and appeal of early film as a series of visual spectacles in which cause-and-effect narrative development was secondary to the display of technological wizardry.[30] As Gunning and many after him have argued, motion, color, light, and "magical" effects are the sine qua non of cinema.[31] The performance of cinema technology in the film experience at the turn of the twentieth century is said to reflect the eruptive experience of modern life. Although there is a clear difference between the abrasive expressions of social modernity in early cinema and the foregrounding of technology in the amateur films of the Nazi period, this privileging of the means over the content offers an optic through which to approach the sensuous qualities of these archival images. In turn, this focus enables us to see them as belonging to larger developments and movements that were taking place within modernity. Thus, this context of modernity is the first within which the films can be seen for their contribution to broader histories beyond that of ideological inflections of everyday life in Nazi Germany.

Like some of the early films of Oskar Messter and Max Gliewe,[32] footage labeled "German Occupation of Kharkov" held in the United States Holocaust Memorial Museum reveals a camera captivated by the passing of daily life.[33] Some of these richly textured images, textured by their clumsy in-camera editing, the jerky hand-held camera, and the aging of the color film stock, were shot on a busy street corner in the eastern city of Krakow. As its title suggests, the blue-tinted film scrutinizes the presence of the German Army in the city: soldiers walking down the street, tanks moving through the city, and medical workers going about their daily business. Not only do the doctors, nurses, and other medical people disappear momentarily as they cross from the left to right side of the screen—presumably as they walk behind a pole that blocks our view of them—but without warning the image shifts to the scene at an open-air market across an awkward edit. At the market, the camera

curiously wanders along the stalls in a tracking movement, stopping occasionally to take a closer look at the goods and wares on sale. The color of the scenes at the market is radiant and, unlike that of the footage taken on the street corner, the dye has not bled across the surface of the frame. The poverty of those who man the stalls is striking: they are lethargic, display obvious exhaustion, and are visibly oppressed by the well-dressed, energetic soldiers who appear to stand over them in the most threatening of manners. Abruptly, the footage then cuts to the main square of Krakow and observes in long shot the dilapidated houses and the bullet- and shrapnel-marked walls before cutting to a soldier talking with a man on the street. Throughout this short example, every two or three minutes the image freeze frames as though the film was momentarily stuck in the camera. In fact, it was at the end of the reel; the cameraman had simply kept filming until the magazine was finished, then turned the camera off and replaced the magazine, ready to film the next scene. And in the jump cuts, the freeze frames, the scratches on the surface of the film, we witness the very process of filmmaking as it takes place before our eyes.

Perhaps the initial response to the footage is a sense of awe at the brilliance of the deep, fully saturated magenta, cyan, and yellow images. There is an intrigue with and a fascination for the awkward handling of the materials: the repetitions, uneven camera work, clumsy framing, and random editing prompt us to ask, Who made this film? What was the intention behind its production? And the so-called flaws of the material put a human touch on the otherwise distant and anonymous long shots and randomly determined beginnings and endings of film fragments. In addition, these interruptions, which are familiar to anyone who has viewed amateur film, can be understood as unique insights into the functioning of the film stock and the camera and into the cameraman's relationship to both. In and through them we see the importance of the camera's marveling at what its lens saw, what it was able to record. Given the unevenness of the camera movements, together with the awkward editing, we can assume that the cameraman who shot the footage at Krakow was still learning his hobby.

Although there is no identification of the cameraman within the image, on the can or the leaders, or in the accompanying documentation, the fact that he had a camera and had access to color footage indicates

that it is unlikely that he was Polish but that he was probably of a privileged social class. He was probably a German soldier, most likely an officer. And given the relative roughness of the images, we can assume that the film was not intended for propaganda or any other official purpose.[34] What we can be certain of is that the cameraman was as interested in the ability of his camera to see life passing by as he was in the life itself. The turning on and off of the camera, the noncausal logic of the fragments, the experimentation with filters and framing suggest a fascination with the medium in use.

As I described earlier, among the shaky images of urban life taken with a handheld camera the film displays a number of instances of the smooth movement of the camera as it tracks across the market stalls and again when it pans around the damaged walls that line the town's central square. It is true that such movements are used for very practical purposes: to survey the world that surrounds the camera in the most economical way. However, again and again, the reproduction of movement was the preoccupation of amateur film from this period. In her examination of Swiss home movies, Schneider also remarks on the tendency of the amateur to film "stationary subjects with a moving camera and moving objects with a stationary camera."[35] Certainly the war and the mobility of soldiers throughout Germany and foreign lands posed multiple opportunities for surveying landscapes—of both an urban and a natural variety—and watching vehicles go by. Added to Schneider's categories of movement in amateur films are the immensely popular moving landscape and cityscape views filmed from moving trains and airplane cockpits and the views seen through the small windows of army tanks. All of these forms of motion were at the heart of the modernity in full swing in the late 1930s and early 1940s. And all of them are found in the films taken during wartime by German cameramen. Schneider goes on to argue that in the home movies she analyzes,

> the panning shot imitates the act of seeing: you let your eyes wander. On the other hand, the panning movement charges the landscape with tension and thus invests it with "significance." . . . A set of views become "worth seeing," become tourist images.

But usually the panning shot remains locked in delight, offering the audience an invitation to enjoy the view as much as the person making the film. . . . These home movie "view" shots are as much about the filmmaker's experience as they are what is seen. It is not the attraction itself that counts in these films, but the filmmaker's personal reaction to it, of which the film is supposed to be a truthful record.[36]

The exact same claim can be made about the color footage taken on the Eastern Front by German soldiers and officers in their documentation of what they encountered. In addition to the technical explorations outlined by Schneider, these short fragments engage in an exploration of the parameters of film motion. As well as reveling in the movement of what lies before the camera and the process of seeing the cameraman see, these films celebrate the capacity of their medium to create and reproduce motion through their technology.

The world at war provided a whole new set of possibilities for further explorations of the moving image. And here we find the first strain of the politics and ideology with which the films under discussion are imbued. Most notably, as is detailed later, the hand-held moving camera became the perfect accompaniment for the soldier as tourist and visitor to "foreign lands" such as Poland, the Sudetenland, and Belorussia. Although, as noted in chapter 2, Poland and other Eastern countries were considered not to be foreign lands but to belong to greater Germany. The imbrication of film camera, soldier, the opportunity for mobility expanded the already growing notion of the leisure industry and its contribution to definitions of modernity. Although I do not want to suggest that the soldier or officer as amateur filmmaker exploited the war for the development of his medium, it is clear that the dynamics and events of war, colonization, mobility, and persecution of the other influenced the realization of these images of daily life in Krakow.[37] Similarly, the images show that there was a coincidence between the expansion of Greater Germany across Eastern Europe's borders and the "expansion" of the individual soldier as a modern subject whose identity was formed by his physical mobility, the transgression of borders enabled by the camera, and all of

the agency of being a soldier. And so, as we consider these images, we see the notion of lebensraum[38] very carefully woven into the infrastructure and identity of a modern Germany and the soldier or officer as a modern German man during this period.

In another example—film taken of the golden and red rooftops of Krakow from Wawel Castle in a fragment taken by a soldier of the 257th Infantry Division, held in the Bundesarchiv, Berlin—the camera pans across the skyline of Poland's medieval capital.[39] Among the green of the copper domes and the ochre tiles of the old residential buildings, the visions of this legendary skyline are brought alive with three layers of discourse in what are otherwise deceptively simple pans—the invitation of the cameraman to see Krakow through the privileged eye of the "soldier-as-tourist," the cameraman marveling at the beauty of this medieval Galician city, and a performance of the camera's ability to move. Footage shot through the window of a train as it pulls into the station of pre-1941 Warsaw is equally complex and layered with meaning. First and foremost, the footage offers this sight of an old city that no longer exists. At this level, its documentation in color of a world that was soon to be destroyed, the film material is invaluable. Similarly, the camera was fixed in a moving vehicle, no doubt a train, which not only brings the vistas alive but offers a perspective that, prior to this moment, would never have been seen.[40] Indeed, the same must be said of the countless fragments shot looking through the cockpits of fighter planes during World War II, whether flying at leisure or on a mission. These visions of a brilliant blue sky scattered with clouds were as captivating to the camera in motion in the early 1940s as they are today because such abstractions of motion are no longer the preoccupation of film. All of this said, however, viewers at the time and since have not been as surprised by or attracted to these simple motions as they might have been at the turn of the century, as were those in Gunning's descriptions of the audience of the cinema of attractions. Rather, by the early 1940s it is more likely that viewers witnessed the display or articulation of the cameraman's fascination with the technology and its resultant aesthetic from a distance.

Odin discusses the attachment of the amateur cameraman to the apparatus and material of his pursuits. Unlike for the professional filmmaker,

who commonly works with hired equipment, for the amateur "the camera . . . is a precious object, an object of love."[41] In addition, film journals for amateurs tell of the amateur film clubs' emphasis on attending to the composition of an image, and the intricacies of composition were always centered on skillful exploitation of the technology at hand. There were many articles written by well-known film critics of the time that discussed the processes of learning to work with the variants of film. Waldemar Lydor, for example, discusses the importance of using contrasting colors, tones, lighting setups, and camera angles to bring out the drama of a landscape or to best represent the narrative of the human character in the frame.[42] Like these other technical explorations, movement must be understood and integrated into the successful film aesthetic. Paul W. John explains the centrality of movement to the amateur camera and its connections to modernity when he discusses the fine art of filming a waterfall.[43] Thus amateur filmmakers, such as the unknown cameraman of the footage in Krakow, assiduously explored the medium in which they worked by exploring the possibilities of film movement. And the filmmakers did this with the verve and commitment of those who wanted to improve in their pastime. In addition, there is a unique connection between the movement explored by these films and the dynamism and kineticism that are the sine qua non of technological modernity.[44]

As yet, I have said nothing of the ideology of occupation. Its shadow does not simply eclipse much of this footage; at times it infuses every frame. As I have said, in spite of the paucity of information about the footage, the longer we spend with it, the more obvious it becomes that it must have been a German behind the camera. It was a German who was using the realities of invasion and occupation to explore his medium. In another example, footage of the quiet observation of crowds, the slow exploration with a handheld camera of the ceiling of the Haus der Kunst in Munich, with its patterns formed by linked swastikas, reiterates the preoccupations of early cinema.[45] However, it was forty years after the beginning of cinema, and for this cinema the social and historical dimensions of what was seen must be given equal weight with the processes of seeing made transparent as they were through the use of the amateur

camera. And when the camera happened to see the design of one of the Nazis' architectural icons of power on the ceiling of the Haus der Kunst, it saw more than movement, color, crowds, and the art nouveau composition. Like all of the film fragments discussed earlier, these are woven together with, even enabled by, the presence of a discourse of Nazi ideology. Observations of Jewish people in a market or trains pulling into stations with soldiers in uniform somewhere in the frame are no more neutral than images of swastikas: they can never be simply about the exploration of the possibilities of the medium being used by the amateur cameraman. This is the case even if for no other reason than that it was their intention to document what lay before the camera: the success of Germany at war. All of these films add another component to the explorations of the silent and, later, the avant-garde cinema of the early twentieth century when they marry the discourse on spectacle and "attraction" with the thrill of a camera embroiled in the hype around Nazi domination.

We cannot assume that the amateur filmmakers took up these strategies with an intention of creating Nazi propaganda. Rather, the strategies make sense within a bifurcated contextual optic. This duel imbrication of technology and event in the interests of marrying realism and representational illusion on film is what makes these amateur films unique. Thus in them we see the convergence of war and cinema, the technological explorations of both, and the ideologically saturated visions of life in everyday Nazi Germany. Although the two are so closely intertwined, there is still a tension between the artistic and the ideological, a tension that forms the basis of their ambiguity as the source of their potential to be involved in processes of historical witnessing. Due to the discrepancies between various levels of meaning, discrepancies typical of early color film and of amateur film from the period, we are offered the privilege of discernment. The multiple ways that these images incorporate a distance—at the visual, historical, and conceptual levels—create the opportunity for multiple interpretations, thus multiple ways of seeing them in our efforts to remember the events they depict. Before elaborating on this, I turn to perhaps the most outstanding way that the films and fragments engage with the modernity in their midst: through their status as travelogues.

The Travelogue

In film 3847 at the Bundesarchiv we see footage shot by a soldier who took his camera to Paris. It was shot on December 1, 1940, and yet the images nowhere reveal that he was in Paris to see the invasion of France. The Arc de Triomphe is shot from an obscure angle, from behind a building, spied from around a corner, in the gap between walls, in a fragment of adventurous filmmaking. An overhead shot shows the perfectly orchestrated and ordered German troops marching in formation from the bottom right to the top left corner of the frame along the Champs-Élysées. And when the camera moves down to ground level, the soldiers continue to march in a diagonal, thus demonstrating the cameraman's keen attention to frame composition and continuity. The "action" then shifts to the Place de la Concorde, where the camera is fascinated by the Luxor Obelisk. As any tourist would be, the filmmaker was eager to shoot the historical site from different angles. Thus, as in the images of most of Paris's great monuments in this footage, we are treated to multiple shots of varying focal lengths, camera angles, and distances. The German troops then march across the screen, again on the diagonal as in previous shots, down Paris's historical axis to the Louvre before turning toward the Opéra and, via the Grands Boulevards, on to Sacré-Cœur. Paris's celebrated tourist sites became stops on the path of this German with a camera. And at each stop the troops penetrate the space of the cameraman and his private travelogue is interrupted by the war as the soldiers march before the camera.

We could easily mistake this footage as having been taken by a tourist who happened to stumble upon events of immense historical significance. Certainly it does not appear as though the cameraman's primary preoccupation was to document the December 1 parade of German power and might. On the contrary, the army's presence appears to have been coincidental to the pleasures of sightseeing. Having visited Paris's familiar tourist sites, the camera travels across a street and finds a *tabac*—another synecdoche of Parisian life—and pans up to find the Nazi flag, cuts back to the Opéra, and once again turns to the soldiers marching. Still in Paris, a man browses though items on display in a flea market, perhaps at the

famous Puces. Thus the cameraman spends an otherwise typical weekend afternoon in Paris.

However, when we look more closely, the image turns first curious, then sour. We see a Hanukkah menorah, and we recognize the goods on sale at the market as Jewish possessions that we immediately assume have either been confiscated by the Nazis or are being sold to make ends meet when there is no other possibility of earning an income.[46] A big man sits next to the table of Jewish objects, but it is unclear whether he is a Jew or a war profiteer. The jerky handheld camera goes traveling along a road where all the houses have been destroyed. Do these nondescript houses in nondescript streets indicate the camera has now left Paris? The location of the footage now seems irrelevant because we are preoccupied with the footage of Jewish goods on sale at the market. We are quickly reminded that the amateur footage only ever presents a single perspective and never the whole story of, in this case, the invasion of Paris and, even if not through direct representation, the exploitation and eventual destruction of Europe's Jews. In addition, the sudden change of mood that descends when the footage shifts from the sites of Paris to the market selling Jewish objects underlines the fragmentary and unpredictable nature of these films from the archive. Within seconds the "tourist" is transformed for us into an anthropologist and a German, and the camera becomes an agent of colonization, appropriation, and mastery. And then we immediately recognize that these people are not being observed as other to the cameraman but as potential targets for extermination. Thus the film takes on a dimension of foreboding that makes it frightening.

Even when the film footage continues its exploration of Paris we do not forget where the camera has been. When the camera comes across identifiably Jewish goods on sale, we immediately ascribe oppression and violence to the story told by the images because of what we now know of history. Subsequently, when it documents Nazi flags flying proudly in the wind and soldiers in formation, or even presents otherwise benign images of Paris's famous icons, we see these "tourist images" as supporting an ideological celebration of German occupation. We no longer see the German with a camera recording an accidental incursion into the mise-en-scène but rather creating highly organized frames through which

to see and understand his world. These images are very quickly placed within discourses of our witnessing the invasion, occupation, and domination of Paris. And very quickly we insert them into a narrative that witnesses the desire to slaughter. These are the multiple layers of now not-so-straightforward fragments.

Like the photographs discussed in chapter 2, many of the fragments of color film footage can be placed in discourses that evidence the use of new visual technologies to document travels in exotic but not-so-foreign lands. Although the production of these visual diaries was the luxury of the well-to-do in possession of cameras at the turn of the century, filming while traveling became a common occurrence among amateur and home movie makers by the 1940s.[47] But still, at that time travel was not a luxury available to all. As scholars of early travelogues agree, there was a coincidence of the amateur or home movie film and the travelogue in the early cinema, and in turn the intersection was intricately woven together with the forces and resultant conditions of modernization. What makes these films unique is a visible tension between discourses of modern life that can be found in other tourists' images and the discourses of German occupation that point up the specificity of the German national imaginary at the time. These two discourses are not automatically contradictory: it is well known that the Germans freely appropriated the discourses of modernity for the propagation of their ideology of hatred. However, seventy years on—that is, at a distance—we are able to perceive the two possible different meanings or interpretations as creating a tension in the images. Thus our remove in time and place enables us to investigate precisely how and where Nazi ideology infected these representations of the everyday.

In the images of Paris and similar fragments, we see that the German soldier-cum-amateur / home moviemaker contributed to the concretization of a new genre of filmmaking. Namely, his footage is among the first to depict the "tourist" experience through colored moving images. In the postwar period in particular, the amateur filmmaker was the product and perpetuator of the leisure industry when he took his family on vacation and, with the family, his camera to create memories of their trip.[48] In addition, as scholars have observed, the genre has as much to do with documentation of the self and the home as it does with the peoples and

cultures encountered on the road.[49] The home movie as travelogue is a form of moving postcard, particularly the "I was there" function already discussed in relation to photographs in chapter 2. As filmmaker Péter Forgács reflects, the home movie as a genre is "not unlike the letter and diary. . . . It is one of the most adequate means of remembrance. It is a meditation on 'who am I?' "[50] Schneider, following Hermann Bausinger, reinforces this notion: when the home movie travelogue documents the exoticism and difference of the encountered landscape and peoples, it is really a reflection on the home, on what it is like for the filmmaker when away from the routine, comfort, and familiarity of home.[51] According to this logic, when the soldier goes to Paris, he captures a world that is identifiable and familiar. He does not "discover" the Eiffel Tower or the Luxor Obelisk or the Opéra; rather, he underlines his identity by confirming that he has now been to Paris on his "travels."

However, the interweaving of personal images of Paris's famous sites together with the grand-scale public history of the marching soldiers and the presence of other signs of the Nazi occupation make these images different from those of just another wartime tourist. For the filmmaker's self-identity—the "I" of the camera—is simultaneously a public identity, an identity that has internalized Nazi pride and power over the occupied land and its peoples. This land and these visions are not those of a tourist marveling at a foreign land but of a soldier proudly documenting the newly acquired wonders of his own nation. Thus the ideology of the everyday is the ideology of reified politics. Even if the public dimension of the private identity is not consciously constructed in the image, its revelation as a truth therein is characteristic of these amateur films. Let us reflect on how to conceive of the political identity of the German presence in Paris 1940.

In a further layering of the connection between the travelogue and modernity, Jennifer Peterson explores the use of the early travel cinema as a commodification of the desert landscape: its affirmation of the modernization and domestication of the pre-Lapserian wilderness in archival films of the American West. In turn, she argues that these modern visions in and of themselves have a mythologizing function when they put forward a new mythology of the desert as a national icon.[52] This apparently instinctual urge to represent familiar synecdoches thereby becomes

a form of colonization, of ownership of the "foreign" landscape. Although the amateur color film shot in wartime by a German cameraman does not depict expanses of Eastern or European landscape, the images of iconic and emblematic monuments depict a comparable appropriation of Paris. Although it is not a modernization of the already modernized capital, the German soldier's film can be seen to "domesticate" Paris when it claims ownership of its rich cultural history. Although the December 1 parade is not the focus of the footage, its insistence on the German takeover is stressed through signs of the occupation of the city, such as the presence of the swastika flag. When footage of German troops is juxtaposed with footage of Paris's great monuments, the perspective is one of German ownership. Moreover, the German invasion of Paris as it is represented in these color fragments can be interpreted as an apotheosis of a takeover that began with Hitler's visit to the Trocadero on June 23, 1940. This event is made famous through photographs and film footage in which Hitler is shown with Albert Speer looking from the Trocadero out to the Eiffel Tower as the synecdoche of all France and of modernity in France. In this famous film footage, Hitler, like the amateur cameraman, visits Garnier's Opéra, the Place de la Concorde, and les Invalides. Indeed, the amateur cameraman's footage retraces Hitler's footsteps as they are represented by the official Deutsche Wochenschau images, images that were shown all over Germany and would have been familiar in all households. Hitler so admired the French capital that, rather than having it destroyed, as had been his intention, he ordered Speer to build a Berlin that imitated Paris, only better. And the footage of the amateur cameraman taken in December 1940 might be understood as another realization of Hitler's visit to the Trocadero and other Parisian monuments in June. It sees the appropriation through occupation of Paris by Germany and its soldiers; that is, it sees another of Hitler's dreams come true.

Even though the footage was shot nearly six months after Hitler's visit to the Trocadero, the tracing of his footsteps, together with the footage of German troops marching down the Champs-Élysées, gives this film a far more complicated meaning than that of an amateur who filmed icons and monuments when on "vacation." If the images express the identity

of the soldier-cameraman, this identity is imbued with a pride in and celebration of his nation's takeover of Paris.

In addition to contributing to the discourse of the German "owner-ship" of Paris, these images are a realization of the textbook instructions for amateurs at this time. The amateur film journals and film clubs were always full of advice regarding how to film when traveling, what to film, mistakes to avoid, and what materials to take on tour.[53] The instructions and the filmmakers' adherence to guidelines and suggestions for film-ing made for somewhat formulaic images. Thus, at the same time that the cameraman followed Hitler's footsteps through Paris, he also demon-strated his following of the guidelines for successful amateur filmmaking.

Even today, tourists tend to photograph the not-to-be missed sites from familiar perspectives. Indeed the repetition of the perspective is in itself further confirmation of the individual's claim to inclusion of the site in his or her identity. The repetitious nature of the images redirects our attention to the amateur behind the camera: these images are not only about the Eiffel Tower as it here appears.[54] The momentary differences reveal the individual significance of the Eiffel Tower as an otherwise mass phenomenon. Despite the lack of originality of tourist images, certainly in the case of the soldier's images of Paris, seventy years on, innovation and uniqueness can still be identified.[55] And in addition to the revelations of a "German-owned Paris," herein lies the importance of the pan or camera movement, the use of color, and the particular camera angle, as the novelty of what this cameraman brings to the otherwise familiar vision.

The most overt markers of such distinctions are the canted and ele-vated angles of the Eiffel Tower, shot through small openings between buildings, clearly from a window to which the cameraman happened to have access. In addition, the color and the sepia tone of the faded color footage mark out these visions as unique. Simultaneous with these indi-vidual gestures, the inclusion of the events of World War II taking place literally in between these images makes the filmmaker's vision of Paris unique. Thus, however many times we have seen such images of Paris, these take on significance when they are acknowledged as important documents of profound historical events from an individual (German)

perspective. And the footage taken of the market at which Jewish goods were sold adds yet another layer of complication because it comes to us as a violent interruption of the continuity of the visit to an otherwise harmonious Paris. It sees a visit by an otherwise proud and self-confident cameraman and his camera on "vacation" in Paris.

Just as the travel film reinforced the expansion of modernity and the myths of modern culture, it has also been theorized for its engagement with discourses on colonization through visualization. Accordingly, the modern practices of tourism and colonialism are twinned in such discourses, a relationship born of their shared desire to capture "souvenirs of a culture of imperial expansion experienced at the level of visual consumption and 'extension' . . . their tendency to embalm the other in the conventions of a picturesque bind that Fatimah Tobing Rony has described as a type of cinematic 'taxidermy.'"[56] The whole discourse of power, control, surveillance, and appropriation pervades these images. And this power begins with a desire to identify oneself through the visual representation of the other. This includes the filming of recognizably Jewish artifacts on sale at the market.[57] However, the profound historical significance of representations of the Jews and other "enemies within" is perhaps most clearly articulated in images taken in Eastern Europe. In turn, the greatest insight into these images is gained when they are seen through the lens of their resonances with discourses on early film ethnography.

Film as Ethnographic Device

Like the photographs discussed in chapter 2, many film images were taken in the Sudetenland, Poland, and the Soviet Union. In all cases, it was not only the local farmers and peasants whose appearance caught the fascination of the cameraman, but also the Jews and, in short, anyone who was not a Nazi soldier. Even a cursory glance reinforces the amateur filmmakers' fascination with peoples from the East. Similarly, the persistent posing for the camera of these peoples reminds us of the turn-of-the-century use of the camera as an anthropological and ethnographic tool to document the behavior and appearance of so-called

foreign people. However, we must also remember that between 1937 and 1945 all distinction between the internal and the external war was collapsed in the German Reich. As Jörg Echternkamp says, the external war in the East merged with the internal war on the home front "against the minorities who were programmatically branded as 'enemies' of the *Volksgemeinschaft,* that community of Germans ordained by fate who were at the same time a 'brotherhood of arms and of blood.' "[58] He continues: "Front and homeland: the difference in nature between these two terms was lost, and through the many intermeshing connections between them they took on a new meaning."[59] Although Echternkamp refers here primarily to the role of civilian Germans on the home front as "actors, onlookers, and victims" in the drive to "purify" Germany of the enemy within, the collapse of internal and external in place, time, and opportunity between 1939 and 1945 also led to the domestication of the Eastern Front as Greater Germany. Within the discourse of the Third Reich, these lands were being "returned" to Germany. Therefore, while the color film images clearly share characteristics with early ethnographic film, they simultaneously depart from this context: the presence of the German camera in spaces of the East was underwritten by the conception of Greater Germany and notions of the homeland within the Third Reich imaginary. As a result, the other of the foreign culture is transformed into an abject presence of which the German nation had to be "cleansed." Often the non-German, non-Aryan is not simply othered but rendered inhuman.

We see this even in the example of the footage taken in Krakow when the film continues its observations of everyday life in the town by showing Russian soldiers pushing and pulling a cart. We identify them through their uniforms. Like the locals who work in the market, the Russians are wasted. But this is perhaps not the point being made by the cameraman. What is significant is that these Russian soldiers simply belong to the fabric of daily life in this Eastern town. The camera pans across the thatched-roof houses, reminding us of the medieval age of the city. And finally, the sequence that concludes this disconnected yet visually complex footage shows a peasant woman plowing a small field behind a dilapidated house while a German tank, replete with periscope, obscures the foreground of

the image. As I have indicated, what the camera's lens sees is ordinary and everyday and yet is potentially devastating. In addition to being instructive in its form and surface details, to a twenty-first-century viewer the footage reveals the extent of German colonization and oppression of the cultures in the East. These fragments capture the suspicion and perpetuation of the unfathomable distinction between Germans and locals, between Germans and Russians in this town that has become so tainted by the German occupation. But first I shall consider the context of early ethnographic film within which to formulate some understanding of the footage.

As Griffiths argues, early travelogues were, in and of themselves, a genre of anthropological and ethnographic film that sought to reinforce colonization and the pleasure of looking at and observing the other in all its strangeness. As is the case with all such discourses, visual representation of the other reified the identity of indigenous people, setting in motion a power dynamic that underwrote the justification of colonial and imperial expansion. Although there might have been ambivalence toward modernization, the ethnographer's attitude toward the other—a vision made possible through the forces of modernization—was rarely anything other than straightforward. The ethnographer typically drew the distinction between the white male, Western colonizer and the uninformed and fragmentary view of women and children of indigenous cultures. And, in the case of the two examples of color film footage from Krakow, the spent energy, the bent-over postures, the apparent lack of choice of the Poles and the Russians are made more striking through their juxtaposition with the German tank, in which we know there must have been soldiers, safe and stationary in their observance of the others who worked in physical, human labor. Typically the Jews, Poles, and Sudetens—in short, anyone who was not a Nazi soldier—are filmed from exactly the same perspective: from a distance, contrasted with the Germans primarily through their posture, performance, and clothing.

When footage depicts the community of the soldiers, typically relaxing, eating, or doing daily chores, there is always an engagement with the camera. Although other cultures are kept at a distance within the frame, soldiers frequently cross the line between profilmic reality and representation, thereby drawing attention to the fact that the cameraman belongs

to the community or "family" of the soldiers. This specific reflexivity observed when the space of representation becomes merged with the space of profilmic reality is not at stake in the footage of other cultures. Thus the instances in which the amateur color footage broaches an anthropological investigation of foreign cultures as other are visually emphasized when such images are juxtaposed with examples of the soldier in his own "family" or community of fellow soldiers. The connection between the amateur films and the cultural modernity of World War II demonstrates that the visual culture of everyday life in Nazi Germany was often not so distant from the broader developments of technological modernity. In turn, through this connection we find aspects of the films that go beyond their identification with Nazi ideology and fit into histories that outlive the extremes of Nazi society.

At the same time, we need to retain the dimension of these "ethnographic" films that makes them fit within a uniquely German imaginary. This is a dimension that stems from the fact that Germans did not see themselves as traveling through foreign lands. Poland, the Soviet Union, Sudetenland, and so on were appropriated territories that needed to be cleansed of impurities. These places were considered to rightfully belong to the German homeland. Thus what the color films see is not simply the non-Aryan as other. Looking back seventy years later, we know that behind the image there was an imperative to destroy and eradicate the people depicted because they would contaminate the purity and coherence of Germany. The only way that the German cameraman's identity is dependent on these people is through their necessary destruction. Thus these amateur films do not simply repeat the traits of early cinema; they take them up and put them into a new context, a context infused with Nazi ideology.

The connection between early cinema and amateur film of the 1930s and 1940s in Germany opens up the possibility of a historical trajectory that complements and extends existing conceptions of film history. It adds texture to the understanding of mainstream and narrative cinema by illuminating the fact that film history did not follow a single path. A much more circumstantial and layered set of influences make up the history we now trace from early to silent, then narrative, avant-garde, art, and commercial narrative cinema. Indeed it is significant that the narrative shape

of amateur film is quite different from the cinemas of more conventional histories. Like the silent cinema as well as the travelogue, the amateur film is often episodic, not interested in plot and narrative progression. Jeffrey Rouff argues convincingly that the travelogue's fragmentary nature, a film form much more concerned with spectacle and performance than with unfolding cause and effect, is testimony to its alignment with an alternative to classical Hollywood narrative. He says of the travelogue what could also be asserted regarding these color amateur movies: it "keeps alive the loose narrative aspects of the picaresque in movies."[60] This more episodic structure of the often in-camera-edited footage is yet another indication that the amateur film kept alive the silent and early cinema's fascination with the medium. The need to keep developing and pushing at the boundaries of cinema's relationship to technological modernity is not yet fulfilled. And, in particular, we see a marriage of the technologically modern visual culture with the visions of the German Reich as the two meet in these amateur images.

Blurring Distinctions

Sanctioned and Unsanctioned Histories

Amateur footage is often thought to have the potential to disrupt or challenge mainstream official histories. Leading scholars such as Citron and Zimmermann, and even filmmaker Maya Deren in her writing on amateur film, agree that amateur film accrues its potency from its oppositional use. Through a focus on the marginalized, the disenfranchised, women and children, those whom history has forgotten, those who do not have a voice, Citron, for example, excavates the suppressed histories of those otherwise unable to speak for themselves. Zimmermann also argues that the fissures and incompletion of amateur film provide spaces of resistance and agency through their reaching out to an audience for completion.[61] To be sure, our interaction with the amateur films from World War II seventy years on casts them as vectors in alternative, unexplored histories.

However, as other critics have been careful to point out, amateur film

does not automatically "counter" or resist the mainstream. Though we might ultimately want to appropriate that footage to give voice to the mute victims of the silent color film, we must first ask, What happens when the family of the more conventional home movie and amateur film is replaced by a battalion of soldiers? What happens when there is nothing disenfranchised or marginalized about those who appear within the image or behind the camera? What happens when despite ambiguities surrounding the provenance of the footage, there is no trace of opposition, when power, privilege, and mobility underwrite those in the images as well as behind the camera? Because for all its disclosure of the injustices of German soldiers to their despised enemies within the newly demarcated Germany, this color footage also tells the story of those who had the power and of their lives with biological families and fellow perpetrators.

Claranne Bechtler recently donated footage "found" or, more accurately, confiscated by her father, John Christopher Bechtler, to the United States Holocaust Memorial Museum. Bechtler was a U.S. soldier at Berchtesgaden serving with the Counter Intelligence Corps in April–May 1945. The films show Hitler's butler, Arthur Kannenberg, fishing with his friends and showing off his catch for the camera. In another reel the same jolly, rotund Kannenberg goes boating with a blonde woman on a lake and proudly flaunts his diving abilities as he frolics among the swans in a serene natural landscape. These are Kannenberg's home movies, and, typical of such films, we see the camera handed around so he, too, can appear in them. In other footage taken by Kannenberg with a 16-millimeter camera, we see the maiden voyage of KdF (Kraft durch Freude, or Strength through Joy) ship *Robert Ley* in April 1939. Again, as is typical in such footage, we see women (including Kannenberg's wife) lounging on the deck, playing games, flirting with men, chatting with each other. We see the glorious expanse of the sea, a destroyer passing by, and later, the Nazi leaders on board. The footage depicts a life of ease and enjoyment in idyllic Germany, with lakes, footbridges over streams, undulating landscapes, and displays of power and might in the form of the ship. On the surface, nothing about this footage suggests a life of impoverishment or destruction. It is a celebration of life at home and on vacation. Again, these

characteristics are very much in keeping with those of amateur footage and home movies. And yet it is also an example of amateur film that revels in the glories of German privilege.

In the archives there are similar examples that depict behind-the-scenes life being lived by the political elite and their families. In one sense, this footage expands our notions of the history of World War II and the Nazis as we see how they lived, the banality and leisure of their daily lives. Rarely does work figure in these images, and when it does, it is usually performed and posed for the camera.[62] Kannenberg's pride in his aquatic abilities does not, however, challenge conventional narratives either of the home movie or of German history. His life was, we gather, one of ease, pleasure, and privilege. Similarly, there is no evidence in Kannenberg's "home movies" of the crimes perpetrated by the Nazis; indeed, it appears as though such events did not touch his day-to-day life. Thus, on the one hand, Kannenberg's footage does more than simply re-present the conventional World War II narrative due to its focus on the private sphere. However, on the other hand, it does nothing to challenge this narrative. This footage was shot by the perpetrator, by the one who wrote history in the first place, by the one who dominated, corrupted, and destroyed. It is typical of amateur and home movie footage for its representation of the happy day-to-day life, perhaps even the vacation, of a middle-class man, and also for its apparent lack of engagement with large-scale historical events. Thus the footage suggests that the lives of Nazi political officials were as run-of-the-mill as those of any other bourgeois family men in the first half of the twentieth century. And yet there is so much more to its story.

Because of the provenance of this particular example, what is not represented here, the absent narrative that is secreted behind what we know as the surface duplicity so typical of home movies, must and can, in Zimmerman's words, be "mined." Although the image it presents is no different from that of any other family or community captured in early home movies, it has a different value and effect because of the mass murder being committed outside of the frame. Seventy years later, it is impossible to look at this footage and not remember the crimes it fails to mention. So much about the German superiority was about relaxing and having a good time, about pleasure, spending time with family and

friends, and the good life. And this good life was unspeakably excessive in our memory of what it covered over. I maintain that it is important to focus on what is revealed by the images rather than to search in them for what is not represented, namely the Holocaust, which we know was taking place elsewhere. However, we also have to use this footage responsibly, and what will be most important is the exploration and exploitation of the space between the sanctioned history represented by Kannenberg's home movies and the unsanctioned truths it nowhere depicts. At this stage, however, it is important to acknowledge that not all of the amateur and home movies taken during the Nazi years were exposing unsanctioned histories. And Kannenberg's exemplify the use of the film camera to celebrate the ease and pleasure of life among the upper echelons of Nazi rule. In chapter 5, when I discuss Eva Braun's films, we will see that similar images have a whole other meaning and effect, quite simply because they are those of a woman, a woman who was meant to be kept secret. Unlike Kannenberg's home movies, Braun's, emerging as they do from the same Nazi elite circles, can be seen to contribute to processes of witnessing. However, at this stage it is enough to note that even with little interrogation, tensions exist in these images, tensions that are nowhere visible when seen through the lens of Nazi ideology.

As in the photographs discussed in chapter 2, especially in their twenty-first-century afterlife, there are examples of color film footage that more overtly oscillate between the sanctioned and the unsanctioned when they simultaneously see things they should and should not. Thus, although Kannenberg's footage, seen through the optic of the amateur, is typically in support of the social status quo, there are examples in which the same length of film disrupts, supports, and expands official existing narratives. Once again, this footage serves to point up the contradictions and impossibilities of National Socialist rules and regulations.

To illustrate these conflicting narratives, I want to return to the archival version of the footage discussed at the beginning of this chapter: that taken inside the Warsaw Ghetto. The footage is provocative because it returns again and again to the starving children whose motionless bodies, which are all but corpses, line the streets of the ghetto.[63] The film begins by observing the daily goings-on: trolley cars glide along just inside the

ghetto wall, a man sits and watches the world go by, the colorful market bustles with activity as goods are bought and sold and people rummage through the wares while vendors wipe down the skins of the produce on sale. The camera sees day-to-day life in the ghetto—the discussions, the movements of people going to and fro, the various stages of preparation for market day, and the ordinariness of the lively market. We see inside the ghetto walls, observing the diverse activities and peoples who weave the fabric of Warsaw Ghetto life. Much like the footage taken in Paris, these images of the quotidian bear no visible traces of the political or ideological allegiance of their cameraman.

In the course of this same footage, which we know was shot in the ghetto sometime between 1942 and 1943, we see the disturbing images of the children that tell of starvation, diseases such as typhoid—diseases for which the Nazis' maltreatment of the Jews is renowned—and death. To reiterate, the children slouch, sometimes lie on the sidewalk, because they have no energy, their muscles so emaciated they are unable to stand or sit up. Underfed, covered in rags, it is all they can do to hold out a hand to ask for food. What makes these images even more disquieting is that, because they were shot level with the children on the sidewalk, we can see the legs of the people who walk past them, never stopping as they move about their daily business. As if the sight of the children with their bones bared, the flies swarming around their sores, their sunken eyes, heads held low, is not enough to horrify us, the images somehow become even more powerful as we see the children being ignored by those who share their world. The children's suffering is all part of daily life in the ghetto.

This footage is distressing because the camera unapologetically observes the children in all their suffering, caring little for the exploitation of their difficulties, preoccupied with documenting the ghetto. Similarly, the abject state of the children's bodies and their distress bring to mind all of the monstrous crimes that the Nazis committed. We are enticed into the process of witnessing the trauma experienced in the ghetto through this footage. However, ours is not the only possible response; the footage has other dimensions. Indeed, it is even possible to interpret the images as reflecting other crimes, not only those committed by the Nazis and by the camera person.[64] Not least of all is the interpretation that stems

from the fact that we know that the images are of the Warsaw Ghetto, and we know of the injustices and violence that went on in that ghetto. Further, we know that these injustices were far more complex than the simple equation of Nazi perpetrators as bad and Jewish victim as good.[65] Other ghetto inhabitants, known to have acted in the name of survival and self-preservation, were not always so ethical in their behavior. To whom belong the legs that walk past, ignoring the starving children? Do they not belong to the ghetto's other inhabitants? Was the violence that took place in the ghetto so straightforward? Does this footage not also tell of the complex layer of abuse and hierarchical abandonment said to comprise the very texture of ghetto life?[66]

Although the amateur footage certainly represents Nazi perpetration, it also reveals much more. For example, we have already seen the fabric of daily life, the bustling intensity of the market, the various different modes of transport in motion, and the infrastructural layers of privilege and poverty so necessary to self-preservation. From these short fragments we might also apprehend the possible hypocrisy of the Jewish ghetto inhabitants: maybe they were concerned first and foremost with saving themselves. Perhaps they were hypocrites, imprisoned and yet pushed to close out the pain of others as a survival mechanism. Once again, the multilayered, fragmentary nature of the images, together with their profound subject matter, casts them as a vector for stirring up our memories and creating complex new visions of World War II and the Holocaust. This is a striking example of the way that this historically complex footage, these amateur images, can be mobilized in a process of witnessing when we see them seventy years later in all their contradictions. And they are especially potent because of their ambiguity and their many different possible interpretations. Therefore, they provide an instance of how, on interrogation, the fluidity of the amateur film of the ghetto not only sees what was otherwise prohibited to film but, in the same frame, if seen from a Nazi German perspective, can be interpreted to depict the cold indifference of the incarcerated. Clearly, through different eyes, it can be seen as either condoning or condemning the ghettoization.

Having recognized the power of these images, if we stay with them, we come to ask, What do they actually depict? Are they about the people

in them or the anonymous person behind the camera? Are they about the system that allowed, indeed encouraged, these events? Are they an indictment of the Nazis? After all, such images of despair were not the officially sanctioned vision that the Germans transmitted to the outside world. Indeed they were considered dangerous to Germany's self-image, and their publication was avoided at all costs. The footage begins to raise more questions than it answers.

In another possible interpretation that complicates the power and agency of images in support of Nazi ideology, even in spite of their harshness, we notice the mistakes in them. In one section, an unidentifiable object fills the frame. The film then cuts to a Nazi guard checking the papers of an elderly Jewish man as he passes through the gates of the ghetto. Then it cuts to a shot of a Nazi officer that has been turned around, on its side; it must be a mistake. Then the film cuts back to the busy produce market that was its subject before the distraction of a funeral.[67] The absence of a linear narrative, the seemingly inductive moves of the in-camera editing, the inclusion of a frame turned on its side—all of these apparent mistakes point to a different kind of authority inherent to this footage. They indicate that the footage cannot have been sanctioned; as Forgács says of the amateur image, the mistakes "are never part of a film's intentions, yet they are always present."[68] They bestow on the amateur footage a truth effect that makes us sit up and take notice. Even if they are not the only reality of ghetto life, we attribute to the visible flaws a truth effect. The possible different interpretations, determined by the lens through which we see the footage and the optic through which we choose to make sense of it, leave us wondering about the relationship of the footage to the sanctioned and unsanctioned visions. Accordingly, the literal and metaphorical muteness of the film opens the space for ambiguity: What is the status of these images? Who shot them? For what purpose? They must have been taken by someone of privilege, someone the Germans allowed inside the ghetto walls. But certainly they are not always in the support of the German project. What took place behind these walls was not allowed to be photographed. Whichever route we travel in our interpretation, the images are never fixed or clear.

Due to the ambiguity of this kind of footage, critics often turn to the

identity of the cameraman as a Nazi Party member in an attempt to fix the images, usually as a way of condemning the Nazis and the horror of their crimes. However, as I demonstrate, the historical truth cannot be located in the images themselves. If there is such a thing as a truth effect or value, it is in the ambiguity and fluidity of the visual representation. If unconvinced by my interpretations of the different perspectives to which the footage lays itself open, one can look at footage taken in the Warsaw Ghetto in 1939 by Benjamin Gasul, a Latvian-born immigrant to the United States on his tour of Europe. Even though the ghetto was not yet in place (we note that none of the people in his footage wear the Star of David) and we see laughter and a sense of vitality that are not present in the later footage, here we find similar images of poverty and distress: people wasted on the sidewalk, the physical duress of the work they did, and the malnourishment of people in the Jewish Quarter of Warsaw. Thus, who is behind the camera is not what is at stake in these films. Rather, in the case of the particular images of the Warsaw Ghetto, it is more productive to focus on, for example, the fluidity of their relationship to the sanctioned and unsanctioned visions of the German Reich. There is no absolute truth to be found in the images or in knowledge of their author. What matters more is what we do with the images. And it is in the use of the images, in their circulation or prohibition, their ambiguities and secretion of details, and the resultant mobility of their interpretation, that a truth can be located. In turn, this means that responsibility for what is seen in these images, both by the camera and by the spectator, is opened wide. It means that we cannot rest in the knowledge that the Germans were evil perpetrators and that their doings are fossilized in the past.

Filming the Ordinary in Extraordinary Times

Due to the difficulties of reproducing and screening 16-millimeter film as opposed to the ease of printing and distributing black-and-white photographs, moving images did not have the wide dissemination or viewing history of the photographs, nor were they intended as public documents, as were Genewein's transparencies. The films were shot for personal and

private viewings, and they were usually stored untouched in attics and cupboards over the postwar years.[69] Nevertheless, they are personal films that also see historical events unfold. As Zimmerman articulately explains, this is a common characteristics of amateur and home movies: "As unresolved, open texts, home movies operate as a series of transversals, translations, and transcriptions between history and memory, between text and context, between the public and the private."[70] Nevertheless, there are examples in which the extraordinary is not apparent in the frame. In such cases, it is our retrospective historical contextualization in processes of remembering that creates the tension between the ordinary and the extraordinary.

Not all extant fragments of amateur color footage from this period are as spectacular as the images of Hamburg on fire and later in cinders. Nor are they all as immediately identifiable as the images of Paris. Indeed much of the footage is quotidian in its visual and substantive concerns. An example that initially seems benign, almost uninteresting, is a fragment of film that apparently documents the ordinariness of daily life.[71] The camera pans from left to right across a snow-covered yard with what appear to be administrative buildings in the background. The film cuts to a long shot of a group of four unidentifiable Nazi officers on a road beside their truck, one of them adjusting what could be a photographic or film camera. As is often the case in 1940s color footage, the sky is a magnificent blue, once again enhanced and preserved by the dyes of the film stock. The camera then moves indoors to an immaculately presented man in civilian dress who sits at a desk in an office and lights a cigarette. Through an in-camera edit we are introduced to another man who is in the same office: he is bespectacled, again without a uniform, also lighting a cigarette. Each of these shots is no more than fifteen seconds in length. Back outside, this time in the sunshine of a warmer season, the next fragment is an overexposed image of six Nazi soldiers of various ranks from various arms of the military.[72] They pose for the camera, adopting their most photogenic facial expressions. After a few seconds, in the fragment's final shot, the camera pans across another snow-covered field in which people stand around in the middle ground of an extreme long shot. As the camera slowly moves from right to left, the organization of

the human figures in the frame changes. At the beginning of the pan, people randomly, apparently aimlessly stand around, but by the end the figures in the frame make up systematically organized rows. Nevertheless, the people and their activities are too far in the distance to be identifiable. The camera finally stops on a sun-drenched, red-brick building in the middle ground. What we cannot know simply from viewing the footage but learn from the documentation that accompanied the film in the archive is that this film was shot at Dachau in 1940.[73]

On first viewing, this footage is ordinary. It is ordinary because we have seen it before: a snowy landscape, a gathering of German officers, a few administration buildings, and Nazis at work. Although the camera's movement across the snow is noticeable for its existence, it is nevertheless a familiar use of the amateur film camera from the period. However, the film fragment is also extraordinary because we have repeatedly been told that all filming in the concentration camps was censored. When cameras did venture inside the fences of these human slaughterhouses, the resultant images are typically still, black-and-white photographs taken by soldiers. Most often, visual knowledge of the concentration and extermination camps has come from images taken by Allied soldiers at the time of their liberation in 1945.[74] Certainly the official film camera never openly documented the goings-on in the camps, camps whose existence was denied all along. Although the color film images of Dachau are striking because they reveal what is usually hidden from our eyes, perhaps the most unsettling aspect of this footage comes in the final few moments as described earlier. In the distant background, behind the figures who populate the middle ground, the sharp focus invites us to identify rows of single-story, barracklike structures. And beyond those we notice what looks like a tower of some sort. Thus we recognize the sites of incarceration and, by extension, eventual incineration that lay behind the seeming banality of everyday life in the camps. Even though the Nazi crimes inside the camps are both beyond the visible frame and in the future relative to the film fragment, for us today they are present, and they are frightening. Thus the extraordinariness of this footage of Dachau Concentration Camp comes to life in our retrospective viewing, seventy years after the fact. The tension between then and now is at the heart of the power of

these films. And if indeed this fragment represents the private musing of its cameraman, once it is repositioned, in both time and space, it effortlessly shifts into the realm of a devastating public history.

If we reflect further on this film, much is revealed beyond images of Nazi officers going about their daily business, engaging in rituals, and taking the time to pose for the camera. Beyond the already discussed privilege needed to have a camera, these images reveal more information about the ordinariness, and simultaneous extraordinariness, of daily life. We can confidently propose that the footage was shot by a senior Nazi. A lower-ranked soldier would not have been allowed such an intimate view of his superiors. Perhaps what is most extraordinary about the technique of this footage is that the camera goes indoors. Not only is footage of Dachau rare; using amateur color film indoors in 1940 was virtually unheard of. And, as mentioned earlier, it was never the Agfacolor filmstrip that caught the goings-on indoors. The reversal color film stock was not yet sufficiently sophisticated to capture the subtle gradations of artificial lighting.[75] Because of the technical constraints, the cameraman at Dachau was not in control of the lighting: the images shot indoors are all underexposed, and those taken outdoors are all overexposed.[76] The in-camera editing, common for the time, indicates that the filmmaker also negotiated the shifts in light intensity at the moment of filming. If the footage of Hamburg draws our attention to the "painterly" possibilities of early Agfacolor film stock, that of Dachau makes us aware of the difficulties posed by the gradations of light in different locations. Again, however ordinary, however everyday or even tedious this life seen through the eyes of a Nazi official in a concentration camp might appear, and however shocking it is when seen today, the footage simultaneously alerts us to a range of concerns present to amateur filmmakers at the time.[77] This complex web of interpretations is the value of these images when seen through the optic of the amateur.

Notwithstanding the novel location of the footage and what it tells us about amateur film techniques and technologies and about the daily lives of the German guards and administration at Dachau, perhaps the most urgent reason for recognizing the extraordinary and thus highly public nature of the private footage comes when we take responsibility for our

relationship to the images. If only because we are viewing the films seventy years later, the color footage always encourages us to see the ordinariness of our own lives in the extraordinary visions of some of these images. It is convenient and always more comfortable to see these images on the basis of who shot them, on the basis of when and where they were shot, and thus for their distance from our lives. They belong in a sealed-off past, a past to which we do not belong, for which we have no responsibility. As long as we are explaining and analyzing the images through the lens of knowledge and assumptions about the Nazi perpetrators and their ideological beliefs, we are refusing to really see them. And in refusing to see them we are denying our own connection to the history that they tell.

The anonymity, the collectivity, the familiar and familial characteristics of the amateur image and home movies discussed here lay them open to multiple interpretations and multiple possibilities. We cannot always identify the subject, the filmmaker, or the precise events depicted, and this ambiguity invites us into the spaces between possibilities. This is the first level of distancing that is the basis of their ethical appropriation for remembering World War II and the Holocaust. Another comes in the historical space between the 1940s and the present. These distances are the creative potential of the "unfinished," as Zimmermann would have it, of the color films here discussed. As I have demonstrated, the incompletion of the amateur moving images from wartime Germany is complicated. It not only embraces all the spaces created by the constantly shifting nature of amateur and home movies in general; it is emphasized by the lack of information surrounding the historical circumstances of the survival, preservation, and archival of these particular examples. To reiterate, the incompletion does not necessarily create a discourse of resistance, but it is the basis on which we are able to reappropriate the images for integration into discourses that are ethically responsible to the memory of the events depicted. The film images of the amateur thus become memory triggers because of the possibilities opened up by the distance of the camera from the subject, the distance in time of the footage from our own lives, the distance of the modernity of World War II Germany from today. Again, the color of the images is significant here because it is often the basis on which we are drawn into the profilmic representations; the color itself

can create distance between the camera and the subject matter when, for example, the films display the marvelous illusions made possible on film. Color contributes yet another level of uncertainty to the amateur film image, adding to the spaces that can be put to creative use in the memory work of the Holocaust. In this work, the archival footage ultimately forces us to confront not only our own relationship to our individual pasts, our families, and the images we have in our own home movie collections. In addition the many different interpretations of the footage, the many different perspectives from which it can be seen and the histories to which it contributes, challenge our assumptions about and biases toward the past and, in particular, the Nazi past.[78] Indeed these color moving images represent much more than the destruction of Nazi ideology.

Recycling to Remember or Forget

In spite of the generative possibilities of the archival footage, as I explain at the opening of this chapter, it is usually only in its recycled form that anyone other than the historian literally and conceptually has access to it. And, as I have discussed, in these recycled forms the amateur film footage is often redeployed to emphasize a single version of history, that is, a history driven by the undisputed villainy of the Germans. The myopism of the reuse of this and similar color footage is primarily explained by the fact that the most common public forum is the television documentary, particularly in Britain, France, Germany, and the United States. Typically, mainstream television will appeal to a mainstream public that is interested in being entertained rather than educated. Although there are examples of independent productions akin to *Fotoamator*'s use of Genewein's images, productions that engage in a dialectical relationship with the images, they are not the overwhelming majority. Nevertheless, to illustrate that they do exist and that it is possible to redeploy this imagery in our ongoing attempts to remember and remain responsible to World War II and the Holocaust, I shall discuss one particular example. The archival footage shot in Dachau, on the soldier's visit to Paris, and in other instances mentioned earlier, take on an extraordinary dimension when viewed in the twenty-first century. Thus we must not turn away from these images or close down

their possibility due to our fear of the responsibilities we might be asked to assume. Rather, their redeployment in contemporary narratives offers an opportunity to write these rare images back into history. And the resultant histories will potentially challenge our existing visions of Germany in wartime and, by extension, our visions of World War II Europe.

Mein Krieg

Harriet Eder and Thomas Kufus's documentary *Mein Krieg* (1990) collates footage of six amateur filmmakers who not only filmed their departure from Germany and invasion of Russia but survived the war and kept their film. The spaces opened up by *Mein Krieg* result from strategies that are typical of the historical documentary yet different from those used by Jablonski. The collisions between past and present, between the films of the soldiers and that of Eder and Kufus, between history and memory, and between the soldier-cameramen's conflicting stories of what took place on the Russian Front are thrust into the foreground. In *Mein Krieg* Eder and Kufus enhance and re-edit the soldiers' footage and use freeze-frames and various other strategies of re-presentation in the visual narration. However, they do not employ the investigative camera that we saw used to provocative effect in *Fotoamator*. Rather, they re-present the soldiers' footage in its original fragmented and often unidentifiable state. In some fragments the colors have bled; in others—again, especially those in which red dominates the composition—the colors shine; and still other images fluctuate between under- and overexposure. To some extent we are at the mercy of both the soldier-filmmakers and Kufus and Eder because together they choose the fragments we see in *Mein Krieg*. However, on another level—namely, that of the substantive content of the images—we are given to assume that the footage is not excessively edited. From this perspective, Eder and Kufus annex the realist authenticity of the amateur image where Jablonski questions it.

In contrast to *Fotoamator*, the openness of *Mein Krieg*'s narrative is almost wholly enabled through the creative use of the sound track. It is in the conflicting stories put forward by the six different soldiers, their respective relationships to their images and the war they represent, that

new memories are ignited, new histories inspired. Although Eder and Kufus signal their presence on the sound track through an introductory passage regarding the origins of the footage and an occasional question asked in a woman's voice (Eder's), for the majority of the film, the voices that accompany the footage are those of the soldier-filmmakers' present-day narration. The soldiers watch the films as old men, fifty years on, and as they reminisce and remember on the sound track we are able to hear their distortion of events, the inconsistencies in their retelling. When the soldiers do not speak, the enhanced noise of their films running through the projector fills the sound track. These sounds function to underline the silence of the original footage, its muteness in archival form. Thus we see image fragments that are by now familiar to us: the hanging corpses of six lynched Jews; bombs exploding on the horizon in multiple takes at different distances from the camera; Russian soldiers herded together, their arms in the air; a village on fire; soldiers eating their lunch or on drill. And while showing these scenes *Mein Krieg* makes no aural comment. Eder and Kufus do not speak through voice-over narration on behalf of the mute color archival film fragments.

In those fragments that run without commentary, the noise of the projector is heard, casting a nostalgia and a sense of loss over the old, of-another-era images. We are overwhelmed by this nostalgia. It directs our attention to the visuals: the presence of scratches and gradations in color, the mise-en-scène, the devastation of destroyer tanks rolling into a town, captive prisoners of war, and even the soldiers' farewells to family members on their return to the front. The silence is unsettling for two reasons: first because this is a silence we are not used to hearing or experiencing in a contemporary film, and second because, due to the familiarity and the sometimes disturbing nature of the images, we are invited to give them a voice, to "complete" the film with a narration that matches the brutalities. Even on occasions when sound is heard—the noise of a plane in the air, for example, as we see a soldier in a cockpit high in the sky—we imagine that these sounds are synchronous and belong to the archival film. Although we cannot be sure whether they were added to Kufus and Eder's film in postproduction, they are subtle and still do not close down or overwhelm meaning. Rather, *Mein Krieg* respects the visual

dimension of the footage. In turn, this respect is the basis of the film as a field of imaginative possibility for an involved audience.

If the soldier-filmmakers' voices are heard on the sound track of *Mein Krieg,* they are usually explaining exactly what is in an image. "That's me!" one soldier excitedly identifies himself. "Look, there's the Russian tank we hit the day before," he says as he animatedly explains a military procedure to accompany images that to us appear generic, as if they could have been taken anywhere. Alternatively, the soldiers discuss the technology, how they came into possession of their cameras, the ease of using them, the brilliance of the color. As one soldier waxes lyrical about the "incredibly beautiful colors" of the film or another discusses the opportunity the camera offers to distance oneself from the reality, the horror, of what a soldier experiences on a day-to-day basis, we are given a clearer picture of what it meant for these soldiers to "journey" (to use their word) with a camera in the East. Their memories, their feelings and thoughts about their experiences, become the substance of their films. Thus we see images of one soldier with his mother and girlfriend. Immediately preceding these images, the same soldier, now sixty years old, discusses the difficulty of integrating those on the home front into a life lived with fellow soldiers on the battlefield because of the indescribability of the war experience.

In a contemporary review of the film, Omer Bartov claims that *Mein Krieg* shows more of the "ability of the camera to distort reality than to record it and more of the ability of the mind to repress memory than to conserve it."[79] However, today, another twenty years after the film was made and Bartov wrote his review, another interpretation is possible. *Mein Krieg* represents footage that claims to record events, a claim commonly made by amateur film: the amateur camera is set to roll, and whatever passes before it ends up on the film. Although choices are made all the way through the filming and in-camera editing, there is an immediacy to the subject matter. It is not that film distorts reality; rather, the minds of the soldiers and the memories they create of events depicted in the films revise, modify, and edit the history they want to see. In turn, the unreliability of their memories creates discrepancies, inconsistencies—in short, gaps—that open up to our creation of memory, our version of history. The soldiers' fabrication in memory as it is represented in *Mein Krieg* is in

fact the impetus for us to revisit this historical period and to see it for our-selves. Thus, twenty years later, it is our memory that is at stake in a film such as *Mein Krieg*. Although the soldiers might have used their cameras to force historical narratives, the distances of the film are an invitation to revivify rather than repress memories of a different order: those of the contemporary viewer who has no firsthand experience of either the war being filmed or the historical context in which *Mein Krieg* was produced.

The most striking moments of *Mein Krieg* come when the soldier-cameramen's voices provide the narration, because their experiences are so dramatically different from one another. The discrepancies clearly underline the belief that theirs is only a perspective, not a finished or authoritative his-tory. Overlaying an image of Russian prisoners being shot, one soldier says he saw it all. On one of the few occasions on which the voice of a filmmaker punctuates the narration, a woman's voice asks if he participated. To answer this question is too painful for this soldier, so he responds with another question: "Do I have to answer?" The next soldier, who throughout *Mein Krieg* presents himself as stoic and a "loyal Nazi subject" merely doing his duty by fighting for his country, is adamant that he never saw people being decimated. And a third discusses the role of members of the Wehrmacht as accomplices, not perpetrators, bystanders, or victims. We are left to believe that we will never be forced into judgments of the Wehrmacht, never take a definitive stance on the soldiers' experience.

Through this process, Eder and Kufus's film functions both to create an archive for films that we would otherwise not have an opportunity to see and as material for the creation of our own memories for the present and the future. What is so striking here is that the relationship between sound and image—between the voices of different soldiers and their respective relationships to their duties as soldiers, as cameramen, as human beings in the midst of war—creates an unevenness and fluidity that effectively invite us to rethink our assumptions about the role of the German soldier in the war effort. Although this discourse has come alive in the literature on German history and memory over the past fifteen years, we remember that in 1990, when *Mein Krieg* was produced, there were no such discussions. At that time, history had convinced us that the German administration and high-level Nazis were guilty and the soldiers were simply cogs in the

larger machinery over which they had no agency. The question of whether the soldier-filmmakers were innocent or guilty, perpetrators, accomplices, or victims is never answered by *Mein Krieg*: its concern is to suggest the possibility that these were thinking, feeling, active men at war. Similarly, their experiences were as varied and as discrepant as their memories were numerous. Thus this apparently obscure film redeploys amateur images, exploits the creative possibilities of their openness, and reanimates a past to throw into confusion all that we might otherwise have assumed to be true.

The use in *Mein Krieg* of archival material to challenge the contemporary viewer to rekindle the past is in stark contrast with the reuse of the footage in the television documentaries that want to shut down all possibility, to reinforce the grand historical narrative that has become so familiar in the postwar period: namely, that Germany and the Germans were in the wrong and the Allies were the figures of salvation in a brutal and bloody war. In these films "the Germans" or individual soldiers are indicted for their crimes and the Jews and other victims remain dead, even if they survived. The familiar intractable narrative of World War II is set in motion yet again. In contrast to *Mein Krieg*'s openness, which derives from a combination of the fragmentation of the narrative and the self-conscious re-presentation of the image by a camera that is unsure of its status, made-for-television documentaries such as the British *Third Reich in Colour* (1998, BBC), *Hitler in Colour* (2004, Granada TV), and similar productions from Germany and France, such as *'33-'45 in Farbe* or *Les Archives en couleurs: Images du 3e Reich* (2004, TF1, France), are characteristically univocal, coherent, homogenous narratives. The intention of almost all of them is to communicate the familiar history of World War II, the inherent evil of Hitler's twelve-year reign, and the devastation it brought to millions of lives. Even when a film promises to focus on a particular aspect of the war, for example, Hitler's rise to power or the invasion of Poland, the narrative is usually the same. In addition, in all cases, irrespective of the country in which the films are produced and exhibited, the extraordinary color footage from the archives is no more than a backdrop to the drama and intrigue of the voice-over narration performed by a well-known, award-winning actor.

Ironically, the redeployment of the moving color images in the popular

television programs uses strategies that remind us of the "archiving" of European Jewry at the time of World War II and the Holocaust. Just as was the wont of the Nazis to rationalize the Jews, we see the familiar urge to order images, to place them in a narrative designed to erase their individuality, to render them invisible and, ultimately, to destroy them. The placement of archival footage in a television documentary causes the images, like the Jews under the Third Reich, to be stripped of their power, their authority. At the same time, the threat posed by the images becomes blunted: the illegitimate narrative of today, which blames others (Germans who lived through and were involved in World War II), is guaranteed to prevail. Whereas for the Nazis there was an imperative to oppress and destroy the Jew as other in order to underline their own superiority, for the makers of television documentary narratives the questions asked by the images, their multiple perspectives, and all the things they expose about the wrongs committed by people other than the Germans have to be quieted and dismissed if the viewer in the former Allied nation is to be absolved of responsibility. Again, this is not to equate the practices of the television production companies with those of the Nazis. Rather, I forge these connections to emphasize the limitations and monocular perspective of the televisual narratives.

If we conceive of the films that recycle amateur film imagery as something akin to an archive, we see very clearly the different intentions and viewing experiences of the different kinds of narratives in which the images are re-presented. The film strip, whether it be a television documentary or an independent production such as *Mein Krieg,* like the creative, melancholic archives described by Hal Foster, retrieves and brings into public circulation images that would otherwise have been lost to memory and history. These films make the amateur images present. And a film such as *Mein Krieg* goes further: in the process of developing a fragmentary narrative-as-archive, a place to store obscure images and to conserve the past, the film initiates a process in which it opens up a space for the images to create memories. In his work on Gerhard Richter's *Atlas,* Benjamin Buchloh understands an archive of images as a memory project that creates a new and coherent temporality, a coherent world. However, there is also another level, one that simultaneously runs counter to the

continuity created in the visible materiality of re-presentation. This is that of the tentativity, the fragmentation, and the caesuras created by the new archive of, in Buchloh's argument, *Atlas*. This same dialectical tension of the archive is kept alive by historical documentaries such as *Fotoamator* and *Mein Krieg*.

The television documentaries, however, do something quite different: they do all they can to fill in the caesuras, to paper over the disruptions of fragmentation—in short, to shut down the possibility of uncertainty regarding and insight into the trauma. Simultaneously, the overwhelm of the images either by the sound track or the visual narration ensures that memory is not stirred or constructed but, on the contrary, any hint of creative memory is actively discouraged. Any threat of disruption to conventional history that may be posed by the mute amateur images is allayed when they are put to rest in the past. There is no place for the viewer of these films to imagine their relevance to his or her life, no invitation to engage in the practice of witnessing. All of these television documentaries absolve their audiences from any responsibility for or any connection to the history to which destruction belongs when they overlay images that could well have been taken by a filmmaker of any nationality with a well-rehearsed, seamless, chronological history of World War II and the Holocaust. Quite simply, the images are recycled in the made-for-television documentary as documents of forgetting. They are used for the very opposite of what historians, social and cultural critics, politicians, and artists have elsewhere determined to be the imperative with which we are charged: to remember and memorialize.[80] The postwar repression of history has here been transposed to a surreptitious burying of history behind a claim to openness and perpetuity.

And yet, on another level, the archival images have a power that means they can never be fully organized into a depersonalized, coherent vision of public history. Because, as Michael Chanan points out, the images comprise a sociohistorical reality through which some in the audience may have lived and through which others may glimpse their disappeared and deceased family members on the streets. Chanan's paternal grandparents were said to have perished in the ghetto at Warsaw or perhaps at Auschwitz; he is not sure. When he sees fragments of a television

documentary, he is instinctively and emotionally compelled to search the images for even the briefest sighting of his deceased family members. Chanan's response to these images is motivated entirely by his personal experiences and his memory, "the interior sentimental life of the spectator as a private individual."[81] Even though Chanan saw only clips from *The Third Reich in Colour,* and thus his response does not speak to the television documentary's reuse of the footage, he does point to the possibility inherent in the amateur images. Film fragments can be manipulated and constrained and flattened out as much as their makers like, but in the end there is always an unpredictability and ambiguity to the way images are seen. Because discourses of historical memory are always open to individual memory, there is no certainty as to how people will see the images. Notwithstanding these important possibilities for the eventual use of the film fragments in memory discourses, multiplicity and an openness to potential reappropriations of the images are not the intentions of documentaries such as *The Third Reich in Colour.*

It is more likely that amateur color films in the recycled narrative become sites for the displacement of fear and anxiety. The amateur color films are redeployed to confirm a history for which, in the case of *The Third Reich in Colour,* Britain and the British people are not compelled to take responsibility. Nowhere, for example, is there any acknowledgment of the British knowledge of the concentration camps in 1941. Rather, World War II, the Holocaust, German perpetration, and the resultant devastating ruptures are all placed at a safe distance from British history and identity at the turn of the twenty-first century. This simultaneous fear of and fascination with the footage tells of an unresolved relationship to the past. It is the lack of tension and discordance referred to by Kansteiner that effectively submerges the images beneath the safety and surfeit of myths. Thus, if the film fragments are indeed icons that hold the potential to memorialize and keep alive the tragedy of World War II and the Holocaust, as indeed we have seen them do in films such as *Mein Krieg* and *Fotoamator,* in this forum of re-presentation we have no choice but to reconsider the status of the amateur images and our responsibility to the histories they envision.

■ 5 ■

At Home, at Play, on Vacation
with Eva Braun: From the Berghof to
YouTube and the Imperative to Remember

> The present tense of the photograph is a layered present
> on which several pasts are projected; at the same time,
> however, the present never recedes.
>> ■ Marianne Hirsch, "Projected
>> Memory: Holocaust Photographs
>> in Personal and Public Fantasy"

> On the surface everything is wholesome and cute, but a
> dark shadow of power bleeds through.
>> ■ Michelle Citron, *Home Movies and*
>> *Other Necessary Fictions*

Of all the photographs and films discussed in *Through Amateur Eyes,*
those attributed to Hitler's mistress, Eva Braun, come closest to tradi-
tional notions of family photos and home movies. The films are conven-
tionally conceived home movies that depict the daily life of Braun and
her family and friends, at home in Munich; on vacation in Italy, Norway,
and Denmark; and at the places where she shared her life with Adolf
Hitler: the Berghof, in Berchtesgaden, and at Kehlstein—a teahouse
twenty minutes' walk through the natural landscape from the Berghof.
Her photograph albums are characteristic of those found in family collec-
tions. We see photographs of Eva with her sisters, her beloved dogs, her
family and friends. We see many photographs and much film footage of
young children, especially those of her close friend, Herta Schneider, as

they take their first steps, play games, celebrate their birthdays and chris-tenings. Also, images of Eva Braun swimming, diving, sailing, and doing acrobatics at beaches and lakes around Germany and Europe abound. The images capture her with her girlfriends, giggling or parading before the camera. In addition, Braun turned her camera on the breathtaking natural beauty of the mountainscapes of the Obsersalzberg, the fjords in Norway, the seas and lakes on which she sailed during her vacations, the canals of Venice. Her fascination with the colors, formations, undula-tions, and rhythms of nature is as typical of home movie footage and the thousands of snapshots that fill family albums as the documentation of a baby's first steps or a sibling's wedding celebration. Finally, the color films in particular bear all the familiar formal features of amateur film and photography. Not only did Braun use her 16-millimeter Siemens camera to explore the colors of fire, water, and landscape but her footage often includes sudden changes in film speed, repetitions, out-of-focus shots, obstructions of a frame by an intruding head or hand, and the shaky, uncertain motions of a hand-held camera. All of these stylistic idiosyn-crasies are, as I argued in the previous chapter, central to the identity of amateur film.

However, Braun's films and photographs are, contradictorily, also un-characteristic of home movies and amateur images, because they are filled with unique shots and footage of her lover, Adolf Hitler, and his entou-rage. His presence and that of his right-hand men such as Albert Speer, Heinrich Hoffmann, Josef Goebbels, and Heinrich Himmler in different poses, on different occasions, and at different times mark these images as more than just another set of home movies and snapshots. Hitler's presence and that of numerous other Nazis in uniform make the images significant public historical documents. These are among the few home movies and family photographs taken inside the circles of high-ranking Nazi officials.[1] Unlike the images of the Goebbels or Goering families, Braun's not only depict Hitler and his official visitors in the less formal environment of the Berghof but include images of significant events. Thus they slide very easily between private documents of Eva Braun's home life and public records of important figures and events in the his-tory of Nazi Germany. The images also betray an indifference to events

we know took place simultaneous with Braun's life at the Berghof. The war that was ravaging Europe, the nearly complete annihilation of the Jews in the Holocaust that was going on not so far away, and the violent, maniacal acts being planned behind closed doors are nowhere to be seen in Braun's images. Although this larger historical context is missing from the films and photographs, it is, as in the case of some of the footage already studied in chapter 4, always on our minds.

The films' and photographs' simultaneous representation of Braun's private life and significant public events provides one of the major themes of this chapter: it allows for a mapping of the contours of public and private life among the highest political and military echelons of Nazi Germany. In addition, enmeshed in the complexity of public-private relations in Braun's films and photographs, these pictures offer a unique depiction of gender dynamics at the Berghof and, by extension, insight into the contradictions inherent to gender dynamics and social conventions as they were played out in the day-to-day life of privileged Nazis. And, in keeping with the premise of *Through Amateur Eyes,* the springboard to both of these discussions is the placement of Braun's work within the context of the amateur photography and filmmaking of the period. My discursive or interpretive shift between the specific images of a single woman as subject and their representation of her social world more generally is made thanks once again to the fluidity of the amateur image and its commonly accepted status as the product of bourgeois familial relations. As I explain in this chapter, the ease with which amateur images flow from individual to collective, from expressions of subjective identity to anonymous historical articulations, from memory to history, is what enables us to see Braun's for their contribution to World War II history. Moreover, this fluidity enables the generation of our ambivalent relationship to them, a relationship that, in turn, provides the impetus for our questioning of official discourses and our continued remembrance of the past.

Braun's images facilitate discussions about her own identity and the cultural gender roles that weighed upon that identity and its construction in Nazi Germany. Although we cannot and must not efface the facts of her life with Hitler, if we allow the meaning of the images to be derived via their status as home movies and family albums, we are able to access

both their biographical and their broader historical value. Unlike in my interpretations of the images in other chapters, in this chapter my focus begins with the way that home movies and family photo albums create an identity for the amateur image maker. Subsequently, as I look at the images from the distance of seventy years, through a particular viewing process, I become the author of the memories that are triggered by these images. The images' status as family photographs and movies enables me to provide what Michelle Citron terms a "second track" at the moment of viewing. Although for Citron the two tracks are temporally determined—the past and the present—in my discourse they also take on a public-private distinction. At one and the same time, I am aware that I observe Hitler's lover on film and, thanks to the constant flux of the home image, I "fuse the present tense of viewing to the past tense of recording. Time folds back on itself. Two places on the time line . . . meet" in my own personal history.[2] As I explain later, via Marianne Hirsch's notion of the "familial gaze," the familiarity of Braun's images can trigger the viewer's own memories of holidays, birthday parties, and social gatherings. There is a potential to see our own distant past when we imagine ourselves, our family, in her images. Simultaneously, this familiarity is violently disturbed because we are constantly aware that we are viewing Hitler and his lover in still and moving images. This awareness creates a historical consciousness that, at one and the same time, undermines and is undermined by the familial gaze, a process that triggers our present-day witness to the Nazi past.

More than in the case of any of the other images discussed in *Through Amateur Eyes,* my argument regarding the Braun home movies and photo albums is very much informed by my own encounter with them in the archive. I am aware that this experience would not be the same, for example, for a younger scholar born and raised on digital film and photographs. The similarity of Braun's family albums to those collected and brought out on special occasions by my own family, the memory of sitting around the projector watching 16-millimeter films on a Saturday night, the secrets and stories triggered by these old images determine my viewing experience as much as they are determined by my identity. Even though the Nazi elite were petit bourgeois, the practice of recording daily life on film as a

bourgeois activity also conditions my familiarity with Braun's images. And just as I am a viewer of a certain class, as a non-German I experience a distance from Braun's images, and a potential objectivity, that would not necessarily be the case for all viewers. Finally, my reading is influenced by my experience of seeing all the images together, in the slow-moving narratives in which Braun arranged them, in the archive, with all their inconsistencies and their redundancies as well as their surprises and secrets. My viewing of Braun's still and moving images at the National Archives and Records Administration (NARA) in College Park, Maryland, resembled the historian's fall into the past world of archival documents as it is best described by Carolyn Steedman's interpretation of the "archive fever" first alluded to by Jacques Derrida.[3] As Steedman vividly captures it, a relationship is struck with the historical moment, the place, the subjects, and, in the case of Braun's archive, the obsolete material images, as they take on a ghostly presence at the time of the research, a presence that continues to haunt long after the fact. Thus the journey into the archive has a personal dimension, a dimension that contributes to the memory space that, in turn, is central to my "double-consciousness" of the viewing experience of Braun's home images. As in the cases of the images discussed in other chapters, there are many possible interpretations of Braun's. My following discussion of the images' reproduction in contemporary spaces—the chosen few that appear again and again on the World Wide Web, in film documentaries, or in made-for-television films—will also serve to illustrate how the experience of affect and understanding that underlies my argument is only one perspective.

Scholars such as Dagmar Barnouw, after Friedländer, have argued that the history of World War II is always going to be incomplete without the perspective of the Germans who committed or contributed to the crimes.[4] In the same way that we cannot afford to ignore the images taken by Germans or to assume that we see through their eyes when looking at their images, it is imperative to acknowledge that the memory of those who suffered goes hand in hand with that of those who shaped that suffering. How they lived, how they conducted their daily lives, and who they were are equally central to the understanding that is the basis of historical witnessing of traumatic events. The historical remembrance

of ensuing generations is key to this more inclusive perspective. Others have discussed and contextualized images in German family albums from the Nazi period, and *Through Amateur Eyes* consolidates these readings as well as emphasizes the necessity of juxtaposing them with those taken on the battlefield in ongoing attempts to come to terms with what is, ultimately, the same past.[5] As a result, memory of the Holocaust, the history of World War II, autobiographical portraits, and anonymous documents come to coexist or, at best, vie for dominance at any one moment in our process of witnessing the Nazi past. Braun's images take an important place in the complex historical tapestry of this period as it is depicted by the images in *Through Amateur Eyes.* They are key to the historical picture precisely because they open new perspectives, and through the moment of "superimposition" of their public and private levels of meaning, "a space is created from which [deeper] insight can arise."[6]

At the close of this chapter I discuss the recycling of Braun's images on the World Wide Web, particularly on YouTube. Among these recyclings we find the images' appropriation to meet very different (political) ends. I have already demonstrated that because of their fluctuation in meaning, all amateur images are open to different political agendas when they are appropriated for use in public memory. However, recycled instances of Braun's images have been extreme, ranging from music video narratives at one end of the spectrum to experimental film at the other, thus representing a very articulate example of both the fluidity of the amateur image and the instability of Eva Braun as a historical signifier. Similarly, in the YouTube reuses of her image and her images we find the most rigid and extreme example of blindness to their historical, let alone their political-ideological, dimensions. I hope that the way these images are being reused in popular Web-based narratives will be an impetus and a justification for the need to find other ways to interpret them.

Who Was Eva Braun, and Where Can We Find Her?

Despite the proliferation of both still and moving images produced, edited, and archived by Eva Braun, critical attention has focused on the twenty-two existing pages of her diary, in which the first entry was made

on February 6, 1935, immediately prior to her attempted suicide.[7] For most historians, the diary entries are of great interest because they offer a melodramatic narrative of an emotionally tormented, psychologically conflicted young woman prone to depression and obsessively focused on her unavailable lover. These insights into Braun's psychic and emotional life, and particularly her commentary on the impenetrability of her lover, appeal to historians. The Eva Braun of the diary is embraced by historians because in her they find a psychological explanation of an otherwise opaque, if vacuous, young woman. Similarly, the diary gives them unprecedented insight into Hitler's psychological instability. Official history relates that Braun was a fickle, flighty, and vain young woman chasing prestige and money, while the diary reveals a different Eva.[8] According to the diary, she was obsessive, dark, and devoted to an older man whom she saw as her potential savior. Critics maintain that this was the "real" Eva: a kept woman forbidden to show, let alone express, herself in public, who is revealed to have had desires and obsessive yearnings beneath her pristine veneer.[9] In turn, for these critics, this information about Braun automatically offers insight into the real Hitler: his otherwise concealed, intimate, personal self is potentially accessed via the psychological instability of his mistress. Unfortunately, the same revelations cannot be identified in Braun's photographs and films: perhaps this is the reason that they are often dismissed as inconsequential.

What is most striking about histories that do turn to the films and photographs is not that they look to Braun's images for private visions that reveal Hitler's intimate secrets and vulnerabilities but rather that they claim that the images are about Hitler in the first place. As we view the endless shots taken by a camera traveling across picturesque landscapes, documenting yet another gathering on the balcony at the Berghof, or taking part in the play of dogs, perhaps reveling in Ursula Schneider taking her first steps or her baby sister being born, and elsewhere the fun had by Eva and her girlfriends at the beach, we are struck by the fact that, for the most part, they have very little at all to do with Hitler and certainly reveal nothing about his inner psychological life. I argue that these films and photographs are documents that narrate Braun's version of history. They represent her memories and explore her identity growing up in Munich

in the 1920s, her family, her life of leisure in 1930s and 1940s Germany.[10] Thus to analyze the home movies and family albums for their cultural and historical significance means that we must refrain from imposing expectations that they will reveal secrets about Hitler and his fragile ego.

In one of the most sustained examples of attention to the images, Angela Lambert includes a chapter on them in her recent biography of Braun. Everything Lambert writes about Braun stems from the belief that she was a vacuous, moody young woman with aspirations to glamour and fame.[11] Lambert uses the images to affirm this now well-rehearsed argument: she claims that they reflect the emptiness, self-indulgence, and performativity of Braun's life. Lambert writes, "Not a single photograph shows her doing anything serious like homework or reading—except one, in which she poses with a book propped on her knees, displaying her legs. The ectoplasm of her character streams through these images. Vain, sentimental, self-centered and shallow, she is a typical pre-adolescent girl."[12] Although it is true that Braun is rarely depicted to be in intellectual or political pursuits, her vanity, sentimentality, and vacuity are debatable. Lambert, like other critics, has expectations that exceed the limits of what family albums and home movies usually depict. For the frivolity of family celebrations and special occasions, the enjoyment of sea and surf, the wistful searches across dramatic landscapes are the typical content of home movies and family albums. Such images, not only Braun's, do not depict the sad, the bad, or the undesirable aspects of family life. On the contrary, "home movies are a medium of joy," a medium for the happy and optimistic moments, the life force, of the family and home.[13] When Braun did parade before the camera or pose to show off her latest bathing suit or her physical grace and dexterity as a gymnast, she did what every young woman does before the amateur camera of her friends and family. Perhaps most important, Braun did not appear in front of the camera reading books or doing "homework" not only because that is not what home movies and amateur photos depict but because she was often behind the camera filming. To claim that Braun lacked serious occupation is to forget entirely that her ideas and imagination were feeding her passion for filmmaking and photography. Thus, once again, the benefit of viewing Braun's images within their context as home movies and family

photographs is that we can look at their surface manifestation, hold in abeyance our expectations of what she and the subjects of her images should have been exposing to the camera, and discover their complex layers of meaning, as well as their contribution to history.

The desire of historians and critics to find an undisclosed secret in Eva Braun's images concurs with what Hirsch, after Roland Barthes, has described as the urge that drives us to look at family photographs for the truth.[14] We always have expectations of the authenticity of family albums and home movies because their images are supposedly unmediated by the technological and economic manipulations of marketplace demands. Indeed, it is the absence of these demands, as I have stressed throughout, that enables the amateur films' and photographs' historical insights. As Citron also says when discussing the family movie, these images are adjudged naïve because there is always a belief that what we see must have existed, and what existed must be accounted for in these visual records.[15] As Barthes says and demonstrates in his discussions in *Camera Lucida,* we look to the family photograph for the truth, a truth that begins with the irrefutability of the photograph's referent, the reality of what once stood before the camera.[16] Unlike the digital photographs of today, family photos from 1930s and 1940s Germany show concrete referents: we have no reason to believe that the events pictured did not take place, that they might exist only at the level of the image. However, as Barthes demonstrates through his reading, as Hirsch elaborates on in her book, and as I have demonstrated in previous chapters, even the truth of the family photograph is complicated. It is always involved in a complex process of concealing and revealing the real body, the real person who was there, and yet is no longer here, because he or she is marked as absent by the very existence of an image in his or her place. Ultimately, this absence underlies the fluidity that enables the double-consciousness of images such as Braun's as I analyze it in the moment of viewing.

A History of the Images

The Braun albums and home movies were discovered and left untouched in her Berlin apartment in 1945 by the Red Army. When the Americans

arrived some months later, they were found as Braun, and later the Red Army, had left them. When the photographs arrived at NARA, they were organized into thirty-three albums. Archivists at the site then organized the loose images into two remaining albums.[17] Although the photographs span Braun's lifetime and include her as a baby, there are only a handful of images taken before 1938, by which time she was nineteen years of age. Rather than giving a chronological account of her life between 1938 and 1945, the albums are organized thematically, and at times geographically. Some of the albums are organized around the individual who is depicted (sometimes Hitler) or, alternatively, to be of interest to the recipient of the album when it was given as a gift by Braun. Due to this organizational logic, there are many repetitions, omissions, and inconsistencies both within single albums and across the thirty-five in existence.

Historians have noted that Braun was given a camera as a young girl and, always interested in photography, she worked in Heinrich Hoffmann's studios as a technical assistant from 1929 onward. It was there that she met Hitler. Once she was working in Hoffmann's studios, Braun had access to the latest camera equipment and processing materials, and eventually Hitler bought her a camera. Lambert says:

> When Hitler rather than Eva was the buyer, Hoffmann advised him and supplied Eva's photographic equipment, making sure it was the best. The film she used was always of the highest quality, the latest Agfa intended for professional use, and because of this her pictures haven't faded or deteriorated as cheaper stock would have done. In the mid-thirties Hitler gave her a splendid twin-lens Rolleiflex, a camera that within a few years would be in demand all over the world for its advanced features and outstanding results.[18]

In the years spanned by the photograph albums, the increase in photographs taken after 1929 when she began work at Hoffmann's studio, and the proliferation of images after 1938 when she took up residence at the Berghof can be explained by her employment at Hoffmann's studio and her subsequent liaisons with Hitler. Once Braun had access to the equip-

ment for shooting and processing photographs her work multiplied. The same was true of the moving color images that were shot in the same period, between 1938 and 1943. Thus it is highly probable that Braun linked her image-making activities with Hitler not for opportunistic but rather for practical reasons.

Despite the attributions, not all the photographs in the albums were taken by Braun. For example, the many professionally produced images, notably portraits of Hitler and other Nazi Party dignitaries that are scattered through a number of the albums, were probably taken by Hoffmann. Similarly, studio portraits of Braun herself, other members of her family, and Adolf Hitler are included in the albums held at NARA. Like all tourists, Braun sometimes preferred postcards of her vacations rather than recorded memories made by her own camera. In Florence, for example, all the views of and along the Arno, the Ponte Vecchio, and the Duomo are provided by postcards pasted into the albums. Most notably, many of the photographs in the albums depict Braun herself. Critics claim that when Braun was before the camera, the photographer and filmmaker had to be one of her sisters or a friend. We do know that her sister Gretl also had a camera from a young age and that the two sisters were in the habit of photographing each other.[19] However, there are also many instances in which Gretl appears in the photographs with Eva, thereby indicating that someone else was behind the camera—when the girls were young, most likely their father, and later, during the years at the Berghof, perhaps other members of Eva's circle of friends. Finally, in addition to the studio portraits, there are many images of Hitler that could not have been taken by Braun because, as a woman with no official status, she would not have had access to such perspectives at these events. For example, in Album 6, which is devoted entirely to Hitler, we see him on a podium at a rally, speaking before a large crowd in extreme close-up, an image obviously shot with a telephoto lens.[20] And in Album 7, following a series of photographs taken on Braun's summer vacation at Seeshaupt in 1939, thirty images of the offensive against France and the occupation of Paris in 1940 could not have been taken by Braun because she was never present at such events.[21]

Thus, if these and other photographs are to be interpreted as Braun's

images, they are hers because she has organized them into albums. She is the author of the narrative written by this reorganization of the images but not always of the images themselves. Again, this creation of a family narrative through an archive of images is the practice of every owner of a family photo album. And, as I turned the pages of the albums, I was reminded of my own albums, filled with my image as a baby, on the first day at school, with a broken arm, at a friend's birthday party, and so on. In this projection of the viewer's own past and own history, Braun's albums facilitate memories that are independent of her albums. Thus we begin to see that they have the potential to be about much more than Braun's subjective image and her version of history. Through their spawning of subjective and objective memories in the moment of viewing, these images open up to their broader historical meaning.

The four and a half hours of color footage that arrived at NARA in fragments are likewise complicated in their authorship.[22] The films include long sequences in which the camera follows Braun engaged in activities such as gymnastics on the beach, bathing at a waterfall, and posing on the balcony at the Berghof. There are also some fragments that depict Braun filming with her own Rolleiflex. Clearly Braun was not behind the moving camera that follows the centrally framed subject in motion and the moving images of her in the act of filming. Once again, however, it is not clear who was filming this footage. Even though there are no studio shots, no footage taken on the Western Front, and no images of official gatherings in the motion picture reels—that is, no footage culled from other public sources—Braun's status as film "author" is not dependent on her position behind the camera. As in the case of the photograph albums, we see that Braun was the kind of filmmaker who compiled and edited fragments into narratives that represented her, as well as moments she wished to remember. Like the photograph albums, Braun's films are an archive, a repository of images through which she constructed her individual story and, by default, a story of the historical moment in which she lived.

In her book on life at the Berghof and the bunker, Hitler's secretary, Traudl Junge, tells us that Braun edited the films herself, always with a specific audience in mind.[23] Junge explains that Braun showed her films

at two points during the day at the Berghof: the first was in the allocated rest period before dinner, and the second was after dinner while Hitler and other officials were occupied with the briefing of the day's political events. Braun was in the habit of showing her films to friends and any visitors not required to attend the after-dinner conference briefings at the Berghof. Unfortunately, the film events cannot now be re-created because we have no record of these original screenings. Nevertheless, we might assume that, like anyone exhibiting their home movies, Braun added her own narration at the individual screenings, explaining and identifying all that was in the images—that is, instructing her audience about how to see them and what to look at. Once again, like the photograph albums, the narratives of the home movies were created in part during their exhibition, with a very specific audience in mind. Braun's status as a film author who made, collated, and exhibited images must be central to the tenor of the images and the texture of the histories they narrate. In a practice typical of the amateur and home movie filmmaker-cum-exhibitor, Braun archived the images as a way of constructing, and thus memorializing, her self-identity and, eventually, due to her association with the most public of figures, the contours of twentieth-century European history. Thus the films belong to a memory culture that begins, like the narrative of all home movies and photo albums, with a self-construction of a subjective identity and then moves out to express the larger social world in which this identity makes sense. Due to the particularity of this memory culture, when contemporary viewers come to see the images, the process of witnessing and remembering the history that surrounds them differs from the processes of witnessing the traumatic past via the still and moving images discussed in previous chapters.

Explorations of the Medium

The complex shifts between the interior world of the Berghof and the political and historical events beyond its walls, between Braun's subjective identity and collective memory as they are enabled through the images, commences with an exploration of her creativity in the countless shots of spectacular scenery, not only that which surrounded the Berghof but also

that which she discovered on her travels abroad. The depictions of soaring mountains, ravines, and undulating hills, in summer and winter, ranging from deep greens and blues through the stark whites of snow-covered fields to the brilliant reds of fires and sunsets and the burnt ochres of the midday sun, are at times extraordinary for the natural beauty of what lay before the camera and also for the artistic and stylistic sensibility with which they were filmed. The breathtaking scenery was shot in close-up and long shot, in long takes and quick cutaways, sometimes with figures in the foreground or background and at other times devoid of human interference. Braun's footage of bathers, skiers, herself as a gymnast, and skaters on frozen lakes reminds us of Leni Riefenstahl's footage of the athletes at the 1936 Berlin Olympic Games in *Olympiade* (*Olympia*, 1936). Like Riefenstahl, Braun used her camera to celebrate the power, athleticism, and beauty of the human body in motion.[24] And yet, as is revealed, unlike Riefenstahl's images, Braun's are the typical shots of an amateur fascinated with herself and her medium at home and on vacation.

In Reel 1 the camera watches Braun engaged in a series of athletic activities. She and her friends swim, water ski, go boating, do acrobatics, and dive while on vacation. At Königssee a figure dives in a movement made balletic through the position of the camera and the deliberate slow motion of the images. In another sequence, Braun is depicted in color as she performs acrobatics of a high degree of difficulty. The camera follows her, slows the motion down, and even freezes the frame in an attempt to capture the rhythm and beauty of the body in motion. Riefenstahl's use of these same camera strategies to revel in the beauty of the human form in motion at the Olympic Games in Berlin represents a pivotal moment in the history of film. Although interest in Riefenstahl among historians is most often linked to her connection to Hitler and as the privileged designated documenter of the Olympic Games and the party rally at Nuremberg in 1934 *(Triumph des Willens),* her works also often broke new ground in the use of the medium.[25] *Olympiade,* in particular, is innovative for its exploration and exploitation of the creative potential of the film camera and the medium more generally. Never before had it been possible to see the trajectories of the body in slow motion, stop-motion, and freeze-frame. Similarly, the balletic movements of the divers, discus throwers, runners,

and pentathletes are mirrored by Riefenstahl's camera in motion, her extraordinary manipulation of time and both in-camera and postproduction editing techniques. The human body and Riefenstahl's camera and other cinematic techniques fuse into a poetic celebration of the perfection of the human form.[26] Though Braun's home movies were made independent of the proliferation of theoretical reflections on the interdependence of cinematic and photographic media with the fabric of modern, industrial life, and obviously not with the skill or artistic sensibility of Riefenstahl's footage, we find the same concerns visualized in them. This imitation of the latest developments in professional cinema is so typical of amateur filmmaking contemporary with Braun. As Roepke explains, it was never enough to know how to use the medium; the amateur was driven to reach great creative levels with his or her "artform."[27]

Braun's depictions of the synergy of camera and body in motion also resonate with explorations from the earliest days of film's narrative development. Yet again we find this anachronism, a recalling of the nascent explorations of the medium at a time of great productivity and development for amateur film in Germany. For whatever the political implications of her experiments, Braun engaged with cinematic history, probably unwittingly, when she mined the love affair between camera and human body in order to display the capabilities of both in motion. In the tradition of images such as those of Muybridge and Marey, Braun's home movies offer a perspective of the body in motion that is otherwise not possible to see with the naked eye. Braun's films were shot much later than those of her predecessors and are without the technical and aesthetic quality; thus, although they are in the vein of some of the early twentieth-century cinematic experiments, forty years later they are nevertheless marked as amateur by their tendency to imitate. Again we find amateur film repeating the technical and technological innovations of the silent film medium, bringing them into the home for the first time in the 1930s and 1940s.

Like the photographs taken on the Eastern Front, Genewein's use of color, and the color film footage discussed in chapter 4, Braun's home movie footage testifies to the interpenetration of more dominant models of twentieth-century filmmaking with these amateur modes. Lambert explains that Braun's cameras were often at the forefront of image-making

technology, and thus, although she retraced already trodden stylistic and compositional paths, she did so with these new instruments in the home movie arena. Thus Braun reignited and extended through the use of the lightweight amateur Rolleiflex camera developments in the capacities and limitations of the cinematic image. Although Braun did not make an outstanding contribution to existing understandings of the cinema, her images, through their resonances with better-known works from the early twentieth century, contribute to the significant place held by amateur film within the history of cinema. And it is a history of cinema that extends further and wider than the conventionally considered trajectory. Similarly, seeing Braun's images through this optic sheds more light on the contribution they make to German cultural history. These are, at one and the same time, depictions of everyday experience and demonstrations of an intrigue with framing, filming, technology, and the cinema in general. This complexity further substantiates the claim that Braun's images challenge the widely propagated vision of her in particular and of the German woman more generally at this time. Braun's enthusiasm for and awareness of her image-making activities demonstrate the existence of creative expression and exploration by women among amateur image makers.

If we are to believe the rigid National Socialist tenets concerning women, such films and such women did not exist. By the late 1930s, when Braun was entertaining with her films at the Berghof and compiling her family albums, the feminist discourse in National Socialism had all but died down. Women, especially bourgeois women, were supposedly relegated to *Kinder, Küche, Kirche* (children, kitchen, church), and by all accounts this was a conception of womanhood in the service of National Socialist culture favored by women themselves. If they were not housewives (or domestic servants in the case of the working classes) in the kitchen and bearing children in support of the Nazis' racist population policy, they were working in support of the war effort, in munitions industries, for example. Abortion was a punishable crime, women deemed socially unworthy were sterilized, the working of bourgeois women was discouraged, and marriage and childbearing were applauded. Braun, the childless photographer and filmmaker, demonstrates that the historical reality of women's lives among those of political privilege was another

thing altogether.[28] In fact, like the prohibitions on taking photographs discussed in earlier chapters, the policy on motherhood and childbearing was clearly upheld in theory only. The laws were ignored by the privileged and enforced with grave consequences against the poor, the apparently socially unfit, the morally suspect, and the disabled. Thus, as Gisela Bock argues, the mandate that women conform socially was just another thin disguise for the ideology of racism in the service of producing a superior Aryan race. Braun's life outside of the Nazi policy is an important historical example of how women, especially among the political elite and thus the socially privileged, not only lived independently but of how that independence was hidden for fear that it would expose the hypocrisy and vulnerability of Nazi ideology.[29] The very existence of these images and of Braun as she constructed her identity through them subverted this aspect of the history National Socialism claimed it was creating. Braun may not have been the agent of this subversion; rather, the force of the images and the narratives they tell are more likely the result of her privilege. Nevertheless, her images are the sole examples made by a woman that reflect the apparent liberty of women of privilege to act beyond the professed Nazi ideology. Hence their historical import.

Returning to Braun's images, it is not only the movement of the body that is repeatedly represented, but, as in all amateur films made at the time, the movement of the camera. This movement also connects Braun's work to explorations of the medium being conducted elsewhere. In particular, as in the example of the footage taken from the window of a train arriving in Warsaw, Braun's camera moved across landscapes. It traveled across the waves of the ocean, at times from the perspective of the boat in which it sat, at other times independently. The patterns created by the surface of the water left in the wake of the boat or the waves breaking on the shore of the sea or a lake were lyrical for Braun and are for her viewer as well. Again and again we see panoramic vistas of the mountainscape beyond the Berghof. The blues and greens of the land and the sky, the abstract patterns created by the clouds, and the perfection of a sun reflecting on the calm of the mountainous horizon at different times of the day were sources of fascination for Braun. Her camera often followed the horizon for the entirety of a three-minute reel. Her camera also panned across

the extraordinary Norwegian fjords and the gently floating ice floes. These shots are juxtaposed with those that represent the speed of the water passing by in direct correlation with the speed of the boat in which she traveled. We also see the sky and the sea change color, from green to red, violet, and blue, as day turned into night. The camera was also in motion as its lens watched the back-and-forth of a game of deck tennis or the movement of bathing women's legs splashing in the water or skating effortlessly on a frozen lake or when it observed activities as domestic as Braun's father chasing the family's dogs around the backyard of their Munich home.

Although Braun's use of the moving camera is consistent with that of her historical and cultural period, her concentration on the beauty and abstract qualities of landscapes makes her images unique among home movies at this time. Indeed, this innovation was made possible only by her privileged access to these landscapes, the technology with which to film them, and the opportunity to travel on repeated occasions to particularly picturesque locations. The colors of the sky and the mountains radiated on the cyan film stock, and all she had to do was direct the camera. However, it is also a tribute to Braun's interest in the abstract patterns and rhythms of nature that she captured their photogenic aspects. Like other amateurs, Braun had an eye for and an interest in the photogenic, the possibilities of her relatively new medium, and image composition. In addition, Braun's aesthetic judgment is underlined in her vision of a natural world seen from a different perspective, that is, through her camera's lens. All of these qualities—the abstraction of the natural world, the body in motion, the privileging of the visual medium—have been discussed as indicative of the image's involvement in the developments of amateur film in their midst. Thus we see the involvement of the amateur image maker in the articulation of modernity, especially technological modernity, thanks to the development of lightweight, portable cameras.

Braun's exploration of the image takes a different form in her black-and-white photographs. In the photographs she reveals a fascination with landscapes and is captivated by the beauty of the natural world, not its expanse but rather its formation of patterns and structures. Most striking among the albums is one containing the photographs taken on her trip to Italy in 1938. Once the party moved south to Capri, Saturnia,

and Pompeii, Braun's photographs of the landscape become abstract. We see sunsets over the island of Saturnia, taken from the boat in which the party approached the island. In one image, the sun's light reaches across from the horizon to meet the boat from which the silhouetted figure of Eva Braun, on the right, admires it (Figure 16). In other images smoke billows from Mount Vesuvius to create an abstract photographic image of light and dark, smoke, air and earth as a source of fascination (Figure 17). The compositions show Braun's keen interest in image composition, balance, and the manipulation of light, all of which were stressed in amateur photography journals from the period.[30] Perhaps most dramatic are Braun's images of the shapes and patterns of the rugged mountainscape of Vesuvius. The strange tendrils of hardened molten earth wind and knot their way across the surface of the photographic image like an aberrant growth that has attached itself to the mountain (Figure 18). These images are abstractions of light that, once again, mimic the preoccupations of other amateur photographers in the late 1930s and early 1940s, demonstrating Braun's impulse to be creative with the medium. This imitation defines both her aspiration to aesthetic experimentation and, by extension, her status as an exemplar of an amateur photographer of the period.

We might argue that the sights of Capri, Saturnia, and Vesuvius provide material sufficient to turn one into a creative photographer. However, in Braun's photographs she consciously abstracts the landscape. Often by taking away the context of the landscape and leaving the patterns it formed in view, Braun demonstrates a manipulation of the light into different densities. This strategy, in turn, enabled her to emphasize the textures inherent to the natural formations, the gestures, of the earth. This sensitivity to the behavior of light, its interaction with the physical geography of mountainous lands, and Braun's ability to manipulate both produce images that are much more than generic holiday snaps. They are the work of someone who was concerned with the creativity of her pastime.

An Amateur Nevertheless

Even though Braun experimented with the aesthetic quality of the image in photographs of landscapes of perfection and Romantic visions of

FIGURE 16. *Sunset on a boat at Saturnia in southern Italy, with the silhouette of Eva Braun at the right side of the image, 1938. Courtesy of National Archives, photo 242-EB-5-13 C.*

coherence, beauty, and idyllic worlds, her home movies and family photo albums, nevertheless, bear all the traces of the amateur as experimenter. In the films she did not always get the lighting quite right, and the content of the images cannot always be determined. Similarly, Braun's films and photographs are filled with flaws, repetitions, jump cuts, and other distractions that contribute to the histories they narrate. Even in the footage of the sea shot from a boat there are flaws: for example, in the footage of Norway, the various parts of the boat come into the front of the frame and our view of the fjords is at times obscured. Alternatively, the pans and tracks across the landscape from the balcony at the Berghof sometimes last too long, that is, they appear endless and dull to the viewer. Such imperfections are instructive, though, because they highlight the limitations of the modern technology and the difficulties of negotiating it. In the images' revelation of, for example, the persistent obstacles to

FIGURE 17. *Mount Vesuvius, with strange patterns in the earth and smoke emerging from the volcano, 1938. Courtesy of National Archives, photo 242-EB-5-28 A.*

FIGURE 18. *Mount Vesuvius, with molten earth in abstract patterns. The artistic experimentation and abstraction of Eva Braun's photographs of Mount Vesuvius are similar to those of any tourist to this dramatic site. Courtesy of National Archives, photo 242-EB-5-26 C.*

landscape filming, we identify the richness of Braun's amateur footage and photographs.

The photograph albums are also replete with blurred images, repetitions, places where images have been ripped out, and even some mistakes. On the one hand, these flaws tell the story of the lives of these images, where they have been. For example, in Album 31 there is a missing photograph. The photograph has left four white marks behind where it was once attached to the page (Figure 19). Underneath this empty space, Braun wrote "Als Schulmädchen" (As a schoolgirl). We wonder where the photo of the schoolgirl has gone. Who removed it? And why? Did it perhaps reveal something Braun did not want the recipient of this album to see? Or did it simply fall out on the album's journey between Eva Braun's bedroom and NARA? Another image has faded to the point at which some of the contents are undistinguishable, the surface is torn, and we see the wear and tear on the surface where it has been folded, perhaps to be put in someone's pocket (Figure 20). Another image of someone riding a horse is now only a fragment,[31] and another of an extended family gathering appears to have been rescued from the trash and pasted back together.

It is not only the lives of the images and the scars of their display that reveal the amateur status of Braun's images but also the flaws that have occurred in the process of image production. These flaws provide insight into developments in photographic material and processing in the short space of twenty years between 1916 and 1939. The 1916 images of Braun's grandparents have faded and lack the clarity of images taken twenty years later because of the still underdeveloped state of photography for home use at this time. The blur due to the figures' being out of focus; the fact that they are all taken in long shot, which makes determination of who is shown in the photographs more difficult; and the 2.5-by-2.5-inch size of the early World War I–era photographs are all in keeping with the state of amateur and family snaps from the period. Through the flaws of another image of the Braun family, namely, the cracked glass of the surface, we are able to see that Eva Braun took glass transparencies at this time. Indeed, the photographs in the Braun albums are absolutely of their time, reflective of the aesthetic and the role of amateur photography at these moments in its development.[32]

FIGURE 19. *Album page with missing photograph. Original German caption:* "Als Schulmädchen" (As a schoolgirl). *The photographs in this album were taken as early as 1916 and are predominantly of Eva Braun in her teens, so the missing photograph was probably taken in 1924 or 1925, when Braun was twelve or thirteen years old. Courtesy of National Archives, photo 242-EB-31-23 B.*

As we turn the album pages and the years of the images progress, the photographs become larger and fall into the conventional 4-by-6-inch aspect ratio of snapshot photography.[33] And as the technology allowed, the close-up becomes more of a regular feature in Eva Braun's albums. This technical development also shows a corresponding shift from a belief in photography as a mode of documentation to that of photography as a

FIGURE 20. *A worn photograph of a woman and two girls. The album page is dated 1916, which would suggest that the girl on the left is Eva Braun's older sister Ilse (born 1909) and the girl on the right is Braun (born 1912) with their mother, Franziska. Courtesy of National Archives, photo 242-EB-31-10.*

form of artistic creativity. True to the tendency of amateur photography to lag behind the artistic developments in professional photography, the developments in Braun's amateur imagery are in keeping with the shift in the ways the photograph was seen and understood in the literature of an earlier period. There was an explosion of writing on photography in the 1930s that signaled the embrace of the creative potential of photography.[34] And the publications of amateur film clubs engaged in animated discussions and offered suggestions to their readers on the creative exploitation of their medium.[35] This does not imply that Braun was reading photographic theory or amateur film and photography journals but rather that she was interested in and had an awareness of developments taking place outside of the Berghof. She explored her medium as did any amateur photographer of her day.

Early images taken in 1919 in which Eva and Gretl as little girls posed

with their grandmother are typical of family portraits of their period.[36] They literally document the subjects in the image. In the same album we find an image that sees the Braun family at play.[37] The subject matter is consistent with that of other family portraits in the albums.[38] However, in yet another quite different example, everyone is joking and the lighting captures all the faces, even though there are thirteen of them (Figure 21). Through the fun and laughter of posing for a photograph we see a conscious interaction of subjects and photography, a tendency to act before the camera as a way of breaking away from the controlled power dynamics between camera and photographed.[39] Similarly, we see a more conscious manipulation of the lighting on the part of the photographer as the albums display images from later years in Braun's truncated life. In addition, the rapidly developing technology in the 1930s—Leica's interchangeable lenses, 35-millimeter cameras, flash lamps, and color film and processing—gave way to broader developments in amateur photography, all of which are brought to the fore in Braun's images from this time.[40]

As mentioned, Braun chose to include images in the albums and home movies that did not quite work: film footage in which overexposure obscures the image or a double-exposure photograph.[41] Braun was not obsessively concerned with perfecting her images, and again, typical of the amateur photographer, she gave priority to content over clarity. For example, even though some of those taken at Ursula Schneider's christening are blurred and indecipherable, they are still included in the album she compiled for her friend Herta, the child's mother.[42] These imperfections are instructive because through them we are able to see Braun experimenting with her camera. In an image such as that in Figure 22 the blur resulted, as the content of the image betrays, from the fact that Braun was taking a photo of herself taking the photograph as seen in a mirror. Although the content of the image itself may not be so revelatory, it is nevertheless indicative of Braun's enthusiasm for the possibilities of her medium and her use of the camera for self-realization. Thus, even though it is not a perfect image, it is significant in the narratives of individual and collective identity that run through her albums. Ultimately, these narratives represent the historical value of Braun's images.

FIGURE 21. *Celebratory photograph of thirteen people, with a crack or tear on the left side of the image. Original German caption: "Einladung zu Hause" (Invitation to the house). Courtesy of National Archives, photo 242-EB-31-45B.*

Careful study of the Braun albums and home movies reveals that the films and photographs challenge existing historical discourses in a unique way because of their amateur status. Whereas Genewein's photographs constantly reiterate his desire to be taken seriously as a photographer, even though he was a self-identified amateur, Braun did not seem to mind staying behind closed doors as a filmmaker and photographer. Indeed, her status as an amateur out of the public eye was empowering to her because she and her camera were able to see from perspectives that represent Hitler and life at the Berghof as no others did. Together with the material privileges she received because she was Hitler's lover, his presence in her "family" combines with the images' amateur status to give them their potential for historical insight.

FIGURE 22. *Eva Braun takes a photograph of herself in a mirror as a teenager. Courtesy of National Archives, photo 242-EB-31-24 F.*

Anonymity and Authorship

Braun's home movies and photo albums cast the distinction between the authored and what I have termed the anonymous image in a new light. I have already mentioned the tension at play in the question surrounding who shot the photographs and films as opposed to Braun as the collator and exhibitor. There are other ways that they challenge the distinction. For example, Braun's images introduce an understanding of the anonymity-authorship bind as changing in status across time. The status of Braun's moving and still images is quite different today from what it was in the 1930s and 1940s. Braun and her images were unknown to the public at the time of their production, and if they were published, they were not recognized as her images. As iterated earlier, she was motivated to take and display these images by a complex set of issues and circumstances. However, despite all of their revelations, they were never conceived with publication or promotion of herself as a famous photographer or filmmaker in mind. At least the photographs' collation into albums as gifts and the films into nighttime entertainment at the Berghof do not give any indication that they were intended for general audiences. To all appearances, Braun was pursuing her pastime with the assiduity of an amateur artist. Today, however, her images are seen beyond the private realm, usually recycled in new narratives that foreground them as the images of Eva Braun, Hitler's secret mistress.[43] And they are looked to for their potential revelations of his private life. Thus, as they move from unremarkable images of an unknown young woman to objects of fascination taken by a historical figure, the challenge made by these images is also realized in time, across history. In the movement from obscurity to identity of her images, in their journey across seventy years and the Atlantic Ocean, Braun is given a voice as a woman and a historical voice as a photographer and filmmaker. In turn, the shift from obscurity to repute (of both the images and Braun herself) has a public dimension: typical of home movies and family albums, especially those made by women at the time, the images become public documents that enable the work of researchers keen to reconstruct and interrogate aspects of everyday life in Nazi Germany.

Annette Kuhn is a feminist scholar who accesses otherwise ignored and forgotten histories of another era through looking at family photographs. Kuhn writes about how the history and identity of the family is constructed, produced, and certified through the creation of the narrative of the family album. Details such as whose photo is situated next to whose, whose is left out, whose is included, whose disappears halfway through the story, and so on are the threads woven into the complex, often silent histories of ordinary men and women. All of these details amount to the narrative the family tells itself in an attempt to create and confirm its lineage, its coherence, its uniqueness, and of course its memory of itself. Kuhn also draws attention to the importance of the struggle for ownership and identity of the image, a command or authority that might be asserted through the captions, captions that might be as simple, yet as deceptive, as the ascription of place and time. Kuhn writes:

> Family photographs are quite often deployed—shown, talked about—in series; pictures get displayed one after another, their selection and ordering as meaningful as the pictures themselves. The whole, the series, constructs a family story in some respects like a classical narrative: linear, chronological; though its cyclical repetitions of climactic moments—births, christenings, weddings, holidays (if not in my culture deaths)—is more characteristic of the open-ended narrative form of the soap opera than of the closure of the classical narrative. In the process of using— producing, selecting, ordering, displaying—photographs, the family is actually in the process of making itself.[44]

Kuhn goes on to explain that the family album often makes up a desired history of the family where one did not previously exist.[45] The family album puts right what did not exist in reality: it creates the memories necessary for a family history. Likewise, when Citron suggests tracing the fault lines in this family history, she does so with a focus on the appearance of women before the camera. She wants to look behind the surface of the image in order to find the truth about family ties and the tenuousness of relations, especially between men and women, adults and

children. Citron's imperative to look to deeper levels of representation is prompted by footage in which the man of the house is usually behind the camera. Therefore, it is the gestures, facial expressions, postures, and activities of the women before the camera that hold the undisclosed "truth" of the family history. On one level, we can pry open the fissures in Braun's visual narratives through focusing on their contents and composition. And on another level, when the images are seen as objects, we can locate the vision of Braun the author simply by recognizing that she built her narrative and her history through the compilation of these images. Thus Braun's images offer a unique opportunity to visualize a woman's identity at multiple levels, thereby extending the interpretations of Kuhn's family albums and Citron's home movie footage.

Accordingly, in order to understand the narrative as Braun's own history, whether she took the photographs or not is not the point. Even though the images can be acknowledged as generic snapshots and home movies of her friends as they relaxed, her family on vacation, and her lover as he entertained business associates, for today's viewer she is always, on some level, the author of her albums. She created a history, different stories in the different albums, because it was she who organized the images into her version of events, her version of how things were. Just like the stories told over the top of the fragmented, troubled world of Kuhn's *Family Secrets,* Braun's images created a happy, carefree life where neither a conventional nor a coherent family existed. It is true that *in* the images her biological family celebrated the expected milestones in the family's history—births, christenings, birthdays, family holidays, and so on. However, once she got to the Berghof, the only family that existed was that created *through* her images. This was a family comprised of her friends, and, where they existed, their children. As a woman who had no family of her own, the maker of these films and albums brought a family into being, authoring a family that took the shape of her community of women friends.

Beyond recognition of her status as an author, Braun is given very little authority as an image maker today. As indicated, critics are quick to criticize her contribution to historical narratives of the period, and among the few images of her that are reproduced, she is typically shown in a swimsuit

or a pretty dress, posing or performing for the camera. However, these critics are blind to the authority and identity that does exist, at the very least, in the narrative organization of her films and photographs. Indeed, Braun found authority, among other places, in her creative rendering of a coherent family. She also found a historical authority in her capturing on film of events and people that were not meant to be seen or shown in public.[46] Thus I want to reflect on the self-identity that, in hindsight, Braun can be said to have constructed through her still and moving images.

The measure of Braun's presence in the narrative is revealed in the difficulty, at times the impossibility, of determining the logic of the editing choices in both films and photographs, a logic only she would be able to decipher. In more publicly minded presentations of home movies and photographs one can expect to find a voice-over narration or accompanying text that functions to direct spectatorship in the logic of the unfolding narrative.[47] However, here, over seventy years after the production of these images, we are left to wonder at their organization. Although Braun's presence can be identified in her home movies and photo albums, their literal muteness ensures that the authorial voice is silenced, awaiting recognition by a contemporary viewer. This silence is, in turn, a key factor in their shift back into more generic home movies and amateur photographs, a status that gives the images an anonymity in the moment of viewing. This silence enables a contemporary viewer to see the home movies and photographs on different levels, alternating between visions of Braun's subjectivity and generic historical documentation.

The muteness of the amateur images invites us to see ourselves therein. However, it is also due to this obscurity and silence that critics such as Lambert judge the images superficial and of little or no historical significance. They are, after all, too vacuous to be worthy of serious concern. And it is the same muteness that opens the images to, for example, appropriation in the tribute videos on YouTube that I discuss later. However, I want to focus on a particular optic of interpretation: namely, that their muteness, both literally and figuratively, is what liberates them from the expectation that they will expose the secret intimate life of Hitler. Furthermore, their muteness is what makes them appropriate to processes of witnessing on the part of the contemporary viewer.

It is true that Braun's images work to construct a truth or truths, namely, the truths of her own identity. To follow Linda Rugg's thinking, these albums of "autobiographical" images reveal "the need . . . to assert a singularity of selfhood for [herself]."[48] However, if we foreground the productivity of the hesitation between identification of Braun as the owner and controller of her image and the images she created as the remnants of a past that we cannot pin down, the Eva Braun represented therein is plural: she is a woman, Hitler's mistress, a historical figure, a filmmaker and photographer, an amateur collator and editor of images. And because she was, in addition, a woman with a camera in Hitler's circle, the absence of this no longer living Eva Braun undergirds the shift to public documents that enable collective memory.

In her work on family photographs and practices of looking at our own and other people's old photos, Hirsch conceives of the "familial gaze," a practice of looking that foregrounds the ideology of "family," overriding the alienating forces of economic, ethnographic, racial, and other differences that separate a subject in a photograph from the one looking. Hirsch believes that this familial gaze is enabled because the family photograph lies somewhere between the mythical notion of the ideal family and the reality of the pictured family. In turn, the tension between the two creates a contingency of the family as an institution, an openness created visually through the series of looks within the photograph. Even if the look is sociological, cultural, psychological, or historical, the photographed subject always knows it is being looked at from outside as well as inside the family. Even though the family may appear closed and turned in on itself, it is always open to the "external gaze." This openness is, in turn, our invitation to project our own vision of our family, likewise caught between the mythical and the real, onto the stranger's family photographs. The meaning of the images is sure when looked at by members of the pictured family, but outside that narrow circle, thanks to these particular conventions of looking that structure the images, they still become available for identification across political, anthropological, and historical divides. It is our life story, the familial and cultural codes within the past, that are triggered by looking at the world of another family.[49] Hirsch says:

Recognizing an image as *familial* elicits, as I have argued, a
specific kind of readerly or spectatorial look, an *affiliative* look
through which we are sutured into the image and through
which we adopt the image into our own familial narrative.
Akin to Barthes's move from the studium to the punctum, it is
idiosyncratic, untheorizable: it is what moves us because of our
memories and our histories, and because of the ways in which
we structure our own sense of particularity.[50]

Following this logic, our memories, our own lives, lives captured in simi-
lar family albums and home movies, might be remembered when we
look at Braun's images. As we look at Braun relaxing on vacation with
her friends and family, spending the day entertaining, engaged in festivi-
ties for her friends' baby's christening, and so on, we are drawn into a
world of family memories. When I looked at these albums and films I
did not immediately see a world of Nazi politics and ideology. Rather I
was distracted by who looks at whom in the images, who touches, who
smiles, who looks out of the frame, who is alone: all of these exchanges
are "traversed by desire and defined by lack."[51] And in visions that are,
just as Hirsch would have it, caught between images of the ideal family
or community and the exposure of real relations, we find "memories of
situations or places which are similar to what we see in the image. We are
not led into the image, we are led back into our memories."[52]

True to the images' construction and role as amateur photographs,
the distance between us and them can give way to a projection of the
viewer's familial experiences and memories into Braun's. This exchange
between Braun's family and friends and those of the contemporary viewer
challenges a reassessment of the collective experiences, of contemporary
processes of looking, and ultimately of the viewer's potential agency and
responsibility in what is seen. Thus, for example, when I look at Braun
on vacation, having fun with her friends, playing hostess on the balcony
at the Berghof, I am reminded of my own childhood, of the parties at
which a camera was always present, the thrill of seeing ourselves on film
as we sat around the projector weeks, sometimes months later, when the
roll of film was finished and finally developed. And in looking at the

photographs I see myself on my first day at school, I see my own birthday parties, and so on. Through this process of projection I as a viewer am placed, if only momentarily, within a field of vision, a way of looking marked by a cultural dialogue and a cultural memory across generations, nationalities, a dialogue that unfolds beyond political, ideological, and social divides.

And then, as quickly as I have fallen into reminiscing about my own past, I am jolted out of my imagination when Hitler, indeed anyone in uniform, enters the film frame or the image on the next page of the photo album. Simultaneously, the same images are shocking, horrifying. I immediately recoil and am repulsed by the apparent nonchalance with which they are going about their daily business. I am promptly distanced and shut out from the subject matter of Braun's images. I remember what I am looking at; I am consciously aware of the ambivalence with which I remember and am all too wary of the unsettling simultaneous diving into and recoil from this world. As the researcher engaged in uncovering treasures in the archive, I am torn between wonder at the imagined "normality" of Braun's life—a normality expressed via the generic historical home images—and a consciousness of the disturbance caused by my own willingness to take part in this serene ideality. Herein lies the distance from the images that is so critical to the process of witnessing the past as I have described it in other chapters. This viewing process of "falling into"—as Hirsch calls it—private memory and the simultaneous jolt into a historical recognition of the past creates a self-awareness of the practice of viewing that, in turn, pushes the viewer to question the formation of memory and history as it is based on this same practice. If we think of the duality of this viewing experience through the lens of Citron's notion of the second track, these personal images have the potential to "hold the promise of both insight and terror" when we are confronted by the personal and public pasts they weave together.[53] Thus, as always, there will be many different responses to these images in their archival context, particularly dependent on viewers' own histories. Nevertheless, these responses are likely to be plagued by a deep ambivalence, and this ambivalence is the basis of a forced recognition that today we still have a responsibility to this past and an agency in how it is remembered.

The Woman, the Home Movie, the Photo Album

At first glance, Braun's films and albums depict happy and carefree lives, as do any other collections of still and moving images through which families and friends understand themselves, their identities, their social contexts. The veneer of harmony and coherence is always an invitation to explore what is lost, covered over, and unfathomable in these or any other set of family photographs or films. Thus, taking our cue from other critics of amateur images, we might ask, What in fact are some of the relations and subjective identities that are masked behind the myth of these "ideal bourgeois families"? One possible understanding might unfold thus: When looking at Braun's films and photographs, particularly those taken in the presence of her biological family, we are immediately struck by the absence of both her father and her mother. Typical of the images that are collated and presented by Braun, as well as private photographs and films more generally, the father is rarely seen. On the few occasions that Fritz Braun is present, he remains aloof, a cold, distant figure who is disconnected both physically and emotionally from the others in the images. Thus, in a rare Braun family portrait, not only is the father at the back of the image on the right physically separated from the women in the foreground; his stern look out of frame right strongly suggests his mental and emotional remove from the other family members (Plate 16). The four women are also linked through their hand gestures: they either touch each other or, in the case of the woman second from the right, communicate to each other through hand gestures. Fritz Braun, however, stands resolute with his hands in his pockets, reinforcing his reluctance to involve himself with the focus of his family's gaze.

The silent rift between father and daughters is underlined in an image taken on the occasion of Fritz Braun's sixtieth birthday. He, in uniform, again stands rigidly in the background. The bodies and eyes of Eva, Gretl, and their mother, Franziska, are all turned toward the left-hand side of the frame. Although Eva's sister Ilse looks in the same direction as her father, opposite to that of the sisters and mother, Fritz's body is backgrounded by Ilse and Franziska, who occupy the same space in the foreground. In the few images in which Fritz appears, he always stands to the side, in

the background, never at the center of the matriarchal world of his wife and three daughters. He is cold and formally attired, and he stares off into the distance, apparently unaffected by and detached from the people who surround him. The silence that exists between him and his wife and daughters is surely revealing of the family structure in which Eva grew up. Although Eva Braun's albums may present the image of a happy bourgeois family that occupies a trouble-free world, if we follow the interpretation of a critic such as Hirsch, we are able to identify tensions between the father and the female members of Eva's biological family.

The matriarchal structure, the strength of female bonds, and the alienation of the father in the Braun family photographs is echoed throughout the later albums and the home movies. By extension, the traces of Braun's identity as it is revealed through the prominence of the female community in the photographs are echoed throughout her life, as it is depicted in the images. We find a dominance of intimate female relationships and strong communities of women in the upper echelons of Nazi Germany. Once we see the images as indicative of the elite social culture of Nazis, the photographs shift to a historical dimension. According to Braun's images, it is always among the women that the expression of community is most vividly represented. The intimate ties among the women that we see in the biological family portraits and holiday albums are transferred to Eva and her girlfriends, Eva and the women of the Nazi officials, once her camera and albums turn their focus on life at the Berghof. To be sure, although the man of the house, be it Fritz Braun, Hoffmann, Hitler, or any other male figure in Eva's life, may well have been behind the camera at times, the narratives created by her images all have women at their center. Thus, when she went on vacation, relaxed at home, or even participated in what appear to have been mixed gatherings of men and women, Braun's camera was typically focused on the women, revealing the bonds among them.

It can be argued that the men in Braun's life are silently pervasive in the same way that image theorists and artists have argued the patriarchal eyes of capitalism author the ubiquitous images of women in the public sphere.[54] Accordingly, the young Bavarian woman may have seen the world through the eyes of her idolization of and desire for Hitler. She

could be said to have created an image of herself as the woman she believed he wanted her to be. Similarly, the images of the communities of women, for example, enjoying the lakes on a summer's day might be understood to depict women as carefree, at leisure, and not concerned with anything too onerous because this was the image of woman prescribed by National Socialism. The women were, perhaps, just as the men would have wanted them to be. It is true, this is one interpretation. But not all of the images corroborate such an interpretation. Many of Braun's photographs taken at the Berghof in the period of her life with Hitler depict a social world from which he was absent. And when he does appear, like her father, he is often aloof, formal, and removed from the social world in which Eva found meaning and identity. In spite of the distance between Braun's Germany and contemporary viewers, how many would identify with the image in which the man of the household is absent or distant from the emotional life of the family?

Again and again, we find a stark contrast between the subservience and devotion of both men and women in Hitler's presence and their often jovial, relaxed demeanor when he is not in the image, apparently not present at the occasion. When Hitler enters a room or an outdoor space where people are gathered, irrespective of their gender, the atmosphere chills, the people's deportment rigidifies, and both camera and people's eyes become fixed on the dictator. To cite one example, of which there are many, in Figure 23 we are drawn to the relaxed postures and convivial atmosphere of the men and women at the Berghof during the celebration of Hitler's fifty-fifth birthday on April 20, 1944. By contrast, in another image we see their postures stiffened, their bodies turned to Hitler, and all eyes focused on his presence. The minute he enters the photographic frame, the events become official, the figures posed, and the warmth of the human relations evaporates. And as we notice this transformation, the images shift to historical documents.

Analysis of Braun's still and moving images reveals many further insights into the relations between men and women as the images flow from private to public, author-identified to anonymous or generic, past to present, and back again. In another example, we see a typical evening spent in the Great Hall at the Berghof.[55] The image, its setting,

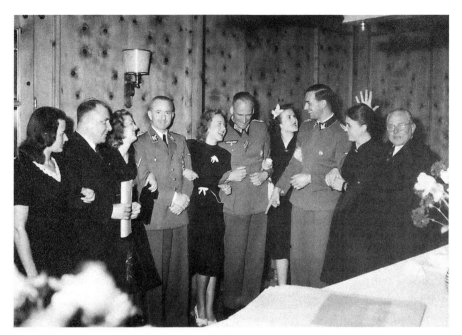

FIGURE 23. *Photograph taken at the Berghof on the occasion of Hitler's fifty-fifth birthday, April 20, 1944. Eva Braun is third from left. Braun named the others (from left): Herta Schneider, Martin Bormann, [Eva Braun], Otto Dietrich, unknown, Dr. Hans von Hasselbach, Gretl Braun, Dr. Karl Brandt (Hitler's personal surgeon, a regular in Berghof group photographs), Anni Brandt, and Heinrich Hoffmann (Hitler's official photographer). Identification courtesy of Geoff Walden. Courtesy of National Archives, photo 242-EB-23-29.*

the paintings, the enormity of the fireplace, the depth of the chairs, the champagne flutes, and the drinks tables with lace cloths betray the opulence and wealth of the event. The careful placement of people and furniture and the evenly composed mise-en-scène tell of the formality of the relations among the people collected here. The men are in uniform, they sit behind the women, and everyone is grouped in twos or threes. There is no warmth or friendliness here—this is a formal gathering of people who are all playing a role—they sit far apart from each other and are dwarfed by the setting in which they find themselves. The fact that the setting is grand in scale, and thus apparently more important than the people, is telling of the fact that their humanity is not what matters in this image.

These people are lost in the formality of the larger picture, the space into which they must fit.

Conventionally groups of people in amateur and home images that depict evening gatherings are united and bound together by emotional, physical, or familial ties.[56] At least an outside viewer would discern some sense of the relations among people. The photograph in a family album is effectively a reiteration of the model of family and community as it is played out under capitalism. As Larry Sultan points out, such images say, "Here is my family replicating the dreams of capitalism."[57] However, in all of Braun's photographs and films of Hitler and his friends or of soldiers or officers—in effect, images that include the men who spent time at the Berghof—there is never a sense of community. The figures never touch, never indicate any interpersonal relationships other than those provided by their uniforms. The mood and tone and atmosphere of these images are typically tense and cold. These more closely resemble documentary reportage than home movies. There is never an image of a social occasion that we would imagine ourselves stepping into. Thus, in an inversion of the happy family photograph, those of "celebrations" and social time at the Berghof depict the official formality of National Socialist German identity at this time. In these moments Braun's photographs migrate into the official public world to reveal the infiltration of the social codes of behavior and a community marked by formality and distance from the self. All traces of the personal and family life at the Berghof are held in abeyance.

However, when women are introduced into the images, this changes. There is often an expression of companionship and even intimacy in the poses, the gestures, and the facial expressions of Eva, her sisters, and her women friends. This said, it is important to remember that there are many examples in which the women also don the uniforms and masks of the bourgeois ideology so typical of the home image world they inhabited. Braun, in particular, poses in her bathing suit, shows off her seductive legs, revels in a life of leisure with abandon. An image in which Braun dramatically looks askance with her sunglasses falling down her nose while the woman next to her pours a drink is typical of this kind of parading of social status (Figure 24).[58] Alternatively, the color image of

FIGURE 24. *Eva Braun with another woman in Italy, summer 1941. Courtesy of National Archives, photo 242-EB-5-8-B.*

what has become known as "the mystery woman" showing off her legs and her figure on the balcony wall at the Berghof shows a woman who sees herself as the object of twentieth-century desire: she becomes the commodity so often referred to in discussions of a woman as the object of the camera's gaze.[59] Once again, these images do not show women as they are supposed to be according to the dictates of National Socialism: mothers at home sewing, cooking, and nursing. Nor were these women consumers and the subjects of modern life as pictured in other countries at the time.

In her canonical work on the social history of women in Nazi Germany, Claudia Koonz describes the entirely separate world of women among the Nazi elite.[60] For the most part, the wives of official Nazis remained uninterested in and disengaged from their husbands' beliefs and activities. Not only did they occupy a realm that was pictured as ideal, but it was imperative that they live this fantasy of purity and virtuous womanhood in order to keep the myth of the happy home intact.

Similarly, the women's disinterest and lack of engagement in the public political power of the Nazi leadership reinforced the ostensible "normality" of life for their men on their return home from a day of organizing killing operations.[61] The corrosive and destructive events taking place in the public sphere were literally wiped away at the end of the day. Although, on the one hand, the apparent estrangement between men and women at the Berghof as it is represented by Braun's images underlines the separate realms occupied by men and women, it is surely also an indication of the measure of other kinds of estrangement between them.

As Koonz points out, although the Nazi elite maintained the myth of their own happy, coherent families as the stalwart of their wholesome society, the reality was, of course, often a different story. For example, in the relationships between Martin Bormann and Rudolph Hess and their respective wives there was known abuse and emotional violence.[62] In the same way that idealized relations between men and women within families can be exposed as the performance of family images, Braun's seemingly happy and carefree life was no doubt also not the ideal of domestic tranquillity it was made out to be. Her stiffness and that of everybody else in Hitler's presence, the literal and metaphorical spaces between men and women, would suggest far from ideal family lives.

The collected moving and still images of Eva Braun suggest that in her years at the Berghof Braun recreated the female intimacy she had known in childhood. In her photographs and films we observe the community established among women in the emotional absence of the male figure, be it her father, her boss Hoffmann, or Hitler. Whether this female community existed in reality or was just the fantasy of Eva Braun, the home image maker, is another question. Nevertheless, Braun did not always depict a female world as Hitler would have wanted it. The female world of Braun's still and moving images is one in which women are not dependent on men for their individual and collective identity, nor are they solely in existence to serve the fortitude of the Nazi Party or to provide convenient refuge from the insanity of the male work sphere. In addition, the gap between the private social world of Braun and her women friends and the public, historical world that comes alive when the men enter the frame is another way of understanding the space into which we can insert

our ambivalent response of almost simultaneous identification and recoil. And the irresolvable contradiction of this response can, in turn, be the basis of our specific use of these images as agents to witness the history they depict and reference.

Within the female world itself, copious photographs of Eva, Gretl, Frau Schneider, and Braun's other women friends dominate Braun's albums. The women are depicted in twos and threes, in small and large groups. Though there may have been hostility, jealousy, and resentments among the wives of the Nazi elite, such emotions are never detectable in Braun's films and photographs.[63] In her numerous portraits of the wives of Goebbels and Boorman, Herta Schneider, her sister Ilse, and other women, we find visual evidence to support the strength and compassion of the relations among these women. However, we must be careful because it is possible that the contempt in which other spiteful Nazi wives held Eva Braun is hidden beneath the smiles and the warmth expressed in the photographs. Lambert quotes Eva's uncle Alois Winbauer and cousin Gertraud to support her claims regarding the contempt in which Braun was held by the other wives. We have no reason not to believe Lambert, but we can at least assert through the evidence provided in the images that when seen through Braun's eyes, the relations among the women were not always strained. Braun's images may represent her fantasy of how she would have liked things to be, but they also offer another layer of complexity to the picture we already have when they suggest the existence of a female community at the Berghof. Like all family images, which perform idealized relations, Braun's have the potential to move along this, yet another double track, as Citron terms it, in the moment of viewing.

Official histories and critical studies of the roles played by the women attached to men of the political elite in Nazi Germany focus on the part of their identities formed in relationship either to Hitler or to the men in their lives. This version of history is, at times, reinforced by Braun's images. Thus, for example, Magda Goebbels, who was referred to as the "mother of Germany" while Hitler was the father, is consistently seen in Braun's still and moving images sitting at Hitler's right side at dinner, a privileged position conventionally reserved for the woman of the house. Similarly, Braun's images confirm critics' and historians' observations

that Magda Goebbels was held up as the picture-perfect blonde wife of Nazism with a brood of Aryan children. She offered, in keeping with her husband's address at the opening of the "Woman Exhibit" in Berlin on March 18, 1933,

> something quite different from the vocation which men have. . . . Her first and foremost, and most appropriate place is in the family, and the most wonderful duty which she can take on is to give her country and her people children, children which carry on the success of the race and assure the immortality of the nation.[64]

The placement of Magda Goebbels in the photographs and films, always on Hitler's arm as he entered official functions, from dinner at the Berghof to state occasions, confirms her importance as the ideal German woman. She is defined by her role as mother to Germany and procreator of the future.[65] In other examples, women such as Emmy Göring and Gerda Bormann were exceptions to the rule of the disinterested and disengaged Nazi wife. They were apparently so committed to their husbands' careers and the Nazi endeavor that they even helped out in their husbands' "business" affairs.[66] Though women such as these were reputedly independent, resourceful, even business-minded, they are always identified in terms of their relationships to men.

Similarly, when Braun is shown in the company of the men, she is typically seen sitting at Hitler's left, with Hoffmann on her other side, at official functions. In this position, she is an empty accoutrement, an ornament that will not distract from the power of the men and of Germany. In contrast to the social occasions, at official functions the women are rarely, if ever, shown to communicate with one another, for their function was to underline the potency of the culture of National Socialism. In these ways, Braun's images confirm the assumption of the Nazi-determined gender roles by the political aristocracy. Nevertheless, for the most part, her private albums capture an alternative vision. The images of leisure time tell a different story: they show Magda Goebbels, Eva Braun, Frau Boormann, actresses-cum-mistresses Lida Baarova and Magda Behren, and other women friends socializing together and

appearing as a harmonious group again and again, a group with no apparent concern for their male companions.

Thus not only do Braun's images tell of the hidden disharmonies and fractures in her biological family—in particular, that disclosed by her father's absence—but we see the same fractures echoed in her adopted "family" at the Berghof. She found, or rather constructed in films and photographs, a community held together by women in the absence of a male focus. Hitler and the National Socialists under him may have been adamant about the role of women in a society of which he was in command. However, Braun's supposedly banal images reveal how they ignored these dictates in their own day day-to-day lives. Although home movies and photographs taken by men typically reveal the fissures and untruths that center around women's lives, Braun's images reverse this expectation when they subvert the alienation of women from their bodies and their selves by depicting a community of (apparently) mutual female support and companionship at the Berghof. This insight into an otherwise unacknowledged aspect of Nazi history not only makes us look at Braun's images anew, it also hints at the fractures in Nazi ideology that were the historical basis of some of the greatest crimes of the twentieth century.

The historical level of the images is most disturbing when it penetrates this private world. That is because, at the same time that we are likely to fall into our own memories as we idly watch Eva and her friends and family enjoying life, relaxing, and just being together, we are impelled to question these memories when the men in uniform or with familiar historical faces enter the frame across the cut of a film, at the turn of a page of an album. What most horrifies me is my readiness, when watching the earlier frames of a film or browsing the earlier pages of the album, to identify with the world depicted in the home images, not with the entrance of Hitler. Indeed, it is the coexistence of the two worlds that perturbs. The deep ambivalence toward the images generated by the simultaneously private and public, personal and historical dimensions also presents an intellectual challenge. Not only are our contemporary memories of the perpetrators' culture challenged or complicated by this viewing process but our own memories, as well as the potential for simultaneous identification and dissociation in the process of witnessing the past, are

brought to our attention. Like the public-private tension in the images, in the moment of viewing, Braun's albums and home movies have the potential to engage the viewer's private memories and historical awareness. This double consciousness in the moment of viewing is disturbing because of the irresolvable conflict between the two. Thus we commence to gain a fuller picture of the complexity of these images when we use them in the process of witnessing the past. The whole process is overrun with contradiction and ambivalence between the mythical image of the ideal Germany and the reality of day-to-day life, between our memories and historical fact, between how we might want to remember and how we actually do. In short, these particular amateur images have a potential to challenge the processes by which we remember history, especially because of their possible appeal to the familial gaze.

The Woman in the Attic

It is often remarked that Eva Braun was a secret, or at least that her relationship to Hitler was never made public. She was supposedly the woman behind the window, secreted away in the mountain resort. Thus, despite her ubiquitous presence at gatherings and in daily life at the Berghof, her relationship to Hitler was said to be that of a secretary. This secrecy is confirmed by Junge, who claimed, "It was something no-one knew about. I think it was the best-kept secret of all; but no-one was *obliged* to keep quiet. The funny thing was, we just instinctively avoided talking or gossiping about it."[67] Junge's memory of Braun's presence at the Berghof is indicative of the contradictions that run through the received wisdom regarding Braun's status. On the one hand, she was supposedly a secret, and on the other, everyone knew she was Hitler's mistress but feigned ignorance.

The assertion that Braun was Hitler's secret mistress is also pinned to her diary, in which she bemoans the fact that she was never allowed to write to Hitler. Cate Haste isolates a passage in the diary in which Braun writes that she went to dinner with Hitler and was "unable to say a single word to him." On May 10, 1935, before she moved into the Berghof,

Braun was despairing at Hitler's silence over the preceding three months. She writes:

> Let nobody say I am not patient. The weather is magnificent and I, the mistress of the greatest man in Germany and in the whole world, I sit here waiting while the sun mocks me through the windowpanes. That he should have so little understanding and allow me to be humiliated in front of strangers.[68]

The Eva Braun created in the diary carries an identity that reminds us of the heroine of a Hollywood melodrama standing behind a window, trapped by the world in which she unfortunately finds herself, yearning for an impossible love. This Eva Braun is self-obsessed, a prisoner to her own love for an emotionally and physically unavailable man of power who is, as historians have repeatedly commented, married to his work. This image of Braun as the pining, illicit mistress had to be maintained to uphold the conventional notion of women's role within National Socialist Germany: intended for marriage, childbearing, and working in the service of the progress of National Socialism.[69] For her only identity was as Hitler's lover. Similarly, and more important, if Braun and her relationship to Hitler had been any more than a well-kept secret, Hitler himself, by having a mistress who lived a leisurely existence, would have been seen to violate the ideals of home and hearth on which his German Reich was founded.

Given this quandary, Braun and the specifics of her relationship to Hitler had to be kept a secret on some level. However, as the films and photographs demonstrate, Braun led an open and active role in daily life at the Berghof. Certainly no other secretaries are depicted with such openness and regularity as Braun. Given her engagement with visitors to the mountain resort, both official and social, if she was on one level a secret, as Junge claims, her existence was also widely known, though not perhaps openly acknowledged. At least to those who visited the Berghof, Braun appears to have been seen as fully integrated into daily life. In addition, we note that although there are images to reinforce the paradoxical myth of Braun as

wartime secret and postwar "teller" of secrets, most of the films and photographs see Hitler and his friends walking around clearly aware that they are being filmed or photographed. Again and again, they look into the camera, even perform and pose for the camera. The many filmed sequences—such as those from Reel 2, in which officials, accompanied by their respective women, survey the dramatic sunset at the Berghof and walk along a snow-covered path to the *Teehaus,* or that in Reel 7, in which Hitler walks past a window and we see Braun filming in the reflection in the window—all of this footage defies the claim that Braun was not allowed to film official visits, that she was invisible. Hitler not only supported Braun's passion by buying her cameras and giving her access to processing; he also allowed her to film him in a multitude of situations, on official and social occasions. These images may have been staged for the camera, but they were nevertheless filmed in the open without inhibition.

All of this said, however, a photographic image that depicts men in uniform seen through a window provides visual confirmation of her seclusion.[70] This series of six images reveals the melodrama heroine who was literally framed by the rigid social conventions that narrated her. Most important, her sexuality was symbolically contained, and she could only ever observe life from behind a curtain and never participate in the world beyond the bedroom. And yet, simultaneously, the organization of the images into albums enables Braun to raise her voice, to articulate her agency as a central figure in Berghof life. Braun took these images from the privileged bird's-eye view of her window, which overlooked the balcony and the approach to the mansion (Figure 25).[71] She may not always have taken part in official activities and meetings, but she was often the only one allowed or able to see many of them in progress. The caption accompanying this series of images assures us that the woman behind the window and the camera is neither self-pitying nor chained by the desire for an impossible love. It boasts, "Through the window it is possible to see everything."[72] The Eva Braun who created the photo albums was indeed anything but a prisoner of love and social convention: the lighthearted tone of the caption suggests that even if she is stuck indoors behind a window, she can still see everything that went on below. Hers was a perspective of omniscience.

FIGURE 25. *Eva Braun took a series of photographs of this same view through the window at the Berghof, each from a slightly different perspective. Original German caption: "Durch die Scheibe kann man allerhand sehen!" (Through the window one can see all kinds of things!). The caption for a similar image reads, "Da oben gibt es Verbotenes zu sehen . . . mich!" (Up there it is forbidden to see . . . me!) (photo 242-EB-6-30a). The captions reinforce the clandestine nature of her photographs. Courtesy of National Archives, photo no. 242-EB-6-26-D.*

By extension, due to the existence of these images, post–World War II viewers see Braun's power to influence history, if only as it is remembered in her future, our present. These images seen through the viewfinder of Braun's camera give us access to otherwise undocumented events. The balanced, geometrical framing of the shot in Figure 25, together with the

caption, suggests that she celebrated the ability of the camera to see from this perspective on high, through the window. These images are about possibility, the possibility to engage with the world outside her window via photography and filming. Eva Braun is not mocked by the sun in these images. Accordingly, although she filled a number of contradictory roles during her time at the Berghof, thanks to the images collected in her albums we can be certain that she was not simply a silenced woman kept in the bedroom.

These contradictory discourses on the hidden-away yet all-seeing woman of privilege in the Third Reich also function at the broader historical level through the very existence of Braun's films and photographs. Braun may have been the best-kept secret of the Third Reich; however, today her documentary images are key representations of otherwise unseen aspects of Nazi German history. And today her still and moving images are among the most quoted and reproduced of all the amateur films and photographs produced at this time. Even though she clearly had an active presence in daily life at the Berghof, at the time Braun had no voice in the public sphere beyond the mountain retreat. This silence and invisibility, however, were defied through the documented presence of a camera. Typical of the amateur who creates a voice and envisions her own agency through photography and film, even when the images, like those described earlier, were taken clandestinely, reminding us of the photographs taken by the Wehrmacht soldiers and other officials of events they were not meant to see, Braun was able to intervene in the representation of the history that was taking place around her. Accordingly, her images are unique as home movies. The ultimate significance of Braun's images comes from their status as private and ordinary documents of a young German woman, her desires and disappointments, her dreams and everyday realities, and, concurrently, significant historical documents. As important historical documents, the images expose a world that did not always follow the conventions mapped out by public orders. In particular, we find a world in which the family was consonant with the bourgeois Western institution as it has always been, not as the Nazis decided it would be: we find families and communities in which impossible ideals

were in conflict with the reality of day-to-day life and the relational ties that belonged to and formed that same life.

Private Histories, Public Memories

The twofold role of Braun as both a secret and a betrayer of the secrets of the Third Reich contributes to another variation on the merging of public and private life as I have outlined it via the photographs and films in other chapters. Junge comments on the spatial organization of the Berghof, particularly as it related to the confusing layout and the blurred spheres of Hitler's private and official life:

> Here on the Berghof he lived more of a double life than ever. On the one hand he was the genial host and master of the house visiting his country estate for rest and relaxation, on the other, even here, he was still the statesman and military supreme commander waging war on all fronts. Purely from the spatial point of view it was often difficult to reconcile these two opposites. The house wasn't divided into private part and an official part, and Hitler's study was on the same corridor as Eva Braun's bedroom.[73]

Junge goes on to explain that Braun also transformed rooms in the Berghof to meet her own purposes; the bowling alley, the Great Hall, and her own room were all spaces in which her movies were shown from 6 to 8 p.m. in the predinner relaxation period. Here again, in the use of the Berghof we find the lack of distinction between public and private life. The one bleeds into the other in the same way that many of the images could represent either official meetings or social occasions. For example, one image depicts a panorama of figures leaning back on the balcony. The men and women, who we note have been separated along gender lines, are nevertheless relaxed: it is as though they have been brought together for the sole purpose of the photograph. Not all of the figures interact with one another; rather, as was so often the case at the Berghof, they either reflect inward or look directly at the camera, for which they are posing.

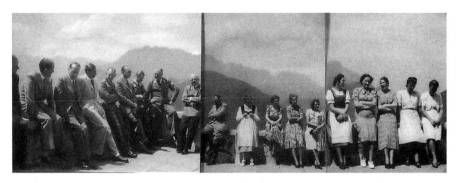

FIGURE 26. *A panorama of three photographs of men and women on the balcony at the Berghof, circa Christmas 1939 or 1940. Original German caption: "Alles wartet auf den Führer . . ." (Everyone waits for the Führer). This image prefaces a later image of Hitler, presumably arriving on the balcony. Under that image Eva Braun wrote "Er kommt . . ." (He arrives). Courtesy of National Archives, photo no. 242-EB-8-16.*

Again, typical of both official and social occasions at the Berghof, some of the men are in uniform and others in civilian suits. Although we assume that the participants are gathered during a break, perhaps specifically for a photograph, there is no telling what events lie on either side of this break. The proceedings from which the participants take a break might be social or official. There are indeed many such images that blur the boundaries between official and social occasions and spaces (Figure 26).

In the blurred uncertainty of the public and the private in Eva Braun's images we become witness to a public sphere continually being penetrated by the private—the presence of women, the playing of dogs, the constant playing with children in the frame. Once again, the private and family worlds depicted in these images are not in accord with the models of either espoused by National Socialism. They are always aberrations. We never witness nuclear families; the women are self-sufficient, resting and socializing. Even though the worlds of men and women coexist, they are separate thanks to the dress, gestures, and spatial arrangements of the men and women. Although the men present images of male fortitude and service to their country, the women interrupt the ideal bureaucratic space because they have no apparent official role. The images' representation

of women as belonging to an altogether separate world, unable to be integrated into the public sphere yet always present in it, might be a visual illustration of Koonz's claim that the wives had to remain almost mythical in their remove from the public sphere. This is the case even when they share the same image, and thus the same space, as the men. One might argue that their presence in Braun's images allowed Hitler and his entourage to maintain the fantasy of home-life harmony. However, again true to the tendency of family images, there are fractures and "other truths" that lie beneath the surface harmony as it is represented at the Berghof. These family images present a very distorted social world.

Simultaneously, seen from another perspective the same images reveal that the public sphere in the form of Nazism blankets all of the private "family" life in the Braun images. There was no escape from the presence of Nazism in daily life. From this perspective, the fact that the men who visited the Berghof usually included officers in uniform, servicemen, and Nazi dignitaries indicates that there was no social, private world outside of war and the struggle for national power. Although Braun may not have become involved in or had any interest in official decisions, the presence of Nazi ideology courses through her photographs and films. This presence is a constant reminder of Braun's isolation from and denial of what was going on concurrently in Germany and Europe. Hitler and Braun's world had no intimate, private dimension. Whichever way we see the images, the public and the private bleed into one another in these depictions of life at the Berghof. In turn, this lack of distinction is a further reason for the unsettling nature of the viewing process because we potentially respond to them as personal and historical documents simultaneously.

The repeated transgression of the line between public and private is also underlined by the films' editing patterns. For example, one series of images lasting approximately five minutes moves from an establishing shot of the Berghof seen from the path before the house to the Mooslahnerkopf, Hitler's teahouse, to Hitler on the terrace with Albert Speer and Martin Bormann, from black-and-white footage of guards walking down the Berghof steps back to color images of a walk with the Speer children. The films then cuts from Baldur von Schirach and Joachim von Ribbentrop to Eva and Margarete Speer picking flowers,

and finally back again to Hitler, von Ribbentrop, and Bormann, once again in black and white. The only connecting thread in this weave of black-and-white and color footage is the presence of the Speer family at the Berghof, because it is unclear whether the footage was shot consecutively or not. It may have been in-camera edited, although the events depicted could also have taken place over a longer time span and post-production edited. However, we can say that these collected fragments illustrate the way that in Braun's films the private or family identity is seen to be on a continuum with public, official meetings between Hitler and his senior henchmen. All these scenes are from her subjective vision, a vision weighed upon by the ideology of family. Whether we interpret this vision as the public consumption of the private world or, contrarily, as the penetration of the public by the private, there is no disputing that the two are tightly woven together in these images.

The tight weave of the private and the public as it is represented in the images, the inseparability of individual memory and collective history, become echoed in the imbrication of our memory and knowledge of this period of German history. The ambivalence of the images undergirds a process of reception that invites viewers simultaneously to recognize their own family histories and, in the very same instant, to see at a historical, cultural, and political distance the Nazi leaders gathered for a conversation we suppose led to unimaginable violence. And the realization of this distance enables us, as twenty-first-century Western viewers of Braun's images of a certain generation, to see how the processes of remembering and continuing to witness the past challenge our preconceived notions of the inseparability of the privacy of past memories and the political responsibility to the formation of memory in the present. We are asked not to take on a responsibility for the events depicted in the images but rather to remember these events responsibly for the next generation.

It is safe to say that Nazi ideology infects these images at every level, because where Hitler and other icons of Nazism—flags, uniforms, even the Berghof itself—are present, so is Nazi ideology. In this regard, we come, once again, to the inescapable presence of ideology in the films and photographs. However, this does not mean that their aesthetic itself is fascist. Nevertheless, although I have demonstrated that this is not the only

optic through which to see Braun's home movies and photo albums, it is important to recognize it as one interpretive trajectory. The proliferation of footage and frames of Hitler bending down to play with children of a certain age will always be understood as being in the interest of showing him as the ultimate adored "father" of Germany. He was the good father in a world in which the family was a microcosm, and therefore he was a good, strong, dependable leader. That is, although such images may appear to be innocent depictions of Hitler wooing small children, we know that they were taken with a desire to reveal his human, and particularly his paternal, side. These fragments are among the most frightening and disturbing of the eight reels of Eva Braun's film. We cannot help but remember that behind Hitler's postures of interest, warmth, and apparent fondness for children stood the same despot who was ready to have them killed at the end of the war.

Thus, on this level the blurring of the public and private spheres in Braun's images visually exposes that the public (here politicized) and the personal are inseparable even for a figure as disinterested in the political as she apparently was. And once these worlds begin to bleed into one another, we see that neither the public nor the private life led by Hitler as represented here conform to National Socialist tenets. This revelation turns Braun's very ordinary home movies and family albums into extraordinary documents of German history. Accordingly, they become more like documents of the contradictory truths of National Socialism and its coercive, deceptive father figure. Of course we knew all this already. However, what is shown in a different light in Braun's photographs and films is the substance of the contradictions: that the women of the Nazi elite freely lived together beyond the confines dictated by public recitations of women's role in the Third Reich. Similarly, great efforts were made to represent the relations between men and women in the upper echelons as congenial. Nevertheless, the superficiality of these relations and the apparent absence of intimacy prompt us to question the harmony otherwise depicted.

And here, in Braun's images, we see a way of life characterized by its expressions of community and family, expressions that are so generic that we are able to identify with them. We might fall into our own memories

of our own family photo albums and the nights spent watching home movies with the family, images that represent a life that is no longer present, just as Braun and her family community are no longer present. This affect, in conflict with our recognition of the historical weight of the sometimes banal depictions, forces on us an awareness of a responsibility to remember this violent chapter of history. This is, to be sure, a radical form of remembering the events of World War II, because effectively, these archival images open up the possibility for the viewer to see his or her own process of looking, and through it remembering, a process that in turn leads to witnessing. In their capacity to engage in this process, of all the images discussed in *Through Amateur Eyes,* it is ironically these that are apparently furthest away from the Holocaust and World War II that enable us to see with utmost clarity just where our responsibility lies as witnesses to the past.

Contemporary Perceptions

Having detailed the complexity of Braun's images and the many different historical discourses woven through them, I come full circle to a consideration of the status given them and the context in which they are placed today. Do we, as other critics would want us to, accept them as the amateur photographs and films of a woman who was infatuated with Hitler? Even though her writings and the images themselves are apparently oblivious to the politics and propaganda of the Nazi Party, surely their very content implicates them in such discourses. Braun was not so naïve as to be ignorant of the fact that when photographing Hitler, Himmler, Speer, and other Nazi Party dignitaries on the balcony at the Berghof she was creating images of scenes that no one else saw. She must have been aware, on some level, of the uniqueness and coveted nature of such images.[74] Or was she in fact the manipulator of her own image? Did she deliberately present her perspective as naïve? With respect to Braun's work, the question is whether she simply filmed what was around her, including Hitler and the Nazi dignitaries who happened to come before her camera or whether the idealized landscapes and the repeated images of Hitler playing with children were manipulations intended to espouse

the idyllic Nazi life. Linda Schulte-Sasse sums up the same vein of controversy as it has unfolded in criticisms of Leni Riefenstahl's work:

> The controversy surrounding Riefenstahl can be summarized in two alternative positions: the minimizing of her "Nazi connection" based on an endorsement of the transhistorical sanctity of the artistic sphere, and, on the other hand, the insistence . . . that her entire career displays a direct connection to Nazi aesthetics and ideology, including her feature films with their romantic anticapitalism and semiotically charged use of landscape.[75]

Despite the obvious correspondences, Braun never reflected on her filmmaking and photographic practice as did Riefenstahl, primarily because she did not survive the war, but also because she was an amateur. Thus we have to see the images for what is in them; we do not have the luxury of interpretation via what Braun might have written about them.[76] Thus, unlike Riefenstahl's documentary films, Braun's are ambivalent because they are amateur. In turn, not only do the images reveal much about Braun; they are also notable for their discourses on the larger social and cultural tendencies of her period. By extension, for us today, Braun's identity as naïve mistress, functionary of National Socialism, or independent amateur image maker accounts for only one level of their meaning. What matters is that, in addition to their covert and overt significance to an understanding of Nazi ideology, the films and photographs are also significant historical documents that engage with other kinds of ideological constructions: family, domesticity, gender relations, and modernity.

Finally, we cannot ignore the fact that Eva Braun's life unfolded in and through her images at the exact same time that World War II was going on elsewhere. In spite of the overall myth of the ideal life represented by Braun's films and photographs, we also see how the world of war and history penetrated this perfection at every turn. I have already mentioned how the presence of Nazi icons and symbols triggers our recognition of the horrors taking place outside the frame. However, Braun's images also contain overt references to the war she chose to treat with irreverence, due to either a performed or a real disinterest. When the images nod toward

the momentous events of war, they are not displayed in any sustained or serious way. For example, in Album 6 there is a series of images in which we see Hitler, Boormann, Dr. Theo Morrell, and Joseph Goebbels among others awaiting von Ribbentrop's return from Moscow in 1939, presumably with news of the nonaggression agreement between Germany and Russia that included plans for the division of Poland. The penulti-mate four images are captioned ". . . und der Führer hört den Bericht am Radio!" The series closes with three obviously clandestinely shot photo-graphs of Hitler and his associates and three further photographs of Braun and her friends on the steps of the Great Hall. The caption given these six images reads: ". . . aber trotzdem, Polen will nicht verhandeln."[77] The series of photographs and the accompanying captions give the impression that Poland is a naughty child that will not do what it is told. This major political milestone is reduced to a benign event in the story told by Braun's album. In addition, we see that the magnitude of the Warsaw agreement is totally lost in Braun's albums, where space is given over to Braun and her women friends. In another example, there are images in Album 7 in which we see Hitler and his men deliberating strategic decisions in makeshift headquarters on the Western Front (Figure 27). In others he converses on a dirt road as he and his men inspect trenches and pose for the camera during a break in the day's activities somewhere in the vicinity of a base camp in France.[78] However, once again, there is no indication that these images might hold any significance to Braun's narrative. Thus when the war is introduced, it is just another event for Braun to incorporate into her story, creating a tension between her world and what we know to have happened. Even in the images taken on the Western Front, there is no sign of the war. When these images are juxtaposed in Album 7 with those of Eva and her friends on the "'Lido' at St. Heinrich!" we are reminded that she saw history from behind a lace curtain.[79] This world of privilege had no room for concentration camps and the awful events taking place elsewhere in Germany and Europe; however, as I have demonstrated, the films and photographs do tell us about strains of history that could so easily be ignored. Moreover, if we are open to these different narratives, we also become open to the possibility of using them to prompt our own discourses of witnessing World War II and the Holocaust.

FIGURE 27. *Hitler on the telephone with two men behind him, 1940. This photograph is included in a section of an album of Eva Braun titled "Bilder aus dem Hauptquartier und dem siegreichen Feldzug gegen Frankreich" (Pictures from the headquarters and the victorious campaign against France). Courtesy of National Archives, photo 242-EB-7-29.*

Recyclings

The narratives that incorporate Braun's images are among the most widely distributed because they have been rediscovered by the YouTube generation. These recyclings are particularly problematic not only because they are historically ignorant but because they celebrate Braun as a (tragic) melodramatic figure. Because YouTube is a form of communication that invites and subsequently foregrounds response, comment, and discussion, the renarrativized images often attract the most unreflective of responses. Because one of the primary goals of YouTube uploads is to promote as much traffic as possible, the more sensational the tags, titles,

and information (including comments), the more successful the postings. Thus often the least concern of participants on YouTube is the political ramification of their uploads. The comments on the short videos made of Braun's footage move between the banal ("Eva was such a beautiful woman who died tragically young") to the neo-Nazi ("Eva was the perfect Aryan woman whose death was a great loss to the cause"). Those engaging in such discourses are interested primarily in the uploader's and participants' right to express themselves and their success in attracting viewers. Any political or ideological significance invoked is either completely ignored or exploited for purposes of sensationalism to attract audiences. Before discussing these reuses of Braun's films and photographs, I want to briefly present an interesting reuse of them that is, at face value, ethically productive because it generates the possibility of remembering the past through a different optic.

In a creative and self-conscious use of Braun's footage, Jay Rosenblatt takes the same familiar images of Hitler greeting children, relaxing at the *Teehaus,* eating lunch, gazing at the expansive mountainscape before him, and so on, in a section devoted to Hitler in his film *Human Remains.*[80] The title of the film is a double entendre—*Human Remains* is about the private obsessions, personal insecurities, and weaknesses of Hitler, Mao, Stalin, Mussolini, and Franco. *Human Remains* sifts through the remnants, or "remains," of biographical information on these five monstrous men. The film does so through the agency of images that are in themselves remains, scraps otherwise lost to the dustbins of history.[81] The segment on Hitler is appropriately bracketed by a barely distinguishable fragment of digging in tight close-up. As in this fragment, the film digs into archives for visual remains that will be brought to life in a narrative about a man who is both a nobody and the most frightening figure of twentieth-century history. Rosenblatt then interprets the images: the voice-over overwhelms the images, and the visual narration is clearly manipulated. However, going back to Kansteiner's prescription for remembering this period in German history, the film's narration creates fissures in the visual fabric as well as in our memories of these five evil dictators. *Human Remains* is a patchwork of fragments: the segment

on Hitler ends abruptly, just as the footage in the camera of the amateur filmmaker did. The image is striated with wear and tear, and Hitler's face is not necessarily centered or even present in its entirety. All of the idiosyncrasies, the characteristic features of the amateur film, are given focus in Rosenblatt's representation of this footage. This fragmentation and emphasized imperfection of Braun's amateur footage is underlined when Rosenblatt's film cuts to black for a number of seconds before the images of the next section on Mao Tse-tung appear. Rosenblatt makes no effort to create coherence or continuity at the visual or sonic levels of the film.

In striking contrast to other compilations that use images of and by Braun in support of their claim to see inside Hitler's private life, when Rosenblatt redeploys Braun's images he does not acknowledge that they have anything to do with her, and indeed their provenance is the least of his concerns.[82] Thus, at this level, Rosenblatt uses the images against the grain of how I have proposed they should be seen—as insights into Braun's identity and the world she created. And yet *Human Remains* manages to open up to the complexity of Hitler's character unlike television films and World Wide Web representations. For this reason it is worth pausing to reflect on the filmic discourse. Rosenblatt uses a fictionalized voice-over narration and excavates Hitler's writings to locate the intimate moments: the narration tells of Hitler's difficulty sleeping, his obsession with the pattern on the fabric of his bedclothes, his dietary requirements, his aversion to alcohol, his difficulty in making the "tiniest of decisions." And we are offered details of his sexuality and sex life, more than other documentaries would dare to reveal. A fictionalized voice-over speaks Hitler's innermost secrets: "I had one testicle, I loved pornography, some thought I was quite a lady-killer." Thus the film conveys Hitler's chilling sense of himself. It does not need to indulge in dramatic music and claims of showing some never-before-screened images found in an archive—even though this is what it does—because *Human Remains* is not interested in claiming the authenticity of its vision of Hitler. Nor does it see Braun's images as potentially frightening, telling a story that might implicate the contemporary bourgeois viewer in the continued memory of what it sees. *Human Remains* is not afraid of what it has found in the

archive and therefore has no problem inviting its viewers to observe the fragments and the flaws in history, creating caesuras that we can, in turn, appropriate for the ongoing construction of memory.

Even though *Human Remains* uses Braun's footage to discourse on Hitler, there is an interpretive instability and self-consciousness to the depiction, an instability underwritten by the oscillation between fiction and documentary. Not only does the film make no claims to authenticity but the fictional is foregrounded, inviting us to question the veracity of the voice-over. Did Hitler really write that some thought of him as a lady-killer? Did he document his obsessions in the way the voice-over narration claims? These questions create a discursive instability, as Kantsteiner would want, because they guarantee the sought-after disruption to identification with or blind acceptance of what is being shown on the screen. By extension, then, this is a film that, even though not designed to memorialize the Holocaust or German history, keeps alive the memory of this villain from a historical perspective because it asks us to rethink what we already know about Hitler. *Human Remains* ransacks garbage cans for discarded pieces of history, and it represents them in the form of an archive film so as to announce that the images are dead and also to give them a forum for reanimation. The film does what all memory work is prescribed to do: it pushes its viewers to continue thinking, it challenges them to reconsider their vision of history rather than telling them how it is, how it should have been. In doing so, a film such as *Human Remains* reinscribes our responsibility for the perpetuation of new optics and new understandings of World War II and the Holocaust.

Eva Braun on YouTube

Up until the last couple of years, the overwhelming majority of re-presentations of Braun's images could be found in popular television documentaries similar to those discussed in chapter 4. In the majority of instances, Braun's home movies and family photographs function almost identically. Thus television recyclings often reinforce the myth of Braun as an obsessive young girl with no identity of her own.[83] With the opening up

of platforms such as Europa Film Treasures and private initiatives such as Romano Archives, much of the noncopyrighted material from archives in Europe and the United States has found its way onto the Internet.[84] Not only are Braun's home movies and collection of still photography available on the Internet, much of the film material discussed in chapter 4 has also been "remixed." Thus my analysis of Braun's images can be extended to describe the exhibition of other amateur footage from the archives in this new, user-generated forum. YouTube offers the opportunity for a viewer-determined memory culture, a culture marked by the opportunity to rethink the ideological overwhelm of the images through visual presentation. And yet this could not be further from what has resulted.

If for no other reason than the resultant production, dissemination, and observation of Braun's footage by a vast audience on YouTube, the reuse of her images points to the necessity of finding different ways of re-viewing amateur images from the Nazi period. YouTube participants' use of the Braun images demonstrates how the proliferation of and open access to these images marks a shift in history writing that sees it taken out of the hands of the official scribes and placed in those of everyday people. YouTube is the ultimate open invitation for inclusion of the images in discourses of contemporary witnessing of the past. To be sure, this invitation is the privilege of amateur images with their lack of copyright restrictions. And yet, as Henry Jenkins confirms, the vast possibilities of the platform rarely materialize. He says:

> One of the things that has excited me about YouTube is the ways that it represents a shared portal where all of these different groups circulate their videos, thus opening up possibilities for cross-pollination. Yet . . . the mechanisms of YouTube as a platform work to discourage the real exchange of work. YouTube is a participatory channel but it lacks mechanisms which might encourage real diversity or the exchange of ideas. The Forums on YouTube are superficial at best and filled with hate speech at worst, meaning that anyone who tries to do work beyond the mainstream (however narrowly this is defined) is apt to face ridicule and harassment.[85]

Jenkins's misgivings accurately describe the uploading of Braun's videos on YouTube.

The appearance of Braun's images on YouTube takes a number of forms: they are presented as archival fragments awaiting appropriation and further manipulation for resale by footage agencies, a form in which they appear either with or without editing, comment, and interpretation. Romano Archives' posting of a number of rare color fragments such as that in which Goebbels, Speer, Bruckner, and others come for lunch at the Berghof or that of the Braun family's trip to Portofino in 1941 are obvious examples.[86] Similarly, the entire archive of Braun's home movies can be found, mostly unedited, on YouTube.[87] Although it is rare to find the photographs that would be considered "mistakes," the color films are reproduced in their entirety on the World Wide Web, awaiting further appropriation.

Perhaps the most interesting and simultaneously disturbing appearance of Braun's footage and the select few still photographs that are usually reproduced comes in the form of "tribute" videos made to commemorate a tragic historical figure. One user puts together a compilation film of images by and of Braun as a tribute to her and claims in the accompanying comments that she did this for other people's "entertainment."[88] Mishima1970 overlays this tribute to Braun with Enya's *Shepherd Moons,* music that is the focus of many of the comments about this "tragic" and "misunderstood" figure, the "epitome of a gorgeous German woman." Among the posts of Mishima1970 and others are a host of tributes to beautiful twentieth-century women who have died equally tragic deaths: Sarah Kane, Dorothy Stratten, and Sylvia Plath, among others. Mishima1970's videos demonstrate a perverse fascination with celebrity death, particularly executions. Side by side with her life of Eva Braun, Mishima1970 has made pieces on the executions of Benito Mussolini and Clara Petacci as well as Josef Goebbels, along with the deaths of Turkish sisters on a hunger strike. Thus if we read the videos contextually, Mishima1970 does not idolize or identify with women such as Braun but rather situates herself on YouTube as a witness to these tragic, untimely deaths.

As Jenkins says, fan videos on YouTube are anything but gender neutral.[89] Although the structures and production of more traditional media

are dominated by men, digital user-generated platforms such as YouTube offer the opportunity for the creative expressions of women such as Mishima1970. YouTube is a forum that allows her to be engaged in public discourse on celebrity death, all of which is headed by the reference to the ritual suicide of the Japanese writer Yukio Mishima. Most significant for Mishima1970 seems to be the element of sensation that will "entertain" others but ultimately attract their attention in the first place. Like many YouTube users, she is motivated by a desire to be heard and seen online. To make her statement, Mishima1970 takes images such as Braun's and places them, unattributed, in a sentimental melodramatic narrative that erases the layered complexity of the images.

Other narratives have been created from Braun's footage to forge histories that are identical to that of the television documentaries: a voice-over narration tells a story that affirms the official version of history. In these instances, the music, usually from the Romantic period in Germany, ranging from Brahms cello solos to the drama and profundity of Beethoven symphonies, is used to create coherence among the images and emotionally move the viewer. When Braun is on the screen we often hear very light, playful, cabaret-type music. And when the music is not of either genre it is guaranteed to be feel-good music that binds the disparate film fragments or the photographs into a coherent historical narrative. In every case, although it is typically music, not a voice-over, that binds the images, they become a background to a well-rehearsed, familiar narrative.[90] Again, such appropriations are the legacy of the amateur image and, simultaneously, an impetus for more reflective reuses of the same images.

A video uploaded by BarnabasFrid sets Braun's images to the Boomtown Rats song "I Never Loved Eva Braun."[91] BarnabasFrid uses familiar images from Braun's still and moving collections as well as footage from *Triumph des Willens* in two different versions of the image track for what can only be described as a reverential tribute to Hitler. BarnabasFrid made the first video in 2006 and the second in 2008, no doubt because of the success of the first, which received nearly four thousand hits. The final image in this video is a portrait of Hitler in his Bavarian brown uniform (taken in the late 1920s) at the center of a frame that declares, "I am

not a bigot!" and "I love People, I am a *good* person," words attributed to the Hitler in the frame by BarnabasFrid rather than drawn from a historical source. In a different script, the voice of BarnabasFrid adds that he finds Hitler sexy. On BarnabasFrid's site, Braun's images appear together with videos of "Jill's graduation" and Basil Rathbone as Sherlock Holmes singing "Beside the Seaside." The viewer comments inspired by the video reflect a similar thoughtless enthusiasm for Hitler: BarnabasFrid comments that the lyrics of the Boomtown Rats song proves that Hitler was homosexual, and the followers of the image similarly engage with Hitler's sexuality, opinions based on nothing other than the viewers' own desires. The fact that the video has nothing whatsoever to do with Hitler's sexuality is beside the point. All of the users and viewers respond to the dehistoricized images of Hitler in a sensational narrative with dehistoricized and even more sensational comments. Taking their cue from BarnabasFrid, many of the commenters focus on Hitler's sexuality and the nature of the relationship between him and Braun. Thus, for example, we read:

> *the82spartans:* Dur Furhur was into women but he also could abuse them. It was reported that he was with a film actress in which he purportedly urinated on her . . . gross.
>
> *JerryF1:* stupidpeopleallgermansofyesteryear
>
> *pineapple1969:* Eva was a big boned girl.
>
> *Voicesoffear:* auslander raus
>
> *xander7ful:* I'm not sure I'd call her a sexual slave of Hitler. Hitler's sexual preference was sado-masochism. He wasn't gay. Eva Braun was his dominatrix. That's why he had her around.
>
> *inhocsignovinces88:* Eva Braun: Spokes model for P-90X?
>
> *tungvan8290:* This scum dog Braun is just a sexual slave of Hitler[92]

Braun's images are thus transformed into a music video that creates a platform for responses ranging from titillation through sado-masochist speculations to neo-Nazi slogans.

On one hand, BarnabasFrid's redeployment of Braun's images in a narrative that speaks the writer's identity—when it is juxtaposed with of a number of significant events in his life and that of his friends—is a vivid illustration of the ease with which we see our own desires, our own lives, in the amateur image, no matter whose family and community is presented. On the other hand, this blind appropriation is disturbing because it holds no historical validity and, most egregiously, historically and culturally isolates the images in their new context. The narrative disturbs because it reflects the absence of any awareness of the historical context, let alone the historical devastation that surrounded these images, and this, in turn, opens the way for other participants to vent their bigoted, homophobic, anti-Semitic diatribes. In short, there is no acceptance of the distance from the images that enables the process of witnessing history, a process based on recognition of one's own process of imaginative projection as described earlier. Of course, such is the tenor of YouTube. BarnabasFrid appropriates the images for a carnivalesque narrative on Hitler's private life and the nature of his relationship to Eva Braun and along the way forgets, or ignores, the level of seeing them that has us turn back and look at our own processes of looking, remembering, witnessing. This forgetting is, in and of itself, perhaps unavoidable given the fluidity and openness of the amateur image, together with the demands of YouTube to entertain. However, when the forgetting leads to discussions about Hitler's sexuality and sexual practices and to random racist commentary that is triggered by Hitler's very presence in the images, it becomes fatal, because the response creates a distance that shuts down all possibility of reflection on the past of which they are a part and to which, through them, we have a responsibility.

Perhaps most disturbingly, the distance at which BarnabasFrid has placed the images derives from the need to make representations of the past more relevant to the history of the twentieth century as we understand it today. In this vivid example of recycling, history is brought into the present through a narrative focused on Hitler's sexuality and the perpetual search to identify his personal life. And although this narrative might contribute to the experience of the present and its memory, it does so at the expense of remembering the past as embodied, vital,

and indispensable to this cultural present. It is the complete erasure of Braun, Hitler, and everything that he stood for, everything he did, that is so problematic about these YouTube recyclings. BarnabasFrid and his interlocutors go one step further than recycling the images on the basis of ideological discourses when they harness history and ideology as the pretext for outbursts of their own pent-up prejudices. The images are plucked out of the archive, cut and pasted into a digital platform, and overlaid with music that places them in the service of the participants' own identities, their own histories.

All this said, however, this is the legacy of amateur archival images accessible on the World Wide Web: they are there to be downloaded, reused and remixed, and, most important, put to music to make music videos. As Günter Grass would have it, the Internet (and by extension YouTube) is a medium of memory for a generation, today's generation. People today, especially young people, use the Internet as a way of bringing to the surface tabooed language, excluded memories, and in this case, forgotten images.[93] But rather than recycling the images as a way of raising consciousness about them, these users are interested in being uniquely creative in their posts and, most important to them, attracting as much attention as possible. The more sensational the images, the more likely it is that there will be hits, comments, and video responses, which are, ultimately, the goals of such activities. Thus, for all its radical potential, YouTube has attracted the most ahistorical and vapid recyclings of Braun's images. At best, these representations return her images and her image to what has always been deemed their proper place in history: as documents that show her as Hitler's devoted but tragic lover.

For all of the potential radicality and possibility of both the archival images and the World Wide Web as a platform for recycling, if we return to the logic of Andreas Huyssen's argument regarding the culture of amnesia in which we live, the proliferation of Braun images across the Internet in fact represents a form of amnesia. If we maintain that there are always two temporal moments at stake in the viewing of images from the past, images that are coded like Braun's as being of the past, the time and nonspace of the producer-viewer of these YouTube narratives is the only time-space there is. A film such as *Fotoamator* maintains a

distance from the past through a focus on the photographic object as a way of historicizing and complicating the temporal narratives at stake in the production and contemporary reception of Genewein's photographs. Contrarily, YouTube re-presentations of Braun's images do away with the importance of the object and thus lose the sense of history. Braun's image and her images are transformed, or reduced, into spectacle and entertainment. All sense of history is erased, and, as Huyssen would have it, the resulting "surface imagery destroys, rather than nurtures, any real sense of time—past, present, or future."[94] Thus the loss of the archival object, and with it all its material qualities, including the colors, composition, and so on as they were laid out earlier, produces a memory that is in pursuit of forgetting.[95] By reducing the image, these videos effectively rob their viewers of all responsibility to witness the past and, in the case of Braun's images, to see the value of the images. And, where history is invoked, in the elevation of the ideological to the sole meaning of an otherwise emptied-out image, not only is the image itself forgotten but we are relieved of any responsibility to engage in historical memory.

The World Wide Web offers a platform for the possibility of more fractured and layered representations of World War II, the Holocaust, and other historical events. A site such as YouTube promises the profound articulation of the way home movies and family snapshots can be used in memory culture today, and yet Braun's images are filled with nostalgia, melodramatic tragedy, and emotional manipulation. This use of Braun's images as depoliticized and dehistoricized, closing down all inspiration for knowledge and viewer reflection, can be held up as evidence of why we need to take archival images seriously. The use of Braun's images in YouTube narratives is an impetus to recognize, first, just how fluid is the memory work that re-envisions the past in the present and, second, the imperative to produce visual narratives that are historically and ideologically responsible. Throughout I have argued for appropriations of amateur and home images that maintain their openness and fluidity, appropriations that work to embrace the tensions of the past in the present moment, tensions that are manifest in the archival images.

YouTube gives us the opportunity to see how the historical relationship to World War II and the Holocaust has shifted for a generation of

people for whom the 1940s is so far out of the realm of experience that it is a basis for entertainment, titillation, and xenophobia. Similarly, as the twenty-first century is now underway, survivors of the war and the Holocaust are fewer and fewer in number. And finally, we have reached a moment at which German people no longer feel obliged to shoulder the burden of guilt for the terrors of their past, when the ghosts of World War II and the Holocaust are slowly being exorcized. On this historical terrain, the question of how to continue to remember, for those who do not and those whose cannot, remains a pressing concern. And it is with this in mind that *Through Amateur Eyes* proposes an optic through which to see and to re-see images—taken by Germans, both Nazis and non-Nazis, officials and soldiers, bystanders and elite party members and associates—that might otherwise be ignored or discounted. Moreover, these amateur images in their archival and recycled forms have the potential to give us new ways of seeing, of remembering, and of keeping alive the memory of these twentieth-century traumas in the twenty-first-century imagination.

Notes

Unless otherwise noted, all translations are my own.

Introduction

1. Bernd Hüppauf, "Emptying the Gaze," in *War of Extermination: The German Military in World War II, 1941–44,* ed. Hannes Heer and Klaus Naumann (New York and Oxford: Berghahn Books, 2000), 351.

2. Ibid.

3. Georges Didi-Huberman, "Against All Unimaginable," in *Images in Spite of All: Four Photographs from Auschwitz,* trans. Shane B. Lillis (Chicago: University of Chicago Press, 2008), 19–29.

4. Ibid., 44, emphasis in original.

5. Ibid., 97.

6. Ibid., 99.

7. Ibid., 101, emphasis in original.

8. I explain this process in detail in chapter 1.

9. Didi-Huberman, *Images in Spite of All,* 347.

10. Marianne Hirsch, *Family Frames: Photography, Narrative, and Postmemory* (Cambridge, Mass.: Harvard University Press, 1997).

11. Saul Friedländer, *Nazi Germany and the Jews,* vol. 1, *The Years of Persecution, 1933–1939* (New York: Weidenfeld and Nicolson, 1997).

12. Andreas Huyssen, *Twilight Memories: Marking Time in a Culture of Amnesia* (London: Routledge, 1994).

13. See Stefan Berger, "On Taboos, Traumas, and Other Myths: Why the Debate about German Victims of the Second World War Is Not a Historians' Controversy," in *Germans as Victims: Remembering the Past in Contemporary Germany,* ed. Bill Niven (London: Palgrave Macmillan, 2006), 210–24. Berger discusses the silence around the bombings of Dresden, for example, the rapes of German women, and the victimization of Germans at the hands of the Russians at the end of the war. There was, until recently, a silence around these victimizations and, as a result of this silence, a deep trauma-induced repression. Indeed, Niven's whole book is instructive on the question of how the German as victim has begun and should continue to be reintegrated into contemporary history.

14. Omer Bartov, *Murder in Our Midst: The Holocaust, Industrial Killing, and Representation* (Oxford: Oxford University Press, 1996).

15. The exemplar of this genre of history is the work of Pierre Nora because it considers the construction of the French historical past through processes of memory. Nora's work relates to French history, but as a model approach to the past it is instructive for the formation and reconsideration of all national identities. See Pierre Nora, *Rethinking France: Les lieux de mémoire*, 4 vols. (Chicago: University of Chicago Press, 2001–2010).

1. Witnessing from a Distance, Remembering from Afar

1. There is now a vast literature on Leni Riefenstahl. See Thomas Elsaesser, "Leni Riefenstahl: The Body Beautiful, Art Cinema, and Fascist Aesthetics," in *Women in Film: A Sight and Sound Reader,* ed. Pam Cook and Philipp Dodd (Philadelphia: Temple University Press, 1993), 186–97. For a discussion of the notion that Riefenstahl's was a fascist aesthetic, see Linda Schulte-Sasse, "Leni Riefenstahl's Feature Films and the Question of a Fascist Aesthetic," *Cultural Critique* 18 (Spring 1991): 123–48; Eric Rentschler, "The Elemental, the Instrumental: The Blue Light and Nazi Film Aesthetics," in *The Other Perspective in Gender and Culture: Rewriting Women and the Symbolic,* ed. Juliet Flower MacCannell (New York: Columbia University Press, 1990), 161–88. See also Peter Zimmermann and Kay Hoffmann, eds., *Drittes Reich, 1933–1945,* vol. 3 of *Geschichte des Dokumentarischen Films in Deutschland,* ed. Peter Zimmermann (Stuttgart: Reclam, 2005). On the entertainment films of the Third Reich, see the references to Linda Schulte-Sasse, Eric Rentchler, and Lutz Köpnick that follow.

2. For examples of the argument that films made in Germany during Third Reich reflect Nazi ideology, see David Welch, *Propaganda and the German Cinema 1933–1945* (Oxford: Oxford University Press, 1983).

3. Eric Rentschler, *The Ministry of Illusion: Nazi Cinema and Its Afterlife* (Cambridge, Mass.: Harvard University Press, 1996), n. 15.

4. Ibid.

5. Schulte-Sasse looks at Nazi entertainment films through the lens of their narrative traditions as well as their social and aesthetic contexts to discover their differentiated aesthetic and historical discourses as opposed to their assumed ideological wholeness. Linda Schulte-Sasse, *Entertaining the Third Reich: Illusions of Wholeness in Nazi Cinema* (Durham, N.C.: Duke University Press, 1996). See also Lutz Köpnick, *The Dark Mirror: German Cinema between Hitler and Hollywood* (Berkeley and Los Angeles: University of California Press, 2002). For another excellent collection that argues for the diversity of the films produced in the Third Reich, see Robert Reimer, ed., *Cultural History through a National Socialist Lens: Essays on the Cinema of the Third Reich* (Rochester, N.Y.: Camden House, 2000).

6. The claim for the aesthetic value of films made by the Ministry of Propaganda has been attributed to the films of Leni Riefenstahl. For a discussion, see Steve Neale, "*Triumph of the Will:* Notes on Documentary and Spectacle," *Screen* 20, no. 1 (1979): 67–119. Brian Winston refutes the claim for Riefenstahl's films as masterpieces in his reinterpretation of Leni Riefenstahl's Nazi-era films. See Brian Winston, "Triumph of the Will," *History Today* 47, no. 1 (January 1997): 24.

7. Sybil Milton, "The Camera as Weapon: Documentary Photography and the Holocaust," *Simon Wiesenthal Center Annual* 1 (1984): 45–68; Sybil Milton, "Photography as Evidence of the Holocaust," *History of Photography* 23, no. 4 (1999): 303–12; Ulrich Baer, *Spectral Evidence: The Photography of Trauma* (Cambridge, Mass.: MIT Press, 2005); Gertrud Koch, *Die Einstellung ist die Einstellung: Visuelle Konstruktion des Judentums* (Frankfurt am Main: Suhrkamp, 1992). In spite of his insistence on the ideological presence of the perpetrator in the image, Baer's analysis of Genewein's photographs is extremely valuable because he believes in their contribution to the memory process. It is, so to speak, a reading of the photographs against the grain.

8. Barbara Maria Stafford, *Good Looking: Essays on the Virtue of Images* (Cambridge Mass.: MIT Press, 1996), 5.

9. Ibid., 4.

10. Ibid.

11. T. J. Clark, *The Sight of Death: An Experiment in Art Writing* (New Haven, Conn.: Yale University Press, 2006); Yve-Alain Bois and Rosalind Krauss, *Formless: A User's Guide* (London: Zone, 2000). For an excellent introduction to the work being done in visual studies, see Marita Sturken and Lisa Cartwright, *Practices of Looking: An Introduction to Visual Culture* (Oxford: Oxford University Press, 2001); James Elkins, *Introduction to Visual Studies* (New York: Routledge, 2003); Nicholas Mirzhoeff, *An Introduction to Visual Culture* (New York: Routledge, 1999).

12. David Levin, ed., *Modernity and the Hegemony of Vision* (Berkeley and Los Angeles: University of California Press, 1993). See also David Levin, ed., *Sites of Vision: The Discursive Construction of Sight in the History of Philosophy* (Cambridge, Mass.: MIT Press, 1999); Jonathan Crary, *Techniques of the Observer* (Cambridge, Mass.: MIT Press, 1992); W. J. T. Mitchell, *Iconology: Image, Text, Ideology* (Chicago: University of Chicago Press, 1987).

13. Alfred Gell, *Art and Agency: An Anthropological Theory* (Oxford: Oxford University Press, 1998), 9. I am grateful to Ivone Marguiles for pointing out the relevance of Gell's work to my argument here.

14. Saul Friedländer, *Reflections on Nazism: Essays on Kitsch and Death* (New

York: Harper and Row, 1984), 19. This notion of dehumanizing the already de-humanized is echoed in the literary examples of representations of Auschwitz. Dominic LaCapra criticizes Georgio Agamben for further silencing the walking dead in Primo Levi's reflections on the Muselmänner. According to LaCapra, he erases their already silent presence as the objects of Agamben's gaze. See Dominick LaCapra, *History in Transit: Experience, Identity, Critical Theory* (Ithaca, N.Y.: Cornell University Press, 2004).

15. Ernst van Alphen, *Caught by History: Holocaust Effects in Contemporary Art, Literature, and Theory* (Stanford, Calif.: Stanford University Press, 1997).

16. The idea of the Nazi's gaze as erotic was first discussed by Susan Sontag and has been used liberally since. See Susan Sontag, "Fascinating Fascism," in *Under the Sign of Saturn* (New York: Picador, 1980), 73–105.

17. See the now classical texts on Nazism's use of the image for illusory self-representation. For example, Ernst Bloch, "Inventory of Revolutionary Appearance" (1933), in *Heritage of Our Times,* Weimar and Now: German Cultural Criticism series (Berkeley and Los Angeles: University of California Press, 1998 (originally published in Switzerland in 1935).

18. For a more recent elaboration of this dangerous exploitation of the image, see Thomas Elseasser, "Subject Positions, Speaking Positions: From *Holocaust, Our Hitler,* and *Heimat* to *Shoah* and *Schindler's List,*" in *The Persistence of History: Cinema, Television, and the Modern Event,* ed. Vivian Sobchack (New York: Routledge, 1996), 145–83.

19. Another form of iconoclasm is brought to attention by Cornelia Brink. She discusses a handful of photographs of the liberation of the camps that are always propagated as iconic of the destructive crimes that took place in the camps. She argues that photographs are not icons in the actual sense of the word, but they are regarded as such and are used as such in contemporary German memory. With reference to photographs taken by the Allies on the liberation of Auschwitz, in which piles of dead bodies and emaciated skeletal figures crowd each frame, Brink convincingly argues that today this handful of images has become symbolic of all crimes committed by the Nazis, of all victims of National Socialism. The repeated publication of the same handful of images blinds us both to what we actually see in the images and to the events we imagine through the imposition of what we have been conditioned to recognize therein. Thus, although Brink does not say so directly, this is another pervasive form of iconoclasm. Cornelia Brink, *Ikonen der Vernichtung: Öffentlicher Gebrauch von Fotografien aus Nationalsozialistischen Konzentrationslagern nach 1945* (Berlin: Akademie, 1998). Marianne Hirsch reiterates the argument in her discussion of the same phenomenon in the Anglo–American memorialization

of the Holocaust. Hirsch focuses on images such as that of a young boy in the Warsaw Ghetto with his hands in the air as it appeared in the Stroop Report on the destruction of the Warsaw Ghetto. See Hirsch, "Surviving Images," *Yale Journal of Criticism* 14, no. 1 (2001): 7. For another version, see Marianne Hirsch, "Nazi Photographs in Post-Holocaust Art: Gender as an Idiom of Memorialization," in *Phototextualities: Intersections of Photography and Narrative,* ed. Alex Hughes and Andrea Noble (Albuquerque: University of New Mexico Press, 2003), 19–40.

20. The separation of these histories began with Raul Hilberg, *The Destruction of the European Jews* (New Haven, Conn.: Yale University Press, 2003).

21. Saul Friedländer, *Nazi Germany and the Jews,* vol. 1, *The Years of Persecution, 1933–1939,* and vol. 2, *The Years of Extermination, 1939–1945* (London: Weidenfeld and Nicolson, 2007).

22. Friedländer's history developed out of his own previous work and that of others on the importance of historicizing the Holocaust. See, for example, Omer Bartov, *Murder in Our Midst: The Holocaust, Industrial Killing, and Representation.* In turn, this work grew out of debates that took place in the late 1980s regarding the pitfalls of historicizing the Holocaust as well as seeing it as a singular aberrant event. See the essays collected in Peter Baldwin, ed., *Reworking the Past: Hitler, the Holocaust, and the Historians* (Boston: Beacon Press, 1990).

23. For an excellent history of how these debates have played out in the United States in particular, see Dora Apel, "A Short History of Holocaust Reception," in *Memory Effects: The Holocaust and the Art of Secondary Witnessing* (New Brunswick, N.J.: Rutgers University Press, 2002), 9–42. For a description of the debates in Germany, see Wulf Kansteiner, *In Pursuit of German Memory: History, Television, and Politics after Auschwitz* (Athens: Ohio University Press, 2006).

24. Andreas Huyssen, "Monuments and Holocaust Memory in a Media Age," in *Twilight Memories: Marking Time in a Culture of Amnesia* (New York: Routledge, 1995), 259.

25. James Young, *The Art of Memory: Holocaust Memorials in History* (New York: Jewish Museum with Prestel-Verlag, 1995).

26. Claude Lanzmann, *Shoah* (1985, *Historia,* Les Films Aleph, Ministère de la Culture de la République Française). See also "Seminar with Claude Lanzmann, 11 April, 1990," in *Yale French Studies* 79 (1991): 82–99.

27. See, for example, Elie Wiesel's experiences of the Holocaust in *Night* (New York: Hill and Wang, 1972). George Steiner, *Language and Silence: Essays on Language, Literature, and the Inhuman* (New York: Atheneum, 1967). Primo Levi, *Survival in Auschwitz: The Nazi Assault on Humanity,* trans. Stuart Woolf (New York: Touchstone, 1996).

28. Sybil Milton, Judith Levin, and Daniel Uziel, "Ordinary Men, Extraordinary Photos," *Yad Vashem Studies* 26 (1998): 267–93. See also Alexander B. Rossino, "Eastern Europe through German Eyes: Soldiers' Photographs 1939–42," *History of Photography* 23, no. 4 (Winter 1999): 313–21.

29. Susie Linfield, "A Witness to Murder: Looking at Photographs of the Condemned," *Boston Review* 30, no. 5 (September–October 2005): 8.

30. James E. Young, *The Texture of Memory: Holocaust Memorials and Meaning* (New Haven, Conn.: Yale University Press, 1993).

31. Ibid., 13.

32. Ibid., 14.

33. See, for example, Erwin Panofsky, "Iconology and Iconology," in *Meaning in the Visual Arts* (Garden City, N.Y.: Doubleday, 1955); Michael Baxandall, *Patterns of Intention* (New Haven, Conn.: Yale University Press, 1985).

34. This notion of memory and its triangular relationship with past and present can be found in the work of twentieth-century French philosophers such as Paul Ricoeur, *Memory, History, Forgetting,* trans. Kathleen Blamey and David Pellauer (Chicago: University of Chicago Press, 2004).

35. He says, "Instead of allowing the past to rigidify in its monumental forms, we would vivify memory through the memory-work itself—whereby events, their recollection, and the role monuments play in our lives remain animate, are never completed. Young, *The Texture of Memory,* 15.

36. Young uses the term in James Young, *At Memory's Edge: After-Images of the Holocaust* (New Haven, Conn.: Yale University Press, 2000).

37. For example, he discusses the monument and memorialization at the former Buchenwald Concentration Camp. The meaning of the site does not sit still: it is no more a memorial to the triumph of socialist resistance to fascism than it is a place to remember German victimization at the hands of Stalinism or a commemoration of the socialists who were murdered at Buchenwald.

38. Kansteiner, *In Pursuit of German Memory,* 315. Note that "normalization" is not Kansteiner's term. On the discourse of normalization, see Stefan Berger, *The Search for Normality: National Identity and Historical Consciousness in Germany since 1800* (Oxford, England: Oxford University Press, 2003).

39. Kansteiner, *In Pursuit of German Memory,* 316.

40. Kansteiner, "Entertaining Catastrophe," *In Pursuit of German Memory,* 109–30.

41. The most notable of these television narratives was the fictional *Holocaust* series in 1979.

42. Kansteiner, *In Pursuit of German Memory,* 176.

43. Ibid., 179.

44. Laurence Allard, "L'amateur: Une figure de la modernité esthétique," Le cinéma en amateur, special issue, *Communications* 68 (1999): 47–48.

45. Michael Kuball, *Familien-kino: Geschichte des Amateurfilms in Deutsch-land,* vol. 1, *1900–1930,* and vol. 2, *1931–1960* (Hamburg: Rowohlt, 1980).

46. Roger Odin, "La question de l'amateur dans trios espaces de réalization et diffusion," in *Le cinéma en amateur,* ed. Roger Odin (Paris: Seuil, 1999), 47–90.

47. Péter Forgács, "Wittgenstein Tractatus: Personal Reflections on Home Movies," in *Mining the Home Movie: Excavations in Histories and Memories,* ed. Karen L. Ishizuka and Patricia R. Zimmermann (Berkeley and Los Angeles: University of California Press, 2008), 47–56. Here he claims, "Mistakes are never part of a film's intentions, yet they are always present. In fact, mistakes make the genre of home movies powerful and real. Even the best, most sensational feature film or journalistic newsreel cannot compete with the latent authority of the home movie. I call that the 'perfection of imperfection.'" Forgács, "Wittgenstein Tractatus," 51. In his films, such as *The Maelstrom* (1997) and *A Danube Exodus* (1998), he often reuses footage from private home movies to trace the plight of European Jews between 1939 and 1942.

48. Forgács, "Wittgenstein Tractatus," 51.

49. André Bazin, "The Ontology of the Photographic Image," trans. Hugh Gray, *Film Quarterly* 13, no. 4. (Summer 1960): 4–9.

50. All of these distinctions are pretty standard ways of thinking about the amateur image. See Ishizuka and Zimmermann, *Mining the Home Movie.* See also Timm Starl, *Knipser: Die Bildgeschichte der privaten Fotografie in Deutschland und Österreich von 1880 bis 1980,* exhibition in the photo museum of Munich Stadtmuseum, June 14–August 20, 1995.

51. Alexandra Schneider, "Homemade Travelogues: *Autosonntag,*" in *Virtual Voyages: Cinema and Travel,* ed. Jeffrey Rouff (Durham, N.C.: Duke University Press, 2006), 160.

52. Frances Guerin and Roger Hallas, eds., *The Image and the Witness: Trauma, Memory, and Visual Culture* (London: Wallflower Press, 2008).

53. Shoshana Felman and Dori Laub, eds., *Testimony: Crises of Witnessing in Literature, Psychoanalysis, and History* (New York: Routledge, 1992).

54. Dori Laub, "Bearing Witness or the Vicissitudes of Listening," in ibid., 57–74.

55. Ibid., 71.

56. Shoshana Felman, "Camus' *The Plague,* or a Monument to Witnessing," in Felman and Laub, *Testimony,* 93–119.

57. For the argumentation on the translation of Felman's theory for the study of images, particularly for the use of the image in discourses of bearing witness

to traumatic historical events, see Frances Guerin and Roger Hallas, "Introduction," in *The Image and the Witness*, 1–20.

58. Guerin, "The Grey Space Between: Gerhard Richter's *18. Oktober 1977*," in Guerin and Hallas, *The Image and the Witness*, 111–26.

59. Marianne Hirsch, "I Took Pictures: September 2001 and Beyond," in *Trauma at Home: After 9/11*, ed. Judith Greenberg (Lincoln: University of Nebraska Press, 2003), 69–86. On this notion of the documentary image's engagement with the issue of the magnitude of the historical trauma, see Bill Nichols, *Representing Reality: Issues and Concepts in Documentary* (Bloomington: Indiana University Press, 1991), 232. For Nichols, magnitude involves our ethical relationship to the victims of historical trauma, so it requires that the traumatic historical experience be the basis of the image and its understanding.

60. Marianne Hirsch, "Introduction," in *The Familial Gaze* (Hanover, N.H.: University Press of New England, 1999), xiii.

61. The NSDAP also subscribed to many of the developments of modernity. These were an extension of the emphasis on the intensification of industrial modernity in the Weimar Republic. See Siegfried Kracauer, "The Mass Ornament," in Siegfried Kracauer, *The Mass Ornament: Weimar Essays*, trans. and ed. Thomas Y. Levin (Cambridge Mass.: Harvard University Press, 1995), 75–86.

62. Kuball presents still images from the film of Willi Beutler, who filmed Hamburg Harbor in 1937 and won the national competition in 1939. Kuball, *Familien-kino*, vol. 2, 84–88.

63. Kracauer, "The Mass Ornament."

64. Kuball, *Familien-kino*, vol. 2, 89.

65. Thomas Elsaesser, "Early German Cinema: A Second Life?" in *A Second Life: German Cinema's First Decades*, ed. Thomas Elsaesser (Amsterdam: Amsterdam University Press, 1996).

66. Kuball quotes this information from the *Jahrbuch des Kino-Amateurs*, 1937. See *Familien-kino*, vol. 2, 89.

67. Ibid.

68. Patricia Zimmermann's work has been groundbreaking in its demonstration of the microhistories written by amateur film and home movies. These films offer insight into the definitions of the ideology of family, gender, sexual practices, and other traditionally private spheres of existence. See, for example, Patricia R. Zimmermann, "Morphing History into Histories: From Amateur Film to the Archive of the Future," *Journal of the Association of Moving Image Archivists* 1, no. 1 (Spring 2001): 109–30. Zimmermann's is a Foucauldian analysis of amateur film as a set of ideological relationships. She is interested in the discourses they

narrate rather than their textual artistry. See Zimmermann, "Morphing History into Histories," 113. See also Patricia R. Zimmermann, *Reel Families: A Social History of Amateur Film* (Bloomington: Indiana University Press, 1995); Patricia R. Zimmermann, "Geographies of Desire: Cartographies of Gender, Race, Nation and Empire in Amateur Film," *Film History* 8, no. 1 (1996): 85–98.

69. See also Michelle Citron, *Daughter Rite* (1979, Women Make Movies), and Michelle Citron, *Home Movies and Other Necessary Fictions* (Minneapolis: University of Minnesota Press, 1998). Although Hirsch writes about photographs rather than films, her first book has also been formative for the study of amateur film. Marianne Hirsch, *Family Frames: Photography, Narrative, and Postmemory* (Cambridge, Mass.: Harvard University Press, 1997).

70. Citron's film explores the possibility of an aesthetic that instantiates an invitation to look closely at the underlying ideologies of gender, family, and culture. Thus her work is an example that begins with the visual expression of otherwise unstated beliefs and relationship dynamics within the family.

71. Zimmermann, "Morphing History into Histories," 112–13.

72. Roger Odin, "La question de l'amateur," 50. See also Ishizuka and Zimmermann, *Mining the Home Movie.*

73. Odin, "La question de l'amateur," 63.

74. For an example outside the German film, see Richard Fung, "Remaking Home Movies," in *Mining the Home Movie,* ed. Ishizuka and Zimmermann, 35.

75. Martina Roepke, "Feiern im Ausnahmezustand: Ein privater Film aus dem Luftschutzkeller," *montage/AV,* February 10, 2001, 59–75. See also Martina Roepke, *Privat-Vorstellung: Heimkino in Deutschland vor 1945* (Hildesheim: Olms, 2006). Also notable here are the essays collected in *Mining the Home Movie,* ed. Ishizuka and Zimmermann. The anthology marks an important shift in the criticism of home movies and amateur films, because the authors give these images the credence that had been claimed for these films but not until this point examined in them.

76. Alexandra Schneider, "Home Movie-Making and Swiss Expatriate Identities in the 1920s and 1930s," *Film History* 15, no. 2 (2003): 166–76. See also Alexandra Schneider, *"Die Stars sind wir": Heimkino als filmische Praxis* (Marburg: Schüren, 2004).

77. Odin, "La question de l'amateur," 54.

78. Zimmermann discusses the amateur film's return to pictorialism in its fascination with pure, untouched landscapes. See Patricia R. Zimmermann, "Cinéma amateur et démocratie," in *Le cinéma en amateur,* ed. Odin, 281–92.

79. Kuball, *Familien-kino.*

2. On the Eastern Front with the German Army

1. Pierre Bourdieu, *Photography: A Middle-Brow Art,* trans. Shaun White-side (Cambridge, England: Polity Press, 1990), 35. Originally published 1965.

2. Starl, *Knipser,* 98.

3. Petra Bopp discusses this and publishes photographs of such albums. See Petra Bopp, "Das Photoalbum im Krieg," in *Fremde im Visier: Fotoalben aus dem Zweiten Weltkrieg* (Bielefeld: Kerber, 2009), 36–39. See Bernd Boll, "Vom Album ins Archiv, zur Überlieferung privater Fotografien aus dem Zweiten Weltkrieg," in *Mit der Kamera Bewaffnet: Krieg und Fotografie,* ed. Anton Holzer (Marburg: Jonas, 2003), 174.

4. Peter Jahn and Ulrike Schmiegelt, eds., *Foto-Feldpost: Geknipste Kriegser-lebnisse 1939–1945* (Berlin: Elephanten, 2000), 50.

5. Ibid., 70.

6. In many cases, the photographs have come to the archives in paper pockets with the names of the firms that processed them stamped on the outsides.

7. The exhibition was reconfigured for its American chapter, which included images donated by families subsequent to the original exhibition. A symposium scheduled to accompany the exhibition went ahead at the New School University. Titled "International Symposium on Military War Crimes: History and Memory," it was held on December 3–6, 1999.

8. Hannes Heer and Klaus Naumann, eds., *Vernichtungskrieg Verbrechen der Wehrmacht, 1941–1944* (Hamburg: Hamburger Institut für Sozialforschung, 1995). Also, for a good overview of the exhibition's impetus and the discourses it sought to challenge or "demythologize," see Bill Niven, "The Crimes of the Wehrmacht," in *Facing the Nazi Past: United Germany and the Legacy of the Third Reich* (London: Routledge, 2002), 143–74.

9. Niven, *Facing the Nazi Past,* 126, 564–65. For panoramic views of the exhibition and some of the accompanying texts, see Verbrechen der Wehrmacht: Dimensionen des Vernichtungskrieges 1941–1944, http://www.verbrechen-der-wehrmacht.de (accessed February 12, 2008).

10. See Hans-Günther Thiele, ed., *Wehrmachtausstellung: Dokumentation einer Kontroverse* (Bremen: Edition Temmen, 1997). There are also many publications that contributed to and documented the debate, which died down around 2004. For discussion of the debate and the critical issues raised by it, see Christian Hartmann, Johannes Hürter, and Ulrike Jureit, eds., *Verbrechen der Wehrmacht: Bilanz einer Debatte* (Munich: C. H. Beck, 2005).

11. In spite of the huge controversy, only a handful of images were questioned by two historians from Eastern Europe and some visitors. There was particular

focus on the photographs of the slaughter at Tarnopol. For discussion of the problems in attribution, see the contributions in Michael Th. Greven and Oliver von Wrochem, eds., *Der Krieg in der Nachkriegszeit: Der Zweite Weltkrieg in Politik und Gesellschaft der Bundesrepublik* (Opladen: Leske and Budrich, 2000).

12. See the corrected catalog: Jan Philipp Reemtsma, Ulrike Jureit, and Hans Mommsen, eds., *Verbrechen der Wehrmacht: Dimensionen des Vernichtungskrieges 1941–1944* (Hamburg: Hamburger Institut für Sozialforschung, 2002).

13. The notion of the amateur film and photograph as orphaned is taken from the recent Orphans of the Storm conferences. The orphaned image is, loosely defined, one that is "abandoned by its owner or caretaker." For examples of films outside of the commercial mainstream that have been accepted into the canons of orphanhood, see the Orphan Film Symposium: Orphans 5: Science, Film, and Education, http://www.sc.edu/filmsymposium/orphanfilm.html.

14. Hirsch, *Family Frames,* 8.

15. See also Citron, *Home Movies and Other Necessary Fictions.*

16. Hirsch's conception of "post memory," the process of experiencing the Holocaust by a generation that has been exiled in time and space from World War II, typically the children of survivors, has been taken up by scholars in the interpretation of a whole array of "witnessing" experiences by people who were not physically present to the traumatic events in question. See, for example, Devin Orgeron and Marsha Orgeron, "Megatronic Memories: Errol Morris and the Politics of Witnessing," in *The Image and the Witness,* ed. Guerin and Hallas, 241ff. See also the essays collected in Judith Greenberg, *Trauma at Home: After 9/11* (Lincoln: University of Nebraska Press, 2003).

17. The unfortunate absence of information is reiterated by most scholars who have attended to the photographs, although, as is illustrated throughout this chapter, some information is available. The relative obscurity that surrounds the images takes on new meaning when they are reappropriated by the exhibition. In addition, as Dieter Reifarth and Viktoria Schmidt-Linsenhoff point out in an informative article on the amateur Wehrmacht photographs, we can be confident that the thousands of photographs that have been handed down to us today are only a small fraction of those that would have been taken at the time. Dieter Reifarth and Viktoria Schmidt-Linsenhoff, "Die Kamera der Henker: Fotografische Selbstzeugnisse des Naziterrors in Osteuropa," *Fotogeschichte* 3, no. 7 (1983): 61.

18. These discussions have taken place primarily in the journal *Fotogeschichte* in the 1990s. See also the many articles published in the wake of the photographs' discovery and exhibition in the *Vernichtungskrieg* exhibition as it toured Germany in the late 1990s. See particularly *Fotogeschichte: Beiträge zur Geschichte*

und Ästhethik der Fotografie 14 (1994). See also the essays collected in Rolf-Dieter Müller and Hans Erich Volkmann, eds., *Die Wehrmacht: Mythos und Realität: Im Auftrag des Militärgeschichtlichen Forschungsamtes* (Munich: Oldenbourg, 1999). See also Jahn and Schmiegelt, *Foto-Feldpost.* Sybil Milton is still one of the only Anglo–American authors to discuss these images. See, for example Milton, "Photography as Evidence of the Holocaust," 303–5.

19. Hanno Loewy, " '. . . without Masks': Jews through the Lens of 'German Photography,' 1933–1945," in *German Photography 1870–1970: Power of a Medium,* ed. Klaus Honnef, Rolf Sachsse, and Karin Thomas (Cologne: Dumont, 1997), 106.

20. In the above-mentioned example from criticism, Gertrud Koch argues that the aesthetic and composition of the photographs of Walter Genewein, discussed in chapter 3, reveal the ideological agenda of the Nazi destruction of the Jews.

21. A good example is Sybil Milton's work on the photographs. As I pointed out in the introduction, Milton's research is important and groundbreaking because it brought these photographs to English-speaking readers in the 1980s. The special issue of *History of Photography* is still one of the only places that these images are considered as images. See Milton, "The Camera as Weapon"; Milton, "Photography as Evidence of the Holocaust."

22. Klaus Latzel, "Kollektive Identität und Gewalt," in *Foto-Feldpost,* ed. Jahn and Schmiegelt, 13–22.

23. Petra Bopp publishes examples of the series of 142 photographs that appear in an album, "Vom Donez zum Don," made in Russia in 1942. In her research Bopp found five examples of the same album with as many different owners. See Bopp, "Vom Donez zum Don," in *Fremde im Visier,* 101–22.

24. In theology, the witness is a martyr to a belief in God, typically suffering in the face of the vehement renouncement of the same. Much more familiar and closer to everyday usage of the term are its roots in the law, where a witness is called upon as a privileged source of information about the absolute truth of an event. John Durham Peters, "Witnessing," *Media, Culture, and Society* 23, no. 6 (2001): 707–23.

25. The best known here is Roland Barthes's discussion of the photograph as an authentication of the occurrence of the past, albeit now lost. Indeed, for Barthes the photograph even takes on the life of what it represents in the mind of the viewer. See Roland Barthes, *Camera Lucida: Reflections on Photography,* trans. Richard Howard (New York: Hill and Wang, 1981), 88–89.

26. Ulrike Schmiegelt, "Macht euch um mich keine sorgen . . . ," in *Foto-Feldpost,* ed. Jahn and Schmiegelt, 26. Bernd Boll traces the history of the prohibition against photographing executions. He also comments that soldiers were

not permitted to photograph dead or injured German soldiers. These injunctions were in keeping with the Nazi policy of propagating a very specific image of Germany's success in the war. See Bernd Boll, "Das Adlerauge des Soldaten: Zur Fotopraxis deutscher Amateure in Zweiten Weltkrieg," *Fotogeschichte* 22, nos. 85–86 (2002): 75–87. This prohibition is reiterated by most scholars who examine the material. See also, for example, Honnef, Sachsse, and Thomas, *German Photography 1870–1970.*

27. See U.S. Holocaust Memorial Museum image 70555.

28. Laub, "Bearing Witness or the Vicissitudes of Listening," 64.

29. Hüppauf, "Emptying the Gaze."

30. This is where the concept of soldier as witness is most significantly undermined. Because the photographs violate the humanity of the victims, they automatically preclude any hint of the responsibility of the soldier as witness, let alone a recognition of his own responsibility either for the murder of his enemy or for the testimony of his trauma.

31. Barbie Zelizer, *Remembering to Forget: Holocaust Memory through the Camera's Eye* (Chicago: University of Chicago Press, 2000), 10.

32. Gerhard Schönberner, *Der gelbe Stern: Die Judenverfolgung in Europa 1933–1944* (Munich: Bertelsmann, 1978), 6. The introduction, to which I refer, was written in 1960.

33. Ibid., 5–8.

34. Ibid., 7. This insight by Schönberner is in itself striking because he is using the photograph as a historical document in which the biases form the basis of the discursive value of the image. It is striking because he wrote this in 1960 at a time when there was a blanket of silence over these events in the German cultural and historical imaginary. And it would be another forty years before the same value would be ascribed to the perpetrators' photographs. However, it is also noticeable that despite his argument, the book includes images taken by a variety of photographers for a variety of purposes, including resistance fighters. He is not interested so much in the images as in the making public of the Holocaust.

35. Ishizuka and Zimmermann, *Mining the Home Movie.*

36. Cathy Caruth, *Unclaimed Experience: Trauma, Narrative, and History* (Baltimore, Md.: Johns Hopkins University Press, 1996), esp. chap. 3, 57–72.

37. Kathrin Hoffmann-Curtius, "Trophäen und Amulette: Die Fotografien von Wehrmachts- und SS-Verbrechen in den Brieftaschen der Soldaten," *Fotogeschichte* 78 (2000): 71.

38. Bernd Hüppauf, "Emptying the Gaze."

39. Schönberner, *Der gelbe Stern,* 36–37.

40. Hüppauf, "Emptying the Gaze," 349.

41. Hirsch also supports the argument that the photographs are witnessing. See, for example, her essay "Nazi Photographs in Post-Holocaust Art: Gender as an Idiom of Memorialization," in *Crimes of War: Guilt and Denial in the Twentieth Century,* ed. Omar Bartov, Atina Grossman, and Mary Nolan (New York: New Press, 2002), 100–120.

42. This notion was first articulated by Jean-François Lyotard in *La Différend* in his discussions of existential and metaphysical shifts. He talks about the impossibility of proving death in the gas chamber. The only way to prove the existence of the killings is to have a witness testify, and all the witnesses are dead. See Jean-François Lyotard, *La Différend: Phrases in Dispute,* trans. Georges Van Den Abbeele (Minneapolis: University of Minnesota Press, 1989), 3–5.

43. Although the photographs make sense within the context of modernity, particularly the growth of modern representational forms, they cannot and should not be accepted as modernist: they do not witness their own mode of production, that is, they are in no way self-reflective.

44. Alan Trachtenberg, "Introduction," in *Classic Essays on Photography* (New Haven, Conn.: Leete's Island Books, 1980), ix.

45. Bernd Hüppauf, "Experiences of Modern Warfare and the Crisis of Representation," *New German Critique* 59 (Spring–Summer 1999): 41–76.

46. This problem was raised when criticism was leveled at the Institute for Social Research's attributions of several photographs in the *Crimes of the Wehrmacht* exhibition. See Niven, "The Crimes of the Wehrmacht."

47. I am thinking here about Baudelaire and his debate with those who were writing about photography in the mid-nineteenth century. Baudelaire celebrated the medium for its "material accuracy" and precision that the eye could not achieve, together with the emphasis on its links to industrialization. See Charles Baudelaire, "The Salon of 1859," in *Charles Baudelaire: The Mirror of Art,* ed. and trans. Jonathan Mayne (London: Phaidon, 1955).

48. This is discussed by Odin as well as Zimmermann, *Reel Families.*

49. Once again, we note that this productive relationship between modernity, photography, and the battlefield is specific to the amateur as opposed to the professional image, for the traditionally defined professional image did not, at this moment in history, reflect the earliest concerns and experiments of photography. On the contrary, professional images in the late 1930s and early 1940s were concerned with exploring entirely different issues. For example, none of the Propaganda Company photographers collected their images in albums tracing their travels east.

50. This rationalization of perception has been explored by a number of

theorists of modern photography. One of the leading proponents was Siegfried Kracauer; see his "Revealing Functions," in *Theory of Film: The Redemption of Physical Reality,* intro. Miriam Hansen (Princeton, N.J.: Princeton University Press, 1997), 46–59. Originally published in 1960.

51. Ibid. See also Walter Benjamin, "A Short History of Photography," reprinted in *Classic Essays on Photography,* ed. Trachtenberg, 199–216; Abigail Solomon-Godeau, "The Armed Vision Disarmed: Radical Formalism from Weapon to Style," reprinted in *The Contest of Meaning: Critical Histories of Photography,* ed. Richard Bolton (Cambridge, Mass.: MIT Press, 1989), 84–109.

52. Matei Calinescu, *Five Faces of Modernity: Modernism, Avant-Garde, Decadence, Kitsch, Postmodernism* (Durham, N.C.: Duke University Press, 1987).

53. Travel snaps and the resultant albums are very much a phenomenon of the twentieth century. Today, in the twenty-first century, such images are digitally produced, collected, cataloged, and distributed.

54. Klaus Latzel, "Tourismus und Gewalt: Kriegswahrnehmungen in Feldpostbriefen," in *Vernichtungskrieg,* ed. Heer and Naumann, 447–59. See also the film by Harriet Eder and Thomas Kufus, *Mein Krieg* (*My Private War,* 1990, Känguruh Film GmbH, *Westdeutscher Rundfunk*), in which one of the soldiers interviewed rejects the possibility that he might regret his experience as a Wehrmacht soldier by explaining that his travels through the East were his opportunity to see the world, an opportunity he would never have had otherwise. This attitude is also evident in the photographs: depictions of soldiers in front of direction signs with locations and distance marked on them, images of exotic locations and landscapes, peoples, and curiosities, which are identical in genre to those taken by civilian tourists in the twentieth century.

55. Marianne Hirsch argues for this in *Family Frames.*

56. Alison Griffiths, *Wondrous Difference: Cinema, Anthropology, and Turn-of-the-Century Visual Culture* (New York: Columbia University Press, 2001).

57. James Clifford, *The Predicament of Culture: Twentieth-Century Ethnography, Literature, and Art* (Cambridge, Mass.: Harvard University Press, 1988), esp. Part 2, "Displacements," 115–85.

58. Ibid., 160.

59. See Ingrid Thurner, " 'Grauenhaft: Ich muß ein Foto machen,' Tourismus und Fotografie," *Fotogeschichte* 12, no. 44 (1992): 23–42. Thurner gives a good introduction to the motivations of tourist photography.

60. I am reminded here of some of the earliest daguerreotypes, which were ethnographic in nature. See Melissa Banta and Curtis M. Hinsley, *From Site to Sight: Anthropology, Photography, and the Power of Imagery* (Cambridge, Mass.: Peabody Museum Press, 1986).

61. Richard J. Evans, *The Coming of the Third Reich* (London: Penguin, 2004), 35.

62. Eduardo Cadava, "Lapsus Imaginis: The Image in Ruins," *October* 96 (2001): 36.

63. Schmiegelt, "Macht euch um mich keine sorgen . . . ," 24.

64. Timm Starl, "Hakenkreuz und Heimatliebe: Propaganda und private Fotografie im Nationalsozialismus," in *Knipser*, 99–110.

65. See also Boll, "Das Adlerauge des Soldaten."

66. Ibid., 62.

67. Like their anonymous counterparts, clandestine photographs taken by professional cameramen lay in obscurity for the duration of the war and much of the remainder of the twentieth century. It is only now that these prohibited secret visions of unsavory sights have become integrated into public histories of World War II. See Boll, "Das Adlerauge des Soldaten," 84–85.

68. Ibid., 77, 79. Again, Stubbening is quoted as being shocked and disgusted at what he experienced of the massacre.

69. Boll, "Das Adlerauge des Soldaten," 78.

70. Riefenstahl volunteered to go to the front as a reporter. See Leni Riefenstahl, *Leni Riefenstahl* (London: Picador, 1995).

71. Thus it was important that people believe that "the whole of Germany now consisted of picturesque sleepy little towns and rugged market traders with rosy-cheeked children." Honnef, Sachsse, and Thomas, *German Photography 1870–1970*, 84.

72. Abigail Solomon Godeau, "Who Is Speaking Thus? Some Questions about Documentary Photography." In *Photography at the Dock* (Minneapolis: University of Minnesota Press, 1991), 180–81.

73. Hamburg Institute for Social Research, ed., *The German Army and Genocide: Crimes against War Prisoners, Jews, and Other Civilians, 1939–1944* (New York: New Press, 1999), 176.

74. Rolf Sachsse, "Photography as NS State Design: Power's Abuse of a Medium," in *German Photography 1870–1970*, ed. Honnef, Sachsse, and Thomas, 83–99.

75. Critics such as Dan Stone also argue that none of these details make the photographs complicit in, even evidence of, Nazi ideology, that without an adequate context, they cannot be identified as in support of an ideological program. See Dan Stone, "The Sonderkommando Photographs," in *Jewish Social Studies* 7, no. 3 (Spring 2001): 131–48.

76. Jo Spence and Patricia Holland, eds., *Family Snaps: The Meanings of Domestic Photography* (London: Virago, 1991). Marianne Hirsch argues this as well.

77. Jahn and Schmiegelt, *Foto-Feldpost.*

78. This tendency to keep the photograph on the person of the soldier is noted by a number of authors. For example, see Reifarth and Schmidt-Linsenhoff, "Die Kamera der Henker," 59; Hüppauf, "Emptying the Gaze," 360.

79. It is interesting that the *Fremde im Visier* project was put together fourteen years after the *Verbrechen der Wehrmacht* exhibition. The recent exhibition demonstrates the shift in attitudes toward and emotions surrounding these photographs in Germany over the past fourteen years. Now that the guilt and shame that surfaced as a result of the *Verbrechen der Wehrmacht* exhibition has been worked through, soldiers, their families, and the next generation of Germans are able to share their experiences without remorse. Thus a project such as *Fremde im Visier* is an indication of Germany's readiness to face the trauma and continue the forward motion toward a fuller understanding and memory of World War II. As in the case of the *Verbrechen der Wehrmacht* exhibition, when *Fremde im Visier* opened in Oldenberg, all the soldiers and their families came forward with their photo albums. See Petra Bopp, "Erinnerungsprozesse," in *Fremde im Visier*, 24–25.

80. This image can be seen in Jahn and Schmiegel, *Foto-Feldpost*, 34–35. There are many examples of such images in the archives. See also, for example, the album pages reproduced in Bopp, *Fremde im Visier*.

81. "EK Glagen," in *The German Army and Genocide*, ed. Hamburg Institute for Social Research, 189, no. 27. Such images are markedly different from the generic, anonymous images that were used for propaganda purposes, for newspaper publications, and for documentation of the crimes in the camps. See Honnef, Sachsse, and Thomas, *German Photography 1870–1970*.

82. Jahn and Schmiegelt, *Foto-Feldpost*, 107–9.

83. Rainer Rother, ed., *Die Letzten Tage der Menschheit: Bilder des Ersten Weltkrieges* (Berlin: Deutsches Historisches Museum, 1994).

84. Patricia Holland, "Introduction: History, Memory, and the Family Album," in *Family Snaps*, 3.

85. For details of the critique from Hungarian and Polish scholars that led to the exhibition's withdrawal, see Niven, *Facing the Nazi Past*, 169–74. See also Kristian Ungváry, "Echte Bilder-problematische Aussagen: Eine quantitative und qualitative Analyse des Bildmaterials der Ausstellung 'Vernichtungskrieg—Verbrechen der Wehrmacht 1941–1944,'" *Geschichte in Wissenschaft und Unterricht* 50 (1999): 584–95.

86. Niven, *Facing the Nazi Past*, 277–78.

87. Ibid., 464–67.

88. See "Introduction," in *Crimes of the German Wehrmacht: Dimensions of a War of Annihilation, 1941–1944* (Hamburg: Hamburger Edition, 2004), 3.

89. See also the articles in *Mittleweg 36* in 1999 and the interview with Norbert Frei by Jan Philipp Reemtsma regarding the ongoing concerns of the Hamburg Institute, "Es ist nie zu Ende 'Verbrechen der Wehrmacht': Die spektakuläre zeithistorische Ausstellung wird jetzt in Hamburg zum letzten Mal gezeigt," *Die Zeit*, January 22, 2004, http://www.zeit.de/2004/05/Wehrmacht_?page=all.

90. Guerin and Hallas, *The Image and the Witness.*

91. Although the historical discourse of the Germans as victims has also come alive over the past ten years, as critics such as Bill Niven argue, this merely sets up an either/or dichotomy with the Germans as perpetrators when, in reality, there was a whole host of Germans who were neither victims nor perpetrators but somewhere in between. Dagmar Barnouw's book addresses exactly this issue. Dagmar Barnouw, *The War in the Empty Air: Victims, Perpetrators, and Postwar Germans* (Bloomington: Indiana University Press, 2005).

92. A film by Ruth Beckerman, *Jensiets des Krieges* (1996), highlights this tendency. It is a film that is about the responses to the exhibition rather than the exhibition itself in its Viennese installation. Despite the fact that the soldiers and others interviewed constantly discuss the photographs (as opposed to the textual documentation), we never see the images concerned. What is interesting, though, is the multitude of different responses that the exhibition gives rise to, indicating that there is never going to be a unified, common identification with the images or the history they tell. This film, in turn, thus reinforces my argument when it exposes the museum's efforts to control the cultural, and in this case national, identity of the visitor through its insistence on providing an "accurate" representation and thus searching for a unified visitor.

93. In this sense we see yet again this continuity between the amateur and experimental image in that it contemplates its own materiality, albeit inadvertently. It is the covert self-exploration of the amateur image that indeed causes the confusion.

94. Donald Preziosi, *Brain of the Earth's Body: Art, Museums, and the Phantasms of Modernity* (Minneapolis: University of Minnesota Press, 2003).

3. *The Privilege and Possibility of Color*

1. In his diaries Goebbels discussed the benefits of color in relation to moving images. However, it is significant that Agfa film stock was used for both still and moving image transparencies. See Gert Koshofer, *Color: Die Farben des Films* (Berlin: Spiess, 1988); Gert Koshofer, *Die Farbfotografie III, Lexikon der Verfahren, Geräte und Materialien: Das System der Verfahren, Chronik der Farbfotografie* (Munich: Lanterna Magica, 1981). See also Michael Kater, "Film as

an Object of Reflection in the Goebbels Diaries: Series II (1941–1945)," *Central European History* 33, no. 3 (2000): 391–414. See also David Culbert, "Joseph Goebbels and His Diaries," *Historical Journal of Film, Radio, and Television* 15, no. 1 (March 1995): 143–49.

2. See this image in Sachsse, "Photography as NS State Design: Power's Abuse of a Medium," 91. See also Janina Struk, *Photographing the Holocaust: Interpretations of the Evidence* (London: I. B. Tauris, 2003).

3. See Sybil Milton, "Photography as Evidence of the Holocaust," 304.

4. *The Mass Shooting of Jews in Ukraine 1941–1944: The Holocaust by Bullets* (Paris: Mémorial de la Shoah, 2006), 94–97, exhibition catalog.

5. Bopp quotes W. Kross, a soldier, from 1941: "Das große Erleben mit dem modernsten und forschrittlichsten Mittle, der Farbenfotografie, im Bilde festzuhalten." W. Kross, "Erst recht für den Soldaten—Farben-photographie," *Agfa-Photoblätter* 18 (1941): 113.

6. See Frances Guerin, "Reframing the Photographer and His Photographs," *Film and History* 32, no. 1 (2002): 43–54.

7. Hanno Loewy and Gerhard Schönberner, ed., *"Unser einziger Weg ist Arbeit": Das Getto in Łódź, 1940–1944* (Vienna and Frankfurt: Löcker and Judisches Museum, 1990).

8. I am grateful to Adelson for willingly showing me the images. Today 197 of the images can be found at the Web site of the U.S. Holocaust Memorial Museum (USHMM), http://resources.ushmm.org/inquery/uia_query.php.

9. Today it is usual for images known to have been taken by Nazis to be donated anonymously. The donor is usually a family member or descendent of the now deceased photographer, who kept his images stored away during his lifetime.

10. The history of their sale to Löcker Verlag can be found in Florian Freund, Bertrand Perz, and Karl Stuhlpfarrer, "Bildergeschichten—Geschichtsbilder," in *"Unser einziger Weg ist Arbeit,"* ed. Loewy and Schönberner, 50–58.

11. The exhibition ran from March 30 through July 8, 1990.

12. The wording is somewhat ambiguous; we assume that the slides were found by the liberator in the Bremen home of Hans Biebow, the chief of the German administration of the Lodz Ghetto.

13. I did not see the original Genewein slides because they were in off-site storage vaults. This information was communicated to me by Judith Cohen of the Photography Archive.

14. USHMM, image 74503.

15. Genewein's were among the first color photographs printed by Agfa, but other Nazis were using color stock in their photographic documentation of their activities. For example, Milton writes of Würth's use of color slides for his

anthropological research between 1936 and 1940. See Milton, "Photography as Evidence of the Holocaust."

16. The only motorized vehicle in the ghetto was a fire truck. See Alan Adelson and Robert Lapides, eds., *Łódź Ghetto: Inside a Community under Siege* (New York: Viking Press, 1989).

17. Grossman was even taking photographs while he was in a line awaiting deportation for Auschwitz, where he was murdered. For an image of Grossman photographing the deportation lines, see Adelson and Lapides, *Łódź Ghetto,* 462. Ross is still alive today and living in Israel.

18. USHMM, image 74521A.

19. See John Tagg, "Evidence, Truth, and Order: Photographic Records and the Growth of the State," in *The Burden of Representation* (Minneapolis: University of Minnesota Press, 1988), 60–65.

20. Ibid., 64.

21. The Nazis did not make direct references to the pseudo-sciences, but their belief that the size, terrain, and characteristics of the human skull parallel the characteristics of the brain has been well documented. They published these images week after week in their illustrated papers, such as *Illustrierter Beobachter* and *Münchener Illustrierte Presse.*

22. See, for example, USHMM, images 95081A, 95083A, and 95086A.

23. Given the absence of titles, together with the shape of the narrative formed by the numbering, we can assume that the titles were provided by Genewein when he ordered that the transparencies be made after the war.

24. As I discuss later, this set of images comes closest to the racist pictures taken by the propaganda companies because they stereotyped the Jews.

25. Pabianice was a work camp that served as a halfway station between Lodz and Chelmo, where the crematoriums were located. At Pabianice, Jews, Gypsies, and others on their way to the death camps were stripped of their belongings, their hair, their gold fillings, and so on.

26. The image of naked Jews in a shower, scared and awaiting water, is never far from death through poisonous gas. USHMM, image 95294.

27. This is the same structured, ordered composition that Abigail Solomon-Godeau identifies as a mise-en-scène of control and power. Solomon-Godeau, "Who Is Speaking Thus? Some Questions about Documentary Photography," in *Photography at the Dock: Essays on Photographic History, Institutions, and Practices,* ed. Solomon-Godeau.

28. USHMM, images 95076 and 95077.

29. Memo from Biebow to all departments, ref. 027/1/Bi/H, file GV 29217, Archiwum Panstwowe w Łódź.

30. USHMM, image 74512A.

31. For what is still the most rigorous examination of the archive and the history of the archived photograph, especially as a tool of social authorities, see Allan Sekula, "The Body and the Archive," *October* 39 (Winter 1986): 3–64.

32. Zygmunt Bauman, *Modernity and the Holocaust* (Ithaca, N.Y.: Cornell University Press, 1989).

33. Ibid., esp. chaps. 2 ("Modernity, Racism, Extermination I") and 3 ("Modernity, Racism, Extermination II"), 31–82. See also Omer Bartov, *Murder in Our Midst: The Holocaust, Industrial Killing, and Representation* (Oxford: Oxford University Press, 1996). Bartov makes a similar argument about the imbrication of racism, modernity, and the Holocaust.

34. In most interdepartmental correspondence in the Lodz city archives, if the recipient is specified it is through the use of his job and rank, never his name. Similarly, the files of the administration of the ghetto indicate that every movement of every day and every payment, no matter the amount, had to be recorded and every piece of correspondence filed in a particular way. If a German wanted to leave the ghetto for any reason, he had to apply in writing with justification, as though he, too, was prisoner within the ghetto walls. The absurdly high degree of documentation was certainly not reserved for the enemy and indeed appears to have been extremely controlling of the Germans themselves.

35. Detlev Peukert, *The Weimar Republic: The Crisis of Classical Modernity,* trans. Richard Deveson (London: Penguin, 1991).

36. See, for example, USHMM, images 95181A and 95190A—images of men making shoes in which heads are cut off by the frames of the images but their hands are shown presenting the shoes to the camera.

37. Günther Schwarberg, *Im Ghetto von Warschau: Heinrich Jösts Fotografien* (Göttingen: Steidl, 2001).

38. It is interesting that Biebow is the officer who appears most frequently in Genewein's photographs, because Biebow was in charge of productivity.

39. For more on the picturing of Jewishness in the National Socialist imagination, see Sachsse, "Photography as NS State Design: Power's Abuse of a Medium." For examples of the anti-Semitic work of other photographers in the ghettos, see also Struk, *Photographing the Holocaust,* 79–81.

40. Baer quotes survivors of the ghetto to argue that the "illusion of survival" was nurtured by the Nazis as one of their tactics of deception. The hope stirred up by these illusions was, presumably, what ensured the productivity levels of the ghetto. However, the illusion must have had a different meaning when it was the Nazi who subscribed to it. Baer, *Spectral Evidence,* 142–43.

41. Gertrud Koch, "Exkurs: Täuschung und Evidenz in gestellten Fotos aus dem Getto Łódź," in *Die Einstellung ist die Einstellung,* 170–84.

42. Loewy, "'. . . without Masks,'" 104.

43. Freund, Perz, and Stuhlpfarrer, "Bildergeschichten—Geschichtsbilder," 54.

44. Quoted in Loewy, "'. . . without Masks,'" 104.

45. For an excellent history of the ghetto and the details of its operation, see Julian Baranowski, *The Łódź Ghetto, 1940–1944* (Lodz: Archiwum Panstowowe w Lodzi und Bilbo, 2005), 28–38.

46. See Freund, Perz, and Stuhlpfarrer, "Bildergeschichten—Geschichtsbilder," 52.

47. Ibid., 53. Obviously, the existence of Genewein's photographs is evidence that these prohibitions were neither observed nor enforced by the German administration.

48. Again, like the prohibitions on photography on the Eastern Front, the orders of the central Nazi administration were obviously ignored, not only by Genewein but also, given their apparent indifference as they appear in his photographs, by other German administrators of the Lodz Ghetto.

49. André Bazin, "The Ontology of the Photographic Image," reprinted in *Classic Essays on Photography,* ed. Trachtenberg, 241, emphasis in original.

50. See Bartov, *Murder in Our Midst,* 67.

51. Ibid.

52. USHMM, image 95212b.

53. USHMM, image 74510A.

54. Here we have these shining examples of Benjamin and Brecht's insistence that reproductions of reality are powerless to say anything about that reality and that an authentically political photographic practice must be "set up" and "constructed." The example from their contemporary world would be the photo montages of John Heartfield. These would be the ultimate politically responsible and "authentic" documents.

55. See Freund, Perz, and Stuhlpfarrer, "Bildergeschichten—Geschichtsbilder."

56. Ibid., 56.

57. Lucjan Dobroszycki, ed., *The Chronicle of the Łódź Ghetto, 1941–1944* (New Haven, Conn.: Yale University Press, 1987).

58. Adelson and Lapides, *Łódź Ghetto,* 368. The files of Chiam Rumkowski *(Älteste der Jüde)* held in the Archiwum Państwowe w Łodi contain order upon order aimed at curbing the behavior of the ghetto population. Rumkowski's attempts to control his subjects are a testimony to the difficult conditions under which these people were forced to survive.

59. Included in the wealth of records generated by the Jewish administration

at the instigation of the German administration is a surfeit of pictorial documentation. These documents were discovered after the war and were taken illegally by the Jewish people who were designated photographers for the Jewish chronicle. Once again, we find official photographers taking unofficial pictures. See Mendel Grossman, *With a Camera in the Ghetto,* ed. Alexander Sened and Zvi Szner (London: Schocken, 1987); Henryk Ross, *Łódź Ghetto Album* (London: Archive of Modern Conflict, 2004). Many of Grossman and Ross's photographs are presented in Baranowski, *The Łódź Ghetto, 1940–1944.* There are also a number of Polish publications with numerous photographs taken by unknown amateur photographers. See Baronowski, *The Łódź Ghetto, 1940–1944,* and Joanna Podolska, *Litzmannstadt-Getto: Ślady Przewodnik po przeszłości* (Lodz: Piatek Trzynastego, 2004). See also Joe J. Heydecker, *The Warsaw Ghetto: A Photographic Record, 1941–1944* (London: I. B. Tauris, 1990). Much can be said about Heydecker's photographs; they are very complex and were not necessarily the call to outrage by the "good German soldier" that they are claimed to be.

60. Oskar Rosenfeld, "Notebook B: Memories for Later Days," in *Łódź Ghetto,* ed. Adelson and Lapides, 213. The writer Rosenfeld was transported to the ghetto from Prague in October 1941 and deported to Auschwitz in the final deportation from the ghetto in August 1944. This collection offers a wide variety of the writings produced in Lodz for both personal and public reference. See also Lucjan Dobroszvcki, ed., *The Chronicle of the Łódź Ghetto, 1941–44,* trans. Richard Lourie (New Haven, Conn.: Yale University Press, 1984).

61. USHMM, image 95145.

62. The particular film that added this new level of meaning to the photographs was Jablonski's *Fotoamator* (1998). Baer, *Spectral Evidence,* 170–76.

63. See U.S. Holocaust Memorial Museum, images 95104A, 95105A, 65700.

64. Solomon-Godeau, "Who Is Speaking Thus?" 180.

65. Again, although Baer makes this argument, he argues for a different usage of the images in their present-day role as agents in the witnessing process.

66. John Berger, "Understanding a Photograph," in *Classic Essays on Photography,* ed. Trachtenberg, 293.

67. Walter Benjamin, "A Short History of Photography," *Screen* 13, no. 1 (1972): 5–26, originally published in *Literarische Welt,* September 18 and 25 and October 2, 1931; Roland Barthes, "The Photographic Message," in *Image-Music-Text,* ed. and trans. Stephen Heath (New York: Hill, 1977), 14–31; and Roland Barthes, "The Rhetoric of the Image," in ibid., 32–51.

68. Gertrud Koch, "The Aesthetic Transformation of the Image of the Unimaginable: Notes on Claude Lanzmann's *Shoah,*" *October* 48 (Spring 1989): 21.

69. USHMM, image 95129.

70. USHMM, image 95200.

71. A sign that Rumkowski put up in 1941 confirms the illegal status of these photographs taken in the Ghetto. Although the same restrictions also applied to the Jewish prisoners, Henryk Ross and Mendel Grossman were permitted relative freedom to photograph in their official capacities as photographers for the ghetto chronicle. See Loewy and Schönberner, *"Unser einziger Weg ist Arbeit,"* 175.

72. "Vor kurzer Zeit erhielt ich nun 6 komplete Farbfilme aus einer Filmserie, deren Haltbarkeit bis April 1942 läuft, und mußte neuerdings feststellen, das weiße Flächen rosa, blaue Flächen violet und grüne Flächen braungrün erscheinen." Walter Genewein, letter to Agfa, file 29388, 61, Archiwum Panstowowe w Łódź.

73. Martha Rosler, "In, Around, and Afterthoughts (On Documentary Photography)," in *Martha Rosler: Three Works* (Halifax: Press of the Nova Scotia College of Art and Design, 1984). See also Solomon-Godeau, "Who Is Speaking Thus?" 169–217.

74. John Roberts, "The State, the Everyday and the Archive," in *The Art of Interruption: Realism, Photography, and the Everyday* (Manchester, England: Manchester University Press, 1998), 72–97.

75. John Tagg, "The Currency of the Photograph: New Deal Reformism and Documentary Rhetoric," in *The Burden of Representation: Essays on Photographies and Histories* (London: Macmillan, 1988), 153–83.

76. Lewis W. Hine, "Social Photography: How the Camera May Help in the Social Uplift" (1909), reprinted in *Classic Essays on Photography*, ed. Trachtenberg, 109–13.

77. Central to Hine's use of this kind of realism was the intersubjectivity between spectator and subject. So he was using this direct camera address as a way of striking up this relationship, as the basis of his realism. Genewein was not exploiting it for these purposes.

78. Janina Struk mentions the three dominant beliefs about the photographic image as they are appropriated by Nazi propaganda; however, she does not go into great detail. See Struk, *Photographing the Holocaust,* 16–27.

79. I discuss this further in chapter 4.

80. See *"Unser einziger Weg ist Arbeit,"* 76.

81. See Struk, *Photographing the Holocaust,* 22.

82. Biebow is particularly present in the Abrams images donated to the USHMM. This is another indication that Genewein made them for Biebow and gave them to him while still in the ghetto. Biebow was known to have organized the transport of belongings (those left by Jews and Germans) back to Bremen once the ghetto had been liquidated in 1944.

83. The photograph is numbered Lodz B 46 in the Jewish Museum–Frankfurt collection.

84. In the correspondence and records of the ghetto that are kept in the Lodz city archives, we note that Germans at all administrative levels had to apply for permission to leave the ghetto. If they did not attend a meeting, they were obliged to provide a written explanation, and every hour of their working day had to be accounted for.

85. This excerpt is read in voice-over in Dariusz Jablonski's *Fotoamator*.

86. Genewein is known to have studied and worked as a salesman in Austria before the war. He joined the NSDAP in either 1932 or 1938 and was sent to Lizmannstadt in June 1940.

87. Amateur photography thrived in central Europe in the interwar period, primarily because there was such a strong tradition already in place, with clubs, publications, and photography schools that nurtured the new technical means of expression and experimentation.

88. USHMM, image 65752/CD 0463; USHMM, image W/S74501/CD0111; USHMM, image 95181A and B.

89. Baer, *Spectral Evidence,* 130.

90. Allan Sekula explains that this manipulation of the photograph in the archive was a way of colonizing the unpredictability of the documentary photograph and its contents as handed down by the regulatory institutions of the nineteenth century. Sekula, "The Body and the Archive."

91. I am referring here to the previously mentioned rejection of the plans to build the museum displaying Jewish culture. See Freund, Perz, and Stuhlpfarrer, "Bildergeschichten—Geschichtsbilder," 54–55.

92. Ibid.

93. For an excellent history of color photography, especially as it has developed in Germany, see *Farbe im Photo: Die Geschichte der Farbphotographie von 1861 bis 1981* (Köln: Josef-Haubrich-Kunsthalle, 1981), exhibition catalog.

94. Michael Kuball, "Der Farbfilm," in *Familienkino,* vol. 2, 123.

95. See Brian Winston, "The Case of Color Film," in *Technologies of Seeing: Photography, Cinematography, and Television* (London: BFI, 1996), 39–57. Even though Winston discusses here moving-image negative film, the development of color photography went hand in hand with that of color film. See Gert Koshofer, "Geschichte der Farbphotograpfie in der Popularisierungszeit," in *Farbe im Photo,* 139.

96. See Peter Hayes, *Industry and Ideology: IG Farben in the Nazi Era* (London and New York: Cambridge University Press, 1987). The chemical dye and transfer company grew exponentially in the first half of the century, and it is

often argued that the Holocaust could not have taken place without this successful German company. Certainly it had the factories, the engineering, the technical skill, and the vast line of products that made a close relationship with the political party of a country at war mutually beneficial. I. G. Farben is best known for its production of Zyklon B, the chemical used in the gas chambers. However, it also furnished the Nazis with weapons, gasoline, rubber, chemicals, plastics, and other indispensable products that were critical to the high level on which the war effort functioned. See also Richard Sasuly, *IG Farben* (New York: Boni and Gaer, 1947). Sasuly argues that the Nazi collusion with I. G. Farben was not only essential to the war effort but extended further and wider than appeared to be the case from the outside. This was because it embraced subsidiaries such as Agfa and Bayer.

97. Rolf Sachsse, "Farbe im Foto und als Erinnerung," in *Die Erziehung zum Wegsehen: Fotografie im NS-Staat* (Dresden: Philo Fine Arts, 2003), 147–53.

98. See Koshofer, "Geschichte der Farbfotografie in der Popularisierungszeit." This belief was so fundamental to the propaganda program that in 1944, when the NS knew they were losing the war, Goebbels ordered that *Kolberg* be made in color.

99. Koshofer, "Geschichte der Farbfotografie in der Popularisierungszeit," 140.

100. In 1942 Kodacolorfilm produced a negative film with completely anchored couplers in each emulsion layer and consequently took over as the market leader. Ibid.

101. This connects to the discourse around the value of the scientific and medical experiments performed by the Nazis. In these discussions, the value is always in tension with the moral issue of using their results for medical research. See the essays collected in John J. Michalczyk, ed., *Medicine, Ethics, and the Third Reich: Historical and Contemporary Issues* (Kansas City, Mo.: Sheed and Ward, 1994), for example, Robert L. Berger, "Nazi Science—The Dachau Hypothermia Experiments," 87–100, and Michael Franzblau, "Relevance of Nazi Medical Behavior to the Health Profession Today," 197–98.

102. Frances Guerin, "Reframing the Photographer," 54.

103. Struk, "Interpretations of the Evidence," in *Photographing the Holocaust,* esp. 206–10.

104. A similar use of the images can be found in the film version of the book, *Łódź Ghetto,* dir. Kathryn Taverna and Alan Adelson (1989, Jewish Heritage Project). Genewein's color photographs are unidentified, presented side by side with images by Henryk Ross, Mendel Grossman, and others. Once again, the unattributed photographs are in the service of the familiar narrative of the ghetto. Baer gives another, more generous reading of the reuse of these images.

See Ulrich Baer, "Revision, Animation, Rescue: Color Photographs from the Łódź Ghetto and Dariusz Jablonski's *Fotoamator*," in *Spectral Evidence,* ed. Baer, 147–49.

105. This was made clear in a conversation with the author in 1998.

106. For discussions of the role of pictures in contemporary media and art forms in particular, see W. J. T. Mitchell, *Picture Theory: Essays on Verbal and Visual Representation* (Chicago: University of Chicago Press, 1995).

107. Dawid Sierakowiak, *The Diary of Dawid Sierakowiak: Five Notebooks from the Łódź Ghetto,* ed. Alan Adelson, trans. Kamil Turowski (New York: Oxford University Press, 1996).

108. USHMM, image 74514A.

109. Andrea Liss, "The Identity Card Project and the Tower of Faces at the United States Holocaust Memorial Museum," in *Trespassing through Shadows: Memory, Photography, and the Holocaust* (Minneapolis: University of Minnesota Press, 1998), 13–37.

110. Dawid Sierakowiak, *The Diary of Dawid Sierakowiak,* 271.

111. Similarly, when I first visited the *Holocaust Exhibition* at the Imperial War Museum in 2001, Genewein's photographs were presented among the unacknowledged photographs taken by anonymous and potentially well-known photographers. Again the images were exhibited as documents of the reality of day-to-day life in the ghetto, visual illustrations of the narrative that, typically in a Holocaust museum, leads through the sites of roundup, ghettoization, deportation, incarceration, and death. The publicity material for the exhibition claimed, "Photographs, documents, newspapers, artifacts, posters and film offer stark evidence of persecution and slaughter, collaboration and resistance." Holocaust Exhibition Web site, http://london.iwm.org.uk/server/show/nav.00b005.

112. Barbie Zelizer, *Remembering to Forget.*

113. W. G. Sebald, *The Emigrants,* trans. Michael Hulse (London: Vintage, 2002).

114. See, for example, Carol Jacob's reading of the images in "What Does It Mean to Count? W. G. Sebald's *The Emigrants,*" *MLN* 119 (2005): 905–29.

115. Mitchell, "Ekphrasis and the Other," in *Picture Theory,* 181.

116. Stefanie Harris, "The Return of the Dead: Memory and Photography in W. G. Sebald's Die Ausgewanderten," special issue on sites of memory, *German Quarterly* 74, no. 4 (Autumn 2001): 380.

117. Sebald, *The Emigrants,* 237.

118. Ibid., 235.

119. For a more elaborate though slightly different interpretation of the film, see Guerin, "Reframing the Photographer and His Photographs."

120. Between October 16 and November 4, 1941, some twenty thousand Jews from the cultural centers of Germany, Austria, Bohemia, and Moravia (including Prague and Vienna) were resettled into the Lodz Ghetto. Curiously, either this period was not chronicled by the ghetto administration or these entries have been lost. See Dobroszycki, *The Chronicle of the Łódź Ghetto, 1941–1944*, 78, n. 92.

121. I do not mean to relativize the truth of the Holocaust. The constant search for ethically substantial representations of the Holocaust over the past fifteen years or so has, in part, responded to Hayden White's claim that anything goes, that all representations contribute something to an event that cannot ultimately be represented. See Hayden White, *Tropics of Discourse: Essays in Cultural Criticism* (Baltimore, Md.: John Hopkins University Press, 1978). The difference of *Fotoamator* is its "correction" or reassessment of the reality contained in Genewein's images. The truth espoused by the film is quite foreign to that intended by Genewein.

122. Jablonski's recontextualization might be criticized here. For the methodical detachment was only one aspect of the Nazis' more mixed approach to operations that were carried out with equal measures of "detachment and brutality, distance and cruelty, pleasure and indifference." To eschew or overlook the irrational physical violence committed under the auspices of building a strong and productive Germany is potentially tantamount to ignoring its existence. Nevertheless, the task of *Fotoamator* as witness is not to represent the totality of the German modus operandi. Omer Bartov succinctly captures the dialectic of the German genocide of the Jews with these descriptive nouns. However, his larger argument here that the Holocaust was intimately conjoined to the technological modernity would need to be afforded a more thorough examination than is possible here. See Omer Bartov, *Murder in Our Midst: The Holocaust, Industrial Killing, and Representation* (Oxford: Oxford University Press, 1996), quotation on 67.

123. The privileged position of certain Jews, the *Judenrat*, within ghetto administration has been the subject of much debate, most notably since Hannah Arendt made her claims regarding the self-interested actions of the *Judenrat* in her report on Adolf Eichmann's trial in Jerusalem. See Hannah Arendt, *Eichmann in Jerusalem: A Report on the Banality of Evil* (London: Penguin, 1963). Even though Arendt brought considerable attention to this controversial argument, it was first articulated by Raul Hilberg in his history *The Destruction of the European Jews* (London: Holmes and Meier, 1985). Indeed, perhaps the most controversial *Judenrat* figure of all was Chaim Rumkowski. The question about him has always been, Was his unquestioned (at least in public) support of the Germans a strategy

to ensure the survival of the ghetto devised by someone who knew that the alternative would be a concentration camp? Or was he indeed a totalitarian leader making decisions based on his own meglomaniacal motivations? See Alan Adelson, "Notes on Rumkowski," in *Łódź Ghetto: Inside a Community under Siege,* ed. Alan Adelson and Robert Lapides (New York: Viking, 1989), 489–94.

4. Europe at War in Color and Motion

1. For a more detailed version of this argument, see Frances Guerin, "The Energy of Disappearing: Problems of Recycling Amateur Nazi Film Footage," *Screening the Past* 17 (November 2004), http://www.latrobe.edu.au/screeningthepast.

2. See the following discussion of Bundesarchiv-Filmarchiv (Berlin), film 20814.

3. Berchtesgaden is the mountain region in Germany where the Berghof was located. The area was purchased by the Nazi Party in the 1920s and in the 1930s became an outpost for the Reich Chancellery Office.

4. For detailed information on this, see Gert Koshofer, *Color.*

5. It is interesting to note that far more amateur filmmakers were ready to experiment with color motion pictures than were photographers. At least there appear to have been far more color films than photographs made by amateurs during this period. This may be because the image in the viewfinder was always in color and thus, as Alexandra Schneider points out, probably only the talented filmmakers were creative in their translation of color into black and white.

6. Koshofer, *Color,* 88. Koshofer cites Carl Hoffmann's *Ein Lied Verklingt* (summer 1938) as the first (short) color film.

7. See Natalie Kalmus, "Color Consciousness," in *Color: The Film Reader,* ed. Angela Dalle Vacche and Brian Price (London: Routledge, 2006), 24–33; Natalie Kalmus, "Colour," in *Behind the Screen: How Films Are Made,* ed. Stephen Watts (London: Barker, 1938), 116–27.

8. The same tension was debated in critical discourses on color film in this period. See Steve Neale, "Colour and Film Aesthetics," in *The Film Cultures Reader,* ed. Graeme Turner (London: Routledge, 2001), 85–94.

9. Martina Roepke, "Bewegen und Bewahren: Die Wirklichkeit im Heimkino," in *Geschichte des dokumentarischen Films in Deutschland,* bd. 3, *1933–1945,* ed. Peter Zimmermann and Kay Hoffmann (Stuttgart: Reclam, 2005), 285–98, esp. 295–96.

10. Dudley Andrew, "The Post-War Struggle for Colour," in *Color,* ed. Dalle Vacche and Price, 44.

11. See the discussion in Yosefa Loshitsky, ed., *Spielberg's Holocaust: Critical Perspectives on Schindler's List* (Bloomington: Indiana University Press, 1997).

12. Quoted in Jeffrey Shandler, "Schindler's Discourse: America Discusses the Holocaust and Its Mediation, from NBC's Miniseries to Spielberg's Film," in *Spielberg's Holocaust*, ed. Loshitsky, 155.

13. Sara R. Horowitz discusses these strategies for authenticity in "But Is It Good for the Jews? Spielberg's Schindler and the Aesthetics of Atrocity," in *Spielberg's Holocaust*, ed. Loshitsky, 119–39.

14. This discussion was echoed in American journals of the time. See Scott Higgins, "Demonstrating Three-Colour Technicolor: Early Three-Colour Aesthetics and Design," *Film History* 12, no. 4 (2000): 358–83. See also Scott Higgins, "Technology and Aesthetics: Technicolor Cinematography and Design in the Late 1930s," *Film History* 11, no. 1 (1999): 55–76.

15. For example, Bundesarchiv-Filmarchiv, film 20349, which was shot by a Wehrmacht soldier, takes us to Saaralben, where a French time bomb has set a house on fire. See also Bundesarchiv-Filmarchiv, film 1824.

16. Bundesarchiv-Filmarchiv, film 20349.

17. See, for example, Robert Delaunay, *Saint Séverin* (1909), Minneapolis Institute of Art; Ludwig Meidner, *Burning City* (1913), Collection of Mr. and Mrs. Morton D. May, St. Louis; Franz Marc, *Fighting Forms* (1914), Bayerische Staatsgemäldesammlungen, Munich.

18. Neale, "Colour and Film Aesthetics," 86, emphases in original.

19. See, for example, Carl Friedrich Schinkel, *Gothic Cathedral by a River* (1813–14), Nationalgalerie, Berlin. See also Ernst Ferdinand Oehme, *Cathedral in Winter* (1821), Gemäldegalerie Neue Meister, Dresden.

20. Bundesarchiv-Filmarchiv, film 1824. The research notes accompanying the footage confirm this.

21. This argument about film was in circulation at the time in Germany. The best-known example of the discourse is, of course, Lotte Eisner's *The Haunted Screen: Expressionism in the German Cinema and the Influence of Max Reinhardt*, 2nd ed., trans. Roger Greaves (Berkeley and Los Angeles: University of California Press, 2008), originally published in 1969.

22. I am grateful to Roger Hallas for pointing out this interpretation.

23. See, for example, Bundesarchiv-Filmarchiv, film 2382.

24. Adolf Hitler, *Mein Kampf*, trans. Ralph Mannheim (New York: Mariner Books, 1998); Steven Heller, *The Swastika: Symbol beyond Redemption?* (New York: Allworth, 2000). Steven Kasher also has a short section on the design of the swastika in his article "The Art of Hitler," *October* 59 (Winter 1992): 48–85. This article gives a good overview of the various avenues of visual propaganda explored by Hitler.

25. There is a substantial amount of footage comprised of images of the sky

shot from the cockpits of fighter pilots held in the Bundesarchiv-Filmarchiv, Berlin. See, for example, Bundesarchiv-Filmarchiv, film 15150, attributed to a Werner Hofe, and the anonymous footage of Bundesarchiv-Filmarchiv, film 244956.

26. See Bundesarchiv-Filmarchiv, film 244956.

27. See, for example, Willi Nissler, "Was machen wir nun mit dem Farbenfilm?" in *Jahrbuch des Kino-Amateurs,* ed. Willy Frerk *Photokino-Verlag* (Berlin: Hellmut und Elsner, 1938): 16–24; Kurt Fritsche, "Fehler bei Aufnahmen auf Agfacolor-Umkehrfilm," *Fotorat* no. 29 (1955): 44–48. A special issue of the journal on "Photographic mistakes and how we remedy them."

28. In addition to Schneider, *Die Stars sind wir.*

29. Griffiths, *Wondrous Difference: Cinema, Anthropology, and Turn-of-the-Century Visual Culture.*

30. Tom Gunning, "The Cinema of Attractions: Early Film, Its Spectator, and the Avant-Garde," in *Early Cinema: Space, Frame, Narrative,* ed. Thomas Elsaesser and Adam Barker (London: British Film Institute, 1989).

31. In addition to his canonical article "The Cinema of Attractions," see Tom Gunning, "Loïe Fuller and the Art of Motion: Body, Light, Electricity, and the Origins of Cinema," in *Camera Obscura, Camera Lucida: Essays in Honor of Annette Michelson,* ed. Richard Allen and Malcolm Turvey (Amsterdam: Amsterdam University Press, 2003), 75–89.

32. See Martin Loiperdinger, ed., *Oskar Messter: Filmpionier der Kaiserzeit* and *Oskar Messter, Erfinder und Geschäftsmann, KINtop Schriften* 2 and 3 (Basel: Stroemfeld/Roter Stern, 1994).

33. USHMM, tape 202B, story 323, file 950. The title has been given to the film by the museum.

34. As Michael Kuball confirms, "The war in amateur film was quite different from the war seen by official film. . . . It is the everyday life of the soldier." Michael Kuball, *Familien-Kino,* 2:104–5.

35. Schneider, "Home Movie-Making and Swiss Expatriate Identities," 170.

36. Ibid., 170–71.

37. For more on the relationships among war, modernity, and representation, see Bernd Hüppauf, ed., *War, Violence, and the Modern Condition* (Berlin: de Gruyter, 1997).

38. Lebensraum—literally, "living space"—was a political-ideological notion at the heart of Hitler's expansionist policies. The German people needed more lebensraum to create wealth and excess. Such space would be in plentiful supply in Poland, Russia, and other Slavic countries once their populations were exterminated. See Richard Evans, *The Coming of the Third Reich* (London: Penguin, 2004).

39. Bundesarchiv-Filmarchiv, film 20349. This view is typical of films taken of Kharkov.

40. Speeding trains and other forms of motorized transport are common sights in silent films, and the sibling relationship between these technologies has been discussed by critics. See, for example, Lynne Kirby, *Parallel Tracks: The Railroad and Silent Cinema* (Durham, N.C.: Duke University Press, 1997). See also Wolfgang Schivelbusch, *The Railway Journey: The Industrialization and Perception of Time and Space* (Berkeley and Los Angeles: University of California Press, 1987). For another type of dizzying camera movement that replicates the motion of technological modernity, see a film such as E. A. Dupont's *Varieté* (1925), which was set in the Berlin Wintergarten. Siegfried Kracauer also builds his argument on the specificity of German silent cinema as a cinema of motion based on F. W. Murnau's "unchained camera" in *Der letzte Mann* (1925).

41. Odin, "La question de l'amateur," 56. This notion of the amateur as a "lover of cinema" is not unique to Odin. It is often remarked upon because the word itself comes from the Latin *amator* or lover, which, in turn, derives from *amare,* to love. See Péter Forgács, "Wittgenstein Tractatus: Personal Reflections on Home Movies," in *Mining the Home Movie,* ed. Ishizuka and Zimmermann, 47.

42. Waldemar Lydor, "Hans Söhnker farbfilmt," *Kino-Amateur* 12, no. 1 (January 1939): 14–15.

43. Paul W. John, "Das Wasser vor der Filmkamera," *Kino Amateur* 12, no. 2 (February 1939): 35–37. See also Hellmut Lange, "Die Bewegung," in *Amateur-Filme mit Erfolg* (Vienna: Otto Elsner Verlagsgesellschaft, 1939), 64. Lange claims, "Der Film dient der Darstellung der Bewegung: Er lebt von der Bewegung und zieht seine Wirkung aus ihr" (The film functions to represent movement. It thrives on movement and takes its effect from it).

44. This is explored by film theorists of the period.

45. This is taken from a section of Michael Kuball's film *Soul of a Century: Private Filmtagebücher des 20. Jahrhunderts,* 2002.

46. Here (and in this film more generally) we are seeing the Nazi symbols at work. So it is still not in the aesthetic that the images are Nazified; it is in the appearance and reappearance of familiar Nazi symbols. And these are made all the more noticeable by the use of the color film.

47. Early travelogue film was available between 1895 and 1905. Jeffrey Rouff, ed., *Virtual Voyages: Cinema and Travel* (Durham, N.C.: Duke University Press, 2006), 1. It was not until well into the 1960s that the working classes in all societies were given the opportunity to document their lives in moving images.

48. Paula Amad makes an interesting distinction between tourism as a distraction from the tensions and stasis of life at home and travel as pursued in the

name of discovery and active experiences. The German films of the soldiers are very much of the first order. See Paula Amad, "Between the 'Familiar Text' and the 'Book of the World': Touring the Ambivalent Contexts of Travel Films,'" in *Virtual Voyages,* ed. Rouff, 106–7.

49. See the articles collected in Rouff, *Virtual Voyages.*

50. Forgács, "Wittgenstein Tractatus," 49.

51. Alexandra Schneider, "Homemade Travelogues: *Autosonntag,*" in *Virtual Voyages,* ed. Rouff, 157–73.

52. Jennifer Lynn Peterson, "'The Nation's First Playground': Travel Films and the American West, 1895–1920," in *Virtual Voyages,* ed. Rouff, 79–98.

53. Christa Reim, "Mit der Kamera auf Reisen," *Kino Amateur* 12, no. 2 (February 1939): 38–39.

54. See also Heather Norris Nicholson, "British Holiday Films of the Mediterranean: At Home and Abroad with Home Movies, c. 1925–1936," *Film History* 15, no. 2 (2003): 152–65.

55. Here we note the interesting difference between film and photographs: although multiple copies of a single photograph were made, this was not the case with the films. And yet there was still an element of repetition when people were shooting the same events and scenes from the same perspective.

56. Allison Griffiths, "The Ambivalent Context of Travel Films," in *Virtual Voyages,* ed. Rouff, 106–7.

57. This idea of the tourist's need to appropriate and own (commodify) through visualization is often spoken of by scholars of travel and tourist films. See, for example, Nicholson, "British Holiday Films of the Mediterranean," 60.

58. Jörg Echternkamp, "At War, Abroad and at Home," in *Germany and the Second World War,* vol. 9/1, *German Wartime Society 1939–1945: Politicization, Disintegration, and the Struggle for Survival,* ed. Ralf Blank et al. (New York: Oxford University Press, 2008), 1–92, quote on 2.

59. Ibid.

60. Ibid., 11.

61. Patricia Zimmermann, "Introduction," in *Mining the Home Movie,* ed. Ishizuka and Zimmermann, 4. Citron, *Home Movies and Other Necessary Fictions;* Maya Deren, "Amateur vs. Professional," *Film Culture* 39 (Winter 1965): 45.

62. See, for example, the photographs taken in France found in the Eva Braun albums, which I discuss in chapter 5.

63. This is how the footage is labeled in the documentation accompanying it in the Bundesarchiv, Berlin. *Im Warschauer Ghetto,* Bundesarchiv-Filmarchiv, film 3366, reel no. 37633. Acquired by the Bundesarchiv February 23, 1999.

64. Again, I hesitate to ascribe these fragments unreservedly to a Nazi

German because they can be so similar to the photographs taken, for example, by Henryk Ross in the Lodz Ghetto. A recent publication of Ross's photographs further complicates the naïve urge to locate the photographer's or filmmaker's political and ideological affiliation in the image. See Thomas Weber, *Łódź Ghetto Album: Photographs by Henryk Ross,* ed. Timothy Prus (London: Chris Boot/ Archive of Modern Conflict, 2004).

65. For example, in recent years the activities of the Jewish councils established by the Nazis in the ghettos have come into the spotlight. The complicity of these servants of Nazism was often carried out in the name of self-preservation, though it is sometimes argued that they could have done more to save their fellow Jews. See Isaiah Trunk and Stephen Katz, *Judenrat: The Jewish Councils in Eastern Europe under Nazi Occupation* (Lincoln: University of Nebraska Press, 1996). Trunk is always sympathetic to the activities of the Jewish councils. For insight into the struggles and conflicts caused by the hierarchical organization of ghetto Jews, see Primo Levi, "The Gray Zone," in *The Drowned and the Saved* (London: Vintage, 1989), 36–69.

66. Here I am referring to the privileges afforded the *Judenrat,* or the Jewish government appointed by the Nazis to run the ghettos. See Hilberg, *The Destruction of the European Jews,* for the initial critique of the Jewish councils. Since Hilberg's seminal history appeared, many others have followed. Also, just because people walked past the children does not mean that they were guilty of deliberate abuse or abandonment. I am merely drawing attention to the complexity of the images.

67. This is Bundesarchiv-Filmarchiv, film 20814.

68. Ishizuka and Zimmermann, *Mining the Home Movie,* 51.

69. Interestingly, these are the films that are most exploited by capitalism for their commercial use after the war.

70. Zimmermann, "Introduction," in *Mining the Home Movie,* ed. Ishizuka and Zimmermann, 9.

71. Here I am reminded of a film that depicts the slow, methodical building of a U-boat over the course of ninety minutes in washed-out brown and green images. The footage, which begins with the snow-covered landscape, is in the Michael Kuball private archives.

72. Although the shot is overexposed and it is impossible to identify the soldiers, we know they are of various ranks and from different parts of the military due to their uniforms.

73. This information accompanied the film footage when it was given to Michael Kuball.

74. See films such as *A Painful Reminder: Evidence for All Mankind* (1985,

Granada Television) and *Memory of the Camps* (1985, PBS *Frontline*), which depict devastating images of Bergen-Belsen, Dachau, and Ebensee captured by the Allies upon liberation.

75. See discussions of the difficulties of indoor lighting with the technology and film material available, such as Dr. Lothar Krügel, "Objektumfang, Beleuchtung und Belichtung," in *Jahrbuch des Kino Amateurs,* ed. Willy Frerk (Berlin: Photokino-Verlag, Hellmut und Elsner, 1941), 59–73. Of the hundreds of meters of color footage shot during the period, this is only one of a handful of fragments I have seen shot indoors. Another watches, for example, the son of a high-ranking Nazi officer open his Christmas present: a model fighter plane.

76. Given that no women appear in the footage, together with the fact that this was a predominantly male culture, we assume that it was a man behind the camera. However, this cannot be verified.

77. On these issues see publications such as the yearly *Jahrbuch des Kino-Amateurs.* See also Helmut Lang, *Amateur-Filme mit Erfolg* (Berlin: Elsner, 1939) and other material published by amateur film groups in Germany in the years leading up to and including the Second World War.

78. The real home movie footage in Bundesarchiv-Filmarchiv, film 21107, works well as an example here. It could easily have been our ancestors pictured on the farm. But at the same time there is all of the association of the ideal National Socialist family.

79. Omer Bartov, "*Mein Krieg,*" *American Historical Review* 97, no. 4 (October 1992): 1155–57.

80. Hal Foster, "An Archival Impulse," *October* 110 (Fall 2004): 3–22, esp. n. 15.

81. Michael Chanan, "History and Memory," in *The Politics of Documentary* (London: British Film Institute, 2007), 256–71, esp. 268.

5. At Home, at Play, on Vacation with Eva Braun

1. The other well-known home movies are those of the Goebbels family, brought to widespread public attention through their recycling in Lutz Hachmeister and Michael Kloft's *Das Goebbels Experiment* (*The Goebbels Experiment,* 2005, First Run Features). Herman Goering's wife also took photos. For a comprehensive shot breakdown of the eight reels of Braun's home movie footage, see Geoff Walden's site, http://www.thirdreichruins.com/eva_movies.htm.

2. Citron, *Home Movies and Other Necessary Fictions,* 23, 25.

3. Carolyn Steedman, *Dust* (Manchester, England: Manchester University Press, 2001), especially "The Space of Memory: In an Archive," 66–88.

4. Dagmar Barnouw, *The War in the Empty Air* (Bloomington: Indiana

University Press, 2008). Barnouw is also interested in the Germans who were victims of the war. This is another area that was underattended to until the past few years. Other texts that were key to lifting the silence were W. G. Sebald's *On the Natural History of Destruction,* trans. Anthea Bell (New York: Random House, 2003), and Günter Grass's *Crabwalk,* trans. Krishna Winston (London: Harcourt, 2004), (originally published as *Im Krebsgang,* Göttingen, 2002).

5. Martina Roepke, "Filmfamilien im Heimkino des 'Dritten Reiches,'" in *Privat-Vorstellung: Heimkino in Deutschland vor 1945* (Hildesheim: Georg Oms, 2006), chap. 4. See also Christian Boltanski, *Sans Souci* (Portikus and Cologne: Walter König, 1991), in which he re-presents family photo albums of Nazi soldiers.

6. Citron, *Home Movies and Other Necessary Fictions,* 25.

7. The original diary is kept in the National Archives in Washington. For a full transcript of the diary in English, see http://www.humanitas-international. org/holocaust/evadiary.htm. For the faked diary, see also *The Diary of Eva Braun,* rev. ed., ed. Alan Bartlett (Bristol, England: Spectrum International, 2000).

8. This characterization of Eva Braun has remained consistent since renowned British Hitler historian Hugh Trevor-Roper first referenced her. He quotes Albert Speer in defense of his argument that Eva Braun is "a disappointment to history." She disappointed because she "had none of the colourful qualities of the conventional tyrant's mistress. She was neither a Theodora, nor a Pompadour, nor a Lola Montez . . . and because she appealed to the triviality not the extravagancy of [Hitler's] nature, she is herself uninteresting." Hugh Trevor-Roper, *The Last Days of Hitler* (London: Macmillan, 1947), 103, 104.

9. See, for example, Angela Lambert, *The Lost Life of Eva Braun* (London: Century, 2006).

10. There are many images of Hitler, but there is no sense in which she was attempting to expose, even document, what other eyes were not allowed to see. As in the cases of all her other subjects, there is an entire album devoted to images of him (Album 6, NARA 242-EB-6)—but there are also four albums devoted to the children of Herta Schneider.

11. Angela Lambert, "The Photograph Albums and Home Movies," in *The Lost Life of Eva Braun,* 161–74.

12. Ibid, 167.

13. Quotation from Michael Roth, "Ordinary Film: Péter Forgács's *The Maelstrom,*" in *Mining the Home Movie,* ed. Ishizuka and Zimmermann, 67.

14. Marianne Hirsch, "Introduction," in *Family Frames,* 1–15. Citron also discusses the "truth" of home images and, in keeping with her argument regarding their double entendre, works to expose the ambivalence of this truth.

15. Citron, *Home Movies and Other Necessary Fictions,* 17.

16. Barthes, *Camera Lucida,* esp. part 1, 3–7.

17. This information is on the record of the photographs at NARA. See NARA 242-EB.

18. Lambert, *The Lost Life of Eva Braun,* 168. Lambert does not acknowledge her sources for this information; however, it can be assumed that she acquired it from other biographies of Braun.

19. Thanks to Geoff Walden for a lot of this information on Eva Braun's photography practice.

20. NARA 242-EB-6-44/45.

21. NARA 242-EB-7-14 to 242-EB-7-48.

22. See Geoff Walden's annotations, which identify all of the images, at http://www.thirdreichruins.com/eva_movies.htm (accessed June 2007).

23. Traudl Junge, *Until the Final Hour: Hitler's Last Secretary,* trans. Anthea Bell, ed. Melissa Müller (London: Weidenfeld and Nicolson, 2003), 72, 107. Here Junge claims that Braun screened her movies in her room or in the bowling alley downstairs. However, in another book, *Er war mein Chef,* her diary is said to relate the way the films were screened in the Great Hall, where the tapestries were raised and a screen lowered to create a movie theater. It is possible that there is an inconsistency to Junge's memories but equally as likely that Braun screened her films in various locations in the Berghof. Certainly in two images, NARA 242-EB-18-44 A and B, we note what appears to be a film screen behind Hitler as he plays with a child in the Great Hall. See Christa Schröder and Anton Joachimsthaler, *Er war mein Chef: Aus dem Nachlaß der Sekretärin von Adolf Hitler* (Munich: Herbig, 2002).

24. See Brigitte Peuker, "The Fascist Choreography: Riefenstahl's Tableaux," *Modernism/Modernity* 11, no. 2 (2004): 279–97. Peuker argues that the fascist in Riefenstahl's aesthetic comes not in the form of the film, its use of fragments in the search of coherence (an argument begun by Siegfried Kracauer and taken up repeatedly elsewhere), but also in the ideal and iconic status of the body in her films and Fanck's films, in which she acted.

25. Steve Neale was the first to point this out in his important essay *"Triumph of the Will."*

26. On Riefenstahl and *Olympiade,* see Cooper Graham, "'Olympia' in America, 1938, Riefenstahl, Leni, Hollywood, and the Kristallnacht," *Historical Journal of Film Radio and Television* 13, no. 4 (1993): 433–50; Taylor Downing, *Olympia* (London: British Film Institute Publishing, 1992).

27. See Roepke on the constant encouragement of amateurs by the film clubs, journals, and handbooks such as *Film für Alle* and *Der Film-Amateur* to strive

for professional standards in their filmmaking. See especially Martina Roepke, "Bewegen und Bewahren: Zur diskursiven Konstruktion des Heimkinos," in *Privat-Vorstellung, 37–104*.

28. Claudia Koonz, *Mothers in the Fatherland: Women, the Family, and Nazi Politics* (New York: St. Martin's Press, 1987).

29. Gisela Bock, "Racism and Sexism in Nazi Germany: Motherhood, Compulsory Sterilization, and the State," in *When Biology Became Destiny*, ed. Renate Bridenthal, Atina Grossmann, and Marion Kaplan (New York: Monthly Review Press, 1984), 271–96.

30. See, for example, the many articles in Agfa's own monthly journal, *Agfa-Photoblätter: Monats-Zeitschrift für alle Fragen der Amateur-Photographie und Kinematographie*, ed. I. G. Farbenindustrie Aktiengesellschaft AGFA Berlin (March 1926–October 27, 1933).

31. NARA 242-EB-31-24 C.

32. Not all of the albums reveal these insights so clearly, because they are not all chronologically organized. And even when they are, it is possible to see that the images were taken with different cameras and some were obviously taken by professionals.

33. For a history of the developments in photography and photographic processing, see Beaumont Newhall, *History of Photography: From 1839 to the Present* (New York: Museum of Modern Art, 1982).

34. See Trachtenberg, *Classic Essays on Photography.*

35. See, for example, *Film für Alle: Zeitschrift für der Amateur-Filmschaffen* and *Der Film-Amateur: Organ des Bundes der Film-Amateure e.V.,* Berlin, both of which were published throughout the war years.

36. NARA 242-EB-31-10.

37. NARA 242-EB-31-45.

38. NARA 242-EB-31-10.

39. The power dynamics disrupted would be similar to those discussed in relation to Genewein's photographs of the Lodz Ghetto prisoners in chapter 3.

40. For a discussion of the facial gestures and expressions of emotion made possible through the use of the camera, see Max Kozloff, *The Theatre of the Face* (London: Phaidon, 2007). We see these gestures again in the form of intense movement of the glances in NARA 242-EB-31-32.

41. NARA 242-EB-18-4.

42. See NARA 242-EB-18-4.

43. The photographs have also been put up for sale at Sotheby's or Christie's, which adds a whole new dimension to them, but again, the interest is not in the photos as such but in the fact that they include images of Hitler and were taken by his mistress.

44. Annette Kuhn, *Family Secrets: Acts of Memory and Imagination* (London: Verso, 1995), 19.

45. Ibid., 20.

46. Alexandr Sokurov's 1999 film *Moloch* addresses this issue.

47. The use of voice-over for identification of the authors of amateur films can be found in numerous examples. To take one, a film such as Lisa Lewenz's *A Letter without Words* (1998) self-consciously inserts the documentarian both visually and in voice-over to identify herself and her paternal grandmother, who was the author of the recycled amateur footage from the 1940s. It was also common for the filmmaker to offer a commentary when he or she screened films for the family and invited friends.

48. Linda Rugg, *Picturing Ourselves: Photography and Autobiography* (Chicago: University of Chicago Press, 1997), 6.

49. Marianne Hirsch, *Family Frames*.

50. Ibid., 93, emphases in original.

51. Ibid., 11.

52. Ibid., 48.

53. Citron, *Home Movies and Other Necessary Fictions,* 23.

54. The references for this are copious; however, the work of photographers such as Cindy Sherman and Martha Rosler has consistently addressed the problem.

55. National Archives, photo 242-EB-22-13.

56. Julie Hirsch, *Family Photographs: Content, Meaning, and Effect* (New York: Oxford University Press, 1981).

57. Larry Sultan, *Pictures from Home* (New York: Harry N. Abrams, 1992).

58. Album 24 contains a number of such photographs.

59. The mystery woman is so called because her identity has never been revealed.

60. Koonz, *Mothers in the Fatherland.*

61. See ibid., especially "Consequences: Women, Nazis, and Moral Choice," 414–20.

62. Ibid., 416. Bormann was head of the party chancellery and Hitler's secretary from 1941 to 1945. Rudolf Hess was Hitler's deputy in the 1930s and early 1940 before he left for Scotland in 1941.

63. Anna Maria Sigmund, *Die Frauen der Nazis* (Munich: Heyne, 2000); Guido Knopp, *Hitler's Women,* trans. Angus McGeoch (New York: Routledge, 2003).

64. Josef Goebbels, "Deutsches Frauentum," *Signale der neuen Zeit: 25 ausgewählte Reden von Dr. Joseph Goebbels* (Munich: Zentralverlag der NSDAP, 1934), 118–26.

65. In official photographs and films, when the two are together, Hitler is

never just another man and Magda Goebbels is not seen as the wife of the propaganda minster. They are the father and mother of Germany, performing the roles of ideal, mythical characters.

66. Emmy Göring, *An der Seite meines Mannes* (Gottingen: Schueltz, 1967).

67. Quoted in Knopp, *Hitler's Women,* 24, emphasis in original.

68. Cate Haste, *Nazi Women: Hitler's Seduction of a Nation* (London: Macmillan, 2001), 54.

69. See Annette Kuhn, ed., "Die Arbeit der Frauen im Haus," in *Frauen im deutsche Faschismus,* band 2 (Dusseldorf: Schwann, 1989), 97–142.

70. The series is on this and the following page of the album: NARA 242-EB-6-33 A-C, NARA 242-EB-6-34 A-C.

71. In the following shot we see the same image without the frame provided by the window panes. So the first series of shots is like an exposition, and the next (242-EB-6-27A-C) is the shot itself.

72. Braun wrote, "Durch die Scheibe kann man allerhand sehen!"

73. Junge, *Until the Final Hour,* 75.

74. The same dilemma arising from the self-attested naïveté of the photographer/filmmaker has been confronted by all of the critics of Riefenstahl's work: Was Riefenstahl a creative genius, victim to her circumstances, or a scheming ideologue?

75. Linda Schulte-Sasse, "Leni Riefenstahl's Feature Films and the Question of a Fascist Aesthetic," *Cultural Critique* 18 (Spring 1991): 126.

76. It is worth noting that on occasions when filmmakers and participants have commented about their home movie or amateur collections, as Nico de Klerk observes in relation to *Volkskino: Amateur Films from the GDR* (1991), "their comments decades later do not significantly differ from what we, nonparticipants, would come up with." De Klerk notes the participants' and makers' mistaking of the images for something they are not, their uncertainty about what is represented, and so on. The same vagueness of memories is present in the commentary of filmmakers on the soundtrack of Harriet Eder's *Mein Krieg.* See Nico de Klerk, "Home away from Home: Private Films from the Dutch East Indies," in *Mining the Home Movie,* ed. Ishizuka and Zimmermann, 149.

77. ". . . and the Führer hears the news on the radio!" (NARA 242-EB-6-41); ". . . but nevertheless, Poland does not want to behave" (NARA 242-EB-6-42 A-F).

78. NARA 242-EB-7-14.

79. NARA 242-EB-7-51.

80. Jay Rosenblatt, *Human Remains* (1998, Danish Film Institute, Denmark).

81. I am reminded here of the digging of Alexander Kluge's Gaby Teichert in

Die Patriotnin (*Yesterday's Girl,* 1979). Teichert is a history teacher who literally goes digging into the earth in search of this period in German history that has been buried.

82. When I asked Rosenblatt for more information on where the footage came from, it took him some time to locate the archives; that is, he did not immediately know from where he had taken it.

83. This is also the image of Eva that is put on the Web. It is also how images probably taken by her sister or Hoffmann are used—as though they are hers—when in fact her own images are noticeably different from these—that is, she is never in them and they are not as dramatic and interesting as hers or, if they are interesting, it is for different reasons.

84. See http://www.europafilmtreasures.eu/ and http://romanoarchives. altervista.org/.

85. Henry Jenkins, "From YouTube to WeTube . . . ," in *Confessions of an Aca-Fan,* http://www.HenryJenkins.org/, February 13, 2008.

86. http://www.webalice.it/romanoarchives/.

87. http://www.youtube.com/user/clasicdocumentaries2#g/c/04BD795F783698E4.

88. http://www.youtube.com/watch?v=xjLg3GWzS3A&feature=related.

89. Henry Jenkins, *Convergence Culture: Where Old and New Media Collide* (New York: New York University Press, 2006), 155. On feminism and fan videos more generally, see "In Focus: Fandom and Feminism: Gender and the Politics of Fan Production," *Cinema Journal* 48, no. 4 (Summer 2009): 104–51.

90. Another user, who claims that it is important to remember history and not let World War II slip from our own histories, includes heavily manipulated material that was so clearly designed for an emotional response that it loses that power. In particular, he uses digital enhancement that makes footage on World War II into a science fiction film. See http://www.youtube.com/user/Librarian74112#p/a (accessed October 2009).

91. http://www.youtube.com/watch?v=9g5vmfwphQQ.

92. Ibid. Note that the comments at these Web sites should be read starting with the last one as the most recent.

93. Grass, *Crabwalk.*

94. Huyssen, "Monuments and Holocaust Memory in a Media Age," in *Twilight Memories: Marking Time in a Culture of Amnesia,* 254.

95. An eschewal of the archival object might in certain cases be a radical gesture, especially when the documentary image becomes freed of all claims to a definitive historical truth. However, here the result is highly problematic.

Index

Frances Guerin is senior lecturer of film studies at the University of Kent, England. She is the author of *A Culture of Light: Cinema and Technology in 1920s Germany* (Minneapolis, 2005) and coeditor with Roger Hallas of *The Image and the Witness: Trauma Memory and Visual Culture*.